DIGITAL
PHOTOGRAPHER'S
HANDBOOK

DIGITAL
PHOTOGRAPHER'S
HANDBOOK

TOM ANG

LONDON, NEW YORK, MUNICH,
MELBOURNE, DELHI

DK

To Wendy

Senior Editor Neil Lockley
Project Editor Richard Gilbert
Senior Art Editor Alison Shackleton
DTP Designer Adam Shepherd
Production Controller Heather Hughes

Managing Editor Adèle Hayward
Managing Art Editor Karen Self

Produced on behalf of Dorling Kindersley by
Sands Publishing Solutions
4 Jenner Way, Eccles,
Aylesford, Kent ME20 7SQ
Editor David Tombesi-Walton

Original edition produced on
behalf of Dorling Kindersley by
HILTON/SADLER
63 Greenham Road
London N10 1LN
Editorial Director Jonathan Hilton
Design Director Peggy Sadler

First published in Great Britain in 2002 by
Dorling Kindersley Limited
This revised edition published in 2004 by
DK Publishing, Inc.
375 Hudson Street
New York, New York 10014
04 05 06 07 08 10 9 8 7 6 5 4 3 2 1

Copyright © 2002, 2004
Dorling Kindersley Limited
Text copyright © 2002, 2004 Tom Ang

ISBN 0-7566-0346-3

Printed in China by Shenzhen Donnelley
Bright Sun Printing Co. Ltd
Reproduced by GRB Editrice s.r.l

Discover more at
www.dk.com

Contents

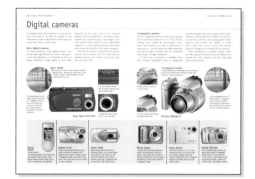

Chapter 2
Photography for the digital age

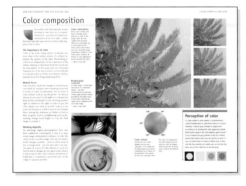

Chapter 3
A compendium of ideas

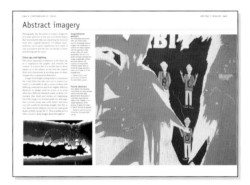

Contents

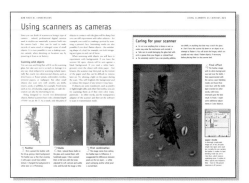

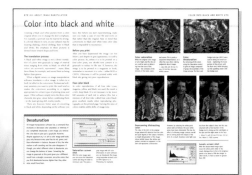

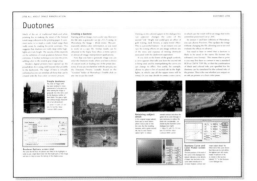

Chapter 6
The output adventure

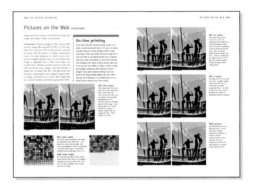

Introduction

One hundred and sixty years after the invention of photography, an enemy rose above the horizon. Digital imaging threatened to sweep away film, make the darkroom obsolete, and exile the hard-won craft skills of picture-making. In a short time the threat grew as numerous new enemies appeared, in the shape of more and more digital cameras, scanners, image-manipulation software, and the Web, all banding together to raze conventional photography to the ground.

As photographers watched with steadily increasing apprehension, however, the threat turned out to be the best friend photography could have hoped for. Instead of opposing conventional photography, digital technologies have in fact revitalized whole swaths of photographic practice, breathed fresh air into forgotten corners of image-making, and opened up a richly rewarding craft to more people than ever before.

In short, what was feared to be a destructive confrontation between conventional photography and digital technology has turned out to be a union of tremendous fecundity – one providing us with new worlds of practical, creative, and enjoyable potentialities.

The *Digital Photographer's Handbook* celebrates this union by bringing together, in one volume, all the best of classical photography techniques with a comprehensive survey of digital photography. So here you will find all the love and enthusiasm I have for conventional photography and its subtle craft skills for creating telling, effective, and rewarding images. At the

same time, I hope to share with you my thrill and wonder at the flexibility, power, and economies that are possible with digital photography. By learning how to bring the two together, you will in fact be operating at the leading edge of image-making, contributing to the development of what is nothing less than a visual powerhouse of as yet undreamed of potential.

This book's aim is to help you to gain the most from this powerhouse. It brings together a vast amount of technical information and practical advice and reveals numerous tips and tricks of the trade. It is the only book that combines a complete account of professional picture-making skills with a thorough grounding in image-manipulation techniques. And it is all offered in order to help you to improve, enjoy, and understand the medium of communication that is photography.

This *Digital Photographer's Handbook* has been fully updated to take account of the latest technologies and developments. Translated into many languages, the book has helped many readers on their journeys of visual, technical, and creative adventures, leading to personal discovery – I hope it will do the same for you. Ultimately, I hope the book will give you the help to surpass its teaching. For you to do so will be your greatest compliment to this book – at which point, you should congratulate yourself heartily.

1

Total photography

Starting out

Covering the basic principles underlying both digital and traditional photography, the range of equipment available for all budgets and degrees of expertise, and a good grounding in the technology – a wealth of information to help you make informed choices. And with its help you can easily keep up with the rapid changes taking place in digital photography. All the key concepts are clearly explained.

Choosing equipment

Many examples from the vast range of available digital and film-based equipment – including lighting equipment, memory cards, image-manipulation software, computers, monitors, scanners, printers, cameras, and lenses – are all clearly displayed and discussed to help you choose the items that best suit your requirements.

The latest technology

Here you will find explanations of the most up-to-date technology – how it works and what it does.

Photographic pathways

Many people will already have made a significant investment in photographic equipment over the years and so will wish, for the foreseeable future, to remain wedded to conventional image-making – recording "analog" pictures (*see opposite*) on traditional film. The good news is that this in no way bars them from the world of digital photography: all images (film negatives or positives, or color or black and white prints) can be digitally scanned and, from that point on, any work on them regarded as digital photography.

Something magical happens when you combine the pathways through film-based and digital photography. A world of unimagined opportunity opens to you, with more than one way to achieve nearly any end – and from every fresh option arises yet new creative opportunities. In short, total photography (the combination of analog with digital) gives you the best of both worlds. By increasing your options, it can inspire as it empowers. It is no exaggeration to say that the only limit is your imagination.

Digital route

Subject

Digital camera
Anything you can photograph using a conventional film-based camera can also be recorded as a digital representation of the subject using a digital camera.

Memory cards
A digital camera uses memory cards to store the digital representation of the subject.

Film-based route

Print

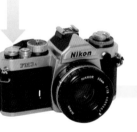

Negative Slide

Film camera
A conventional camera records an analog representation of the subject, with each image being recorded on an individual frame of film.

Film
Once exposed to light from the subject, minute changes take place in the composition of the image-carrying emulsion layers of the film. At this stage the image is invisible and is known as a latent image.

Processing
Processing the film in special chemicals amplifies the latent image so that a recognizable image of the subject appears. Depending on the film used, you could have a positive image (or slide) or a negative, which requires printing, in color or black and white.

Analog and digital

Analog representation of the world is the one we are most familiar with as it is based on a perceptible relationship between the representation (the movement of the hands of a clock, say) and the thing itself (the passage of time). Map locations possess relationships similar to the real places, so the map is an analog representation. Digital representation uses arbitrary signs whose meanings are predefined but bear no obvious relation to the thing. A digital watch could show the time in Chinese characters or Arabic numerals. Your zip code uses numbers arbitrarily to define a location. To know what the code refers to, you need a code book. Similarly, computer files (strings of symbols) may digitally represent the analog image you see as a print or negative. But a point on the negative corresponds to – is an analog of – a real thing in the original subject.

Storage
Once you are satisfied with the results of your work, you can store digital images on any of a range of removable media, including CDs, DVDs, and Zip and Jaz disks.

Processing in the computer
Images are downloaded directly into your computer as digital files. Now, using image-manipulation software, the digital adventure can begin.

Publish on the internet
If you are connected to the World Wide Web you can send your digital images anywhere in the world as an attachment to an email. Equally, if you have a Web site you could exploit the internet to reach a potentially enormous audience.

Scanning
Taking a print or a film original as your starting point, you can use a scanner to create a digital representation of your analog image. Each scan is an individual digital file and you can work on it as if it had been taken with a digital camera.

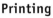

Printing
In the time it takes to prepare chemicals to print in a darkroom, you could run off several prints from a desktop printer – all in normal room light. And even with readily affordable printers, print quality easily comes close to photographic papers.

Digital pathways

Digital pathways through photography start with the digital capture of an image. But even here you have a range of choices: such an image may, for example, be obtained from a CD-ROM, or it could be downloaded from a Web site on the internet, transferred from a video camera, or, let's not forget, captured on a digital camera.

Once your image is in a digital format, it is then similar to any word-processor, spreadsheet, or other computer file. You can store it on normal computer hardware, such as a removable disk or your computer's internal hard disk, transfer the file between computers, send it around the world via the internet, and so on. Like any computer file, however, it must be in a form that will be recognized by the program or software before you can use it for image manipulation, combine it with text or other images, or print it out.

The digital adventure

Once an image is in a digital form, what you can do with it is practically endless. In addition, the flexibility and fineness of control you can exercise over the appearance of the image would simply be

Digital cameras
As well as still cameras, many video cameras and some cell phones have the capacity to capture images, which you can then use without delay.

Internet
Thousands of images can be downloaded from the World Wide Web. In many cases, you do not even have to pay for them.

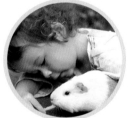

Subject

Picture CDs
Royalty-free CDs offer an inexpensive source of professional-quality images. It is worth adding a few to your collection.

Scanner
Using a scanner, you can turn any of your existing photographs – whether prints or negatives – into digital image files with ease.

Computer
Digital image files and image-manipulation software meet in the computer. There you can perfect your images for their final use, combine images in endless permutations, and store them for future use. From the computer you can also send images anywhere in the world.

impossible to achieve in the darkroom dealing with conventional film and paper chemistry.

One important feature that distinguishes image files from those produced by other computer applications is that most are in a standard format, such as TIFF or JPEG (*see pp. 222–3*), which can be used by a very wide range of software applications. These include page- and graphic-design programs, those intended for Web-page or presentation creation, and even spreadsheets and databases. From this fact alone arises much of the versatility of the digital image.

A new era of photography

Time and time again as you discover more about digital-image processes, the ease and convenience of this method of working shine through. For a start, you have no chemicals to mix or running water to deal with, nor do you need a room specially darkened for you to work in. All you have to do is turn on your equipment and within minutes your images are displayed on the screen, ready to be worked on. And a simple command is all it takes to send your pictures to the printer or to family and friends on the other side of the globe.

Publish on . . .

The World Wide Web
This is the major mode for sharing and exhibiting photography. Not only will your work be available to as many people as visit your Web site, your work is on show 24 hours a day, every day, every week, for as long as you like. And you can change it, completely or in part, at a moment's notice.

Output with . . .

Color printer
Desktop inkjet printers can now produce prints that may fool even the experts. There is no question that the quality possible is extremely high, yet prices are well within the reach of any computer owner. Even the early doubts about the longevity of the printed image are being banished.

Store on . . .

CDs and DVDs
The CD is the most ubiquitous and by far the least expensive method of digital storage. Many computers offer built-in CD burners for creating CDs, and every modern computer has a built-in CD player. DVDs are more costly but offer greater capacities; DVD writers are found on more and more computers.

The technology

Digital and film-based cameras work on the same principle – both make a record of a scene using the energy of light to make a change in a light-sensitive material. This change is then amplified, or intensified – either by chemical or electronic means – in order to make it visible. The main difference is that in digital cameras a light-sensitive electronic sensor absorbs light, while in traditional cameras a piece of light-sensitive film is used. In practice, all the main phases of image recording take place within the digital camera itself: image capture, image processing, and image storage. In film-based cameras, the processing and storage phases take place outside the camera.

How digital cameras work

The image-recording sensor in a digital camera is built up of a grid, or array, of individual light-sensitive cells. Each cell acts like an exposure meter by responding to different amounts of light to generate a corresponding signal. In most sensor array designs, each cell is covered with a red, green, or blue filter – thus, each cell responds to just one of the primary colors of light (red, green, or blue). The filters are arranged in groups of four, with two green filters for each pair of red and blue. The extra green filter is present because the human eye is most sensitive to green light.

At this stage, the electrical output of each cell is proportional to the amount of light reaching it. But in order to turn the information into digital form, signals must be digitized, or quantized – numbers must be assigned to the signals. Once this is done, the information can easily be handled by a computer.

The different values of each cell are processed by the camera so that the pixels in the image are given an appropriate color value: each pixel's value is calculated, or interpolated (*see opposite*), from the data gathered from neighboring cells. This color-interpolation step is crucial because the precise calculation affects the final quality of

Pixels and film grain

The picture elements (pixels) of a digital image are arranged in a regular array of uniformly colored squares so small as to be individually invisible. In film-based images, picture elements are randomly arranged grains (in most black and white film) or clouds of dye, also commonly called grain, in the case of all color and some black-and-white film.

Film grain
A random distribution of varying-sized grains and just three colors characterize the composition of color film.

Pixel structure
The regular distribution of same-sized, uniformly colored picture elements from a wide range of colors are characteristic of digital images.

Sensor and film in the camera
The light-sensitive element, or photosensor, in a digital camera is positioned exactly where photographic film would be located – in the lens's focal plane. A photosensor is actually superior to film in that it is perfectly flat and is in precisely the same position for each exposure – something not guaranteed with film.

Image capture

Light reflected from subject

Film/sensor imaging
In both film and digital cameras, the lens projects an upside-down and reversed image of the subject onto the focal plane. With film, you turn the film over to view it correctly; in a digital camera, this is done by software.

the image. Advances in image quality are as attributable to improvements in this interpolation process as they are to improvements in the sensors themselves. This completes the image-capture phase of the process.

The values for all the pixels are collected together to create the image file – in this process, other data, such as the format or structure of the file, are also determined. Some cameras will further process the image to improve its sharpness and most also compress the image using JPEG (*see pp. 222–3*) algorithms. This, the image-processing phase, is followed by the image being recorded (written to disk or to memory).

The first part of the process – image acquisition – can be very rapid, but processing and writing data to disk take longer. To speed things up, more advanced cameras have large amounts of built-in RAM, a type of memory that temporarily stores images as they are captured so that the slower processes do not hold up your picture-taking.

Color filter array
The image is analyzed in an analog fashion by an array of colored filters lying over the photosensors.

Mosaic filter

The commonest type of color filter array used in digital cameras is the Bayer pattern. In this, every other filter (and its corresponding pixel) is green, while one in four pixels is either red or blue.

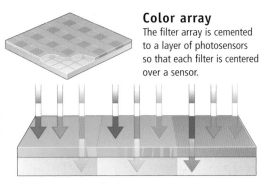

Color array
The filter array is cemented to a layer of photosensors so that each filter is centered over a sensor.

Color separation
Filters pass most of their own color but also some others: for example, blue passes mostly blue but some green, too.

Red filter pattern Green filter pattern Blue filter pattern

Color data before interpolation
To create an image, the camera software analyzes the three grids of color information to work out the intermediate color values – a process called color interpolation.

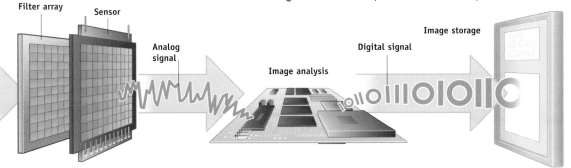

Filter array Sensor Analog signal Image analysis Digital signal Image storage

Sensor
The array of light-sensitive sensors turns the image into a mosaic of picture elements, or pixels, with luminance (brightness) and chrominance (color) information.

Analog signal
The photosensors produce a single stream of electrical signals that are converted by integrated circuitry into digital data.

Image analysis
The digital data is next taken apart by powerful computer chips and software to extract the color and brightness data in order to construct the final image.

Writing to memory
The circuitry sends the image data to the electronic memory card, which is inserted in the camera, for storage. Some cameras use a temporary storage, which speeds up the picture-taking operation.

The technology continued

Film-based and digital cameras

The modern, film-based single lens reflex (SLR) camera is a complex of electronics, mechanics, and ultra high-precision optics. A major part of its operation is concerned with advancing and rewinding the film – in the camera illustrated here (*see below left*), a motor performs this function as well as controlling the mirror action. As you would expect, autofocus cameras require a further layer of complicated integration between the electronics, optics, and mechanics.

While a digital camera (*see below right*) is no less complicated in its mechanical and optical construction, its electronics are far more powerful than you would find in a film-based model. A major saving is not having to transport the film – the design for a static photosensor is far easier than that for a moving strip of film. But nearly all other film-based camera operations are needed.

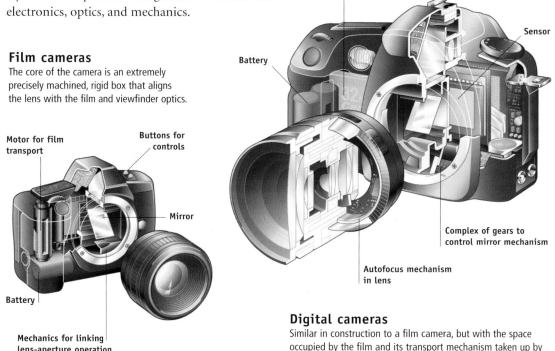

Film cameras
The core of the camera is an extremely precisely machined, rigid box that aligns the lens with the film and viewfinder optics.

Motor for film transport

Buttons for controls

Mirror

Battery

Mechanics for linking lens-aperture operation with mirror mechanism

Memory card

Battery

Sensor

Complex of gears to control mirror mechanism

Autofocus mechanism in lens

Digital cameras
Similar in construction to a film camera, but with the space occupied by the film and its transport mechanism taken up by electronic components for processing electronic image data.

Differences between film and digital

	Film	Digital
Image structure	Silver grains or dye clouds of varying size distributed in a random pattern.	Same-sized sensor pixels arranged in a regular grid, or raster array.
Color recording	Colors in the scene separated by red-, green-, and blue-sensitive layers.	Colors in the scene separated by a regular pattern of colored filters.
Color reproduction Image amplification	Dye clouds of cyan, magenta, and yellow. Development by chemical action.	Interpolated from color filter array. Electronic and digital processes.
Image quality	Depends on film speed, grain structure, and processing regimen.	Depends on sensor resolution and interpolation methods; also compression, if used.
Storage	Image fixed by removing unexposed silver: black and white stable, color less so.	Image stored temporarily on memory cards or hard disks.

Sensor technology

Practically all microprocessor and memory chips are sensitive to light and so are normally protected by light-tight covers. There are several varieties of CCD and CMOS devices used in digital cameras, and although they do not differ in the basic principle of how they work, they do vary in the way in which the information captured by the sensors is used.

In CCDs, the charges built up in each sensor must be read off serially – one-by-one. Thus, the image is effectively scanned over its whole area to retrieve the data. In addition, the reading must be taken before the sensor array is ready to make another exposure.

CMOS devices are wired differently: each sensor element can be read off individually – they are said to be X-Y addressable – and each one can be reached by giving its reference. As a result, CMOS sensors may be put to many uses – not just image capture but also exposure metering and even autofocusing.

What CCDs lack in versatility they compensate for by being far simpler and cheaper to make, while giving a clean signal that is easier to process than that from CMOS sensors. In digital cameras, however, CMOS has the advantage of working at a single, low voltage, compared with the high and varying voltages of CCD devices.

CCD sensor array

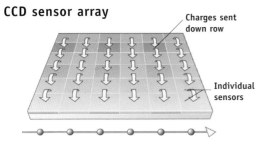

Charges sent down row

Individual sensors

Serial read-out
Since charges need to be handed down each row, sensor by sensor, and then read off, there is a limit to how quickly the picture-taking process can be achieved.

CMOS sensor array

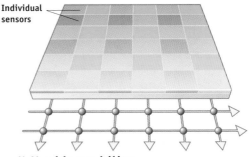

Individual sensors

X-Y addressability
Each sensor on a CMOS chip has its own transistor and circuitry, so that nearly all can be read independently of the others, giving great versatility.

Triple-well sensors
In this type of CCD, each sensor measures all three colors of light using a sophisticated design that depends on how deeply each color penetrates the sensor. In this way, there is no need for a separate color filter array and, in theory, the sensors can obtain at least three times more information than the equivalent using a Bayer pattern of colored filters through a much-reduced need for color interpolation. In addition, the integration of color separation into individual sensors means that pixels can be simply grouped – this lowers resolution but can increase sensitivity as well as the speed of image capture.

Each sensor measures blue, green, and red light

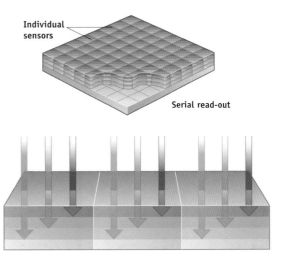

Individual sensors

Serial read-out

Digital camera features

Many features of digital cameras are based on those of traditional cameras. The main handling difference is that rather than loading film you slot in a memory card. Nearly all digital camera features require electrical power, while many traditional camera features can be mechanically governed.

Digital zooming

This feature takes the biggest image produced by the lens and then enlarges the central portion – typically by two or three times. Digital cameras thus offer a zoom range that appears to be longer than that offered by the lens. The process is like you using your software to open the image produced by the camera's longest focal length setting and enlarging the middle of it. Digital zooming saves you the trouble and may possibly give better image quality, but it enlarges only the middle part. If you were to "zoom" into the image yourself, you can choose what part of the scene to enlarge.

Shutter control
The shutter button on a digital camera is in reality a switch that sets a whole series of complicated electronic operations in gear.

Windows
You view the subject through the viewfinder window while other windows are used for autofocusing functions.

Flash
A built-in flash is handy for working informally in low-light conditions.

Zoom lens
Many digital cameras offer a zoom lens so you can easily change the field of view. But extreme wide-angle effects are harder to obtain.

Digital zoom
This feature takes the image produced by the lens's longest focal length setting and then enlarges the central portion of it. The digital camera thus offers a zoom range that appears to be longer than that offered by the lens alone.

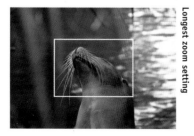

Longest zoom setting

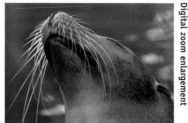

Digital zoom enlargement

Transferring images
The camera's capacity to record images is limited by the capacity of the memory card in use. You can slot in a new card as the first fills up or transfer files to other storage devices or a computer. Some cameras connect directly to a printer, allowing you to print without any intervening computer.

Focusing in the dark

In one method, a beam of infrared (IR) light is projected from the camera. The beam scans the scene and reflects back from any object it meets. A sensor on the camera measures the angle at which the beam returns, translates this into a subject distance, and sets the lens accordingly. However, this method is prone to interference from, say, an intervening pane of glass, which reflects the beam prematurely. The other method uses a pattern of light from the camera or flash unit, which directly assists the focus detectors to assess the image itself.

Subject

Sensor

Beam transmitter

Zoom control

Controls
Switches and buttons set different modes of operation, such as the image-quality settings.

DISP

Canon

LCD screen
The LCD enables the camera to display images within seconds, as well as providing information on the camera settings used.

CF OPEN

Setting buttons
Combinations of buttons and LCD information enable a large range of settings to be made, adding to the camera's versatility.

SET | WB MENU

Viewfinder systems

Four viewfinder systems (to enable you to frame and focus an image before recording it) can be found in digital cameras. The simplest uses an LCD (liquid crystal display) screen to present a low-resolution image of the subject. Most cameras offer in addition a direct-vision viewfinder. This is a small lens (separate from the image-taking lens) through which you view the subject. Having this allows you to turn off the LCD and so save battery power, but since you are not viewing the subject through the image-taking lens, subject framing is prone to inaccuracy.

The best system is the single lens reflex (SLR) arrangement, identical to that in a conventional camera. It gives you an accurate view of the subject and makes focusing very easy (*see pp. 32–3*). An alternative is what appears to be an SLR system, but the traditional focusing screen is replaced with an LCD screen viewed through the eyepiece. This screen is sufficient for framing but resolution is not high enough for precise focusing.

Digital cameras

The digital camera that is best for you depends on what you want to do with the images. If you only want to make small prints or send images via email, then a basic model is best.

Basic digital cameras

For many purposes, a basic digital camera – one producing image definition of 1,024 x 768 pixels – is not only adequate, it is preferable to those of higher resolution. Image quality is more than adequate for use with email or for pictures printed small in newsletters or brochures. Most models are viewfinder-types, and designs vary from small modules, which fit onto a hand-held organizer, to camera phones and those that look and operate like autofocus, film-based compacts.

You will find it more convenient if the camera records onto a memory card. If it relies only on internal memory, you cannot record any more once the card is full.

Basic model
Make sure even a basic camera accepts removable memory cards – otherwise you will have to return to base in order to off-load images once the internal memory is full.

Even basic digital cameras offer shooting, reviewing, and option-setting modes.

A 50x enlargement from a 2 MB image (produced by a 0.7-megapixel camera) shows poor detail and color, but it would still give images perfectly acceptable for postcard-sized prints.

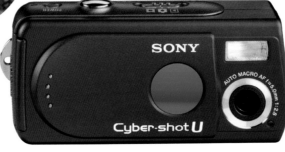

Sony Cyber-shot U30

A simple lens helps to keep costs as low as possible.

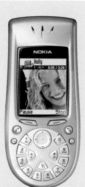

Nokia 3650
Camera phones are amazing bundles of technology. They are capable of taking VGA or better digital images and even video clips, as well as having Web-surfing abilities.

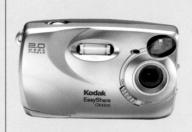

Kodak 4210
Simple cameras with fixed lenses and modest resolution are ideal for the beginner. This model, for instance, takes 2-megapixel images, has a built-in flash, and is very easy to use. It sits on a cradle for easy connection.

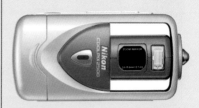

Nikon 2500
Digital cameras lend themselves to innovative designs that are both stylish and practical. In this model, the lens swivels for different picture-taking positions, capturing 2 megapixels with a 3x zoom lens and a built-in flash.

2-megapixel cameras

These 2-megapixel cameras produce good-quality ink-jet prints up to about 10 x 8 in (25 x 20 cm), making them suitable for good-quality news-letters and brochures, as well as publication to postcard size – and all without the high equipment and data-storage overheads that are associated with images of higher resolution.

A wide choice of cameras is available, from ultra-compact rangefinder types to substantial SLR-like designs with wide-ranging zoom lenses. All these cameras offer built-in flash, LCD screens, a zoom lens, autofocus, and autoexposure. Other features may include the ability to make short video clips, record sound, and control exposure settings such as shutter time or aperture.

When deciding on a suitable camera, make sure the camera's connection and its software are suitable for your computer and the operating system that you use.

2-megapixel model
Cameras offering SLR-viewing give accurate framing but are much bulkier than viewfinder models with otherwise similar specifications.

Rotating dials are easier to use than buttons.

Hot-shoe mounts accept fitting of supplementary flash.

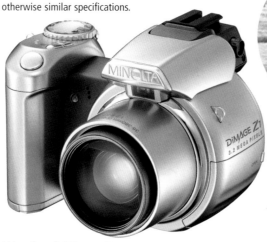

Minolta DiMage Z1

A 50x enlargement from a 6 MB file (from a 2-megapixel camera) shows a marked improvement in image detail and smoother tones compared with the 2 MB file (*opposite*).

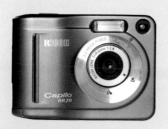

Ricoh Caplio
Cameras with fixed focal lengths are easiest for the beginner to use. This model is also sturdy since it lacks an autofocus mechanism, its focal length is equivalent to 50 mm, and it captures a 2-megapixel image.

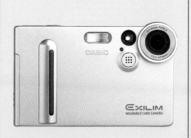

Casio Exilim
Extremely slim (just ⅖ in, or 12 mm) compact cameras such as this model can be taken anywhere and used instantly. Despite their size, 2-megapixel images are possible, and some even capture video.

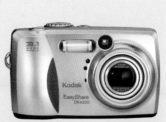

Kodak DX4330
Even modestly priced cameras can deliver good-quality 3-megapixel images with a 3x zoom lens. This one also offers sound handling, easy connectivity through a cradle, and LCD for indoor and outdoor viewing.

Digital cameras continued

3-plus-megapixel cameras

With a 3-plus-megapixel digital camera you have really crossed over into the realms of professional-quality image-making. Cameras in this category are capable of producing good-quality ink-jet prints up to A4 size, or even greater. If work requires the type of reproduction quality demanded by a magazine, you can enlarge to A5 size; with non-critical subjects, or certain "artistic" treatments, such as graininess, blur, or other distortion-type filters, then you can safely enlarge prints to A4 and greater, since these treatments disguise any slight imperfections in image quality.

If your camera is intended for professional use, then ruggedness and reliability should be key factors in your decision-making process. In these respects, cameras in this class are generally built to a higher quality and with better electronics and a wider range of features than cameras of lesser image resolution. But bear in mind that these

An automatic flash is convenient, but make sure it can be turned off.

A sliding lens cover helps protect the optics.

5-megapixel model

Modern digital cameras combine stylish design with compact dimensions and good-quality lenses. In good light, the majority can produce very good images.

Konica 510

A 50x enlargement from a 9 MB file (from a 3-megapixel camera) may not show much more detail than a 6 MB file, but detail is sharper and clearer (*compare with enlargements on the previous and following pages*).

Pentax Optio 33L

Inexpensive models from the experienced camera manufacturers, such as this, often present the best combinations of good handling with high quality. This has a 3x zoom and captures a 3.2-megapixel image.

Canon PowerShot A70

Tiny cameras may not suit everyone: some users prefer slightly chunkier designs with more substantial build quality. Numerous digital models, including this one, have a 3x zoom lens and capture 3-megapixel images.

Ricoh Caplio G4W

The majority of compact digital cameras offer limited wide-angle coverage of the equivalent of 35 mm at best. The Caplio G4W has a true wide-angle lens with a widest setting of 28 mm equivalent. Similar models are worth hunting down.

cameras not only cost more to purchase in the first place, but are also costlier to maintain. This is due to the fact that their larger files require more storage space (images with more pixels take up more memory space) and larger files take more time to work with than smaller ones. So, opt for one of these higher-resolution cameras only if you really need the extra quality.

Note that some cameras give images containing more pixels than the specification of the camera seems able to produce. If so, these figure have been arrived at by adding pixels through a process of "interpolation" (*see pp. 256–7*) and may not represent any true improvement in the detail captured by the camera.

When deciding on a suitable camera, make sure the connection is suitable for your computer. As was mentioned earlier, USB is faster than serial, while FireWire (also IEEE 1394 or iLink) is better than either. In addition, check the type of battery: Li-ion or NiMH types are better than NiCd.

There is a growing number of single lens reflex (SLR) designs in this class of digital cameras, but not all of them allow for interchangeable lenses. If your photographic work is likely to demand that you use a wide range of lenses, make sure any camera you are thinking of buying is suitable (*see pp. 26–7 and 34–9*).

Real resolution

In photographic terms, resolution is a measure of how well an optical system is able to discern, or separate out, fine subject detail to a "visually useful" extent – in other words, so that there is usable contrast to distinguish one detail from another. Camera manufacturers may make claims that their 2.5-megapixel sensor can produce files equivalent to a 4-megapixel sensor through pixel interpolation (*see pp. 256–7*). The fact is that while an image cannot reveal more information than was captured in the first place, it is certainly possible to process the basic information of an image file in different ways in order to give the impression that there is more information than is really present. But the final arbiter of any such claim is your subjective check of the image itself. Not only should you confirm that you can see more detail and see it more clearly, do not forget to make sure that subject colors are true, that contrast is realistic, and that the file-size output is appropriate to the task in hand. Why handle a 12 MB file, for example, when all the detail you need is contained in 8 MB? Note, however, that a form of interpolation, that of color (*see p. 17*), usually takes place in the capture of the image by hand-held digital cameras (some cameras work in a different way).

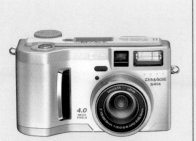

Minolta DiMage S414
If you intend to travel far from base, cameras that run on standard AA batteries are a good idea. These cameras, for example this 4-megapixel model, are quite chunky and heavy as a result, which can be an advantage.

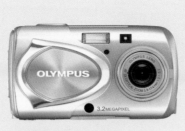

Olympus Mju 300
If your camera has to survive tough conditions, a weatherproof model is a sensible choice. In addition to its sturdy construction, this model offers a 3x zoom and 3-plus-megapixel capture, producing very good images.

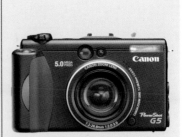

Canon PowerShot G5
A 5-megapixel model such as this can offer first-class imaging, together with extensive features and controls. Look for models that accept adapter lenses, which extend the range of wide-angle or telephoto performance.

Digital cameras continued

SLR digital cameras

The single lens reflex (SLR) design, in which the lens that projects the image for viewing and focusing is the same as that used to record the image (*see p. 33*), is the most versatile available. With digital cameras there are now two different types of SLR. In the focusing-screen type you look through an eyepiece to view the image on a focusing screen. The advantage here is that no power is consumed. In the second type (the most common) you look through an eyepiece but what you see is a magnified view of an LCD. Since this is not an optical view, but depends on the sensor to send signals to the LCD screen, it consumes power.

If it is important that you view the actual image, you will need the more professional digital cameras such as the increasing number from manufacturers including Canon, Nikon, Fuji, Kodak, or Sigma.

Another distinction between digital SLRs is whether or not the lens is interchangeable. The less-

SLR model

This extremely well-liked camera has good handling qualities and sells at a price that brings professional-quality digital photography closer to more people.

Many buttons and dials on digital SLRs do jobs similar to those on film-based SLRs.

Interchangeable lenses give most versatility.

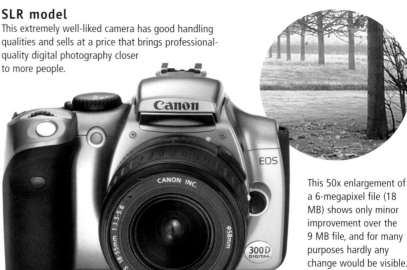

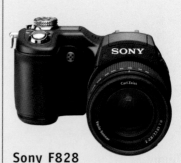

This 50x enlargement of a 6-megapixel file (18 MB) shows only minor improvement over the 9 MB file, and for many purposes hardly any change would be visible.

Canon 300D

FujiFilm S3000

SLR-type digital cameras equipped with electronic viewfinders can be compact yet versatile. The already useful 6x zoom range on this 3-megapixel camera can be further extended by attaching supplementary lenses.

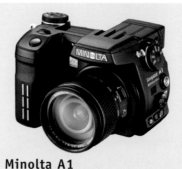

Minolta A1

More advanced digital cameras, such as this 5-megapixel model, offer numerous options and controls that suit the experienced user. The zoom range starts at 28 mm equivalent and extends to 200 mm.

Sony F828

Given a high-quality zoom lens, image quality will improve as sensor resolution increases. This model captures an 8-megapixel array through a superb 28–200 mm (35efl) lens – easily capable of making excellent large prints.

expensive SLRs do not feature interchangeability, but their zoom lenses may accept accessory lenses. These are screwed into the front to extend either the wide-angle or the telephoto coverage.

To judge a camera's suitability for sports photography and photojournalism, for example, you need to check three basic features: burst-rate, capacity, and latent period. The first is a measure of how many shots the electronics will allow you to take in rapid succession: a burst-rate of 3 fps (frames per second) is regarded as a minimum. The capacity indicates how many pictures can be taken at the burst-rate before the camera needs to stop and process the information: ten or more is good. This is followed by a latent period, in which images are written to the memory card, taking several minutes. Needless to say, film-based cameras have an advantage here, since some can expose 36 frames in under five seconds. The film-based latent period is, of course, the time needed to reload the camera.

Sensor size and field of view

A camera lens projects a circular image. The sensor or film captures a relatively small rectangular area at the center of this projected field of view. If the rectangle extends to the edge of this circle of light, the sensor is able to capture the full field of view. If the rectangle falls short of this, then the field of view is reduced. Many SLR digital cameras of the type that accept conventional 35 mm format lenses use small sensors – thus, the field of view available to the sensor is reduced. As a result, the 35efl (35 mm equivalent focal length) is multiplied: in other words, the field of view is equivalent to that of a lens with a longer focal length. For example, on the Nikon D1, focal length is increased by about 50 percent compared with the 35 mm format coverage; while the Contax, with its large sensor, does not increase effective focal length at all.

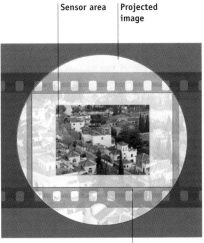

Sensor area | Projected image

35 mm film area

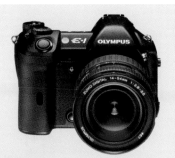

Olympus E-1
This model attempts to create a new open standard for digital cameras. In its own right it is a powerful photographic tool with a good range of high-quality lenses and accessories and many professional features.

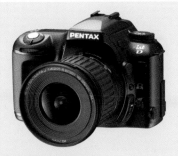

Pentax *ist D
This model (pronounced "first") opens digital photography to the millions of existing manual-focus Pentax mount lenses. It is a compact, lightweight SLR with a 6-megapixel sensor increasing effective focal length by 1.5 times.

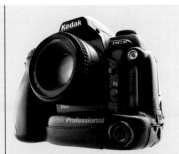

Kodak DCS-14n
For full use of 35 mm format lenses, you need a camera with a sensor the same size as the film format. These models are costly but can produce the very highest quality without the need to invest in new lenses.

Studio digital cameras

Professional quality in digital cameras is not defined only in terms of very high image resolutions. Part of the definition also has to do with equipment sturdiness and reliability – the general build quality that is required to be sure the highest levels of operation are maintained under the most testing conditions. This explains why although some professional digital cameras may be as much as ten times the price of amateur models, they offer lower image resolution. However, these cameras – widely used by news and picture agencies all around the world – are robust enough to be taken into war zones, use military-grade components to survive punishing conditions, and produce color consistency that can be relied on.

Studio work

In the studio environment, professional cameras do not have to be easily portable, since many subjects are either stationary or can be confined

Professional studio model

This 6-megapixel digital back is available to fit most medium-format cameras. For location work, the back can be tethered to a power pack with disk drive.

Digital backs allow medium-format cameras to be used as normal.

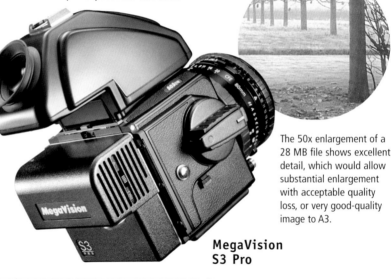

The 50x enlargement of a 28 MB file shows excellent detail, which would allow substantial enlargement with acceptable quality loss, or very good-quality image to A3.

Apart from an adapter, all digital backs are identical.

MegaVision S3 Pro

MegaVision 4 x 5 adapter
An accessory that allows a digital back to be attached to the rear of a standard 4 x 5 in studio camera is very handy: frame and focus the image, then simply slide the digital back across to record the shot.

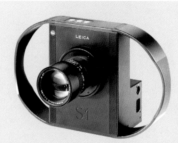

Leica S1 Alpha
Specialist instruments such as this are useful in a museum or any documenting environment. This model accepts several different manufacturers' lenses to produce 26 MB images to high quality, but it requires long exposure times.

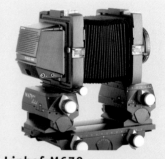

Linhof M679
Studio monorail cameras are increasingly being specially designed for the very high precision required for digital photography using high-resolution digital backs. They offer precisely repeatable settings – important for catalog work.

within a small area. Here a different type of digital camera can be employed. These dedicated studio models are tethered to a computer – the camera sends image data directly to the computer as it is captured, rather than storing it internally as a portable camera does. The camera is, therefore, simpler to make: indeed, most devices are simply built into a box that fits into a standard film back of any conventional studio camera, such as Sinar, Linhof, Arca, or Cambo, or onto conventional medium-format camera bodies, such as those made by Hasselblad, Rolleiflex, or Mamiya.

Being studio-based, these cameras employ a type of image capture different from that of a portable model – the scanning back. This is essentially the same mechanism as that used in a flatbed scanner (*see pp. 214–15*): a row of CCDs is run along the length of the film format to capture the image. A variant of this is the triple-shot camera. In this, three exposures are made through separate red, green, and blue filters. Exposure times are lengthy, calling for very steady lighting.

The result of these arrangements is not only far higher resolutions (some cameras can churn out massive 244 MB files or larger), but scanning backs easily exceed film in terms of the dynamic range – the range between the brightest and darkest subject areas – that can be recorded.

Moiré patterns

One problem that can affect the quality of images recorded by a digital camera is known as "moiré." This occurs when the regular pattern of the sensor array in the camera interacts with some regular pattern in the image area, such as the weave of the cloth worn by your subject. The overlapping of two regular patterns, which are dissimilar and not perfectly aligned, leads to the creation of a new set of patterns – the moiré pattern – which is sometimes seen as bands of color or light and dark. Kodak SLR cameras use a sophisticated optical solution – the so-called "anti-aliasing" filter – while some other manufacturers use a filter – known as a "low-pass" filter – that very slightly softens the image by cutting out detail.

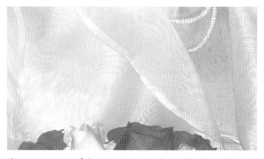

The appearance of the moiré pattern is readily discernible in the open weave of this fabric.

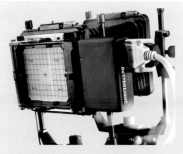

Betterlight Super 8K
Scanning backs are designed to fit standard 4 x 5 in studio cameras and are, therefore, identical in size to double-dark slide-film holders. Image definition and dynamic range are excellent, but the back must be tethered to a computer.

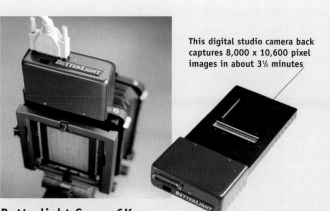

This digital studio camera back captures 8,000 x 10,600 pixel images in about 3½ minutes

Betterlight Super 6K
The simple construction of scanning backs and their similarity to the flatbed scanner is visible here. Power and data are exchanged through a standard cable.

Film-based cameras

If your requirement is for a film-based camera, relying on a scanner to create digital image files, you have many choices in terms of camera size, features, degrees of automation, and price.

Rangefinder cameras

The least expensive, most compact, and easiest cameras to use are autofocus rangefinder types. These are distinguished by a small window through which you view the subject. Other windows are used by the rangefinder mechanism, which is most often based on a system that transmits infrared light to the subject and senses when it returns (*see p. 21*). Other features include automatic film advance and rewind, automatic flash, autoexposure, and usually a zoom lens.

With these cameras, you simply turn them on, point, and press the shutter button – everything else is taken care of automatically. The best of these cameras are capable of professional picture

Konica Hexar

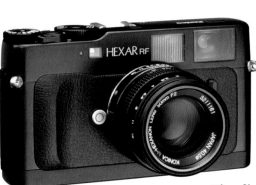

The viewfinder design creates a bright viewing image.

Simple construction permits almost silent shutter operation.

Lenses, though compact, can have wide maximum apertures.

Viewfinder camera
Typical of 35 mm rangefinder cameras of high quality, the Hexar offers satisfying photography by combining good construction with compact and rapid operation to give high-quality imaging.

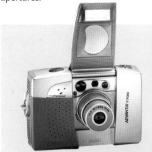

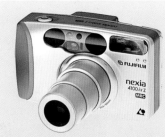

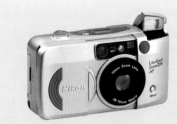

Kodak Advantix T700
APS cameras such as this model, which is weatherproof and compact, are a very attractive buy. Despite being compact, the cameras can incorporate a 2x zoom lens and even the ability to imprint the date, time, and a title on each image.

Fuji Nexia 4100
Many APS cameras offer the convenience of being able to change film in mid-roll. Pay a little more and you can obtain a wide-ranging zoom lens and date imprinting on the film, as well as the three different formats.

Nikon Zoom 70W
Well-featured 35 mm cameras that are easy to use and capable of producing fair results can be very inexpensive. A zoom range of 28–70 mm is usefully wide-angle. Look out for extra features, like the infinity focus setting.

quality, while most give very good results under a wide range of conditions. Manual-focusing rangefinder cameras, however, can give the very best image quality and reliability. Film-based rangefinder cameras can easily produce results superior to comparably priced digital models.

Rangefinder cameras can be found in a wide range of formats, the most common being for 35 mm film. There are also cameras that accept medium-format film, for different formats.

Rangefinder

Many optical and autofocus rangefinders work by measuring the angle between the subject and a reference point on the camera itself. This is then mechanically transferred to the lens setting.

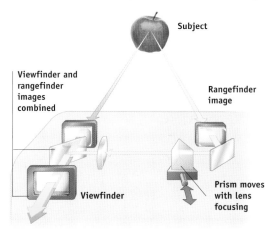

Subject

Viewfinder and rangefinder images combined

Rangefinder image

Viewfinder

Prism moves with lens focusing

APS format

The Advanced Photo System (APS) format is a film-based format designed to produce good-quality results while improving the ease with which film is handled and prints ordered. The basic APS format is 3 x 1.7 cm, but three print proportions – from classic 35 mm to a "panoramic" (*see below*) – can all be shot on the same roll. To scan this type of film, you need a scanner equipped with an APS adapter.

Panoramic format

APS film cassette

HDTV format

Classic format

Variable masking

APS cameras are able to offer different formats by changing the masks used at the focal plane to vary the crop of the circular image produced by the lens. The largest format is the HDTV, as it makes the fullest use of the lens image. The so-called Panoramic format is, in fact, a narrow crop of the HDTV format, while the Classic is an even smaller crop.

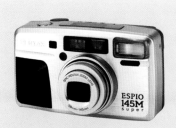

Pentax Espio 145M

Even relatively compact 35 mm cameras can offer very wide-ranging zoom lenses. Some, including this model, cover 38–145 mm in focal length. Simplicity of use, familiarity of controls, and availability of film are all issues to consider in choosing a 35 mm camera.

Minolta Vectis 3000

The viewfinders of small cameras can be most inconvenient to use, distracting you from your photography. Minolta's Vectis 3000 offers a better-than-average viewfinder. The camera also provides a handy focus lock for its autofocus system.

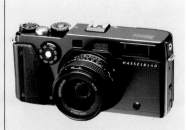

Hasselblad XPan

This unique interchangeable-lens viewfinder camera, which can mix normal-format images with panoramic views on the same roll of film, produces extremely high-quality images, but at a high purchase price.

Film-based cameras continued

SLR cameras

The single most important feature of the design of the single lens reflex (SLR) camera is that it allows you to view the subject through the picture-taking lens itself. This means that no matter what lens is attached to the camera – whether it is a 14 mm ultra wide-angle or a 1,000 mm super-telephoto – the view through the viewfinder is an accurate reflection of what will be recorded. This feature gives the SLR its unrivaled versatility, but the cost is a far more complicated mechanical design than is found in a rangefinder-type camera (*see pp. 30–1*), resulting in a larger, heavier body and more operating noise.

However, the SLR is without doubt the preeminent camera design, and because of this it is backed up – both by the camera makers themselves and independent manufacturers – with a very extensive range of lenses, flash lighting units, filters, and other accessories.

A pop-up flash is useful for providing fill-in lighting.

Motordrive shooting possible, but shutter lag may be long.

Single lens reflex model
Compact and lightweight, yet capable of very high quality, this type of camera offers a full range of operation modes with autofocusing.

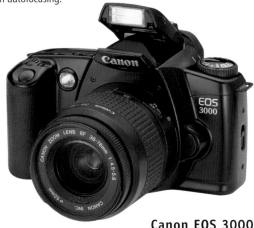

Canon EOS 3000

Dial-operated setting selection aids the ease of handling.

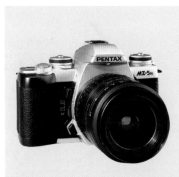

Pentax MZ-5N
Easy to handle and compact, a simple autofocus SLR camera such as this is capable of producing very good results. It accepts a wide range of inexpensive lenses.

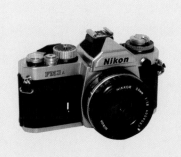

Nikon FM3A
A hybrid electronic–mechanical shutter in a manual-focus SLR camera is perfect for work in challenging environments and is capable, at less than half the cost of digital equivalents, of first-class results.

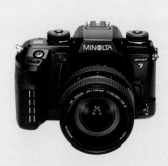

Minolta Dynax 7
Select this model if you want a substantial SLR camera with rapid autofocusing, a flash system that takes focusing distance into account, and a top shutter time of $1/8,000$ sec.

Special lenses If the photography you are interested in calls for the use of specialist lenses (*see pp. 38–9*), it is prudent to choose a camera with this in mind. For example, Nikon produces a first-class close-up lens with a true zooming ability. This is the 70–180 mm Micro-Nikkor, and it is a unique instrument capable of excellent results – but only if you use a Nikon camera. Minolta, too, has an impressive range of macro (close-focusing) lenses, and in the medical field some of the lenses from this range are commonly used to take the extreme close-ups required in the study of dentistry. But, of course, you need a Minolta camera body. At the other extreme, if you have a Canon EOS camera, a perfect landscape optic is Canon's 24 mm tilt-shift lens. Wildlife and sports specialists might also bear in mind that Canon makes by far the widest range of image-stabilized lenses – optics with a built-in mechanism to correct for camera shake (*see p. 94*).

SLR viewing system

Light enters the camera, where it is reflected upward by an angled mirror to the focusing screen and then into the pentaprism's mirrored interior, where a correctly orientated image can be seen through the viewfinder. Pressing the shutter flips the mirror up (blanking out the viewfinder), allowing light to reach the film.

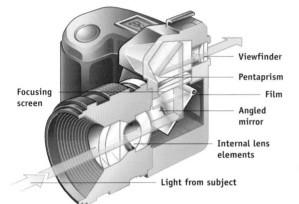

Viewfinder

Pentaprism

Film

Focusing screen

Angled mirror

Internal lens elements

Light from subject

Shutter lag

With all cameras there is always a lag between the moment you press the shutter button and the moment the shutter opens to expose the film. This can be as long as ¼ sec – a delay that will in, say, action sports be the cause of missed shots. For the shortest shutter lag, opt for models such as those from Leica, Canon, and Nikon that feature mechanical shutters. Costly autofocus SLRs have a relatively short shutter lag, and the general rule is that the more you pay, the shorter it tends to be. Autofocus compact and digital cameras tend to suffer from very long shutter response times.

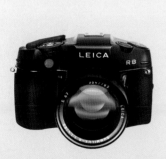

Leica R8

Some models offer an aesthetic experience in themselves: this is sleek yet very substantially built with very smoothly operating controls. Lenses are manual-focusing and high quality. Film advance is manual but can be motorized.

Canon EOS 1V

This superb camera is refined, highly rugged, and moisture-proof. Its autofocus is extremely rapid yet offers 45 different focus points. Features versatile exposure controls and a supplementary, class-leading motordrive.

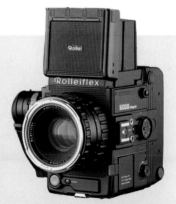

Rolleiflex 6008 Integral

For the ultimate in portable quality, the best is still the medium-format camera. This model almost guarantees immaculate results with its large, bright viewfinder, motorized film transport, and system of superlative lenses.

Choosing the best lenses

The quality of the image projected by the camera's lens sets the upper limit of the image quality you obtain from your camera. If you have an inferior image – one that is not perfectly focused, for example – no increase in the number of pixels you employ or the use of better film will help.

There is no doubt that the more you pay, the better the lens is likely to be. If you can afford to pay for professional lenses, you are unlikely to be disappointed. Before spending a lot of money,

however, it may be prudent to rent a similar lens for a week and put it through its paces. All the major camera manufacturers maintain the quality of their lenses with remarkable consistency.

Do not ignore lenses produced by the major independent lens manufacturers – some of these optics represent excellent value, giving very good performance at prices much lower than those of the camera makers. However, it is generally true to say that the quality of lenses from the best of the

Leica 35 mm
This lens is very fast, offers top-class image quality in low light, but is large and heavy.

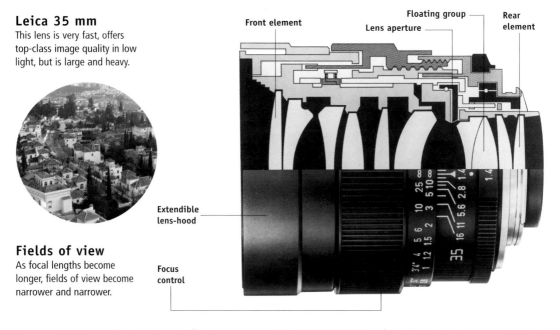

Front element · Floating group · Rear element
Lens aperture
Extendible lens-hood
Focus control

Fields of view
As focal lengths become longer, fields of view become narrower and narrower.

Sigma 14 mm
An ultra wide-angle for the 35 mm format is the only way to obtain true wide-angle on digital SLR cameras. The 14 mm is equivalent to about 21 mm on many SLR digitals.

Canon 20 mm
A 20 mm lens is a very useful ultra wide-angle for 35 mm, giving a 35efl of about 30 mm on digital SLR cameras. These single focal length, or prime, lenses tend to give excellent, distortion-free results.

Canon 28 mm
Compact and easy to use, a 28 mm lens is one of the most versatile there is. It is excellent for many subjects, from portraiture to landscapes, as well as close-up and fast-moving action.

independents is not as good as the best lenses from the camera manufacturers. But bear in mind that image quality is often only really tested when very large-scale prints are called for – so if you do not need the extra quality, why pay the price? For best value in terms of the balance between price and quality, consider these points:

● Lenses with modest apertures and near-normal focal length, such as 50 mm f/2.8 or 60 mm f/2.8, usually give excellent image quality at low prices.

● Zoom lenses with modest ranges and maximum apertures, say, 35–70 mm f/4 or 70–200 mm f/4, usually offer good image quality at low prices.

● Avoid zoom lenses with extremely wide focal length ranges, such as 28–300 mm or 50–500 mm, unless you can afford premium-quality optics, such as the Canon 35–350 mm.

● Opt for wide-angles with modest apertures, such as 24 mm f/2.8 or 21 mm f/4, for better image quality, less light fall-off, and lower cost.

Equivalent focal length

Focal length tells you if a lens is a wide-angle or a telephoto. A "normal" lens is taken as being one whose focal length is about equal to the length of a diagonal line drawn across the film format. With the 35 mm format, the diagonal of a frame of film is 43 mm; so the normal focal length for a 35 mm camera is 50 mm.

With digital cameras, normal focal length varies with image-sensor size. One approach is to quote the equivalent focal length (efl) for the 35 mm format. The maximum wide-angle of many digital zooms is a 35efl of 35 mm, while a 35efl of 28 mm is offered on only a few digital cameras. However, focal lengths can extend to a 35efl of 300 mm or more.

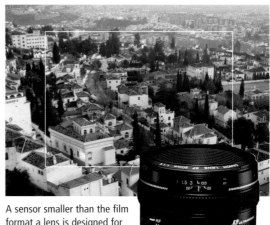

A sensor smaller than the film format a lens is designed for takes in a view smaller than that projected by the lens.

Nikkor 45 mm
Based on a classic optic, a 45 mm lens is extremely compact yet capable of producing top-class images. An ideal lens for a quality, lightweight outfit, and usable with a wide range of subjects.

Canon 50 mm
A 50 mm lens is a very useful focal length – lenses with ultra-fast maximum aperture are among the most versatile you can own. This prime-grade lens gives impeccable image quality.

Canon 300 mm
Ideal for sports photography and wildlife work, 300 mm lenses are heavy, however, and require support.

Zoom lenses

Zoom lenses (those in which focal length and, hence, the field of view can be adjusted without affecting focus) are fitted almost universally to non-SLR digital cameras. Not only are these optics convenient for the photographer – they provide a choice of subject framings and magnifications all from the same shooting position – but their optical form also allows camera designers to build more efficient autofocusing systems into them. The benefit of this from the photographer's point of view is a less bulky lens system that requires less battery power to operate.

Most zoom lenses on digital cameras start at quite a moderate wide-angle focal length of a 35efl (*see p. 35*) of approximately 35 mm. More extreme focal lengths are difficult to achieve because of the optical characteristics of the small photosensors used for image capture, which tend to cause a darkening at the periphery of wide-angle images. When wider angles of view are

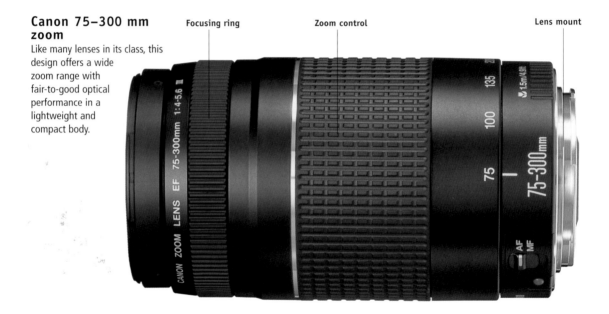

Canon 75–300 mm zoom
Like many lenses in its class, this design offers a wide zoom range with fair-to-good optical performance in a lightweight and compact body.

Focusing ring Zoom control Lens mount

17 mm

35 mm

Sigma 17–35 mm
Although 17–35 mm may not seem extensive, the range of visual impact is large. Such a range is required to give the digital SLR coverage from wide-angle to "normal."

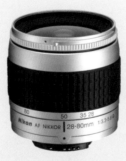

28 mm

80 mm

Nikkor 28–80 mm
The range 28–80 mm covers the vast majority of ordinary picture-taking situations, from groups of people to scenes, through normal to telephoto effects for portraits.

required, accessory lenses can be screwed into the front of the digital zoom to extend its range, though image distortion is likely as a result.

At the other end of the zoom range, however, lenses can reach high image magnifications – a 35efl of 350 mm in one model – although focal lengths of around 120 mm are more common. Be aware that, along with magnifying a small part of the field of view to fill the frame, long focal lengths also magnify the effects of camera shake on the image. Some cameras and lenses, notably those from Olympus and Canon, offer image-stabilization technologies that significantly reduce the effect of camera shake (*see p. 94*).

The greatest range of lens focal lengths is available only with digital SLR cameras (*see pp. 26–7*). With these cameras, zoom lenses can extend from ultra wide-angle focal lengths of, say, 16 mm to a moderate 35 mm, or from a modest 100 mm focal length to a 560 mm super-telephoto.

The most tempting zooms are those covering a range from wide-angle through to telephoto – 28–300 mm, for example, or 35–350 mm. The best of modern designs can deliver excellent image quality over these ranges, but you will have to pay a high price for these lenses. You pay in another sense, too: maximum apertures are often limited, making them suitable for use in bright light only, and the lenses are large and heavy.

●POINTS TO CONSIDER

● Use a lens-hood: stray non-image-forming light within the many internal lens elements can seriously degrade otherwise excellent image quality.

● Avoid using the maximum aperture or the minimum aperture. With most zoom lenses, at least one stop less than maximum is required to obtain the best image quality.

● Adjust focal length first and focus on the subject just before releasing the shutter. Avoid altering focal length after you have focused, since this can cause slight focusing errors to occur.

● When using a wide-ranging zoom, remember that a shutter setting that will ensure sharp results at the wide-angle setting may not be sufficiently short for the telephoto end of the range.

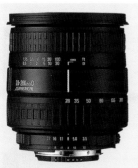

28 mm

Sigma 28–200 mm
Zooms that range from wide to long focal length are attractive as an all-in-one package, but the downsides are bulky construction and relatively small maximum apertures.

200 mm

50 mm

Sigma 50–500 mm
Very extensive zoom ranges call for large and impressive lenses: at a price, good optical quality can be obtained. These lenses are perfect for travel and expedition photography, but use on a tripod is advisable.

500 mm

Specialist lenses

In return for their high price, specialist lenses can make a huge difference to your photography. With all these lenses, however, an SLR is essential.

Shift/tilt lenses

The optical elements of a shift lens are mounted on a mechanism that allows the lens to be raised or lowered from its normal shooting position. Tilt lenses contain a mechanism that allows the lens to be rotated, to a limited degree at least, so that it points upward or downward. A few lenses in this category combine both movements in one lens.

Shifting allows you to reduce or increase, say, foreground coverage without moving the camera. Tilting the lens allows you to position the plane of best focus, to give very deep or shallow depth of field (*see pp. 84–7*), without adjusting the aperture. These lenses are ideal for architectural and landscape photography and are invaluable for still-life, tabletop work, and portraiture.

Leica shift lens
This is a high-quality wide-angle lens with the ability to shift the image circle up, down, or across the center of the film format in order to reduce, say, the foreground without having to tilt the camera.

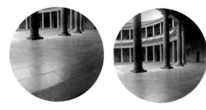

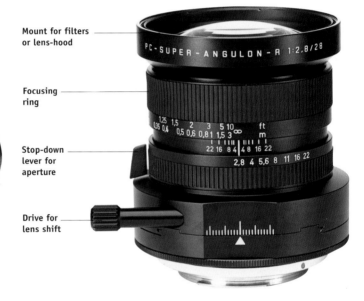

Mount for filters
or lens-hood

Focusing
ring

Stop-down
lever for
aperture

Drive for
lens shift

Shift views
With the camera held level, too much foreground is visible (*above left*). But with the lens shifted up, you can preserve the verticals while reducing the amount of foreground, and so allow more of the building to be seen (*above right*).

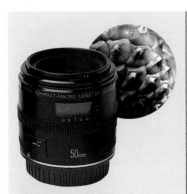

Canon 50 mm
A shorter focal length macro lens allows you to work close to the subject – useful when used in conjunction with a copystand (*p. 207*).

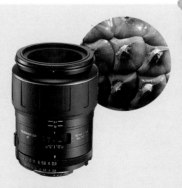

Tamron 90 mm
Several relatively inexpensive optics of specifications similar to this one give superlative performance, particularly at life size.

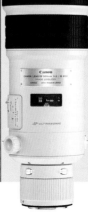

Canon 500 mm
A long telephoto is essential for bird or other wildlife and sports photography. It is essential to use a tripod or some other support if you want sharp, shake-free images.

Macro lenses

Turn to these lenses when peerless image quality is required. Available in focal lengths from 50 to 200 mm, these lenses focus very close and their level of image distortion is the lowest in general photography. Digital cameras do offer close focusing, but usually at shorter focal lengths. This means that in order to obtain a magnified image, you have to work at close subject distances.

Super-telephotos

Lenses with very long focal lengths are difficult to manufacture, so prices are usually high. However, for serious wildlife photographers they are indispensable. An advantage of digital photography is that many digital SLR cameras effectively increase focal length over their 35 mm equivalents because of their small sensor size. Thus, a 300 mm lens can become a 450 mm lens. Needless to say, a tripod is essential, even if you can afford the top-grade lenses from Canon, which are equipped with image-stabilization technology (*see p. 94*).

Catadioptric lenses

These lenses use a combination of curved mirrors (hence their common name of "mirror" lens) and glass lens elements in their optical construction, and are characterized by extreme compactness in

relation to their focal length – a 500 mm focal length, for example, can be folded into a barrel barely 4¾ in (12 cm) long. These optics usually feature high correction for color aberrations, regardless of cost, and can focus at very close subject distances. On the down side, all but one model is manual focusing and they have only a single working aperture – the maximum – and that is usually rather limited: a nominal aperture of f/5.6 or f/8 is usually the case.

What is lens aperture?

The terms lens aperture, f/number, and f/stop all mean roughly the same thing: they measure the size of the aperture sending light to the film or sensor. The actual size of the aperture depends on a control consisting of a circle of blades, called a diaphragm, which open up to make a large hole (letting in lots of light) or overlap over each other to reduce the aperture size which restricts (stops down) the amount of light coming through. The maximum aperture is the setting of the diaphragm that lets in the most light. Lens aperture is measured as an f/number and is a ratio to the focal length of the lens. For example, with a lens of 50 mm focal length, an aperture of 25 mm gives f/2 and an aperture of 3.125 mm gives f/16.

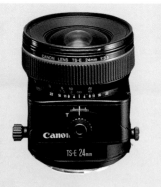

Canon 24 mm
A very wide-angle lens that offers tilt as well as shift movements, with extremely high image quality, is a superb optic for landscape and travel photography.

Centon 500 mm mirror
Optics that bend light using a combination of mirrors and lenses are known as catadioptric, or mirror, lenses. They offer long focal lengths in a compact design, very good correction for chromatic aberration, and close subject focusing. Out-of-focus highlights, however, are rendered with a characteristic dark middle.

Folded light-path makes for a compact lens design

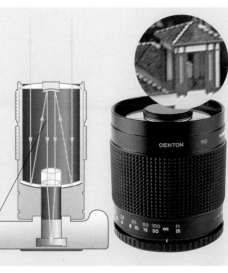

Camera accessories

Small items can make a big difference in how your camera handles and greatly improve the quality and scope of your photography.

Exposure meters

While almost all cameras made today have built-in exposure meters, some photographers still rely on hand-held types, especially to make incident-light readings (of the light falling on the subject), preferring this to built-in meters, which read the light reflected from the subject. Some hand-held meters also offer far higher accuracy, especially spot meters, which read reflected light from a very narrow field of view – commonly 1° or less.

Flash meters are designed to measure electronic flash exposures. Most modern hand-held meters can measure flash exposures as well as ambient light and, indeed, indicate the balance between the two. A flash meter is an essential accessory for serious still-life and portrait work.

Tripods

The best tripods are heavy, large, and rigid, while small, lightweight ones are often next to useless. As a rough guide, a tripod should weigh at least as much as the heaviest item you put on it. For the best balance between weight and stability, look for those made from carbon fiber. A good, less-expensive compromise is a tripod made from aluminum alloy. Very small tabletop tripods are handy for steadying the camera, and shoulder stocks, which allow the camera to be braced against your shoulder, can help reduce camera shake.

Bags

Modern, padded soft bags combine high levels of protection with lightweight construction: those from

Shooting on the move
Carry only essential accessories – too much gear only gets in the way.

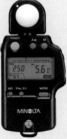

Combined exposure meter
Professional exposure meters can measure flash as well as ambient light and accept a range of accessories.

Spot meter
For the most precise measurement of light, a hand-held spot meter is needed.

Simple meter
A simple exposure meter is excellent for checking camera performance and for teaching you to judge lighting by eye.

3-D tripod head
For the flexible control of a heavy camera, a tripod head that adjusts in three directions is best.

Ball-and-socket head
Compact and lightweight, this type of tripod head is ideal for travel photography.

Tripods
Although often bulky and heavy, a tripod is simply the best way to ensure that images are free from camera shake. Carbon-fiber models are expensive but lighter than metal types.

Large camera bag
Traditional-style bags or backpack designs are useful for carrying and organizing your equipment.

Small camera bag
Smaller bags are useful for compact cameras and also for accessories, such as memory cards, cables, and discs.

Waterproof housing
Digital cameras are ideal for taking underwater – inexpensive plastic housings let you take your camera snorkeling.

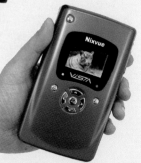

Portable storage
When the camera's memory card is full, unload images onto a portable hard-disk and keep shooting.

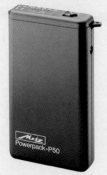

Battery pack
A digital camera's total reliance on battery power means that it is prudent to have backup power sources – these can improve flash and camera performance.

Lowepro, Tamrac, Tenba, Domke, and Billingham are all likely to give excellent service for many years. For work in highly challenging conditions, or if your equipment has to travel in cargo holds or on the backs of trucks, a hard case is best.

Waterproofing
A waterproof camera housing is essential in situations such as shooting from a canoe or when sailing – not just if total immersion is likely. Camera housings are also ideal for particularly dusty conditions, such as industrial sites and deserts.

Power packs
The power capacity in cameras and flash units is necessarily a compromise between portability and functionality. If you need relatively large amounts of power on the move – for example, an extended period covering a festival or carnival, a large wedding, or a long hike in the cold – then it is best to carry a separate battery pack. The pack may be designed to screw into the tripod bush of the camera, or larger ones can be carried on a waist belt.

Before buying a power pack, confirm that it is compatible with your camera and that you are given the correct power cord: not only must the power supply be correct, it must have the correct polarity – errors could damage your camera.

Digital image storage
When traveling with a digital camera it is often impractical, and always inconvenient, to carry a laptop computer for storing image files. The best alternative is a portable hard disk equipped with a small LCD screen. These units can hold 10 GB or more of data and are equipped with slots for reading memory card devices. Data can be copied straight from the card devices onto the drive. A unit offering 30 GB of data capacity should be sufficient even for a major extended expedition. Examples include the Nixvue, Digital Wallet, and FlashTrax.

Another option is the portable CD writer, which writes data to the CD direct from an inserted memory card without the need for a computer.

Digital "film" memory cards

For a time, it seemed that there would be just three types of digital-image memory cards. Unfortunately, there are now several systems all vying for pole position. For the photographer, the main consideration is compatibility between personal equipment: if you own only one camera, there is no problem: you can download images directly to your computer. But as soon as you have another camera or you want to use another device, you must ensure compatibility. In this respect, the most versatile memory card is the CompactFlash. But cards from other manufacturers promise higher transfer rates or better capacity, economy, or size.

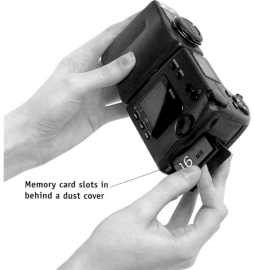

Memory card slots in behind a dust cover

Using the memory card
Memory cards are easily replaced in a camera, but do not try to change cards when the camera is reading from or writing to the card – usually a light warns you when the card is in use.

All cards have to be slotted into the camera so that recorded images can be saved onto them. The first time you use one, it may have to be formatted (structured to receive data) by the camera. Unlike film, you can remove the card at any stage before it is full and slot it into a reader to transfer files to a computer. You can also erase images at any time to make room for more. However, do not try to remove the card while the camera or reader is accessing it: wait for the lights indicating card activity to go out before removing the card.

CompactFlash
The most widely used and available memory card, with a choice of card readers and a variety of capacities to suit different budgets. Capacities range from 8 MB to at least 1 GB – with the best-value cards being those offering 128–256 MB capacity. Some types offer faster operational speeds: this is worthwhile for improving camera response.

SmartMedia
Extremely lightweight, compact, and wafer-thin – and therefore fragile. The maximum capacity of the card is limited by the camera's circuitry, so you cannot take advantage of advances in card technology without changing the camera's features.
Maximum capacity is 128 MB. Falling out of favor.

Microdrive
Ultra-miniature hard disk drive that fits into CompactFlash type II slots. Used by professional-quality digital cameras because it is relatively robust, fast, and offers very high capacities – from 170 MB to 2 GB, with good economy.

MemoryStick
Introduced by Sony and used on a variety of digital equipment, including Sony video cameras, thus allowing interchange, but independent card readers are scarce and compatibility with other makes of digital camera is poor.

Capacities of the Pro version may reach as much as 2 GB.

Secure Digital and MultiMedia cards

One of the newest standards, Secure Digital is based on the MultiMedia card: it combines very small size with the promise of large capacities (at least 512 MB), yet with low draw on current. They are also sturdy, both electrostatically and physically, and are in increasingly widespread use for a range of electronic equipment. The cards feature a mechanism to prevent accidental writing or erasure.

xD-Picture Card

The newest, smallest, and some of the fastest-working cards for digital photography: these promise capacities protected to an astonishing 8 GB. Despite these features, power consumption is low, robustness and reliability are very good, and the price of average-sized units (128 MB) is comparable to that of other cards.

CD-R

This small 3-in (7.5-cm) version of a CD-R disc is used by, for example, the Sony MVC-CD 1000 camera. The disc cannot be reused but it is inexpensive and offers a good capacity of 156 MB. The discs can be read by nearly every CD-ROM player, though they may not be very widely available for purchase.

Card care

● Keep memory cards well away from magnetic fields, such as magnets, television monitors, audio speakers, and so on.
● Keep cards cool: do not leave them in a car on a hot day or lying around in bright sunshine.
● Keep cards dry: do not take them out into warm, humid conditions immediately after coming out of an air-conditioned room, for example.
● Keep memory cards dust-free: the contacts are extremely fine and can easily be damaged by small particles of dirt or grit. In sandy or dusty conditions, do not remove a card from the camera unless you are safely sealed inside a tent or car.
● Keep memory cards in their protective cases whenever they are not in use.

Memory card readers

There are two ways of transferring images taken on your digital camera. First, you can connect the camera to your computer and instruct the camera's software to download images. Second, you can take the memory card out of the camera and read it to the computer. To do this, you need a memory card reader, a device with circuitry to take the data and send it to the computer, usually via a USB cable (though some use a FireWire interface). The reader needs to be designed for the different cards that are available. Models that consist of a core reader and adapters for the different types of cards are preferable, though dedicated readers may be more reliable.

Using a reader

When slotted in, the reader opens the card as a volume or disk. You can then copy images straight into the computer.

Choosing the best film

There are two film speeds commonly used: 100-speed (ISO 100/21º), for work where image quality matters and the lighting and circumstances allow its use; and 400-speed (ISO 400/27º), where light levels are low or short shutter times are required but not too much loss in quality can be accepted. Film "speed" refers to its sensitivity to light; the more sensitive it is, the faster it is said to be.

For the finest quality work, choose 25- or 50-speed films, as these offer good image sharpness, fine grain, low fog, smooth tonal gradation, and high color saturation. For work in minimal light conditions, 1000-speed films can give acceptable results, provided contrast is controlled during development. Many of the quality problems associated with high-speed films are, in fact, due to the use of inferior lenses at full aperture.

Black and white

There are modern black-and-white films, such as Ilford's Delta series or Kodak's T-Max series, as well as legendary films, such as Kodak's Tri-X and Ilford's HP5. The older films give a rich, textured image quality that many photographers favor, while modern emulsions use relatively thinner, more even emulsion coatings to achieve better sharpness and smoother tonal rendering.

Another type of black-and-white film, such as Ilford's XP-2, is known as "chromogenic." This is processed in the standard C-41 chemistry used for color negative film. However, while the image is formed of dark-colored dyes, the final image does not reproduce color. With this film, overexposure tends to produce smaller, not larger, grain (although sharpness drops just as it does with standard black-and-white film). Scanning chromogenic films can often produce better results more easily than conventional black and white.

Color

Modern 100-speed film gives a superb balance of image quality with speed. Nonetheless, 400-speed film is excellent and produces results in which the loss of sharpness and increase in graininess is

Fine-grain black and white
This close-up of a print from ISO 125/22º film shows the fine grain typical of slow- to medium-speed film: excellent for fine detail and smooth tones. Grain sizes are very similar, giving rise to higher contrast and narrower exposure latitude.

High-speed black and white
In return for its high sensitivity, or speed – which allows you to work in low light with shorter shutter times or smaller apertures – film grain has to be larger. Note the excellent detail captured by a modern high-speed film enlarged nearly 20x.

acceptable. However, contrast is higher and the subtlety of color discrimination is lacking.

Color films come in families these days, so you can choose speeds of film that are appropriate for different tasks while still enjoying family resemblances in terms of contrast, saturation, and color palette. For weddings and social portraiture, for example, where you may need to retain detail in the highlights of, say, the bride's dress or in light-colored clothes, you need a film with lower contrast and moderate color saturation. For general family photography, you may prefer to use a film that offers punchier colors and more lively contrast. Industrial, travel, and commercial photographers may go for even more vibrant color rendering with high color saturation.

If you are working in mixed lighting – tungsten lights combined with daylight, say – use color negative films. These show a greater tolerance to both exposure and color balance variations compared with color slide material, thus allowing corrections to be carried out more easily.

Color negative scans

With no silver to scatter light, lower contrast than slides, and a wide exposure latitude, color negatives often produce good scans. Problems come when translating the negative color information into a positive, as you need to correct for the overall orange cast of color negative film. There is also the problem with color negative film of knowing exactly what is the right color when you cannot see it for yourself.

Color printing paper corrects the low contrast of a negative: slight overexposure of a negative can improve printed color.

Fine-grain color
Fine-grain color films offer not only good resolution of detail and smooth tonal transitions but also better saturation and hue discrimination. The price for these advantages is lower sensitivity to light, leading to longer exposures or larger apertures.

High-speed color
You could treat the graininess, low contrast, and poor saturation of high-speed color as disadvantages or creative opportunities. In return for allowing you to work in low light with shorter shutter times or larger apertures, image quality is poor.

Choosing the best film continued

Specialist film

Silver-based films are made up of layers of silver-halide crystals sensitive to wavelengths of, mostly, visible light. However, it is possible to sensitize film to wavelengths such as infrared. Film layers must also be balanced for a specific white balance – most often, daylight white. If this is incorrect, a color cast results. The use of special-purpose film is not limited to their designed tasks. You can exploit their characteristics for creative purposes.

Color casts

For a subject to look correct, the illumination must contain all wavelengths of light – a street lamp producing yellow light makes a blue car look black, as there is no blue in the light for the car to reflect. Although digital cameras can correct for the orange cast of tungsten lamps, it may not be possible to see all the colors that would be available with a subject viewed in daylight.

 Tungsten
With a white point biased toward blue to counter the orange of household bulbs, tungsten-balanced film looks blue in daylight. The light from the lamp here is a warm white, but the daylight glows blue.

 Infrared black-and-white
With sensitivity shifted toward red, IR film is relatively insensitive to blue. Thus, the blue sky here looks black, while the stonework and metal, strongly reflecting IR light, appear white.

 Polaroid Polapan
This film produces black-and-white 35 mm slides within minutes, using a special developer pack and a simple developing machine. The slides offer very wide dynamic range and a unique tonal quality, but they are extremely difficult to scan.

 Infrared false color
This rare film assigns false colors (different from those seen in life) to images – for example, greens are rendered blue, reds become green, and infrared is shown as red. This film, if it can be found, needs a near-extinct form of processing.

Accessory lighting

The best lighting for photography on nearly all occasions is natural light. However, there will be times when daylight needs to be supplemented or you need to provide all the light yourself. The most convenient and readily available source of supplementary lighting is electronic flash.

On-camera flash

Virtually all digital cameras carry their own small flash units. These are convenient and offer automatic flash-exposure control, and some feature red-eye reduction, too. However, not only is their power limited, their position very close to the lens causes unsightly shadows when the flash is the sole source of light and the subject is close to a wall. The best use for on-camera flash is to lighten shadows in high-contrast or backlit situations.

Off-camera flash

To use off-camera flash, your digital camera must have an external flash-synchronization socket. These sockets differ, so obtaining the type of flash recommended by the camera manufacturer is the safest course to take. With an off-camera flash, go for a model with a tilt-and-swivel head, in which the flash head can point up (sometimes downward, too) and turn from side to side. These movements enable you to bounce the light before it reaches the subject and so soften its effect.

Ring-flash

While most flash units are used at a distance from the lens, ring-flash is designed to light the subject from as close to the optical axis as possible. The flash tubes are arranged in a circle surrounding the front of the lens, producing nearly shadow-free light. Ring-flash is useful for lighting close-ups of any small objects (as long as they are not shiny, flat, and taken directly face-on, since the light will bounce straight back into the lens) as well as portraiture and fashion subjects.

Continuous light

Any light source can be used for digital photography because digital cameras can correct automatically for the non-neutral colors produced by incandescent sources using the white-balance or white-point correction feature. This gives digital photography a great advantage over conventional color photography: domestic light bulbs, which usually produce a very orange light, can be used with impunity and with few worries about color balance.

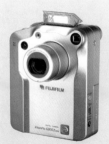

Built-in flash

This type of small, built-in flash is convenient, featuring fully automatic operation. However, output is weak, the flash-recharge time is slow, and results are likely to show the effects of red-eye.

On-camera flash

This type of unit delivers a useful amount of lighting, has fairly rapid recharging time, and flexible output settings. However, it can unbalance the camera, is not compatible with all camera types, and is costly.

Handle-bar flash

This is a very powerful, rapid-recharging, high-capacity flash unit, and very flexible to use. But it is also bulky as well as expensive to buy.

Ring-flash

This flash unit is perfect for close-ups, giving shadowless or modeled lighting with automatic control. Due to its specialized nature, however, it can be costly to buy.

Studio lighting

Studio flash units consist of a delicate, gas-filled glass tube with wire wrapped round it. When electricity is discharged into the wire, the gas in the tube is excited and emits a burst of intense light. A power unit is used to build up the necessary charge, and dials or slider controls are used to vary the output of the flash.

Two different types of flash unit are available. One – the monobloc – combines the lamp, controls, and the power supply in a single unit. This is the less-expensive option, but when mounted on stands these units are ungainly. However, if more power is needed, you simply add another monobloc. The alternative option is a separate power pack connected to the lamp by a cable. The advantage of this design is that lamps are compact and lightweight compared with the monoblocs; in addition, all lamps can be controlled from the camera position. However, power output is limited by the capacity of the power pack.

A Pyrex glass dome protects the hot lamp.

Bowens Esprit 1500
Monobloc designs – in which lamp, controls, and generator are all included – are easy to use and are good for a wide variety of work.

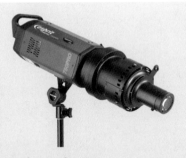

Multiple units are easily synchronized via slave triggers.

Dials control operation modes and power on/off.

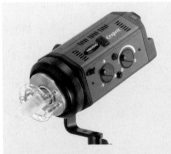

Esprit 250
A monobloc of modest power and relatively low cost, suitable for portraits and small-scale still-life work. It accepts a wide range of light-shapers and is also easy to use. Its light weight makes it a candidate for location work.

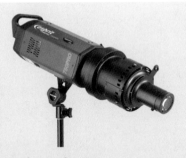

Universal spot
The light-shaper attached to the monobloc delivers a controllable and intense beam of light that is suitable for projecting images. Precision control of light power is especially important with spotlights.

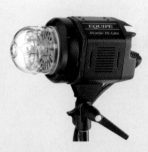

Equipe Studio Hi-Lite
A very compact and lightweight head is the benefit of separating the power unit from the lamp. This unit packs a powerful flash output, as well as having a strong modeling light to allow you to preview the fall of shadows.

A suitable starting outfit for portraiture and still-life comprises two units of at least 500 Ws (Watt/sec power) offering variable power over at least a 2-f/stop range. You will also need lighting stands, a synchronization lead, and a range of light-shapers appropriate for the type of work you do.

Light-shapers

The light from a flash unit can be shaped to give many styles of illumination. A spotlight creates a concentrated, intense beam; honeycombs give directional light favored in portraiture; but the most useful of all is the soft-box – a large reflector and diffusing screen hung on a frame. With the diffuser attached, a soft-box provides soft, low-contrast light; with the diffuser removed, the unit produces a directional, though not harsh, light.

Slave units

In the usual setup, the flash connected to the camera is the master light. When this unit fires, sensors, known as "slaves," attached to any other lights, fire their flash units in synchronization. This removes the need for all flash units in a multilight setup to be cabled to the camera.

Continuous light sources

Tungsten-halide lights are returning to the fore as a convenient light source with digital cameras, which are tolerant of varying color temperature. The best, such as those from Dedo, give a good output and are easily controlled. HMI lamps offer high output at lower operating temperatures, but they are expensive and complicated to use. Professional fluorescent lights are a good solution for digital photography: the light is diffused, color temperature is stable, and they run cool compared with tungsten units.

Versatile outfit
Two or three monoblocs with umbrella reflectors (*left*) and a soft-box (*below*) can tackle subjects from portraits to still-lifes and interiors.

Generator
A separate generator keeps controls and the power supply separate from the lamp itself. This arrangement allows for faster recharging times and more flexible control of the power output.

Esprit Digital
Touch-sensitive controls and digital read-outs of power on this monobloc unit help to ensure consistent and repeatable results – important factors for professional set-ups. Digital controls allow changes to be made in very fine increments.

Remote control unit
A further advantage of the digital control of flash power and mode settings is that units can be set remotely. This handset, working much like a television remote, can control up to eight different units.

How color monitors work

There are two main methods of producing the monitor through which we control the computer and assess images before printing them out. Both require extremely high levels of precision in manufacture and sophisticated control.

Cathode-ray tube

CRT, or Cathode-Ray Tube, technology is essentially the same as that used in domestic televisions: an electron gun, the cathode, is heated up to produce electrons that are accelerated and focused onto a phosphor-coated screen, which glows when hit by the electrons. For color images, phosphors that glow red, green, and blue are used. To ensure that the correct color phosphor is stimulated to glow by the beam, a grid is placed between the electron

beam and the phosphor. This grid consists of very fine wires or a series of holes precisely aligned to mask unwanted electron beams from the phosphors. When you consider that each phosphor dot is as little as a $\frac{1}{100}$ in (0.25 mm) away from its neighbor, you can appreciate the high levels of precision required. Furthermore, for a phosphor to continue emitting light, it must be bombarded by electrons: after an interval, which varies with each color, the light decays. So, for a steady screen image, each phosphor must be hit by electrons for different periods of time.

As the electron beams all originate from a small central point – the cathode – they fan out and focus on a section of a circle. However, the resulting curvature on a screen is uncomfortable to

CRT monitors
Similar to domestic televisions, these monitors are large and bulky but offer good color reproduction, high variable resolution, and wide viewing angles, as well as being relatively inexpensive compared to LCD screens.

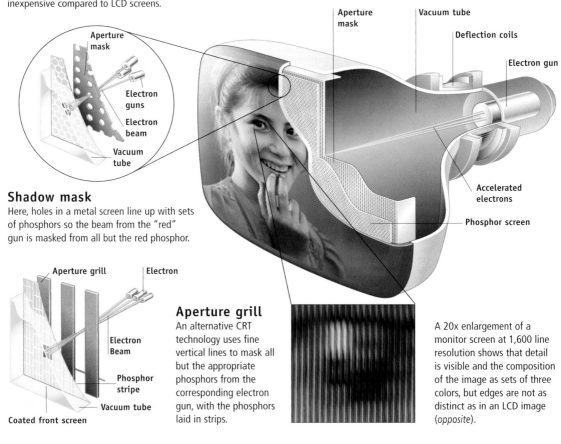

Shadow mask
Here, holes in a metal screen line up with sets of phosphors so the beam from the "red" gun is masked from all but the red phosphor.

Aperture grill — Electron

Aperture grill
An alternative CRT technology uses fine vertical lines to mask all but the appropriate phosphors from the corresponding electron gun, with the phosphors laid in strips.

Electron Beam

Phosphor stripe

Vacuum tube

Coated front screen

A 20x enlargement of a monitor screen at 1,600 line resolution shows that detail is visible and the composition of the image as sets of three colors, but edges are not as distinct as in an LCD image (*opposite*).

Aperture mask — Electron guns — Electron beam — Vacuum tube

Aperture mask — Vacuum tube — Deflection coils — Electron gun — Accelerated electrons — Phosphor screen

view and picks up background reflections. To produce a flat screen takes extremely sophisticated electronics and optics.

LCD screen

In an LCD (Liquid Crystal Display) screen, the crucial element is the liquid crystal itself – a liquid or semiliquid material whose molecules behave like crystals when subjected to the influence of an electrical field. Due to their structure, some types

of liquid crystal can polarize light – a property used either to allow or restrict the passage of light. LCDs, therefore, consist of one or more layers of liquid crystals sandwiched between or lying on top of very fine electrical plates and red, green, and blue filters. As a plate is turned on or off, the area controlled by it appears in the display alternately bright or dark leading to the sensation of color. Modern LCDs are backlit (a panel of light shines through the LCD) to improve visibility and contrast.

LCD monitors

Characterized by their thin profile, light weight, and small footprint, LCD monitors offer the best image quality for reading text and good color. Off-center viewing, however, reduces color accuracy and limits resolution.

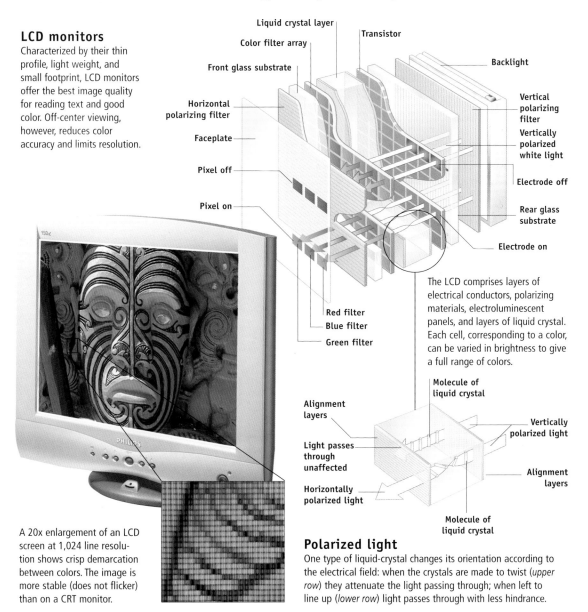

The LCD comprises layers of electrical conductors, polarizing materials, electroluminescent panels, and layers of liquid crystal. Each cell, corresponding to a color, can be varied in brightness to give a full range of colors.

A 20x enlargement of an LCD screen at 1,024 line resolution shows crisp demarcation between colors. The image is more stable (does not flicker) than on a CRT monitor.

Polarized light

One type of liquid-crystal changes its orientation according to the electrical field: when the crystals are made to twist (*upper row*) they attenuate the light passing through; when left to line up (*lower row*) light passes through with less hindrance.

Choosing the best monitor

Your choice of monitor is crucial, since you could easily spend as much time in front of the screen as you do taking photographs. The best advice is to buy the best and biggest monitor you can afford. Poor-quality screens may flicker and cause eye-strain, color and brightness will be uneven across the image area, and they may be difficult to calibrate and maintain (*see pp. 228–31*).

For image manipulation, the minimum screen size recommended is 15–17 in (38–43 cm), and you should make sure the screen is capable of displaying millions of colors, which may require the installation of a suitable video card or board to help the computer run the monitor. The screen resolution should be 1,024 x 768 pixels or better: many professionals work at 1,600 x 1,200 pixels.

Flat-screen monitors

Many cathode-ray tube (CRT) monitors offer a perfectly flat screen. A slightly curved type may be

LCD monitor

Modern LCD screens offer the best balance of ergonomic features with image quality, as well as minimizing eye-strain. Images are stable, geometry is perfect, and color rendition is excellent. But they cost far more than a CRT monitor with the same screen size. Bear in mind, too, that less-expensive LCD models may have restricted viewing angles.

Screens should tilt and swivel for the best viewing angle.

Buttons on the monitor are used to set screen brightness, contrast, and color.

Mitsubishi

Modern 19-in (48-cm) flat-screen CRT monitors are good value, offering very high resolutions up to 1,600 x 1,200 pixels at an economical price. An excellent beginner's monitor.

Philips

The smallest size for image manipulation is a 15-in (38-cm) screen with a resolution of 1,024 x 768 pixels, as offered by this model. An optional multi-media base with speakers can be added.

LaCie

A very large 22-in (56-cm) screen, an ability to project up to 1,800 x 1,440 pixels, and good color control make this an ideal monitor for image manipulation. The deep hood is a useful bonus, too.

much less costly but a flat screen reduces reflections from other light sources and is a mark of a high-quality monitor. Liquid-crystal display (LCD) screens are lightweight and slim but cost more than CRT monitors of the same screen size. Nonetheless, if you are prone to eye-strain they are worth considering because they exhibit no flicker at all. A good-quality modern LCD screen, displaying millions of colors, is perfectly suitable for image manipulation and needs less maintenance.

Color management

A modern CRT monitor should allow you to adjust the size of the image on the screen and to alter the shape and position of the image. An important control is convergence, which ensures that images do not display colored fringes.

However, perhaps the most important controls are brightness and contrast. Once these have been optimized, you are in a position to calibrate your monitor for a color-managed flow of work. Software utilities, such as those provided by your computer's operating system or by Adobe Photoshop, are available to help you in this. You may also use hardware calibrators: these are instruments that connect to the computer and are then placed on the monitor to measure its output. Adjustments are then automatically made.

Controlling reflections

Sidelight reaching CRT or LCD monitors can reflect into the user's face, causing uncomfortable glare (*below left and right*). The use of a deep hood (*below center*) reduces this problem.

CRT monitor Monitor hood LCD monitor

Which screen is best?

CRT monitors are capable of very high picture quality at relatively low cost. However, there are some health concerns regarding radiation emissions as well as the operator fatigue caused by the flicker from what is an essentially unstable image. This flicker, though not normally visible, can cause cause eye-strain. Modern LCD monitors offer a stable image, and some offer extremely high image quality, but at a cost two or more times that of equivalent-sized CRT screens. If you work for very long hours at the screen, especially in detailed work such as writing or image manipulation, an LCD screen is recommended.

Apple
Top-quality LCD monitors providing 1,280 x 1,024 pixel resolution or better will provide excellent image quality. They make good all-arounders and can be used for image manipulation.

Philips
LCD monitors have a larger viewing area than equivalent-sized CRT monitors: this 43 cm (17 in) LCD monitor provides a viewing area comparable to a 48 cm (19 in) CRT screen.

Silicon Graphics
If you can afford it, it is well worth paying for ultimate quality and reliability offered by large, professional-quality screens such as these: work becomes a pleasure.

How scanners work

In digital photography, flatbed and film scanners are the types most often used. In principle, they work in the same way as a digital camera – sensors convert differences in light values into electrical signals. The key difference is that a scanner provides its own source of light to illuminate the object, which is usually a print or film.

Inside the scanner's casing, a line of sensors covers the width of the bed holding the object to be scanned, and when scanning begins the sensors sweep along the entire length of the object. To direct light from the light source – usually a cold-cathode or set of LEDs (light-emitting diodes) – to the sensors that read light values, various optical devices, such as mirrors and lenses, are used. And the quality of a scanner depends greatly on the quality of the optical components.

The amount of light reflected by or transmitted through the print or film is picked up by a sensor, which produces an electrical signal that is then converted into a stream of digital information. This analog-to-digital conversion is highly susceptible to electrical interference and the scanning process itself is sensitive to vibration and noise.

The most common type of sensor is the CCD (Charge Coupled Device); another type is the CIS

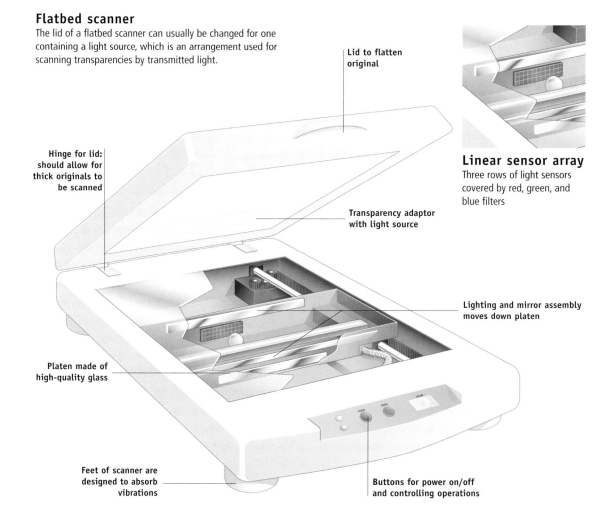

Flatbed scanner
The lid of a flatbed scanner can usually be changed for one containing a light source, which is an arrangement used for scanning transparencies by transmitted light.

Lid to flatten original

Hinge for lid: should allow for thick originals to be scanned

Transparency adaptor with light source

Linear sensor array
Three rows of light sensors covered by red, green, and blue filters

Lighting and mirror assembly moves down platen

Platen made of high-quality glass

Feet of scanner are designed to absorb vibrations

Buttons for power on/off and controlling operations

(Contact Image Sensor), a technology that uses tightly packed LEDs and with sensors placed very close to the object. This arrangement allows extremely compact scanners to be made.

TWAIN driver

TWAIN is a standard for devices that acquire an image, such as scanners and digital cameras, allowing them to transfer their data to software applications. It enables software to work with these devices without the software having to know a thing about the device itself: any TWAIN-compliant device should be able to work with any TWAIN-compliant software application without any compatibility issues ever arising.

Since it is possible to connect multiple TWAIN-compliant acquisition devices to a computer, each device will have its own TWAIN module. Your software application must allow you to select which TWAIN device to use. For example, in Photoshop, the "Acquire" option in the File menu lists all the devices installed on the system.

Scanner features

- Some scanners detect and automatically remove dust particles on the film. With some types of film grain (*see pp. 44–5*), this process may somewhat soften the image, so a small amount of Unsharp Masking may be needed (*see pp. 248–51*). Although this process adds to scanning times, it can save you a lot of effort later on by eliminating the need to remove specks of dust manually.
- More advanced scanners can read film more than once. As noise (*see pp. 246–7*) in the data is random, repeated sampling of the film evens out and so reduces its appearance in the final image. Some software can add this feature to a scanner whose software does not provide it, though it does add considerably to scanning times.
- All modern scanners offer a color depth of at least 8-bit per channel or 24-bit RGB color (*see p. 271*). This means, in theory at least, that they can discriminate between some 16 million colors – in practice, the range may be a mere 10 million or less. High-quality scanners can work to 42-bit or 48-bit color – this enables greater color fidelity and smoother tonal transitions, particularly in the highlights and shadows. Note that 48-bit color produces enormous file sizes and few software applications can handle the data.
- Scanners offering higher optical resolution are generally preferable to those with lower resolutions, but beware of inflated resolution claims, such as 9,600 dpi (dots per inch). These are the result of using software to squeeze in extra pixels: there is no real increase in detail, although results in the final image may look superior because of smoother tonal transitions.

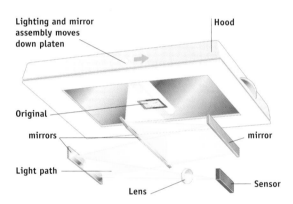

Transparency scanning
Light from a lamp in the hood passes through the original, which modulates the beam that is then analyzed by the sensors at the end of the light path.

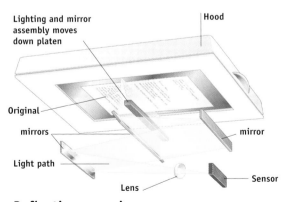

Reflection scanning
Light from a lamp under the platen shines light onto the original, and mirrors and lenses relay the image to the sensors. The design must ensure that stray light from the lamp does not interfere with the image reaching the sensor.

Choosing a scanner

Today's scanners are so powerful and capable that instruments capable of professional-quality results are within the reach of anybody who can afford a digital camera or computer.

Flatbed scanners

Flatbed scanners work somewhat like photocopiers – you place an original face down on the glass and a sensor runs the length of the original to make the scan. If your print is large enough and good enough, even inexpensive scanners are capable of producing results that can, with a little work, be turned into publication-quality images. These scanners can also be used as a type of close-up camera for taking images of flat subjects at full size or high magnification (*see pp. 220–1*).

Flatbed scanners can be adapted for transparent originals using a transparency adapter, which is usually another light source that resides in the lid above the scanner bed that moves in step with

Microtek flatbed scanner
Typical of numerous flatbed scanners, this model produces excellent results from prints, is easy and quick to operate, and is reliable.

Buttons to launch applications and initiate scanning make the machine easy to use.

Scanmaker X6
Inexpensive 600 x 1,200 ppi resolution scanners working with a SCSI interface are suitable for older computers. Choose a USB or FireWire version if available, but older instruments offer excellent value for money.

Scanmaker X12
A resolution of 1,200 x 1,200 ppi is very good performance for a flatbed scanner – and more than you need for prints. Even with a transparency adapter and USB interface, good results are attainable at a reasonable cost.

Scanmaker 3600
You do not need to purchase the newest scanner to obtain pleasing results. Older ones are simply more bulky and a little slower to operate. If you only scan prints, a scanner such as this is perfectly adequate.

the scanner head under the original. Check that the adapter is supplied with the scanner, since a separate one can add considerably to the total cost.

If you intend to scan flat originals of about A4 size, an entry-level scanner offering resolutions in the region of 600 ppi (points per inch) – often quoted as 600 dpi (dots per inch) – will be fine.

For scanning artwork up to A3, you will need an A3-size scanner, which is far more costly than an A4 type. Scanning a large original in sections in order to blend the parts together is not recommended with entry-level machines: unevenness around the edges is likely to make a poor match.

Well-known manufacturers, such as Umax, Microtek, and Epson, offer machines that cater to a range of needs, from the home-office worker upward. In general, it is true that the more you pay, the better performance you can expect – in terms of mechanical operation, reliability, and quality of software interface.

Before you buy

● Examine the interface – the software with which you control the scanner – since some are confusing and badly laid out.

● Make sure the scanner's connection is suitable for your particular computer: the best is FireWire (also known as IEEE 1394); USB is a low-cost option, USB 2.0 a faster version. Some professional-grade equipment uses SCSI.

● Make sure that you can return the scanner to the store if it does not work with your computer and software. Operating conflicts are not uncommon.

● If you need to scan film or transparencies, ask whether a transparency adapter is extra. If so, find out how much it costs.

Transparency adapters

Should you need to scan medium- or large-format film, you need, in the first place, a scanner with a transparency adapter. This is simply a light source that shines light through the transparency or film onto the scanner's sensor. The area for scanning transparencies is almost always smaller than that for artworks or prints, which are scanned by reflected light. Many scanners use a light panel something like a light-box; others a light that traverses the length of the glass platen. Yet others use a sliding tray arrangement.

Transparencies require a higher scan resolution than prints. So-called "repro-quality" scanners offer resolutions of at least 1,200 ppi in one direction, and their maximum density ratings should equal or exceed 3.5.

CanoScan FB1210U
Newer scanners are compact and offer good interfaces as well as rapid, fuss-free operation: this one offers 1,200 x 2,400 ppi resolution and good-quality color. Its transparency adapter, designed for medium-format film, works well.

Heidelberg Linoscan 1200
Heavier, bulkier desktop scanners with an optical resolution of 2,400 x 1,200 ppi are suitable for professional work. The integrated transparency unit makes it attractive for those who have large-format transparencies to scan.

Heidelberg F2650
Large scanners accepting up to A3 in size are very costly but produce top-quality scans of prints as well as transparent materials. This scanner uses a respected, difficult-to-learn software driver.

Choosing a scanner continued

Specialist film scanners

For the digital photographer, a specialist film scanner represents the best balance of features and quality. Modern film scanners can provide excellent-quality results at a very reasonable cost, producing reproduction-ready scans for a fraction of the cost of an SLR camera and less even than a middle-of-the-range digital camera.

The principal manufacturers, such as Minolta, Canon, Nikon, Umax, and Microtek, all offer film scanners capable of producing results that, with a little work, are suitable for professional use. For 35 mm film originals, it is hard to beat the Nikon Coolscan range: the 4,000 ppi performance gives results that are more than adequate for the production requirements of virtually all publications. Minolta and Nikon also make fine instruments for larger film formats.

Most scanners accept 35 mm both as cut film strips and mounted transparencies, using film

Canon FS4000 US

This modern desktop film scanner offers remarkably good optical performance – sufficient for many professional tasks – as well as convenient features and easy connection to the computer.

A spring-loaded door accepts film and slide carriers while keeping dust out. It also accepts adapters for APS film.

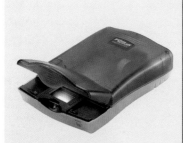

Microtek FS 35

Basic and inexpensive film scanners can give results acceptable for use on the Internet and for small enlargements. They are usually controlled by simple software with few features.

Minolta DiMage Scan Elite

For relatively low cost, there are many compact and efficient scanners for 35 mm film that can scan to resolutions of up to 2,820 ppi. Look out for those with dust-removal features.

Microtek 4000t

A higher-cost option is a scanner with an excellent software interface, able to scan up to 4,000 ppi for the 35 mm format. Good-quality accessories such as a color-calibration target are a benefit of the higher price.

carriers or slide holders that are inserted into a slot on the front of the machine. For the medium-format, all scanners accept cut film strips but some also accept mounted transparencies. Some scanners are available with an adapter suitable for APS (Advanced Photo System) film cartridges.

Selecting a scanner

Scanner features that you should consider before buying include:

Resolution Choose a machine that offers an optical resolution of at least 2,700 ppi (points per inch). This will create files around 20 MB in size, which should be enough for fair-quality A3 ink-jet prints or for magazine reproduction up to about A4 size.

Maximum density Look for a machine offering a maximum density of at least 3.6 – this will allow you to scan color transparencies to fair quality.

Quality of film carriers Some carriers are flimsy and you may find others awkward to use.

Film formats An APS adapter is usually an extra cost. For a panoramic format 35 mm, you are likely to need a medium-format scanner. These offer as many as eight different film carriers but many will be optional items at extra cost.

Driver interface On many scanners you have no choice but to use the manufacturer's, and some are far easier to use than others. VueScan scanner drivers work with many machines and may be superior to the manufacturer's own.

Over-sampling Some scanners can sample an original more than once, combining information so that differences are averaged. This has the effect of keeping genuine, repeatable information – and because unwanted data or noise is random, over-sampling strips out image-degrading artifacts.

Computer connection The best option is FireWire (which is also known as IEEE 1394). USB is a low-cost option, while USB 2 is faster; SCSI is used by older equipment.

Other useful features

If you have occasion to make many scans at a time, it is useful to be able to present a stack of transparencies to the scanner and leave it to work on them automatically – this is known as batch scanning. The Nikon scanners are very well designed in this respect.

Another useful feature is automatic dust removal, available on scanners from Nikon, Canon, and Minolta, among others. When implemented well, this can save much post-scanning work eliminating the hairs and dust always found on film. Note, however, that scratches and large defects in the film may not be removed.

Minolta Scan Multi II
Medium-format film scanners generally offer excellent performance with scans of up to 2,820 ppi. Accessories are well made, the interface is excellent, and dust-removal features are offered for formats up to 2½ x 3½ in (6 x 9 cm).

Nikon LS-8000
For superior quality, machines need to be heavy and solid. The Nikon LS-8000 scans at a resolution of up to 4,000 ppi with dust removal. High-quality accessories are often available, but the driver software may not be to an equal standard.

Powerlook 3000
Professional-quality scanners will give many years of service. This model scans up to A4 size by reflected light and handles transparencies (slides) up to 4 in (10 cm) wide with resolutions up to 3,000 ppi.

Choosing the best software

It is likely that with the purchase of your digital camera, scanner, or computer, you will have all the software you need to get started in digital photography. In addition to the utility software that enables your computer, digital camera, and scanner to talk to each other, you will need an image-manipulation application, and the most widely used is Adobe Photoshop. However, many photographers do a great deal of satisfying work using much less costly, easier-to-learn software.

Entry-level image editors are all easy to use. For example, consider MGI PhotoSuite, which offers many features at a very low cost, while JASC Paint Shop Pro has a good suite of features at a slightly higher price. Other low-cost options to consider include Ulead PhotoImpact, Microsoft Picture It, and MGI LivePix. Adobe PhotoDeluxe is easy to use but you may outgrow it quickly. A better choice is Adobe Photoshop Elements, which has a powerful feature set and is easy to use.

Adobe Photoshop

Ease-of-use is not the first feature that Photoshop is noted for, but that is what experienced users most appreciate. The reason is that it is easy to customize Photoshop so that working with its numerous features can be highly streamlined and efficient. Besides this, there is Photoshop's power

Adobe Photoshop
While Photoshop is not easy to use, its ability to manipulate numerous layers and masks is unrivalled by any other software. Despite certain limitations concerning Brush and tonal controls, Photoshop continues at the top of any list of recommendations.

and versatility. This power has been greatly extended by the numerous software plug-ins that allow you to extend its every feature – from specialized saving of JPEG files and the removal of dust-specks to an infinity of filter effects. However, in addition to its relatively high purchase price, Photoshop also requires large amounts of RAM for it to function efficiently and fully. If you handle files not larger than 5 MB, then 64 MB of RAM will be adequate; however, most digital photographers work with file sizes of 10–20 MB, in which case 256 MB or more RAM should be installed. Don't forget that more RAM will be needed if you wish to run a desktop publishing or web-page design program at the same time.

Other image editors

More professional and costly software provides powerful features with slightly different slants.

JASC Paint Shop Pro
This Windows-only program is a very popular alternative to Photoshop. It is cheaper and less system-intensive.

Ulead PhotoImpact
A Windows-only program offering graphics and web-design tools, as well as a good features for image editing.

Adobe Photoshop Elements
A stripped-down version of Photoshop but offering extra features, such as panorama-creation. Good for beginners.

Corel Painter (Mac and PC), for example, produces a multitude of paintlike effects (*see pp. 316–19*) together with image-editing tools, some far more powerful than those available in Photoshop. Corel Photo-Paint is a serious competitor for Photoshop and at a cheaper price. Equilibrium DeBabelizer is designed for image processing in batches and its tools for making global changes to many images are extremely powerful.

Plug-ins and extras

Plug-in software applications are programs in their own right, but they are written to make use of another application's core program, or "engine." Photoshop itself comes with many of its own. PhotoTools from Extensis is exceptional in adding a good range of tools, including convenient buttons to supplement the standard menu. Another popular choice from Extensis is Intellihance, which is used to make quick, overall image improvements. The most popular plug-ins are those that produce special effects, such as sunbursts, metallic and bevelled text, blurs, and so on. Kai's Power Tools, Alien Skin, and Xenofex each offer a wide range of effects – and between them, more than anyone would ever need. But beware, special effects are exactly that – effects for special occasions. Repeated use rapidly becomes overuse.

Before you buy

When purchasing software, particularly professional applications with more advanced features, you should check the following:

The operating system required If you do not have the latest computer, check that the version of your operating system, such as Mac OS 9.2 or Windows 95, will run the software.

Minimum RAM Check how much RAM the software needs to run efficiently. One advantage of amateur software is its modest demands for RAM, while Photoshop will take all the RAM you can give it. If you wish to run many applications at once – word-processor, page-design, and image-manipulation software – you will need a great deal of RAM to keep your machine running quickly and smoothly.

Minimum hard-disk space Check how much hard-disk space the software needs. In addition to the space for the software itself, it will need space to store temporary working files – the larger your files, the greater the space required.

Dongle protection A very few applications use a special plug – the dongle – that connects between your keyboard and computer to prevent software piracy. Avoid these if possible, as the dongle itself can be incompatible with your computer's connections.

Corel Painter
A very powerful and satisfying program for producing a vast range of effects simulating artist materials for print and web.

PhotoRetouch Pro
Powerful, sophisticated, and elegant to use – probably the best program for photographers working digitally.

Corel Photo-Paint
A fully professional program, rivalling Photoshop for features, with powerful tone controls and brushes.

Additional software

Modern photographers need to be multiskilled – able not only to visualize a photograph, but also capable of handling the computer resources required to make the most of the resulting images. The remarkable fact is that, for a relatively modest outlay, anyone can produce professional-looking brochures, booklets, posters, and websites, provided you have the extra software.

DTP

Desktop publishing (DTP) software enables you to design page-based products with greater ease than working with word-processing applications – however powerful the word-processor. DTP applications enable you to handle pictures and type flexibly and fluidly. Microsoft Publisher (PC-only), Serif Page Plus (PC-only), and Appleworks (Mac-only) are inexpensive and suitable for basic publishing needs such as newsletters, short brochures, or simple books printed on ink-jet or laser printers. For professional work, consider QuarkXPress, CorelDraw, or Adobe InDesign (all PC and Mac).

Fonts

A good collection of carefully chosen fonts helps distinguish your presentations from others – look out for elegant faces that complement your design and avoid using standard faces such as Times, Helvetica, and Arial. Don't use typewriter-like (so-called monospaced) fonts such as Courier unless you know what you are doing. Fonts are inexpensive to buy and many hundreds are available for free or at very low cost. For work intended for book publication, high-quality fonts are important to give the text a clean appearance. A font-management utility, such as Font Reserve or Extensis Suitcase, is inexpensive but invaluable for handling large collections of fonts.

Fonts for web-based work should be chosen not only on design criteria, but also with legibility in mind, especially when used in dense text. For this, Verdana or Georgia are good choices as they remain legible down to quite small sizes.

Clip art

If you need a simple illustration – for example, of a telephone, road sign, or animal symbol – it can be quicker and easier to use or modify one already created. These clip art collections are very inexpensive – the main problem you will have is selecting from the innumerable choices offered.

Protection

It does not take long for your computer contents to represent a considerable investment in money,

QuarkXPress
Powerful, industry-standard software that works rapidly and efficiently. It is well worth mastering but is extremely expensive to buy.

Publisher
Optimized for business design needs and so is relatively easy to use. It is provided with numerous templates and guides to aid design. Windows-only.

Dreamweaver
Powerful software for writing and designing web pages and for managing websites, using visual design tools.

Adobe GoLive
A versatile and extensive program for producing dynamic content of web pages using visual design tools.

time, and effort – one worth protecting from computer viruses. Windows PC users are vulnerable if they surf the net or share files with other PC users. While Mac viruses are not as destructive, they can still cause lost time. All computers should have virus-protection software. Other software to monitor the state of the hard disk or aid file recovery after a crash or other problem can also be useful. Consult computer magazines for the latest software, as new types are frequently introduced. Well-known examples include Norton Utilities, TechTools, FWB Tool Kit, and McAfee Disk First Aid.

A virus attack may not be obvious: your computer may simply become unreliable or slow. Avoid uncertainty by installing and using virus protection software, especially Windows users.

Virus protection

Antivirus software such as Norton AntiVirus or NA Virex can slow down operations – a small price for the protection provided. To maintain its usefulness, you need to update the database – usually by downloading an updater file from the internet. Remember to turn off virus protection when installing new software.

Installing software

To avoid problems that can often occur with newly installed software, the following may help:

● Read the instructions – you may have to install items in a specific order or ensure a system file is up-to-date before the software works properly.

● Turn off all virus-protection software when installing a new program.

● Ensure you install via the installer or install shield program: to do otherwise may make it very difficult to uninstall the program correctly.

● If the software does not work properly, it may be easiest simply to reinstall it from scratch – existing files belonging to the software will be overwritten.

● If the computer crashes when you first run the software, there may be a conflict somewhere within the system. Try starting the software with no other software running. Check the "Read me" files or contact the manufacturer's help line. Mac OS users can remove new extensions to try resolving the conflict.

● Mac OS users can color code all files in a given folder with, for example, a blue color before installation. After installation, any new files will not be color coded and so are easily spotted. This is invaluable for locating new files in the Extensions or Preferences folder when resolving software conflicts.

Suitcase
A useful tool for managing and keeping track of fonts as your collection grows. Mac-only.

Fontographer
Create and modify your own fonts and symbols with this powerful application. Suitable for Mac-only.

ACDSee
A powerful picture viewer, graphic converter, and digital image-management tool. Windows-only.

Portfolio
An excellent tool for managing and organizing your collection of pictures, and for basic publication to the web.

How printers work

Digital printers place inks or pigments at precisely determined points on a substrate, such as paper or cardboard. The dominant printer technologies in use are the laser and the ink-jet, with other types, such as dye-sublimation, available in far fewer numbers. (*For a discussion on the permanence of printouts, see p. 356.*)

Ink-jet principles

These types of printers squirt minute quantities of ink onto the substrate. In most cases, the ink is a dye (a soluble colorant), but some use solid color pigments, which offer better color permanence and image longevity.

As well as the ink, the composition of the receiving substrate is also vital to the final quality of the print. Modern ink-jet papers are a complex sandwich of layers designed to absorb ink without allowing it to spread too far. Paper surfaces vary considerably, from attractive matte to metallic glossy, and some also very closely imitate photographic papers.

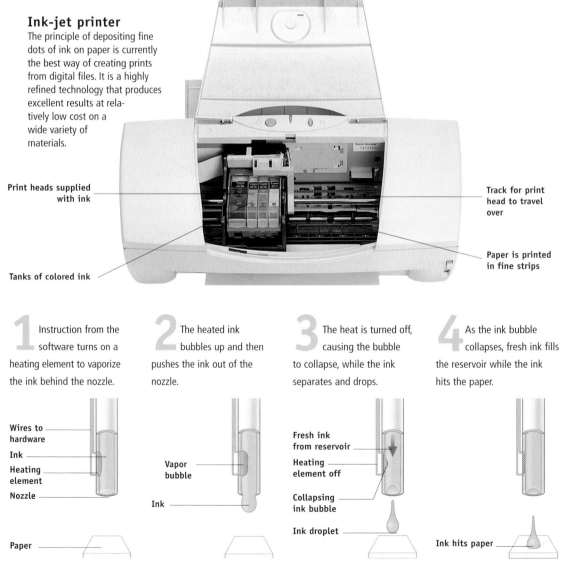

Ink-jet printer
The principle of depositing fine dots of ink on paper is currently the best way of creating prints from digital files. It is a highly refined technology that produces excellent results at relatively low cost on a wide variety of materials.

Print heads supplied with ink

Tanks of colored ink

Track for print head to travel over

Paper is printed in fine strips

1 Instruction from the software turns on a heating element to vaporize the ink behind the nozzle.

2 The heated ink bubbles up and then pushes the ink out of the nozzle.

3 The heat is turned off, causing the bubble to collapse, while the ink separates and drops.

4 As the ink bubble collapses, fresh ink fills the reservoir while the ink hits the paper.

Wires to hardware
Ink
Heating element
Nozzle

Paper

Vapor bubble

Ink

Fresh ink from reservoir
Heating element off
Collapsing ink bubble
Ink droplet

Ink hits paper

Dye-sublimation printers

Sublimation is the change in a substance from a solid to a gas without first becoming liquid. This is exploited in dye-sublimation printers by using colored ribbons close to the receiving layer. When the ribbon is heated, the dye sublimes into a gas, which is deposited on the paper. A good dye-sublimation print looks most like a photograph even when viewed close-up. However, most of these printers are costly professional models.

Laser printers

These printers work on the same principle as photocopiers: electrical charges on the surface of a drum alter according to the light falling on it. The drum picks up toner or not, according to the pattern of the charge, and deposits the toner onto the paper. The toner is then fused onto the paper by heat and pressure. Laser printers differ from copiers in that the charge is built up dot by dot and line by line. A laser beam reflects off a mirror that spins around: as it turns, the beam of light scans across the drum. By rapidly turning the laser on and off, a series of dots is applied to the drum. Color printers use colored toners to build up the image, usually one at a time, so a full print needs four passes. Laser printers are useful for rough proofing and good-quality text output.

Multipurpose laser
For a small business or home office, a laser machine that can print, scan, fax, and copy – all in one unit – is an economical, space-saving solution. Image quality may not be the highest, but modern machines provide print output suitable for flyers, small posters, and letters. However, be aware that a serious breakdown will leave you with all functions out of order.

Dye-sublimation printer
Dye-sublimation printers are in general costly to purchase and run, requiring special papers as well as dye ribbons. The return for your investment, however, is image quality that is the closest to true photographic-quality output presently available. Small dye-sublimation printers can be very portable and are an excellent way to produce prints for gifts.

Checking printer output

Today's desktop printers can out-perform the quality of many digital cameras. But to ensure that you produce the best possible image, color settings have to be correctly made (*see pp. 342–5*).
● Examine closely any areas of very dark tones in your test print: do the dots of color appear to run together into uneven clumps or puddles? If so, the paper is unsuitable. Produce another test print on better-quality paper (*see pp. 346–7*).

● Examine any large areas of even midtones, such as blue sky or evenly painted walls. Do they appear banded (as if painted in strips with tiny gaps between) or uneven in any way? If so, reject the print.
● Examine closely any small areas of what should be smooth, even transitions in tone, such as the side of a face falling into shadow or the bodywork of a car. Are the changes smooth or do they look mottled or banded? If so, reject the print.

Choosing the best printer

Modern ink-jet printers produce excellent print quality at low prices. They are generally reliable, and most are easy to use. The only downside is the cost of the inks and good-quality paper. However, while the ink-jet is the dominant technology, it is not the only one. When near-photographic quality is required, there are dye-sublimation printers, and for printing graphics-heavy pages, the color laser is more suitable (*see pp. 64–5*). Features you should consider in an ink-jet printer include:

Paper handling Some printers detect paper size and adjust settings accordingly, particularly those able to print off a card reader. Others take a range of papers, from ordinary weight to cardboard. Some models also accept paper on a roll, allowing small posters to be printed (*see pp. 346–7*).

Resolution In general, higher-resolution printers deliver better-quality results, but the issue is not simply about resolution. The difference between

Ink-jet printer
Typical of modern ink-jet printers, this model takes a variety of papers on a nearly straight paper path and is simple to use, but good prints need several minutes to output.

Being able to change ink tanks separately is a cost-saving feature.

A paper-thickness-adjustment control is a useful feature.

Canon BJS 800

Canon BJC 85
Portable printers are compact and lightweight and can be powered with an optional battery pack. Quality can be surprisingly good, considering size, although operation is slow.

Hewlett Packard 940C
Modern ink-jet printers can be used for printing letters as well as photographic-quality prints. If you do a lot of printing, choose one with a large paper capacity.

Lexmark Z52
Even very low-cost printers can produce entirely acceptable image quality. Good printing speeds are also possible. These models are very suitable for the home-office environment.

2,000 dpi (dots per inch) and 2,880 dpi is of no practical significance: the precise way in which the printer software uses the dots available is far more important (*see right*). Looking at results when comparing printer quality is better than reading technical specifications.

Four or six inks In general, printers using six colors for printing are more likely to produce photographic quality than those using only four.

Separate ink cartridges Most desktop printers keep all color inks in an integrated cartridge (the black is usually separate). This means that if you print out a lot of images with, say, blue skies, you will have to change the cartridge when the cyan ink has run out even though there is still plenty of magenta and yellow. Choose desktop printers that use separate tanks for each color.

Printers with card readers Some printers able to read card devices, such as CompactFlash and SmartMedia, can print directly off a card, without the need for a computer. This is convenient for basic proof-printing – to check the quality of images from a shoot – or if you repeatedly need to make prints to order, since you can store prepared files on a card and print them off as needed.

Half-tone cells

Printers can lay more than 2,000 dots of ink per inch (dpi) but since no printer can change the strength of the ink and not all can vary dot size, not all dots are available for defining detail. Thus, printers use groupings of dots – half-tone cells – to simulate a grayscale. At least 200 gray levels are needed to represent continuous tone. Therefore, a printer must control a large number of ink dots just to represent gray levels, reducing the detail that can be printed. In practice, detail resolution above 100 dpi meets most requirements. Now, if a printer can lay 1,400 dpi, it has some 14 dots to use for creating the effect of continuous tone. If you multiply together the four or more inks used, a good range of tones and colors are possible.

Filling in cells
Each cell accepts up to 16 dots – counting a cell with no dot, 17 grayscale levels are thus possible. Cells should be randomly filled. Here, they have a regular pattern, so when cells are combined a larger pattern emerges. The device resolution is used to place more dots in each cell.

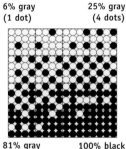

6% gray (1 dot) 25% gray (4 dots)

81% gray (13 dots) 100% black (all dots on)

Epson Stylus Photo 895
Printers offering a built-in card reader are very convenient if they are completely independent of computers. Look for a LCD screen able to show pictures.

Hewlett Packard 1220 CPS
Printers capable of reliably outputting prints to professional quality up to A3 size and larger may cost more. However, they will offer good color control with PostScript capability.

Epson 2000P
Printers that use pigment-based inks, such as this model, offer the best in print longevity as well as high image quality. Operation and color control, however, can be tricky.

How computers work

At the heart of digital photography is the computer, yet when you open a computer you find mostly air and a board with a few tiny items attached. The most remarkable fact about this assembly of items is that if there is the slightest fault in any one of them, then the computer will probably not work at all. This gives us an insight into the way computers work: a strict hierarchy of control and instructions so interrelated that the failure of one exchange can bring the whole system down.

At the top of the hierarchy is you: by turning on the computer and entering commands via the mouse or keyboard, you tell components in the computer what to do. Data goes into a controller, which turns it into the appropriate type for specific parts of the computer – the key component being the central processor unit (CPU).

One way to visualize the CPU is to imagine that a city has a traffic system in which every intersection is controlled by a set of lights, and that at each

Desktop computer

Many components in modern computers – such as the CD and hard disk drives, memory, and graphics cards, are common to all and easily interchangeable. Their internal structure is also largely similar, regardless of make.

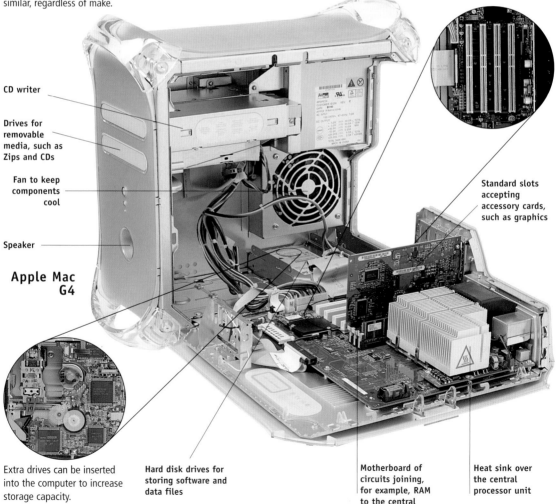

Slots accepting extra cards for graphics, interface, and so on.

CD writer

Drives for removable media, such as Zips and CDs

Fan to keep components cool

Speaker

Apple Mac G4

Standard slots accepting accessory cards, such as graphics

Extra drives can be inserted into the computer to increase storage capacity.

Hard disk drives for storing software and data files

Motherboard of circuits joining, for example, RAM to the central processing unit

Heat sink over the central processor unit

intersection the lights can order a car to turn left, right, stop, and so on. When you load a program, such as an image-manipulation application, into the CPU, you are programming the way the traffic lights work. Now if you speed up the vision, so that the cars are electrical pulses and the lights change hundreds of millions of times a second, you are close to seeing how a CPU works.

The CPU forgets everything every time the power is turned off, which is why start-up takes a few minutes: the CPU must be loaded with instructions before it can work. To back up its operation, it relies on memory stores – fast but unstable, dynamic access memory (RAM), and stable but slower memory from the hard disk or other storage devices. The computer also has other controllers specializing in taking care of, say, the monitor, modem, or a digital camera.

To the average user, this is irrelevant to the job of obtaining results from the computer, but if you bear in mind that the computer is only as good as the instructions given to it, you may remember to approach it systematically and methodically.

Computer care

Computers are usually built to run continuously for years in an office, so they should be very reliable when used in a domestic environment: most problems have to do with the software. You can safeguard your computer's useful life by following some simple rules:

● Connect your computer to a surge-protected power supply or block for power plugs.

● Do not jolt or attempt to move the computer when it is working.

● Earth yourself before opening the computer and touching any internal part or before picking up a component for installation. An earthing wire that attaches to your wrist is readily available.

● Once a year, open the computer and carefully vacuum away the accumulated dust – usually worse on the cooling fans and around the drives.

● Use virus-checking software and keep them updated, particularly if you are a Windows user.

● Keep ample free space at the back of the computer for the air to circulate and keep the machine cool.

Mac versus PC

A complicated question for anyone wishing to buy a computer is "Do I buy a Mac or a PC?" In fact, you can work for your entire life on one machine or the other without being aware of any substantial differences between them. It is easy and natural to compensate for features that you find awkward, and you will naturally make full use of features that suit you. There is no single difference between PC-compatibles and Apple Macs that makes for a clear choice. Modern computers, if well built, are very reliable and perform extremely well. Modern operating systems are superbly powerful and generally highly stable, with few of the crashes that used to be part of the computing experience.

However, independent market surveys have shown that workers on Apple Macs are more productive and profitable, possibly because the design of the interface enables smoother work-flows. Added to these factors is

the Mac's relative immunity to virus attacks. In the first two years of the Mac OS X, there were no reported viruses and it attracted only a fraction of a percent of hacking attacks – during the same period there were literally thousands of viruses and attacks on Windows machines. In general, Apple Macs appear to accept new peripheral devices such as cameras, scanners, or drives with more ease than do Windows machines. And if you wish to create a network, Macs of nearly any vintage will network within seconds of being plugged together.

Another important advantage of the Mac is that it can run Windows programs easily – with special software such as Virtual PC – and it can also easily read Windows-produced disks. While nearly everyone in the world uses a PC-compatible machine, most creative people producing content for Web pages, magazines, photography, books, and advertising are Mac users.

Choosing the best computer

The serious digital photographer will spend at least as much time at the computer as actually out and about taking pictures. The computer has, in effect, replaced the darkroom.

What to look for in a computer

All Apple Mac computer models G3 and higher are capable of digital photography, but they may need extra RAM. All Windows machines with Pentium series chips and higher are also suitable, but are also likely to need a boost in RAM. You should consider 256 MB to be the minimum.

However, less-obvious features, such as the quality of the mouse and keyboard, can make a difference to your enjoyment and comfort. If the keyboard action is not to your liking or if you find the mouse uncomfortable, then do not hesitate to change it: these replacement accessories are inexpensive, and if you ask for the change at the time of purchase they may be even cheaper.

Desktop computer

Modern computers at their best combine style with tremendous computing power. Despite its very compact form, this iMac is capable of professional-quality image manipulation, as well as video and music editing.

Apple iMac

LCD screen

iMac ports

Your computer should offer at least two FireWire (IEEE 1394) ports, two USB ports, and Ethernet for networking.

Adjustment for screen swivel, tilt, and height

Computer casing and door for CDs

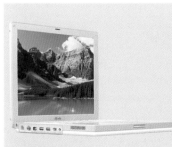

Apple iBook

Although compact and lightweight, this laptop is capable of full-scale image processing as well as Internet access. It makes an ideal companion for the digital photographer on location, since some models can burn CDs.

Packard Bell laptop

Laptops running Windows software are very numerous and similar to each other. Modern examples, like this model, are well capable of image manipulation, but they may need extra drives to burn CDs.

Apple PowerBook

Slim but offering a large screen, this machine is more powerful than most desktop computers and is capable of all but the most processor-intensive tasks. Highly recommended machine for digital photography.

Software packages

When budgeting, do not forget the cost of software – a full suite of software for image manipulation as well as desktop and Web publishing can easily cost more than the computer itself. However, it is sensible to start with modest applications until your skills develop. Professional software can be very frustrating and hard to master, while simpler packages are far cheaper and still produce good results (*see pp. 60–3*).

Adjustable viewing

For best viewing comfort, you should be able to adjust both the height as well as tilt of the screen to suit different work practices: close for Web design or word-processing; farther away for image manipulation.

Laptop or desktop?

Modern laptops have more than enough power for digital photography. Some, like the Apple laptops, are not only more powerful than most desktop types, but have screens of sufficient quality and size for serious work. Set against the premium cost of miniaturizing is the convenience of a computer that takes up no more desk space than an open magazine.

Computer interfaces

When making your purchase, make sure that the computer interfaces available match those of the equipment you wish to use with it. Note that you may need to install some software to make a connector work.

● Universal Serial Bus (USB) is easy to install and use, with data-transmission speeds adequate for printers, removable drives, and digital cameras. USB 2 is a faster version, more suitable for data transfer, but is generally not as fast as FireWire.

● FireWire (IEEE 1394), also known as iLink, is a high-speed standard suitable for professional work. It offers an excellent choice for removable drives, extra hard disks, and digital cameras.

● Small Computer Systems Interface (SCSI) is tricky to use with heavy cables and is mostly used by older equipment.

Mesh 1.8 GHz
Desktop computers running Windows offer good value for money, and often come with accessories, such as speakers, thrown in. They can be used for image manipulation, but poor color control may be a problem.

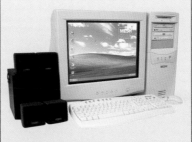

Mesh 2.0 GHz
Windows computers with ultra-fast chips may appear to be more than a match for Apple computers, but chip speed is not everything. Try out both Windows and Apple computers to discover your preference.

Apple G4
All the capacity, computing power, and convenience you need for the highest levels of digital photography. Scanners, extra hard disk drives, and printers are easily installed and color control is easy to set up.

Computer accessories

As your expertise in digital photography increases, there are many computer accessories that will make life easier and increase your enjoyment.

Graphics tablets

These input devices are an evolutionary step up from the mouse. Comprising a flat tablet, like a solid mouse mat, and a penlike stylus, graphics tablets give you excellent control over hand-drawn lines. They also allow you to increase line width or color depth by varying the pressure of the stroke – something that is impossible to do with a mouse. The tablet part can be small, about the size of a mouse mat, or as large as your desk.

Removable media

Digital photography produces huge amounts of data, and removable media provide the essential storage space you need. In general, the bigger the capacity, the cheaper it is per megabyte of data. The smallest you should work with is the 100 MB or 250 MB Zip disk: these are inexpensive and the 100 MB size is very widely used by both Mac and Windows owners. But for digital images, even the 250 MB disk is limited in capacity.

Although strictly not removable media, portable hard disk drives are, overall, the best solution for the photographer. Not only are their capacities ample for most workers – 40 GB is average – they are cost-effective and offer the fastest data transfer rates.

DVD-RAM technology offers remarkable capacities for the lowest cost – a disc holding 9 GB of data (9.4 GB nominally) will cost less than three DVD video films. The disadvantage is that reading and writing speeds are relatively slow. The best choice of all are the DVD-RAM drives that also write CDs.

Compact discs (CDs)

The best option for exchanging files with other people is the CD. It holds up to 700 MB, and once written it cannot be changed. Rewritable CDs (CD-RW) are available: these can be written, erased, and rewritten many times, but inconvenience and compatibility worries mean that the CD-RW is not a recommended option. CD writers (now often integrated with computers) are relatively inexpensive accessories, costing less than about the price of three or four DVD movies.

CD writers with the fastest write speeds do not cost that much more than slower writers – a 52x write speed is not unusual – and they will save you a great deal of time in the long run. So-called "burn-proof" writers are more reliable at writing disks than those without this feature.

Wacom graphics tablet
Graphics tablets come in a range of sizes – starting with models smaller than a mouse mat – to suit different ways of working. Large sizes can take up the entire desk area. The pen and mouse tools also cover a range from simple devices to those sporting several buttons to access various functions.

Zip 100
Zip disks hold just less than 100 MB of data, which is really the minimum size of removable storage for digital photography. Drives are very widely used in computers while the disks are sturdy and reliable, making them ideal for general use. Higher-capacity, 250 MB Zips are also available.

UPS, surge protectors, adapters, and cables

Computer systems are very susceptible to even very small fluctuations in the amount of electrical current powering them. Because of this, you may want to consider protecting your equipment from power surges and failures – something that is even more worthwhile if you work in areas with uncertain power supplies. Saving frequently as you go ensures that, if the worst happens, and your machine does crash, then at least not too much of your work will be lost. However, apart from the frustration and wasted time involved in restarting your computer, an uncontrolled shut-down does carry with it the risk of damage to your hard drive. To safeguard against this, an uninterruptible power supply (UPS), although possibly expensive to buy, is essential. This is a battery that powers the computer and monitor for a short period in case of a power loss, giving you time to quit the application and shut the computer down safely.

A surge protector prevents sudden rises in power from damaging your delicate equipment and is well worth its relatively low cost. Other accessories you will accumulate are cables to connect devices to your computer and to each other, and adapters that allow older equipment, such as those based on SCSI, to be used with newer systems, such as FireWire.

USB ports
USB (Universal Serial Bus) is a widespread protocol allowing devices to be plugged straight into a working computer and be recognized and connected.

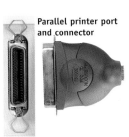

Parallel printer port and connector

SCSI ports
The SCSI interface is used in older, professional-grade scanners and studio digital cameras.

Adapters
You can adapt SCSI to FireWire or to USB, serial to parallel, and so on. If equipment is incompatible, there is likely to be an adapter to solve the problem, though conflicts with other devices may result.

USB peripheral port and connector

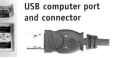

USB computer port and connector

Parallel ports
Connectors using parallel technology are complicated and can be less reliable, so their use is falling.

SCSI computer port and connector

CD writer
CDs are universally readable in modern computers anywhere in the world, so they are ideal for sharing data. But make sure that the format is ISO 9660 to ensure compatibility between Mac and PC machines. Compact, portable forms can be powered directly through the FireWire lead.

DVD writer
DVD is the most cost-effective technology for removable storage. It is compact and can store 9 GB or more with ease. However, it is slow to read and even slower to write, being several times slower than modern CD writers.

Setting up a workroom

A workroom for digital photography has the huge advantage over the traditional darkroom used by film-based photographers in that it does not need to be light-tight – any spare room, or just a corner, is suitable. Nor are chemicals, trays, timers, safelights, or running water required.

The ideal environment

The key requirement of a digital workroom is comfort: you are likely to be spending long hours sitting in the same position, so don't allow the computer to become a source of ill health. Take note of the following points:

• Ventilation should be adequate to dissipate the heat produced by the computer and monitor during hot weather.

• You should be able to subdue the lighting with heavy curtains or blinds to help screen contrast.

• There should be sufficient electrical outlets for your equipment needs.

• The desks you work on should be stable and capable of taking the heavy, static weight of a large monitor without wobbling.

• The desk/chair should be at the correct height so that, when seated, your forearms are horizontal or inclined slightly down when at the keyboard.

• There should be ample space underneath the desk for your legs.

• The chair should support your back and legs.

• Arrange desklamps so they do not shine onto the monitor screen. Some lamps are especially designed for computer use, illuminating the desk without spilling light onto the screen.

• Keep an area free for drink and food. Make sure anything spillable is kept away from electrical equipment or disks.

• Arrange the monitor so the top of the screen is about level with your eyes, or slightly higher.

• Your monitor's screen should not face any light source, such as a window or a lamp.

• You can make a hood at least 8 in (20 cm) deep from black cardboard to block unwanted light reaching the screen and degrading the image.

• Arrange for a picture-editing area, containing a lightbox and your files, away from the computer and monitor.

The digital photographer's desk

The ideal desk area has all the equipment within easy reach. The arrangement of equipment will vary, depending on precisely what you are doing and your own preferences, but everything should be conveniently at hand. It is convenient to locate the monitor in the middle, preferably in the inside corner of an L-shaped or curved desk.

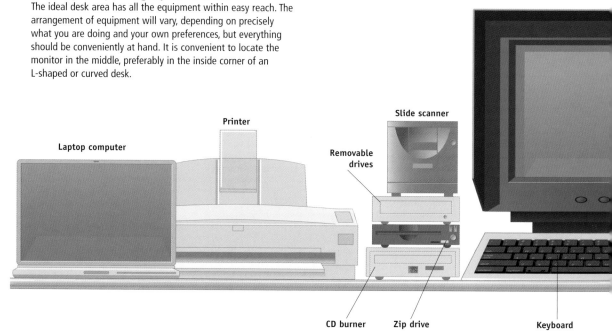

Laptop computer

Printer

Slide scanner

Removable drives

CD burner

Zip drive

Keyboard

● Ensure you have safe storage for data files – any magnetic-based media, such as Zip, Compact-Flash, and so on, should be stored at least 12 in (30 cm) away from the strong magnetic fields produced by monitors, speakers, and electric motors. In addition, keep magnetic media away from direct sunlight and other heat sources.

Electrical arrangements

Most types of computer peripherals draw only low current at low voltages compared with domestic appliances. This is fortunate, because the peripherals you tend to accumulate for even a modest office configuration could easily sprout a dozen power cables:

● If you are in any doubt about electrical safety, seek advice from a qualified person.

● Never wire more than one appliance into the same plug.

● Don't plug a device into a computer or peripheral that is switched on unless you know it is safe to do so. Even then, never unplug a device that is halfway through an operation.

Avoiding injury

It is unlikely that you will work the long hours at high levels of stress that lead to repetitive strain injury, but you should still take precautions:

● At least every hour, get up and walk around and take a few minutes away from the screen.

● After two hours in front of the screen, take a longer break – stretch your limbs and look out of window at distant objects to exercise your eyes.

● Listen to your body: if something starts to ache or is uncomfortable, it is time to make adjustments or to take a break.

● Keep your equipment clean and well maintained – sticky mouse rollers or a streaky or dirty monitor screen or keyboard can all add, in more or less subtle ways, to stress levels.

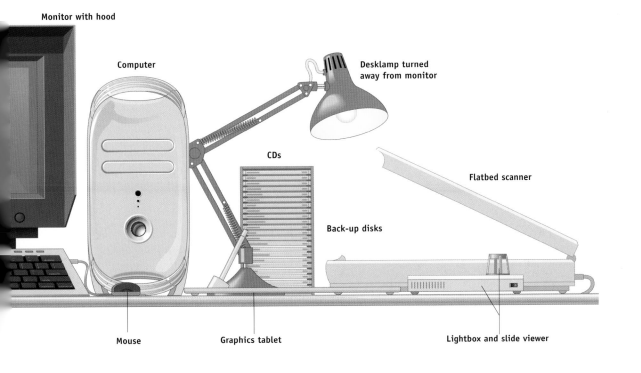

Monitor with hood

Computer

Desklamp turned away from monitor

CDs

Flatbed scanner

Back-up disks

Mouse

Graphics tablet

Lightbox and slide viewer

2
Photography for the digital age

Technical skills

The skills, trade secrets, and techniques of basic photography – everything from handling a camera to focusing and depth of field, from working close-up to the secrets of exposure control.

Visualization

Composition – image orientation, proportions, and principles – and working with color. Examples of images exploiting the use of vivid color contrasts, as well as those that depend on their pastel shades for impact.

Creative options

Working with silhouettes and backlighting, and creating low-key as well as high-key images, are explained. The basics of lighting are also clearly presented.

Help on hand

Quick-fix sections help you with image distortion, how to correct leaning buildings, improve color balance, and show you how to obtain the best results from flash.

Handling cameras

There is no one best way to use a camera, as you need to adapt your technique according to the type and model you have. While it is true that it is the photographer who makes the picture, not the camera, it does not follow that the camera is of no importance. For certain tasks, having the right camera can make photography easy; a different model can make your work very difficult.

Digital quirks

The main operating difference between digital and traditional cameras is response times. For example, digital cameras tend to react sluggishly – like some less-expensive autofocus compacts, they need several seconds to warm up and become fully operational when you first turn them on.

In addition, you may also notice what is called "shutter lag" – the delay between the moment you press the shutter and the instant the image is taken. This can be long enough to make the timing of fast-action photography a tricky business.

Essentially, you get what you pay for – better-quality digital cameras power up quickly and have

Using an SLR
The SLR type camera is ideal for viewing and framing, but it is very bulky. This shows the best way to hold it: with your left hand cradling the lens.

a much shorter shutter lag. However, only very expensive digital cameras have the same response times as film-based cameras. In light of this, if the precise timing of the exposure is a crucial factor for you, try out any digital camera carefully before deciding to buy.

LCD screen
Taking a picture by viewing the image on a digital camera's LCD screen is not ideal: for a start, it is difficult to hold the camera steady and, in addition, unless you have good close-up vision, you cannot see the image in any detail.

Viewfinder
The type of optical viewfinder on most digital cameras enables you to hold the camera close to your face. This helps to brace the camera and prevent movement during exposure. But the image you see is small and not accurately framed.

Battery life

For some photography, such as documentary, news, and travel, it is important to keep your camera on and be ready to respond instantly to any changing situation. You could, for example, pound the streets for hours in search of the right juxtaposition of people and buildings and then have just a second to take the picture. You can leave film-based cameras on all day and batteries will still have plenty of life in them. The same, unfortunately, cannot be said of most digital cameras, so spare battery packs are essential accessories.

Viewing systems

Viewing through many digital cameras is via a small viewfinder or an LCD (liquid crystal display) screen, while some have only an LCD screen. The reduced view of the viewfinder is adequate for many tasks, but it is neither the most precise nor a particularly pleasant device to use. The LCD screen gives a bright, through-the-lens view, but the images tend to jump in a disconcerting fashion as the camera moves. Because of the rate at which the screen electronically refreshes – or rebuilds – the image, it cannot keep up with rapid subject movement. In addition, LCD screens are also heavy users of battery power.

Another aspect of using some types of LCD screen is that if they oblige you to hold the camera some distance away from your body they are then difficult to keep steady while shooting.

Photographer and camera

If you are comfortable with your camera and are at ease using it, your photography will gain in fluidity and confidence. If, however, you are not comfortable with the camera, the most likely reason is that you have not taken enough time to become familiar with handling it (*see box below*). If you have had extensive experience with it but are still not happy, then you should consider changing it. Perhaps the shutter takes too long to respond to the shutter button, or it could be that the viewfinder is too small for you or the controls too cramped. Make sure, though, that you don't make the same mistakes with your next purchase.

Using supports
Whenever you use long focal settings on a zoom or a long lens, take advantage of any support that is available – a tree, lamp post, or wall will help to steady the camera while you view and shoot.

Body tripod
Use a half-kneeling position when there is no convenient support. Your knee and feet form a tripod, which is inherently stable, and your left arm can then be supported by your left knee.

Picture composition

Advice found in specialized photographic books and magazines concerning picture composition is often treated in a very proscriptive fashion – as if the adherence to a few "rules" can somehow bring about satisfactory outcomes. It may be better to think of any rules simply as a distillation of ideas about features that photographers – and, of course, painters and other artists in the centuries before the invention of the camera – have found useful in making effective pictures.

Any photographic composition can be said to work if the arrangement of the subject elements communicates effectively with the image's intended viewers. Often, the trick lying behind this is learning to recognize the key ingredients of a scene and then organizing your camera position and exposure controls to draw those elements out from the clutter of miscellaneous visual information that is the ruin of many photographs.

If you are new to photography, it may help to concentrate your attention on the scene's general structure, rather than concentrating too hard on very specific details – these, often, are only of superficial importance to the overall composition.

Symmetry
Symmetrical compositions are said to signify solidity, stability, and strength; they are also effective for organizing images containing elaborate detail. Yet another strategy offered by a symmetrical presentation of subject elements is simplicity. In this portrait of a Turkana man, there was no other way to record the scene that would have worked as well. The figure was placed centrally because nothing in the image justified any other placement – likewise with the nearly central horizon. The subject's cane provides the essential counterpoint that prevents the image appearing too contrived.

● Bronica SQ-A with 40 mm lens. ISO 100 film. Heidelberg Saphir II scanner.

Radial
Radial compositions are those in which key elements spread outward from the middle of the frame. This imparts a lively feeling, even if subjects are static. However, in this family portrait, taken in Mexico, the radial composition is consistent with the tension caused by the presence of a stranger (the photographer), combined with the transfixing heat. The composition suggests that a modest wide-angle lens was used; in fact it was taken with a standard focal length.

● Nikon F2 with 50 mm lens. ISO 64 film. Microtek 4000t scanner.

Diagonal

Diagonal lines lead the eye from one part of an image to another and impart far more energy than horizontals. In this example, it is not only the curve of the palm's trunk, but also the movement of the boy and his dog along it that encourage the viewer to scan the entire picture, sweeping naturally from the strongly backlit bottom left-hand corner to the top right of the frame.

● Canon EOS-1n with 80–200 mm lens. ISO 100 film. Microtek 4000t scanner.

Overlapping

Overlapping subject elements not only indicate increasing depth perspective, they also invite the viewer to observe subject contrasts. In the first instance, distance is indicated simply because one object can overlap another only if it is in front of it. In the second, the overlap forces two or more items, known to be separated by distance, to be perceived together, with any contrasts in shape, tone, or color, made apparent as a result. In this example, shot in Spain, over-lapping architectural elements jostle for dominance.

● Nikon Coolpix 990.

Picture composition continued

Framing

The frame within a frame is a painterly device often exploited in photography. Not only does it concentrate the viewer's attention on the subject, it often hints at the wider context of the subject's setting. The colors of the frame may also give clues about where the photograph is set. In this portrait, the colors of the painted wood suggest Central or South America, while the structure of the building and the subject himself lead you to expect the unexpected. In fact, the house is in an "African" village built in Mexico populated by descendants of escaped African slaves.

● Nikon F2 with 50 mm lens. ISO 64 film. Nikon LS-2000 scanner.

Geometric patterns

Geometrical shapes, such as triangles and rectangles, lend themselves to photographic composition because of the way they interact with the rectangle of the picture frame. Here, in this shuttered store in Spain, shapes from squares to thin rectangles and narrow triangles are all at work. In parts they are working harmoniously (the gaps between the shutters); in others (the thin wedges created by the sloping road), they create tension in the composition.

● Nikon Coolpix 990.

Irregular pattern

The imperfectly regular rows of sacks left out to dry in the hot, Mombassa sunshine lead your eye inexorably to the man who has authored the work. Both the pattern and the repetition are obvious, but the more thoughtful photographer learns to work with these elements rather than using them as the actual subject.

● Canon F-1n with 200 mm f/2.8 lens. ISO 100 film. Microtek 4000t scanner.

● **TRY THIS**

Look out for various types of pattern – squares, circles, triangles, swirls, and so on – whenever you have a camera readily on hand. When you find an interesting example, take several shots, shifting your camera position slightly between exposures. Examine the pictures carefully and you may discover that the shot you thought most promising at the time does not produce the best result. Try to think why this might be the case: often, it is because our response to a scene is an entire experience, while photographs have to work within the limits of the viewfinder and the proportions of the format.

Triangles

The windows of a building reflected in the curved glass of the front of a parked car in Andalucia, southern Spain, appear strongly distorted within the triangle implied by the frame of the wind-shield itself. The overall shape is not immediately apparent, but it is the framework on which all the elements – the repeated lines and rectangles, for example, and the bands of light and dark – are organized. The triangular shape in composition is most often encountered in scenes where parallel lines seem to converge, such as the sides of a road or the rails of railroad lines, as they recede into the distance. In the two-dimensional photographic print or computer monitor image, this is powerfully suggestive of both depth and distance.

● Nikon Coolpix 990.

Focusing and depth of field

Depth of field is the space in front of and behind the plane of best focus, within which objects appear acceptably sharp (*see opposite*). Though accurate, this definition tells you nothing about the power that depth of field has in helping you communicate your visual ideas. You can, for example, use it to imply space, to suggest being inside the action, or to emphasize the separation between elements within the picture area.

Varying depth of field

Your chief control over depth of field is the lens aperture: as you set smaller apertures (using f/11 instead of f/8, for example), depth of field increases. This increase is greater the shorter the lens's focal length, so that the depth of field at f/11 on a 28 mm lens is greater than it would be at f/11 on a 300 mm lens. Depth of field also increases as the subject being focused on moves further away from the camera. The corollary of this is that at close focusing distances, depth of field is very limited.

Using depth of field

An extensive depth of field (resulting from using a small lens aperture, a wide-angle lens, distant focusing, or a combination of these factors) is often used for the following types of subject:

● Landscapes, such as wide-angle, general views.
● Architecture, in which the foregrounds to buildings are important features.
● Interiors, including nearby furniture or other objects and far windows and similar features.

As a by-product, smaller apertures tend to reduce lens flare and improve lens performance.

A shallow depth of field (resulting from a wide lens aperture, a long focal length lens, focusing close-up, or a combination of these) renders only a small portion of the image sharp, and can often be usefully applied to:

● Portraiture, to help concentrate viewer attention.
● Reducing the distraction from elements that cannot be removed from the lens's field of view.
● Isolating a subject from the distracting visual clutter of its surroundings.

Lens focusing

Spreading light reflected from or emitted by every point of a subject radiates out, and those rays captured by the camera lens are projected onto the focal plane to produce an upside-down image. The subject appears sharp, however, only if these rays of light intersect precisely on the film plane (achieved by adjusting the lens's focus control). If not, the rays are recorded not as points, but rather as dots. If the image is reproduced small enough, then even dots may appear sharp, but as a subject's image diverges further from the film plane, so the dots recorded by the camera become larger and larger, until, at a certain point, the image appears out of focus – the dots have become large enough to be seen as blur.

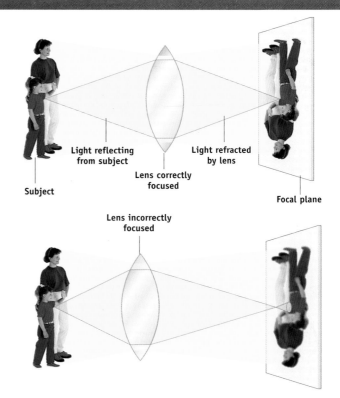

Light reflecting from subject

Light refracted by lens

Lens correctly focused

Subject

Focal plane

Lens incorrectly focused

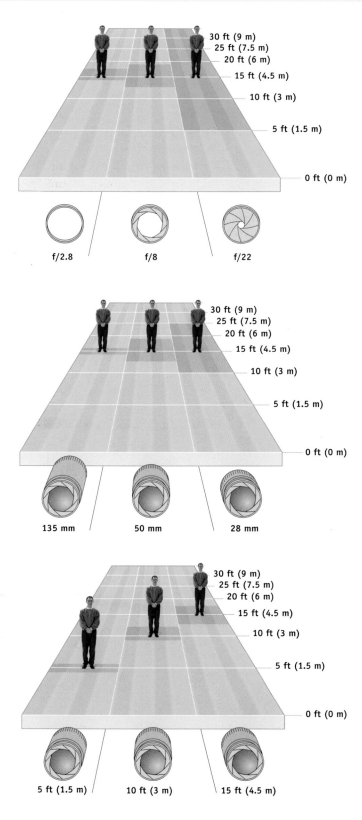

Effects of lens aperture

The main reason for changing lens aperture is to adjust camera exposure: a smaller aperture restricts the beam of light passing through the lens. However, the aperture also alters depth of field. As you set smaller apertures, the cone of light passing through the lens becomes slimmer and more needlelike. As a result, even when it is not perfectly focused, light from the subject is not as spread out as it would be if a larger aperture were used. Thus, more of the scene within the field of view appears sharp. In this illustration, lens focal length and focus distance remain the same, and depth of field at f/2.8 covers just the depth of a person, whereas at f/8 it increases to 6 ft (2 m) in extent. At f/22, depth of field extends from 5 ft (1.5 m) to infinity.

Effects of lens focal length

Variations in depth of field resulting from focal length alone are due to image magnification. With our figure at a constant distance from the camera, a long focal length (135 mm) will record him at a larger size than does a standard lens (50 mm), which, in turn, creates a larger image than the wide-angle (28 mm). To the eye, the figure is the same size, but on the sensor or film, the figure's size varies directly with focal length. Where details are rendered smaller in the image, it is more difficult to make out what is sharp and what is not. As a result, depth of field appears to increase. Conversely, longer focal length lenses magnify the image, so magnifying differences in focus. Thus, depth of field appears to be greatly reduced.

Effects of focus distance

Two effects contribute to the great reduction in depth of field as you focus more and more closely to the camera, even when there is no change in lens focal length or aperture. The main effect is due to the increased magnification of the image: as it looms larger in the viewfinder, so small differences in the depth of the subject call for the lens to be focused at varying distances from the sensor or film. Notice that you must turn a lens more when it is focused on close-up subjects than when it is focused on distant ones. Another slight but important reason for the change in depth of field is that effective focal length increases slightly when the lens is set further from the focal plane – in other words, when it is focused on closeup subjects.

Focusing and depth of field continued

Autofocusing

Two main methods of autofocus are used. In compact cameras, a beam of infrared (IR) light scans the scene when the shutter button is first pressed. The nearest and strongest IR reflections are read by a sensor, which calculates the subject distance and sets it on the camera a fraction of a second before the picture is taken.

The other main method is "passive." Part of the light from the subject is sampled and split up, but only when the lens is in focus do the parts of the image coincide (or are said to be "in phase"). The crucial property of this system is that the phase differences vary, depending on whether the lens is focused in front of or behind the plane of best focus. Autofocus sensors analyze the pattern and can tell the lens in which direction to move in order to achieve best focus.

Though sophisticated, autofocus systems can be fooled. Beware of the following circumstances:
- The key autofocus sensor is in the center of the viewfinder image, so any off-center subjects may not be correctly focused. Aim the focusing area at your subject, "hold" the focus with a light pressure on the shutter-release button, and then return the viewfinder to the original view.
- When photographing through glass, reflections from the glass may confuse the IR sensor.
- Extremely bright objects in the focusing region – sparkling reflection on polished metal, say – could overload the sensor and mar accuracy.
- Photographing beyond objects that are close to the lens – say, through a bush or between the gaps in a fence – can confuse the autofocus system.
- Moving close-up subjects may be best kept in focus by setting a distance manually and then adjusting your position backward and forward in order to maintain focus.

Mimicking depth

While a narrow field of view usually yields a shallow depth of field, you can simulate a more generous zone of sharp focus linked with a narrow field of view by cropping a wide-angle image. Here, a 28 mm view has been cropped to that of a 200 mm lens, and the scene appears sharp from foreground to background.

● Canon EOS-50 with 28– 105 mm lens. ISO 100 film. Nikon LS-1000 scanner.

Selective focus

A telephoto shot taken with the lens aperture wide open throws the girl in the foreground out of focus. One unwelcome consequence is that color from the background merges with the foreground, making color correction a tricky matter. It proved difficult to make a satisfactory duplicate of the original transparency, and the resulting scan also required a good deal of corrective work.

● Leica R6 with 70–210 mm lens. ISO 50 film. Microtek 4000t scanner.

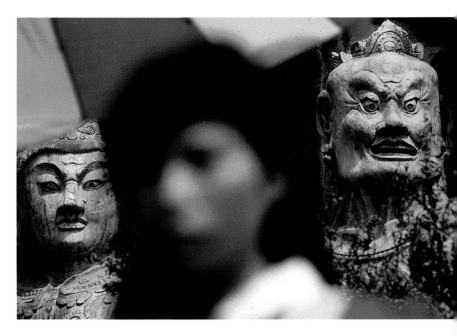

● With very fast-moving subjects, it may be better to focus on a set distance and then wait for the subject to reach that point before shooting.

Hyperfocal distance

The hyperfocal distance is the focus setting that provides maximum depth of field for any given aperture. It is the distance to the nearest point that is sharp when the lens is set at infinity and it is the nearest distance at which an object can be focused on while infinity appears sharp. The larger the aperture, the farther away this point is. With autofocus-only cameras, you cannot set the hyperfocal distance; however, with manual-focus cameras, you can set hyperfocal distance and then not worry about the clarity of any subject falling within the range of sharp focus.

Off-center subjects

When the subjects are off-center, as here, you must not allow your camera to focus on the middle of the frame. To take this image, I simply focused on the boys, locked the setting, and recomposed the shot. Even in bright conditions and focusing at a great distance – 330 ft (100 m) – depth of field is limited because of the very long focal length of the lens.

● Canon EOS-1n with 100–400 mm lens with 1.4x extender. ISO 100 film. Microtek 4000t scanner.

Right aperture

Medium-to-close-up pictures taken with a long lens will have a shallow depth of field unless a small aperture is set. In this shot, the charm of the scene would have been lost had unsharp subject elements dominated. The smallest aperture on this lens was set to give maximum sharpness, but the long shutter time then needed to compensate meant that a tripod was necessary to prevent camera shake.

● Nikon Coolpix 990.

Perceived depth of field

Acceptable sharpness varies according to how much blur a viewer is prepared accept. This, in turn, depends on how much detail a viewer can discern in the image, which, in turn, depends on the final size of the image (as seen on a screen or as a paper print). As a small print, an image may display great depth of field; however, as the image is progressively enlarged, it then becomes easier and easier to see where the unsharpness begins, and so depth of field appears increasingly more limited.

Image orientation

Since most camera formats produce rectangular pictures, you can change the way you hold the camera to give either horizontal or vertical results. Image orientation produces different emphases and can alter the whole dynamic of a shot.

Picture shape should normally be dictated by the natural arrangement of subject elements – in other words, by the subject's own orientation. In portraits, for example, the subject will usually be sitting or standing, and so the camera most often is turned on its side to give vertical framing. As a consequence, vertical picture orientation is often called "portrait." Landscapes scenes, however, with their usually horizontal orientation, have given their name to horizontally framed pictures.

Landscape-shaped images tend to emphasize the relationship between subject elements on the left and right of the frame, while portrait-shaped pictures tend to relate foreground and background subject elements. And bear in mind that picture shape strongly influences what is included at the periphery of a scene, so you can use image orientation as a useful cropping device.

Breaking the "rules"

If you decide to move away from these accepted framing conventions, or "rules," you then have an opportunity to express more of an individual vision. Simply by turning the camera on its side you could create a more striking picture – perhaps by increasing the sense of energy and movement inherent in the scene, for example. Using an unconventional picture orientation may, therefore, reveal to the viewer that you are engaging more directly with the subject, rather than merely reacting to it.

Think ahead

Another factor to consider is that since most printed publications are vertical in format, pictures are more likely to be used full-size if they are vertically framed. As a safeguard, commercial photographers often take vertically framed versions of important views or events, even if an image's natural orientation is horizontal.

A potential problem in this regard occurs with cameras having swiveling LCD screens (*see p. 24*), as these can be awkward to use vertically. Even if the camera has a viewfinder, if you attach any type of lens accessory you then have to use the LCD screen exclusively for viewing and framing.

If, however, your images are intended for publication on the web, you need to bear in mind that the orientation of the monitor's format is more horizontal in shape, and so appropriately framed images will then be easier to use at full-size.

Reclining figure
The strong horizontal lines of both the bench and the metal cladding on the wall behind, as well as the elegant, reclining pose of this Fijian lady, all insist that horizontal framing is appropriate here.

● Canon EOS-1n with 17–35 mm lens. ISO 100 film. Microtek 4000t scanner.

Landscape scenery

A horizontal, or "landscape," view (*above*) is often an obvious choice for a landscape subject. However, vertical, or "portrait," framing (*right*) can effectively suggest space, especially when some natural feature in the scene – the snaking crash barrier in this example – leads the eye right from the foreground through to the background.

● Nikon Coolpix 990.

Still-life

Different sets of lines that may be contained within a picture can be given additional prominence depending on the framing you decide to adopt. Horizontal orientation (*above*) allows the strong, diagonally slanting plant stems to make a visual statement, while the vertical image orientation (*right*) allows the parallel slats of the blind to make their mark.

● Nikon Coolpix 990.

Image proportions

As you take more pictures you may start to notice that the proportions of the image have a subtle effect on the picture's ability to communicate. A square image, for example, more often than not evokes a sense of stability and balance. However, an image that is just slightly rectangular can communicate a sense of indecision or make subject matter look "uncomfortable" within its frame. This type of framing is, therefore, best avoided unless you have clear reasons for it.

Panoramas

The "panoramic" picture has been popularized most recently by its availability on APS (Advanced Photo System) cameras. In reality, this system simply crops the top and bottom off an ordinary image, changing it into a narrow one, and so it is not a true panoramic image.

Digital cameras, however, can produce true panoramas (in which the camera swings through the scene, from side to side or up and down), so

True panorama
A true panoramic camera uses a swinging lens to project its image onto a curved piece of film. The movement of the lens causes the typical curvature of lines away from the middle of the frame, as you can see in this example taken at an exhibition in a picture gallery.
● Widelux. ISO 400 film. Heidelberg Saphir scanner.

Horizontal cropping
As you can see, the sofa pattern here competes strongly with the child and her collection of much-loved toys (*left*). A severe crop more clearly defines the image content (*below*).

● Olympus OM-1n with 28 mm lens. ISO 100 film. Nikon LS-2000 scanner.

Vertical cropping

An attractively framed, if conventional, shot of a lake in Scotland (*above*) has been transformed into a sharper, more challenging composition (*right*) simply by cropping it into a narrower, more vertical shape, in imitation of a traditional silk wall hanging.

● Nikon Coolpix 990 with wide-angle attachment

that the field of view of the image is greater than the field of view of the lens. This is achieved by taking a number of pictures that overlap and "sewing" them together (*see pp. 198–201*).

To achieve best results, pivot the camera around a fixed point, such as a tripod, so that as you rotate the camera the image does not appear to move. To aid you, some digital cameras have a "panorama function," which indicates where the next pictures should be taken by showing you on the LCD screen the previous image as a guide.

Taking time to select just the right view to experiment with really pays dividends with panoramic images. For example, you need to be aware that panoramas made up of individual pictures that include subjects positioned close to the camera, or even in the near middle-distance, will show a perspective distortion that makes the scene appear bow-shaped once images are combined.

Exposure is another consideration when taking panoramas. If you swing your camera across a scene, you will see that the exposure settings in the viewfinder read-out alter as different areas of light and shade influence the changing picture area. If you were to take your panorama like this, you may find that, the foreground area fluctuates between dark and light from frame to frame. To prevent this from occurring, take the camera off automatic and set the exposure manually.

Cropping

One of the simplest, and often one of the most effective, changes you can make to image proportions is to "crop" them – in other words, slicing portions from the sides, top, or bottom of the picture area. This can change the whole emphasis of a shot by, for example, removing unnecessary or unwanted subject matter or by changing the relationship between various subject elements and the borders of the frame. This can turn a mediocre picture into a truly arresting image.

Composition and zooms

Zoom lenses allow you to change the magnification of an image without swapping lenses (*see pp. 36–7*). Zooms are designed to change the field of view of the lens while keeping the image in focus. When the field of view is widened (to take in more of the subject), the image must be reduced in order to fill the sensor or film area. This is the effect of using a short focal length lens or a wide-angle setting on a zoom. Conversely, when the field of view is narrowed (to take in less of the subject), the image must be magnified, again in order to fill the sensor or film area. This is the effect of using a long focal length lens or a zoom's telephoto setting.

Working with zooms

The best way to use a zoom is to set it to the focal length you feel will produce the approximate effect you are aiming for. This method of working encourages you to think about the scene before ever raising the camera to your eye to compose the shot. It also makes you think ahead of the picture-taking process, rather than zooming in and out of a scene searching for any setting that seems to work. This is not only rather aimless, it is also time-consuming and can lead to missed photographic opportunities.

A professional approach

Many professional photographers use zooms almost as if they were fixed focal length, or prime, lenses, leaving them set to a favorite focal length most of the time. They then use the zoom control only to make fine adjustments to the framing. Zooms really are at their best when used like this – cutting out or taking in a little more of a scene. With a prime lens, you have to move the camera backward or forward to achieve the same effect. Depending on the type of subject you are trying to record, you could leave the zoom toward the wide-angle or telephoto end of its range. On some digital cameras, however, zooms are stepped rather than continuously variable, and so cannot be used for making small adjustments.

80 mm

135 mm

200 mm

Zooms for framing

Zoom lenses come into their own when you find it difficult or time-consuming to change your camera position, as they allow you to introduce variety into what would otherwise be similarly framed images. In this large outdoor performance, one shot was taken at 80 mm (*top*), one at 135 mm (*middle*), and the other at 200 mm (*above*), all from approximately the same camera position.

● Canon EOS-1n with 80–200 mm lens. ISO 100 film. Microtek 4000t scanner.

Zoom movement

Color and movement literally seem to explode out from this photograph of a simple tulip – an effect achieved by reducing the zoom lens's focal length during a long, manually timed exposure. And in order to emphasize the flower's blurred outlines, the image was also slightly defocused before the exposure was made.

● Canon F-1n with 80–200 mm lens. ISO 100 film. Microtek 4000t scanner.

Zooms for composition

Zooming from 80 mm (*above left*) to 200 mm (*above right*) produced an intriguing abstract image by allowing patterns of light and dark, color and noncolor, to reveal themselves. But as the focal length increases, depth of field also diminishes (*pp. 84–7*), so select the lens apertures with care.

● Canon EOS-1n with 80–200 mm lens. ISO 100 film. Microtek 4000t scanner.

● POINTS TO CONSIDER

Distortion Most zoom lenses distort the image by making straight lines look curved. This is especially the case at wide-angle settings.

Camera shake At the very long effective focal lengths some digital cameras offer – such as a 35efl of 350 mm – there is a great danger that camera shake during exposure will reduce image quality. Make sure you hold the camera steady, preferably supported or braced, and use a short shutter time.

Lens speed As you set longer focal lengths, the widest available aperture becomes smaller. Even in bright conditions, it may then not be possible to set short shutter times with long focal lengths.

Lens movement Some lenses may take a few seconds to zoom to their maximum or to retract to their minimum settings. Don't be tempted to rush the action by pushing or pulling at the lens.

Digital zooms

The term given to a computer-generated increase in apparent focal length is "digital zoom." Although the lens focal length does not increase, the image continues to be magnified.

It works by taking a central portion of an image and enlarging it to fill the format, using a process called "interpolation" – extra pixels are added, based on the existing one, to pad out the space (*see pp. 256–7*). This does not add information; indeed, it may even mask it. Clearly you can obtain exactly the same effect – sometimes even better-quality effects – by altering the picture using image-manipulation software, but it is then an extra step and thus more work for you.

Long focal length settings on a zoom lens come into their own when you want to magnify a small part of a scene: a 35efl of 135 mm is ample for most purposes. This produces the characteristic "telephoto perspective," in which distant objects look compressed, or backgrounds in close-up shots are thrown strongly out of focus.

Nonetheless, some recent digital cameras offer focal lengths of 300 mm and more. Some models reduce the effects of camera shake by using image-stabilization technology. Even so it is worthwhile making every effort to reduce unwanted camera-movement problems at the source (*see pp. 78–9*).

Telephoto perspective

Even a modest telephoto shot of a distant scene depicts well-separated objects as if they are compressed and piled on top of each other. This is because the relative differences in distance within the picture are small when compared with the distance between the subject and the camera. In this photograph, houses that were in fact hundreds of yards apart look squashed together, and depth of field extends throughout the image.

● Nikon Coolpix 990 with tele-attachment.

Image stabilization

Technology to reduce the effect of camera shake takes two forms. One uses a motion sensor to control a lens or thin prism that shifts the image to counter camera movement. This form, pioneered by Canon, is most suitable for still images and is available in several of their 35 mm format lenses. Olympus offers image-stabilized digital cameras and it is likely to become standard in more sophisticated, higher-end equipment. The other method analyzes the signals from the sensor and filters out the slight repetitions in image structure typical of camera shake. This system is used mostly in video cameras.

Secondary image Corrector lens elements

Focal plane recording blurred image

Corrector shift

Sharp image at focal plane

How it works

A blurred secondary image, represented by the dotted lines here, can result if the lens moves while the picture is being exposed (*upper diagram*). A corrector group of lens elements within the lens hangs from a frame, which allows these elements to move at right-angles to the lens axis. Motion sensors tell the frame which way to shift the corrector group to compensate for any movement of the lens (*lower diagram*).

Camera movement

While the generally available advice is that you should hold the camera completely steady when taking pictures, so that camera shake does not introduce unwanted movement that might spoil your image, there is a place for pictures that display a thoughtful or creative use of subject blur.

Experimentation

Experimentation with this technique is essential, as the effects of movement are unpredictable. They are, in fact, unique and no other recording medium represents movement in quite the same way. However, in order to produce the occasional winning shot you must be prepared to make a lot of exposures, and here the digital camera's ability to delete unwanted frames gives it a distinct advantage over film-based cameras.

While taking pictures from a moving vehicle is generally not recommended, it is nevertheless a technique worth experimenting with. In a fast-moving car or train, for example, even a short shutter time will not be able to prevent motion blur, especially of foreground objects. But you can introduce blur in almost any situation simply by setting a long shutter time – at least ½ sec – and then deliberately moving the camera during the exposure. Another possibility is again to set a long shutter time and then zoom the lens during the exposure. This gives the resulting image a characteristic "explosive" appearance (*see p. 93*).

As a bonus, digitally produced motion-blur images compress to a very high degree with little additional noticeable loss in clarity because of their inherently lower image quality.

Moving camera
The blur produced by taking a photograph from a speeding car streaks and blends the rich evening light in a very evocative and painterly fashion in this example. To the eye at the time of taking, the scene was much darker and less colorful than you can see here. It is always worth taking a chance in photography, as you never know what might come of it.

● Canon EOS-100n with 28–135 mm lens. ISO 100 film. Microtek 4000t scanner.

Digital close-ups

In the past, true close-up photography required specialized equipment and cumbersome accessories. However, this situation has entirely changed thanks to the introduction of digital cameras. These cameras work at close-up subject distances as if they were designed for the job.

Digital's ability to handle close-ups is due to two related factors. First, because the sensor chips are small (*see p. 27*), lenses for digital cameras need have only short focal lengths. Second, short focal length lenses require little focusing movement to bring nearby subjects into focus. Another factor, applicable to digital cameras with zoom lenses, is that it is relatively easy to design lenses capable of close focusing by moving the internal groups of lens elements.

In addition to lens design, there is another feature common to digital cameras that also helps: the LCD screen. This provides you with a reliable way of framing close-ups with a high degree of accuracy, all without the complex viewing system that allows traditional SLRs to perform so well.

There will be occasions when you need to keep a good distance between yourself and the subject – a nervous dragonfly, perhaps, or a beehive. In such cases, first set the longest focal length on your zoom lens before focusing close up. In these situations, an SLR-type digital camera (one that accepts interchangeable lenses) is ideal, due to the inherent magnification given by the small sensor chip working in conjunction with lenses designed for normal film formats.

Simple subjects
Learning just what to include and what to leave out of a picture is a useful skill to master – not only is the image itself usually stronger for being simpler in visual content, as in the example shown here, but it is also often easier to use it for a range of purposes, such as compositing (*pp. 312–19*). Subject movement is always a problem with close-ups, especially plants outdoors where they can be affected by even the slightest breeze. If you cannot effectively shield the plant from air currents, then set the shortest shutter time possible, consistent with accurate exposure, to freeze any subject movement.
- Nikon CoolPix 990.

Avoiding highlights
One of the secrets underlying good close-up photography is avoiding unwanted highlights intruding on the image. These usually appear as insignificant out-of-focus bright spots when you frame the shot, but in the final image they can appear far more prominent and be very distracting. To take this shot, I moved slowly around the subject, watching the LCD screen continually, and released the shutter only when the highlights were positioned just as I wanted.
- Ricoh RDC-5000.

Long close-up

A long focal-length lens with close-focusing ability allows you to approach small, nervous subjects, such as this dragonfly, yet obtain a useful image size. In addition, the extremely shallow depth of field with such a lens throws even nearby image elements out of focus. The bright spot is in fact a flower.

● Canon D30 with 100–400 mm lens.

Safe distance

It was dangerous to get too near to this constrictor, so a close-focusing long lens was the best way to obtain good magnification in this case.

● Canon EOS-1n with 300mm lens.

Normal close-up

With static or slow-moving subjects, a normal focal length lens used at its macro setting will suffice.

● Nikon 775.

Digital depth of field

On the one hand, the closer you approach your subject the more rapidly depth of field diminishes, at any given lens aperture (*see pp. 84–7*). On the other, depth of field increases rapidly as focal length decreases. So the question is whether the increase in depth of field with the short focal lengths typical of digital cameras helps make close-up photography easier than with film-based equipment? The calculations are not straightforward, partly because in order for the shorter focal length lens to produce a given magnification, it must approach closer to the subject than a longer lens, which works

against the increase in depth of field. Another confusing factor is that digital cameras, with their regular array of relatively large pixels, cannot be treated in the same way as film-based cameras, whose images are based on a random collection of tiny grains of light-sensitive silver. With many digital cameras, you do not have the option of setting apertures at all, and, even when you do, the minimum aperture may be relatively large – say, f/8. Nonetheless, taking all these factors into account, depth of field often appears greater with digital photographic equipment than with conventional cameras.

Extreme lenses

Lenses with special capabilities, such as the ability to take ultrawide-angle views or focus at very close subject distances, call for extra care when in use. And since they are often costly to buy, you need to know how to get the very best from them.

Ultrawide-angles

Wide-angle lenses with a 35efl (equivalent focal length) of down to around 28 mm are easy to use, but when focal lengths become shorter than about 24 mm, successful results are less certain.

● To ensure the image is evenly lit (all wide-angle lenses project significantly more light onto the center of the image than the edges), avoid using the widest apertures available.

● To avoid accessories such as filters intruding into the lens's field of view, never use more than one filter at a time; also make sure lens hoods are designed for the focal length of the lens.

● With their extensive fields of view, ultrawide-angles can catch a bright source of light, such as the sun, within the picture area. These highlights can cause flare or strong reflections within the lens barrel. Using smaller apertures help control this.

● Avoid having very recognizable shapes – a face, say, or a glass – near the edges of the frame. It will

Problem horizons
In the hurry to record this scene on a beach in Zanzibar, the slight tilt of the camera, which went unnoticed while using the 17mm setting on the lens, has produced an uncomfortable looking

horizon. Though far from a disaster, the picture would have benefited from a moment's extra thought before shooting.
● Canon EOS-1n with 17–35 mm lens. ISO 100 film. Microtek 4000t scanner.

appear obviously distorted if a small-sized image is then produced (*see below*).

● Line up wide-angle lenses very carefully with the horizon or some other prominent feature, as the broad sweep of view will exaggerate the slightest error in picture alignment.

● Avoid pointing the lens up or down unless you want to produce an exaggerated image projection.

Wide-angle "distortion"
An ultrawide-angle lens encompassed both the stall holder and her wares, but not only does she appear very distorted by being projected to the corner of the frame, so, too, are the tomatoes in the right-hand corner. If, however, you were to make a large print of this image and view it from close up, the apparent distortion disappears.
● Canon EOS-1n with 17–35 mm lens. ISO 100 film. Microtek 4000t scanner..

Long telephoto
In this version of the scene shown on the right, the zoom lens was set to 400 mm and a 1.4x extender was also used, giving an effective focal length setting of 560 mm.

● Canon EOS-1n with 100–400 mm lens with 1.4x extender. ISO 100 film. Microtek 4000t scanner.

• Avoid using the minimum aperture: you rarely need the depth of field produced and image quality is likely to be degraded. However, selecting a small aperture may improve image quality when focusing on very close subjects.

Wide-ranging zooms
Zooms that offer a wide range of focal length settings, such as 35efl of 28–300 mm or 50–350 mm, are attractive in theory, but in practice, they may require special handling.

• Zooms with a wide range of focal lengths are far bulkier than their single focal length counterparts: a 28 mm lens used in a street is inconspicuous, but a 28–300 mm zoom set at 28 mm is definitely not.

• The wide-angle setting is likely to show considerable light fall-off, with the corners of the image being recorded darker than the middle, so avoid images that demand even lighting to be effective.

• Image distortion is always the price you pay for a wide range of focal lengths, so avoid photographing buildings and items with clearly defined sides and straight lines. There will be a setting,

Short telephoto
This view shows a beach scene in Zanzibar as imaged by a moderate 100 mm telephoto setting. At this magnification, the lens shows the general scene but not any of the activity or recognizable subject details (*compare this with the top image*).

● Canon EOS-1n with 100–400 mm lens. ISO 100 film. Microtek 4000t scanner.

usually around the middle of the range, where distortion is minimized; but even here, straight lines may appear very slightly wavy.

• As you set longer and longer focal lengths on a zoom lens, the maximum available aperture becomes smaller and smaller. This can reduce the scope you have for setting short shutter times, and the need for brighter shooting conditions increases as lens apertures become smaller.

Quick fix Image distortion

Anybody whose photography involves taking accurate pictures of buildings or other prominent architectural, or even some natural, features is likely at some stage to come up against the problems associated with image distortion.

Problem

When using an extreme wide-angle lens, or an accessory lens that produces a "fish-eye" effect, the straight lines of any subject elements – such as the sides of buildings, the horizon, or room interiors – appear to be bowed or curved in the image. With ordinary lenses, this effect (known as distortion) is usually not obvious, though it is a feature of many zooms. Don't confuse this problem with converging verticals (*see p. 259*).

Analysis

Distortion is caused by slight changes in magnification of the image across the picture frame. Lenses that are not symmetrical in construction (in other words, the elements on either side of the aperture are not similar) are particularly prone to this type of imaging distortion, and the asymmetric construction of zoom lenses means that they are highly susceptible.

Solution

Corrections using image-manipulation software may be possible, but turning curves into straight lines is more difficult than adjusting straight lines. Try using the Spherize distortion filter. The implementation in Photoshop is not very usable, but those in some other software packages offer more control and a better chance of correcting distortion. You could try applying a succession of filters – first, slight Perspective Distortion, then Spherize, then slight Shear – or apply filters to just a part of, rather than to the entire, image.

Problem...

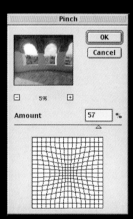

Barrel distortion

In the original shot (*above*), a wide-angle attachment has introduced barrel distortion. A combination of Pinch filter, to squeeze the image from all sides, with the Shear filter engaged (*left*) has partially helped to correct the problem (*below*).

● Nikon Coolpix 990 with wide-angle attachment.

...solution

How to avoid the problem

● Don't place straight lines, such as the horizon or a junction of two walls, near the frame edges.

● Avoid using extreme focal lengths – either the ultrawide or the ultralong end of a zoom range.

● Use a focal length setting that offers the least distortion, usually around the middle of the range.

● Place important straight line in the middle of the image – this is where distortion is usually minimal.

Quick fix Lens problems

Although many lens problems can be solved, or at least minimized, using appropriate software, prevention is always better than cure.

Problem: Lens blurring

The image looks unsharp, blurred, or smudged. Contrast is not high and the highlights are smeared.

Analysis

A dirty lens or lens filter, lack of sharp focus, damaged optics, camera shake, or subject movement may separately, or in combination, be the cause of blurred pictures.

Solution

You can increase contrast to improve image appearance using the Levels or Curves controls of image-manipulation software. Applying a Sharpen or Unsharp Mask filter is also likely to improve the image. The main subject can be made to appear adequately sharp if the background is made to look more blurred. To do this, select areas around the main subject and apply a Blur filter.

Camera movement

While trying to catch the light on the dust raised by a running zebra, the camera slipped a little, giving this blurred image – most evident in the highlights on the zebra's back and in the grass. However, blur can suggest mood and setting.

● Canon F-1n with 300 mm lens. ISO 100 film. Microtek 4000t scanner.

How to avoid the problem

Clean the lens or lens filter if it is marked; use a tripod to steady the camera for long shutter times or when using a telephoto lens or setting; if available, use an image-stabilization lens.

Problem: Lens flare

Bright spots of light, sometimes fringed with color, can be seen in the image. Spots can be single occurrences or appear in a row, and stretch away from a bright point source of light in the scene. Similarly, a bright, fuzzily edged patch of light, known as veiling flare, fills part of the image area.

Analysis

These types of fault are most likely the result of internal reflections within the lens. Stray light entering the lens from a bright light source has reflected around the lens and then been recorded on the film or picked up by the sensor of a digital camera.

Solution

Working with a digital file, small spots of light can easily be removed by cloning or rubber-stamping adjacent unaffected areas of the image on to them. Large areas of flare, however, are more difficult to correct, since they cover a significant area of the picture and contain no information to work with.

Flare

An unobstructed sun in the frame causes light to reflect within the lens, resulting in flare. By changing camera position, it was possible to mask the sun with a column of the building, while allow-ing a little flare through to suggest the brilliance of the light. Some of the reflections may be removed, but probably not all of them.

● Leica R6 with 21 mm lens. ISO 50 film. Microtek 4000t scanner.

How to avoid the problem

Use a correctly designed lens hood to stop light from entering the periphery of the lens; even so, avoid pointing the lens directly toward bright light sources. If shot framing demands you include any intense light source, select a small aperture to reduce the size of any resulting internal reflections.

Quick fix Lens problems continued

Problem: Black skies

A blue sky is rendered almost black. This type of effect seldom looks realistic or believable.

Analysis

This is probably the result of a polarizing filter on the lens combined with underexposure. This can reduce the sky to the point where most, or even all, color is removed.

Solution

First, highlight the problem sky area and then use Replace Color in Photoshop, or a similar software package, to restore the color. The best way to work is by making small changes repeatedly rather than a single, large change. Check that you do not introduce banding, or artificial borders, in the areas of color transition. You can also try using a graduated layer (*see below*).

How to avoid the problem

Don't set a polarizing filter to produce maximum darkness: in the viewfinder you may still be able to see the blue of the sky but the recording medium may not have sufficient latitude to retain color if the image is then underexposed.

Problem...

...solution

1 Original image
The skies of Kenya seldom need a polarizing filter in order to emphasize their color – indeed, it may even cause a portion of the sky to turn too dark, as you can see here in the top left-hand corner of the image.
● Canon F-1n with 20 mm lens. ISO 64 film. Microtek 4000t scanner.

2 Gradient Fill
To correct this, you need to re-move the dark gradient while leaving the rest of the image unaffected. This calls for a transparent-to-solid gradient that runs counter to the darkness. Here, a Gradient Fill of black-to-transparent, with its blend mode set to Screen, was applied. The gradient was adjusted until the dark corner was neutralized.

3 Sky correction
Once the new layer was applied to the image, the carefully positioned Gradient Fill restored the natural color of the sky. Once you have made one adjustment you may find the image needs more work – for example, the top right-hand corner may now seem too dark. With digital photography it is easy to create perfect tonal balance.

Problem: Dark image corners

Corners of the image are shadowed or darkened, with a blurred edge leading to blackness, or the middle of the image looks significantly brighter than the periphery.

Analysis

Images showing dark corners with a discernible shape have been vignetted. This is usually caused by a filter with too deep a rim for use with a (usually) wide-angle lens, by stacking too many filters on a lens, or by an incorrectly aligned or overly deep lens hood.

Solution

If the areas affected are small, vignetting can be corrected by cloning adjacent portions of the image. Light fall-off may be corrected using a Radial Graduate or Gradient Fill (*see opposite*) – experiment with different values of darkness and opacity.

Darkened corners
It is easy not to notice a lens hood interfering with the image. The shadows in the corners here were not noticed until after film processing. Small apertures give deeper, sharper shadows.
● Canon F-1n with 20 mm lens. Nikon LS-1000 scanner.

How to avoid the problem

Vignetting is easy to avoid if you are careful with your filters and lens hoods. Light fall-off, as an optical defect, can only be reduced, not eliminated altogether: use either smaller working apertures or a higher-quality lens.

Problem: Poor-quality close-ups

Images taken at the closest focusing distances are not sharp or lack contrast.

Analysis

Lenses usually perform best at medium or long distances: the degree of close-up correction depends on lens design.

Solution

Poor image sharpness may be improved by applying Sharpness or Unsharp Mask filters. Contrast will be improved with Levels or Curves. Try localized burning-in to improve contrast, which will also increase apparent sharpness without increasing visual noise.

How to avoid the problem

Small apertures are likely to improve sharpness. Try using different focus and zoom settings – there will be a combination that gives the best possible quality. An alternative solution, is to attach a close-up lens to the main lens. This acts as a magnifying glass and can improve close-up performance.

Improving close-ups
The original image (*right*) shows the features characteristic of a low-quality close-up: poor sharpness and reduced contrast. Applying an Unsharp Mask filter and an increase in contrast significantly improves results (*far right*).
● Olympus 920.

Problem...

...solution

Influencing perspective

You can exercise control over the perspective of a photograph by changing your camera position. This is because perspective is the view that you have of the subject from wherever it is you decide to shoot. Perspective, however, is not affected by any changes in lens focal length – it may appear to be so, but in fact, all focal length does is determine how much of the view you record.

Professional photographers know perspective has a powerful effect on an image, yet it is one of the easiest things to control. This is why when you watch professionals at work, you often see them constantly moving around the subject – sometimes bending down to the ground or climbing onto the nearest perch; approaching very close or moving farther away again. Taking a lead from this, your work could be transformed if you simply become more mobile, observing the world through the camera from a series of changing positions rather than a single, static viewpoint.

Bear in mind that with some subjects – still-lifes, for example, and interiors or portraits – the tiny change of perspective between seeing the subject with your eyes and seeing it through the camera lens, which is just a little lower than your eyes, can make a subtle difference to the composition. This difference in perspective is far more pronounced if you are using a studio camera or waist-level finder on a medium-format camera.

Using zooms effectively

One way to approach changes in perspective is to appreciate the effect that lens focal length has on your photography. A short focal length gives a

Alternative views
This classic wide-angle view (*above left*), tells of a flock of sheep grazing on the rolling moors of Scotland. It is a simple, effective, but essentially commonplace interpretation of the scene. However, when I stepped back a little and crouched down, I noticed tufts of wool caught on a wire fence (*above right*), which had been there all the time, literally right under my nose. A change to a long focal length setting on my zoom lens entirely changed the perspective and delivered a very different, and entirely more engaging, account of this attractive rural scene. (*For another treatment of this view, see pp. 244–5*)

● Nikon Coolpix 990 with tele-setting (*above*) and wide-angle attachment (*above left*).

perspective that allows you to approach a subject closely yet record much of the background. If you step back a little, you can take in much more of the scene, but then the generous depth of field of a wide-angle tends to make links between separate subject elements, as there is little, if any, difference in sharpness between them.

A long lens allows a more distant perspective. You can look closely at a face without being nearby. Long lenses tend to pull together disparate objects – in an urban scene viewed from a distance, buildings that are several blocks apart might appear to crowd on top of each other. However, the shallow depth of field of a long lens used at close subject distances tends to separate out objects that may actually be close together (*see p. 94*) by showing some sharp and others blurred.

Perspective effects

Wide-angle lenses
- Take in more background or foreground.
- Exaggerate in close-ups the size of near subjects.
- Exaggerate differences in distance or position.
- Give greater apparent depth of field and link the subject to its background.

Telephoto lenses
- Compress spatial separation.
- Magnify the main subject.
- Reduce depth of field to separate the subject from its background.

Telephoto perspective
Overlooking the action there is a sense of the crush of people at this festival in mountainous Tajikistan (*above*). Two children holding hands complete the scene. The long focal length version (*above right*) focuses attention on the dancer, but excludes all sense of setting beyond the crowd watching the traditional performance.
- Canon EOS-1n with 80–200 mm lens. ISO 100 film. Microtek 4000t scanner.

●TRY THIS

For this exercise, leave your zoom lens at its shortest focal length setting. Look for pictures that work best with this focal length – ignore any others and don't be tempted to change the lens setting. This will help to sharpen your sense of what a wide-angle lens does. You may find yourself approaching subjects – including people – more closely than you would normally dare. The lens is making you get closer because you cannot use the zoom to make the move for you. Next, repeat the exercise with the lens at its longest focal length setting.

Changing viewpoints

Always be on the lookout for viewpoints that give a new slant to your work. Don't ignore the simple devices, such as shooting down at a building instead of up at it, or trying to see a street scene from a child's viewpoint rather than an adult's.

Your choice of viewpoint communicates subtle messages that say as much about you as they do your subject. Take a picture of someone from a distance, for example, and the image carries a sense that you, too, were distant from that person. If you photograph a scene of poverty from the viewpoint of a bystander, the picture will again have that distant look of having been taken by an aloof observer. Lively markets are popular photographic subjects, but what do they look like from a stall-holder's position? If you enjoy sports, shoot from within the action, not from the sidelines.

Practical points

Higher viewpoints enable you to reduce the amount of foreground and increase the area of background recorded by a lens. From a high vantage point, a street or river scene lies at a less acute angle than when seen from street or water level. This reduces the amount of depth of field required to show the scene in sharp focus.

However, from a low camera position subjects may be glimpsed through a sea of grass or legs. And if you look upward from a low position, you see less background and more sky, making it easier to separate your subject from its surroundings.

Less can say more
At markets and similar locations, all the activity can be overwhelming – and the temptation is often to try to record the entire busy, colorful scene. At your feet, however, could be images showing much less but saying so much more. In Uzbekistan I noticed next to a fruit stall a lady who had nothing to sell but these few, sad tulips.
● Ricoh RDC-5000.

Subjects and setting
By climbing up to a convenient vantage point overlooking the lawn, I could leave the classic wedding group pictures behind and record a more complex image, one that revealed not only the wedding party and guests, but also the surrounding to be the romantic ruins of a castle.
● Nikon F60 with 24–120 mm lens. ISO 100 film. Microtek 4000t scanner.

● In some parts of the world, it is a good idea to avoid drawing attention to your presence. Your search for an unusual camera viewpoint could attract the unwanted interest of officialdom. Even climbing onto a wall could land you in trouble in places where strangers are not a common sight or photographers are regarded with suspicion.

● As well as being discourteous, it might also be illegal to enter a private building without permission in order to take photographs. You may be surprised at how cooperative people generally are if you explain what you are doing and why, and then ask for their assistance.

● Try to be open and friendly with people you encounter – a pleasant smile or an acknowledging wave is often the easiest, and cheapest, way to elicit a helpful response from strangers.

● Prepare your equipment before making your move. Balancing on the top of the wall is not the best place to change lenses. With manual cameras, preset the approximately correct aperture and shutter time so that if you snatch a shot, exposure will be about right.

Changing viewpoint

This conventional view of the Mesquita of Cordoba, Spain (*above*), works well as a record shot, but it is not the product of careful observation. Looking down from the same shooting position, I noticed the tower of the building reflected in a puddle of water. Placing the camera nearly in the water, a wholly more intriguing viewpoint was revealed (*right*). An advantage of using a digital camera with an LCD screen is that awkward shooting positions are not the impossibility they would be with a conventional camera.

● Nikon Coolpix 990.

Quick fix Leaning buildings

Buildings and architectural features are always popular photographic subjects, but they can cause annoying problems of distortion.

Problem

Tall structures, such as buildings, lamp posts, or trees, even people standing close by and above you, appear to lean backward or look like they are about to topple over.

Analysis

This distortion occurs if you point the camera up to take the picture. This results in you taking in too much of the foreground and not enough of the height of the subject.

Solution

- Stand farther back and keep the camera level – you will still take in too much of the foreground, but you can later crop the image.
- Use a wider-angle lens or zoom setting, but then remember to hold the camera precisely level – wide-angle lenses tend to exaggerate projection distortion.
- Take the picture anyway and try to correct the distortion by manipulating the image (see p. 229).
- Use a shift lens or a camera with movements. This equipment is specialized and expensive, but technically it is the best solution.
- Exaggerate the leaning or toppling effect to emphasize the height and bulk of the subject.

Problem...

Tilting the camera
An upward-looking view of the spires of Cambridge, England, makes the buildings lean alarmingly backward.
● Nikon Coolpix 990 with wide-angle adaptor.

...solution

Using the foreground
By choosing the right camera position, you can keep the camera level and include foreground elements that add to the shot.

Problem...

Losing the foreground
To record the red flags against the contrasting blue of the building there was no option but to point the camera upward, thus dismissing much of the foreground. As a result, the nearest building appears to lean backward.
● Canon EOS-1n with 20 mm f/2.8 lens. Microtek 4000t scanner.

...solution

Alternative view
Keeping the camera level, a shift lens was used, set to maximum upward movement. This avoided the problem of converging verticals. Although this is the best solution to optimize image quality, it does require a costly professional lens.
● Canon EOS-1n with 24 mm TS lens. Microtek 4000t scanner.

Quick fix Facial distortion

Distorted facial features can be a problem with portraits. To make the subject's face as large as possible, the temptation is to move in too close.

Problem

Portraits of people taken close-up exaggerate certain facial features, such as noses, cheeks, or foreheads.

Analysis

The cause is a perspective distortion. When a print is viewed from too far away for the magnification of the print, the impression of perspective is not correctly formed (see also p. 98). This is why at the time you took the photograph, your subject's nose appeared fine, but in the print it looks disproportionately large.

Solution

Use a longer lens setting – a 35efl of at least 80 mm is about right, so that for a normal-sized print viewed from a normal viewing distance, perspective looks correct.

- Use the longest end of your zoom lens. For many, this is a 35efl of 70 mm, which is just about enough.
- If you have to work close-up, try taking a profile instead of a full face.
- Avoid using wide-angle lenses close to a face, unless you want a distorted view.
- Don't fill the frame with a face at the time of shooting. Instead, rely on cropping at a later stage if you need the frame filled (see pp. 90–1).
- Don't assume you will be able to correct facial distortions later on with image-manipulation software. It is hard to produce convincing results.
- If you have a digital camera with a swiveling lens, it is fun to include yourself in the picture by holding the camera at arm's length – but your facial features will then be so close they look exaggerated.
- Make larger prints. With modern ink-jet printers it is easy to make 8½ x 11 in sized images (much larger than the usual photographic snapshot), and at normal viewing distances they are far less prone to perspective distortion.

Profile

Taking portraits in profile avoids many of the problems associated with facial distortion in full-frontal shots. Make sure you focus carefully on the (visible) eye – other parts of the face may appear unsharp yet be acceptable to the viewer.
- Leica R-4 with 60 mm f/2.8 lens. Nikon Coolscan LS-2000 scanner.

Full-frontal

To emphasize the friendly character of this man, several "rules" were broken: a wide-angle lens was used close-up; the shot was taken looking upward; and the face was placed off into one corner, thus exaggerating the distortion already present. But the total effect is amiable rather than unpleasant.
- Canon F-1n with 20 mm f/2.8 lens.

Color composition

Successful color photography means learning to use color as a compositional tool – as a form of visual communication in its own right – rather than just reproducing a scene or subject that happens to be in color.

The importance of color

Color is far from being merely incidental, any more than is the surface texture of a subject or, indeed, the quality of the light illuminating it. Color is an integral part of our experience of the subject, helping to determine both the mood and the atmosphere of the scene and our emotional responses to it. One way to come to terms with this is to record colors as if they were distinct entities, separate from the things displaying them.

Mental focus

Once you have made this change in mental focus, you could, for example, start evaluating scenes not in terms of vistas or panoramas, but in terms of color content. Look at, say, the greens – are they as intense as you want? Is the light too contrasty for them to have real depth? Is your shooting position right in relation to the light in order to give the color impact you want to record? Look at a city scene not because it is full of activity but because there, among the drabness, are flashes of red, or blue, or green. And if a neighboring color is distracting, change focal length or crop the final image to exclude it.

Working digitally

An advantage digital photographers have over their traditional counterparts is that it is easy, using image-manipulation software, to alter the colors of the recorded image. Not only are broad-stroke changes possible – such as whole areas of sky or foreground – you can also select very precise parts of a scene for the software to work on. And if radical changes are not appropriate, then it is just as easy to alter color contrast, saturation, or brightness to emphasize a particular part of the image or suppress another.

Color saturation

Red is such a strong color that it inevitably draws attention to itself. In this image (*right*), the reds coupled with the green reflections in the water are so strong that the fish almost seem to blur before your eyes. Using the image-manipulation software's Color Picker option, however, all manner of color adaptations become possible (*far right*).
● Nikon Coolpix 990.

Bright/pale contrast

A simple subject – floral table decorations in a restaurant (*below*) – has been transformed by an overhead camera angle and the contrast provided by the bright colors of the flowers with the far subtler tones contained in the rest of the image.
● Nikon Coolpix 990.

Color wheel

Strictly, the color wheel displays only hue and saturation: in the middle are the desaturated colors (those containing a lot of white); on the perimeter of the wheel are the most saturated colors.

The colors are organized in the order familiar from the spectrum, with the degrees marks around the rim being used to help locate different hues.

Perception of color

If a pale subject is seen against a complementary colored background, its saturation seems to increase. Similarly, a neutral gray changes its appearance according to its background color, appearing slightly bluish green against red, and magenta against green. If you compare the gray patches in the two colored panels here (*below right*) you can see this at work. If you cut small holes in a piece of white card, so that only the four patches are visible, you can see that the blues are, in fact, identical, as are the grays.

Adjacent colors

Colors that lie immediately next to each other on the color wheel (*see p. 111*) are said to be analogous or adjacent colors. Examples of these include light green and yellow, dark green and blue, purple and cyan, and so on.

Color and harmony

Although it is difficult to generalize about what are essentially subjective reactions to the inclusion of particular colors, as a general rule if you include combinations of adjacent colors in an image you invariably create more of a harmonious effect. This is especially true if the colors are approximately equivalent to each other in brightness and saturation. As well as being pleasing to the eye, color harmony also helps to bind together what could perhaps be disparate subject elements within a composition.

Color and mood

There is much to be said for learning to work with a carefully conceived and restrained palette of colors. A favorite trick of landscape photographers at some times of the year, for example, is to select a camera viewpoint that creates a color scheme that is composed predominantly of browns and reds – the hues redolent of autumn. Thus, not only does a harmonious color composition result, all of the mood and atmosphere associated with the seasonal change from summer to winter are brought to bear within the image.

Depending on just how the photographer wants a picture to communicate with its intended audience, images that feature gardens as the principal subject might be dominated by colors such as various shades of green or blues and purples.

Monochromatic color

Another type of picture harmony results when the colors are all of a similar hue. When most of the colors in an image are variants of each other, the picture rewards you with tonal subtleties. Duotone or sepia-toned effects (*see pp. 278–81*) are highly monochromatic, as are views of the sea and sky containing a range of different blues. Sunsets can comprise mainly oranges and reds, while flower close-ups are often rewarding due to their narrow, subtle shifts in color.

Color contrast

On the color wheel, the yellows, like those seen in this shot taken in Picardie, northern France, are distant from the blues, and so provide a strong contrast. But, as you find in many scenic shots, the color green, being adjacent to yellow and blue, helps to bridge the two. This unbroken color span works with other features – such as the compositional device that adds emphasis to any subject elements that are positioned a third of the way from either the top or bottom, or the left or right, of the frame.

● Canon F-1n with 135 mm lens. ISO 100 film. Nikon Coolscan 4000 scanner.

Emotional content

Even though all the main colors in this photograph are tonally very close, the image lacks impact when it is rendered in black and white. The emotional content of the warm reds, pinks, and purples is essential to the success of the study.

● Nikon Coolpix 990.

Blue on blue

Although the strong and adjacent blues, which have been given extra depth by the bright sunlight illuminating them, are what this picture is all about, a total absence of some form of contrast –

provided here by the small red label and the subject's flesh tones – would have left the picture unbalanced and overstated.

● Nikon Coolpix 990.

●TRY THIS

First, choose a color. It could be your favorite one – blue, yellow, orange – or any other. Next, set out to photograph anything that is largely or wholly composed of that particular hue. Allow only variations of that color within each picture. If any other colors are present, don't take the picture – unless you can get in close enough, or change your camera viewpoint, to exclude them. When you are done, put your collection of pictures together. The assembly of similar colors in different shades will have an impact that may surprise and delight you.

Red and purple

When I first noticed this painted wall, it appeared to have promise, but it was not until it was strongly lit by oblique sunlight that the picture really came together – the dominance of the red and the strongly graphic crack both being powerful visual elements. A little post-processing work served to heighten the colors and strengthen the shadows.

● Nikon Coolpix 990.

Pastel colors

Referring to pastels as being watered-down versions of colors does them a disservice. Certainly, they are paler and less saturated than full-strength hues, but for all that they are a vital part of the photographic palette.

Evoking mood

Within the photographic image, pastels tend to generate a sense of calm and an atmosphere of softness. They are gentle and refined, whereas strong colors tend to be more strident; they are soothing as opposed to invigorating; subtle rather than obvious. Pastels, therefore, evoke emotional responses that are simply not possible where bright colors dominate. And, as a result, they are often chosen as the principal color theme in home interiors, especially where a calm, relaxed, or soothing environment is the aim.

Appropriate exposure

In portrait photography, the accurate exposure of pastel shades is often a crucial factor in the success

Creating harmony
The soft light and gentle colors, together with the smooth curves of the plates and glasses, have all combined in this image to create a sense of calm and repose. Anything other than pastel colors would disturb the composition and mood of this table setting. The scene was carefully exposed and a small aperture set to produce maximum depth of field.

● Nikon Coolpix 990.

Skin tones
The most natural way to articulate the softness and vulnerability of the naked human figure is with pastel colors illuminated by a gentle form of lighting. In this image, water has further softened subject details, while the wide-angle view has exaggerated her form. A slight reduction in color saturation was given in order to soften the original image even further.

● Nikon Coolpix 990.

of an image. Many skin tones, for example, are essentially desaturated hues – pinks being pale versions of reds, and oriental skin tones being light versions of golds or yellow-browns.

Pictures that are composed predominantly of pastel colors are often associated with "high-key" imagery (*see pp. 124–5*). An exposure reading taking in areas of dark shadow is likely to result in the camera controls being set to record shadow detail. This has the obvious effect of overexposing all the brighter parts of the scene, turning colors into

pastel-like hues. This high-key technique can be effective in nature and landscape photography when you are trying to achieve a more interpretative, less descriptive effect.

However, if you are working with digital image files, you have the advantage of being able to tone down and lighten colors deliberately in order to create pastels from more strident hues (*see p. 294*). Another way to achieve a similar type of effect is to introduce pale colors into a black-and-white image (*see pp. 290–1*).

Color variety

A scene that utilizes pastel shades is not one in which all the colors have to be similar. In this selective view of a Scottish moor, a whole spectrum of different colors is on display, but the soft light has toned them all down so that they blend gently together to create a harmonious composition.

● Nikon Coolpix 990.

Color restraint

It is easy to be overwhelmed by strong colors and brilliant light. But there are times when a subtle color palette works far better – as in this near-abstract impression photographed during Holy Week in Mexico City. An overly strong color rendition, by using slight underexposure, would have recorded the bare heads as being too black, while the slight overexposure employed here has given a pastel effect and better detail in the shadow areas.

● Nikon F2 with 135 mm lens. ISO 64 film. Nikon LS-4000 scanner.

Strong color contrasts

Color contrasts result when you include hues within an image that are well separated from each other on the color wheel (*see p. 111*). While it is true that strongly colored pictures may have initial visual impact, they are not all that easy to organize into successful images. Often, it is better to look for a simple color scheme as part of a clear compositional structure – too many subject elements can so easily lead to disjointed and chaotic pictures.

Digital results

Modern digital cameras are able to capture very vibrant colors that look compelling on your computer's monitor screen. Because of the way the screen projects color, these are, in fact, brighter and more saturated than those film can produce. However, one of the advantages of using computer technology is that the color range offered by film can be enhanced by the application of image-manipulation software, giving you the opportunity, first, to create and, then, to exploit an enormous range of vibrant colors.

Distracting composition

Combine strong colors with an unusual and an appealing subject, and you would think that you have all the important elements for a striking photograph (*above*). In fact, there is far too much going on in this picture for it to be a successful composition. The painting in the background distracts attention from the man – himself an artist, from Papua New Guinea – while the white edge on the right disturbs the composition. A severe crop, to concentrate attention on the face alone, would be necessary to save the image.

● Nikon Coolpix 950.

Lighting for color

The unbelievably strong colors seen in this image, recorded on an isolated Scottish shoreline, are the result of shooting in the bright yet diffused light from an overcast sky, which has had the effect of making all the colors particularly intense. The palette of contrasting dark reds and blues not only looks good on screen, it also reproduces well on paper. This is because the particular range of colors in this image happen to be those that print well. A range containing, say, bright purples or open blues would not be so successful.

● Nikon Coolpix 990.

Simple composition

Bright colors are attractive in themselves, but they tend to be most effective when they are arranged in some type of pattern or sequence. This arrangement imposes a structure on them and, hence, suggests a meaning or order beyond the mere presence

of the color itself. The main problem I encountered when taking this photograph of brightly colored fabrics was avoiding the reflections from the store window in front of them.

● Nikon Coolpix 990.

Color gamut

The intensity of computer-enhanced colors gives them real appeal, but it is in this strength that problems lie. Strong colors on the page of a book or website will compete with any text that is included; they are also likely to conflict with any other softer image elements. In addition, you need to bear in mind that even if you can see intense, strong colors on the screen, you may not be able to reproduce them on paper. Purples, sky blue, oranges, and brilliant greens all reproduce poorly on paper, looking duller than they do on screen. This is because the color gamut, or range of reproducible colors, of print is smaller than that of the monitor.

Of the many ways to represent a range of colors, this diagram is the most widely accepted. The rounded triangle encloses all colors that can be perceived. Areas drawn within this, the visual gamut, represent the colors that can be accurately reproduced by specific devices. The triangle encloses the colors

(the color gamut) of a typical RGB color monitor. The quadrilateral shows the colors reproduced by the four-color printing process. Notice how some printable colors cannot be reproduced on screen, and vice versa.

Quick fix Color balance

Correct color rendition depends on many differ-
ent factors, one of which is ensuring that the
recording media and light sources match.

Problem

Pictures taken indoors have a distinct color cast – either
orange or yellow – and images appear unnaturally warm-
toned. A related problem occurs in outdoor shots – there
is a blue cast and images appear unnaturally cold. In
other situations, pictures taken under fluorescent lamps
appear greenish overall. Problems are compounded if you
work in mixed lighting, such as daylight from a window
and light from a table lamp. If you correct for the orange
cast of the lamp, the window light looks too blue; if you
correct for the window light, the lamp looks too orange.

Analysis

All imaging systems, whether film-based or digital,
assume that the light falling on a scene contains the full
spectrum of colors. This produces the "white" light of
daylight, often called 6,500 K light – a reference to its
color temperature (*see p. 262*). If, however, the light is
deficient in a specific band of colors, or is dominated by
certain color wavelengths, then everything illuminated by
it will tend to take on the strongest color component. We
do not experience indoor light, for example, as being
unduly orange because our eyes adapt to the dominant
color and our brains "filter" it out. Likewise, we seldom
notice the blue color cast that is often present in the
shadows on sunny days because our eye/brain
mechanisms compensate for the color cast – and so
we see the colors we expect to be there.

Solution

There are various solutions, depending on whether you
are using a film-based system or digital technology.

Film-based systems
● Use the correct film type for the principal source of
illumination in the scene. For indoor photography, shoot-
ing under incandescent lights, use tungsten-balanced
film. This advice, and that following, applies principally
to slide film, as the film image is usually the final result.
With color negatives, however, at least some color

1 Orange domestic tungsten
Photographs taken of rooms by domestic tungsten
light often display an orange cast because the film used
is intended to be exposed by daylight, which has a high
color temperature.
● Sinar P with 90mm lens. ISO 100 film. Umax Powerlook
3000 scanner.

2 Color Balance screen shot
Tones lighter than mid-tone are strongly yellow-red.
To correct for this, "Highlights" was selected in Color
Balance, and blue increased using the lowest slider.

3 Corrected color
Notice that the corrected image has retained a hint
of the orange cast – removing it completely would have

- Attach a color-balancing filter to your lens so that the light reaching the film corresponds to that film's color balance. Use an 85B for daylight-balanced film exposed indoors under tungsten light; an 80B for tungsten-balanced film exposed in daylight. Pink or light magenta filters help to correct the color casts produced by fluorescent lamps.

Scanned images

- Scanner software can make corrections while it is scanning. If you have many images to correct, apply the settings that give the best results to all of them.
- Or make corrections using image-manipulation software. This may be more accurate since you will then be working with the full image data.

Digital cameras

- Most digital cameras automatically correct for the white balance – they analyze the colors of the light and remove the color cast. In some situations, however, you will obtain more accurate results if you present the camera with a neutral color and set white balance manually.
- Images recorded by a digital camera showing an unwanted color cast can be corrected using image-manipulation software (see pp. 261–3).

It is worth bearing in mind that you may not always want to correct a color imbalance, or at least not fully correct it. In some situations, the color cast may be helping to set the atmosphere of a scene or be providing the viewer with additional information about the subject.

How to avoid the problem

- **Don't choose to photograph in mixed lighting conditions unless you specifically want the image to display unpredictable colors.**

- **Don't take color-critical shots under fluorescent lamps – it is very difficult to correct precisely the resulting cast.**

- **Don't rely on color-balancing filters as they make only approximate corrections. But partial correction does make later refinements – when printing or using image-manipulation software – far easier**

1 Blue dawn light

Taken at dawn, this shot displays a distinct blue bias, suppressing the warm colors I perceived at the With film, the blue cast would have been more pronounced – but, as you can see, even the digital came white balance did not fully compensate for the disto
- Nikon Coolpix 990.

2 Levels screen shot

The quickest way to correct the image was to u Levels. The Highlight Dropper (far right tool) was app to the area to be rendered a neutral white (the white walls of the foreground building). The Shadow Dropp was then selected and a deep shadow chosen.

3 Corrected color

The finished result shows greatly improved colo overall, but note that the blue hills in the far distanc have now been lost

Exposure control

The process of determining the amount of light that is needed by the film or sensor for the required results is called exposure control. Unlike conventional photography, many digital cameras can change sensitivities to maintain practical camera settings. For example, in low light, sensor sensitivity increases (just as faster film might be used in conventional photography) to allow you to set shorter shutter times or smaller apertures.

It is important to control exposure accurately and carefully, as it not only ensures you obtain the best from whatever system you are using, but it also saves you the time and effort of manipulating the image unnecessarily at a later stage.

Measuring systems

To determine exposure, the camera measures the light reflecting from a scene. The simplest system measures light from the entire field of view, treating all of it equally. This system is found in some hand-held meters and some early SLR cameras.

Many cameras, including digital ones, use a center-weighted system, in which light from the entire field of view is registered, but more account is taken of that coming from the central portion of the image (often indicated on the focusing screen). This can be taken further, so that the light from most of the image is ignored, except that from a central part. This can vary from a central 25 percent of the whole area to less than 5 per cent. For critical work, this selective area, or spot-metering, system is the most accurate.

A far more elaborate exposure system divides the entire image area into a patchwork of zones, each of which is separately evaluated. This system, commonly referred to as evaluative or matrix metering, is extremely successful at delivering consistently accurate exposures over a wide range of unusual or demanding lighting conditions.

As good as they are, the exposure systems found in modern cameras are not perfect. There will be times when you have to give the automation a helping hand – usually when the lighting is most interesting or challenging. This is why it is so crucially important to understand what exactly constitutes "optimum exposure".

Optimized dynamics

Every photographic medium has a range over which it can make accurate records – beyond that, representation is less precise. This accuracy range is represented by a scale of grays on each side of the mid-tone – from dark tones with detail (say, dark hair with some individual strands distinguishable) to light tones showing texture (perhaps paper showing crinkles and fibers). If you locate

What is "correct"?

To the eye, this scene was brighter and less colorful than seen here. A technically correct exposure would have produced a lighter image – thus failing to record the sunset colors. Although it looks like this might challenge a basic exposure-measuring system, by placing the sun center frame you guarantee underexposure, resulting, as in this example, in a visually better image than a "correct" exposure would produce.

● Canon F-1n with 135 mm lens. ISO 100 film. Nikon LS-II scanner.

Narrow luminance range

Scenes that contain a narrow range of luminance and large areas of fairly even, regular tone do not represent a great problem for exposure-measuring systems, but you still need to proceed with care for optimum results. The original of this image was correctly exposed yet appeared too light because, pictorially, the scene acquires more impact from being darker, almost low-key (*pp. 124–6*). The adjustments that were made to darken the image also had the effect of increasing color saturation, which is another pictorial improvement.

● Nikon Coolpix 990.

Wide luminance range

The range of luminance in this scene is large – from the brilliant glare of the sky to deep foreground shadows. Exposure control must, therefore, be precise to make the most of the film's ability to record the scene. In these situations, the best exposure system is a spot meter, with the sensor positioned over a key tone – here, the brightly lit area of grass on the right of the frame. Evaluative metering may also produce the same result, but you will not know until you develop the film.

● Canon EOS-1n with 80–200 mm lens. ISO 100 film. Microtek 4000t scanner.

your exposure so that the most important tone of your image falls in the middle of this range, the recording medium has the best possible chance of capturing a full range of tones.

Exposure control is, therefore, a process of choosing camera settings that ensure the middle tone of an image falls within the middle part of the sensor's or film's recording range in order to make the most of the available dynamic range.

The easiest method for achieving precision in exposure control is to use a spot-metering system to obtain a reading from a carefully selected tone within a scene. This may be a person's face or, in a landscape, the sunlit portion of a valley wall.

Sensitivity patterns

Cameras use a variety of light-measuring systems, and the representations shown here illustrate two of the most common arrangements. With a center-weighted averaging system, most of the field of view is assessed by the meter, but preference is given to light coming from the middle of the frame. This produces the correct exposure in most situations. However, the optics of a light meter can be arranged so that all its sensitivity is concentrated into a small spot in the very middle of the field of view. This spot-metering system gives a precision of control, which, if used with care and knowledge, produces the best reliability.

Center-weighted averaging metering
Blue color has been used here to give an impression of the light meter's sensitivity – the more intense the color the more sensitive the meter.

Spot metering
Here, the blue spot shows that the meter's sensitivity is limited to a very small area in the middle of the frame – everything else is ignored.

Silhouettes/backlighting

Although images may look different, silhouetted and backlit shots are variations on the same theme. In terms of exposure, they differ only in how much light is given to the main subject.

Silhouetted subjects

To create a silhouette, expose for the background alone – whether the sky or, say, a brightly lit wall – so that foreground objects are recorded as very dark, or even black. Make sure the exposure takes no account of the foreground. For this technique to be most effective, minimal light should fall on the subject, otherwise surface details start to record and shape becomes less prominent. The main point is to exploit outline and shape, and to help this a plain background is usually best.

When taking pictures into the light, you need to be aware of bright light flaring into the lens. Try to position yourself so that the subject itself obscures the light source, though it can be effective to allow the sun to peep around the subject to cause a little flare. Using a small aperture helps reduce unwanted reflections inside the lens.

Backlit subjects

The classic backlit subject is a portrait taken with a window or the sky filling the background, or figures on a bright, sandy beach or on a ski slope.

The challenge in terms of exposure in these types of situation is to prevent the meter from being overinfluenced by the high levels of background illumination. If you don't, you will end up with a silhouette. To prevent this, either override the automatics or manually set the controls to "overexpose" by some 1½–2 f/stops.

Another approach is to set your camera to take a selective meter reading (*see pp. 120–1*). Alternatively, with a center-weighted averaging meter reading, fill the viewfinder with the shadowy side of your subject, note the reading, or lock it in, move back, and recompose the image.

Backlit scenes are prone to veiling flare – non-image-forming light – which is aggravated by the need to increase exposure for the subject. In strong backlighting, however, it is hard to prevent light from spilling around the subject edges, blurring sharpness and reducing contrast.

Conflicting needs

In this strongly backlit portrait of a Kyrgyz shepherd (which has been cropped from a wide-angle shot), I positioned myself so that the subject shielded the lens from the direct rays of a bright sun. It is very difficult to achieve the right balance of exposure – if the horse is fully exposed, the sheep will be too light. This is clearly the type of situation that would benefit from a little fill-in flash (*pp. 130–3*). However, there was just enough light to pick out the color of the horse when the sheep were correctly exposed.

● Canon EOS-1n with 20 mm lens. ISO 100 film. Nikon LS-4000 scanner.

Dealing with flare

As the sun sets on a market in Tashkent, Uzbekistan, the dust raised by street cleaners fills the air, catching and spreading the still bright sunlight. The lower the sun is in the sky, the more likely is it to become a feature in your composition. In the example here, the flare has been caused as much by the atmospheric dust as by any internal reflections within the lens itself. A normal averaging light reading taken in these conditions would be massively overinfluenced by the general brightness of the scene, and so render the backlit subject as featureless silhouettes. Therefore, what may seem like a gross overexposure – an additional 2 f/stops – is needed to deal with this type of lighting situation.

● Canon EOS-1n with 80–200 mm lens. ISO 100 film. Nikon LS-4000 scanner.

Sky exposure

Strong light from the front and a symmetrical foreground shape immediately suggest the potential for a silhouette. A passing windsurfer, in the Penang Straits of Malaysia, completes the picture. Simply by exposing for the sky, all the other elements fall into their correct place – the black, shadowy palm, the sparkling water, and the surfer are transformed. Using a catadioptric (mirror) lens produces the characteristic "hollow" look of the out-of-focus palm.

● Canon F-1n with 350 mm lens. ISO 64 film. Nikon LS-2000 scanner.

Virtue of necessity

When shooting into a fierce, tropical sun, you may have no choice other than to produce a silhouette. If so, the strategy then becomes a search for the right type of subject. Here, on Zanzibar, dhows and beachcombers are complementary in terms of tone, yet contrasting in shape. Notice how the central figure seems diminished in size as his outline is blurred by the light flaring all around his body.

● Canon EOS-1n with 100–400 mm lens. ISO 100 film. Nikon LS-2000 scanner.

High-key/low-key images

The key tone in the majority of images lies at or near the mid-point between darkest or black tones and the brightest or white ones. The visual effect of deliberately shifting the key tone is not merely to make an image lighter or darker overall, but to signal a mood or feeling to the viewer; it is to use the tonality of the image to convey meaning. In this sense, the exposure is "incorrect," or not compliant with the standard, since you are deliberately causing under- or overexposure.

Visually, it seems that when the key tone is shifted it is best to alter the other values further to suit. Thus, with high-key images there are generally few, if any, truly black areas, while in low-key images, white-bright areas are minimized.

Bright and high

High-key overcomes shadows and signals a style full of light and air. But making a high-key image is not just a matter of increasing exposure; it is ensuring that as many tones as possible are lighter than mid-tone. You can do this by lighting your subject evenly from both sides, using fill-in flash or reflectors to reduce shadows, or shooting from a position that minimizes shadows. However, if you are working in low-contrast conditions, you may indeed have to increase exposure.

High-key owl

High-key images may result not only from exposure control or the nature of a subject, but also from the treatment given to an image after it has been captured. The original portrait of this eagle owl was full of dark tones, but manipulation of the image concentrated on bringing out the bird's strong features by turning unnecessary details into pure white or a few hints of color.

● Canon F-1n with 135 mm f/2 lens. ISO 100 film. Nikon LS-1000 scanner.

Snow scene

Both snow and white sand seen in full sun reflect back a lot of light, which can, if not corrected, lead to dark, underexposed images. To retain the character of snow or sand, the exposure must be greater than normal by between 1 and 2 stops. In this snow scene, taken in Uzbekistan, exposure was measured from a nearby object (not visible) that contained mid-tone colors. Compared with that meter reading, the snow called for 1½ stops less exposure. The resulting deliberate overexposure lightens the snow to produce a high-key tonal rendering.

● Leica M6 with 35 mm lens. ISO 400 film. Heidelberg Ultra Saphir II scanner.

With digital cameras, you can easily see the effect of setting non-standard exposures as soon as you take an image. However, it may be easier to record the image normally and then create the high-key effect using image-manipulation software.

The easiest way to create a high-key picture is to base exposure on the shadow areas by ensuring that your meter reads light values in these areas alone. If your camera has a spot or selective-area meter, point it at a shadow that still retains some subject detail, lock the reading in, and recompose the shot. If you don't have this facility, you may need to move close enough to a suitable shadow so that it fills the sensor area. If you place the darkest area with detail as your mid-tone, all the other tones in the image will be lighter and you should have very little in the image that is darker than mid-tone.

Deliberate overexposure with a digital camera can cause electronic artifacts as photosensors become overloaded. If this occurs, the best option is to record the images using normal exposure settings and create the high-key effects later, via your image-manipulation software.

TRY THIS

Look out for subjects that have a narrow range of luminances – those with relatively small differences between their brightest and the darkest parts – such as flatly lit subjects on an overcast day. Take a series of exposures, starting with the metered correct exposure and steadily increase exposure to overexpose the subject. You will find that overexposure of 1 stop or more is sufficient to fill the colors with light to create a relatively pastel image, provided there are not any black or very dark areas. This is a high-key image. At the same time, look out for scenes with a broad subject-luminance range – say, a building with one side brightly lit and the other in deep shadow. Take a series of exposures, starting with the correct exposure, and steadily decrease exposure to underexpose the subject. You will find that while the mid-tones deepen to black, the highlights simply become smaller until the image consists of sharply drawn highlights. This is a low-key image.

Shadow scene

The exposure you give a scene determines the placing of the mid-tones: less exposure places mid-tones toward the dark end; more exposure places them toward the light end. This in turn places all the other tones either higher or lower than normal. In this still-life of tulips placed in front of a curtain, deliberate overexposure ensures that there are virtually no tones that are lower than mid-tone, thus creating a high-key effect. An equally valid image would result from a much darker picture, but its mood would then be very different.

● Mamiya 645 ProTL with 75 mm lens. ISO 400 film. Heidelberg Ultra Saphir II scanner.

High-key/low-key images continued

Moody landscape

In reality, this scene was a pale landscape with swirling clouds occasionally pierced by shafts of sunlight. By forcing most of the tones to be darker than mid-tone, while allowing the relatively small, light areas to remain bright, the drama of the light has greatly increased. You can darken the image with the burning-in tool (part of image-manipulation software) or, since this image was taken on black-and-white film, you can burn-in the print in the darkroom. Then, after scanning, you can make any further tonal refinements.

● Olympus OM-2n with 200 mm lens. ISO 25 film. Heidelberg Ultra Saphir II scanner.

Dark and low

The mood of low-key images is in sharp contrast with that of high-key: with darkness comes a more somber and metaphorically darker mood, perhaps with more drama implied.

Technically, low-key images are easier to create than high-key ones, as less light, exposure, and somewhat less control are required. However, you must be aware that when it comes to outputting the images, ink-jet prints with large areas of dark tone easily become overloaded with ink.

In a similar approach to high-key imaging, the most flexible technique for determining the exposure for low-key pictures is to concentrate your exposure reading on the light values that still retain subject detail. If you point your spot or selective-area metering at such a region of your subject, that tone will be rendered as a mid-tone gray. This means that everything darker than the light area (most of the image) will be darker than mid-tone gray. Shadows with detail will, therefore, become featureless black.

Note that underexposure with digital cameras can introduce unwanted visual noise, so it may be best to create a low-key effect from a normally exposed image via image-manipulation software.

Dramatic portrait

For a low-key portrait, all that is often required is low angle sidelighting, as here, and enough underexposure to shift mid-tones into shadow areas. The absence of real highlights has the effect of darkening mood and concealing all kinds of defects. The very dark tone also makes it easy to burn-in any distracting highlights.

● Olympus OM-2n with 85 mm lens. ISO 400 film. Heidelberg Ultra Saphir II scanner.

Advanced metering

Determining correct exposure with precision is a challenge to any automated system. For experienced photographers, there is no substitute for taking more or less full control of the process. Unfortunately, this requires not only skill, but it takes time and careful attention to detail. However, not all work is hurried, and even with digital photography, precisely correct exposure always saves time and work later.

Incident-light metering

For much studio photography, taking an incident-light reading is a favored technique for determining exposure. The light-sensitive cell of a hand-held meter is covered with a translucent white hemisphere that collects light from a very large area. The meter is held at the subject position with the hemisphere pointing toward the camera. Thus, the meter integrates all light falling on the subject to arrive at a cumulative average.

The meter cannot distinguish between one side of the subject being in shadow while another is in bright light; it simply adds the two together. It also takes no account of the nature of the subject itself, which could be dark and absorbent or bright and reflective. The meter reading would be exactly the same.

The advantage that this method has over a reflected light reading is simplicity; and it always provides a good basis for bracketing exposures (*see below*). However, you do need to move from the shooting position to the subject position, which may sometimes be difficult. In addition, small differences in the meter position can make a big difference to the reading, facing you with the problem of deciding which is the "correct" reading. Incident-light metering is, therefore, most useful where bright light is falling on the subject from the side or from behind the camera position; it is tricky to use in backlit situations.

Deciding which method to use

Bright, contrasty lighting from behind the camera or from the side, as in this scene, is ideally measured using an incident-light meter. The key tones in the image are the fish and chair, and if you get those correct then the rest of the scene falls into place. It would have been easy to underexpose this scene, as a normal reflected-light reading could be misled by the light-toned foreground and middle ground, and so set a smaller aperture or shorter shutter time.

● Canon EOS-1n with 20 mm lens. ISO 100 film. Nikon LS-2000 scanner.

Bracketing exposures

Since correct exposure is central to good image and reproduction quality, many techniques have evolved to ensure that pictures are properly exposed. The simplest is to take several bracketed exposures, using slightly different settings each time, so that they run from having more exposure than the metered "correct" setting through to having less exposure. It is then likely that one of the images will have just the qualities of exposure you want to see.

Some cameras offer an automatic bracketing mode: they take several exposures in quick succession all at different settings. Alternatively, you can take a series of manual exposures yourself, each time setting a different value on the override – for example, + 0.5, +1, -0.5, -1 (in addition to the meter's recommended exposure) – in order to produce a bracketed set. Steps of ½ stop are generally recommended: steps of 1 stop are too large except for color negative film, while steps finer than ½ stop are needed by professionals working with color transparency material.

Advanced metering continued

Spot metering

Many SLR cameras and some handheld meters enable you to take a reading from a very small area of the subject – typically from some 5 percent of the total field of view, down to just 1 percent (with professional-grade cameras). For work on location, spot metering has two major advantages: first, it allows you to be highly selective in choosing the key tone; and, second, even when you cannot approach your subject, it allows you to take a reading as if you were close up.

The easiest way to use a spot-meter is to decide which patch of color or tone in the subject should be exposed normally, which should be the mid-tone, in other words. Then you simply take a light reading from that area and ignore the rest of the image (as far as exposure is concerned). Some authorities suggest taking several readings – of highlight, shadow, and mid-tones – to determine the mid-point. Indeed, some cameras will automatically make the calculations for you. However, not only is this time-consuming, multiple readings do not deliver results that are any more reliable than those from a single reading.

However, multiple spot metering is useful for determining the luminance range of the scene – its span of brightness values. You can take a reading from a shadow area with detail and from a highlight area with detail and see by how many stops they differ. If this difference is less than 2 stops, you can comfortably record the entire scene. If, though, the subject luminance range is greater than 3 stops, then because of the film's or sensor's recording limitations, you will need to decide to sacrifice some subject details in the shadows or in the highlight values of the scene. The only other option is to adjust the lighting ratios (*see pp. 122–3 and 130–3*) to reduce the luminance range, if lighting is under your control.

Technical readings

One technique for dealing with variable lighting conditions is to present your exposure meter with a standard target, such as a gray card. This target is printed in a neutral gray color with 18 per cent reflectance: in other words, it reflects back 18 per cent of the light falling on it. Instead of measuring the light reflecting from the subject or scene, you take your reading from the card instead.

Not only is this a cumbersome method, there are also variations in readings when the card is illuminated by directional light depending on the angle at which the card is held (even though the card has a matt surface).

However, the gray card is an excellent control where image density or color accuracy is crucial, as it provides a standard patch whose density and color neutrality is a known quantity, and this enables an image to be calibrated to a standard. This degree of accuracy is important for technical imaging, such as copying artwork, clothing, or certain types of products for catalogs.

Preset metering

With fast-moving clouds, Nelson's Column in London, England, was bathed in changing light, while the blue sky behind remained relatively constant. I wanted to catch the sun just bursting through the rim of a cloud – too much sun created excessive flare while too little lost the attractive burst of rays. If the meter had been left on automatic, the instant the sun appeared the exposure settings would compensate for the extra light and so render the sky almost black. In anticipation of this, I set the camera controls according to a manual meter reading of the sky, which included some bright cloud – thus ensuring the sky was a deep blue. The rest simply consisted of waiting for the sun to emerge, resisting the urge to respond when the meter reading shot up to indicate massive overexposure.

● Canon EOS-1n with 20 mm f/2.8 lens. ISO 100 film. Microtek 4000t scanner.

Taking a spot reading

Light from in front of the camera, as in this late afternoon scene, is best measured using the camera's spot-metering option (if available). You can then select the precise area of the scene that you want correctly exposed. In this shot, the reading was taken from the men's shadowy faces and bodies. The crucial goal is to ensure that the brighter areas of the scene are not rendered too light while retaining details in the shadows. Here, shadow detail has been helped by the reflective qualities of the sand.

● Canon EOS-1n with 80–200 mm lens. ISO 100 film. Nikon Coolscan LS-1000 scanner.

Color accuracy

You can use a gray card – one printed with a mid-tone gray – as a standard target for the exposure meter when faced with subjects that are very dark or very light. However, gray cards are also useful when you need objective accuracy – as in this shot of a rare embroidery from Afghanistan. If you include the gray card, as you can see here, it provides a known standard for accurate color reproduction. The colored tabs also included with the object are useful for comparison with any paper print, again to help ensure color accuracy.

● Nikon Coolpix 990.

Averaging metering

This view of silver birches is the ideal subject for meters that average light values throughout a scene. Indeed, it demonstrates how rare it is that this method of metering is applicable, as not many scenes have such a small dynamic range and even tone distribution. This scene is such that every method of metering should produce the same result – one that ensures the blues are rendered to mid-tone while the narrow tree trunks retain both highlights and shadows.

● Canon EOS-1n with 20 mm lens. ISO 100 film. Nikon Coolscan LS-1000 scanner.

Accessory flash

Digital cameras, almost without exception, are equipped with built-in electronic flash. What makes modern flash so universal is that it is both highly miniaturized and "intelligent." Most units, for example, deliver extremely accurate computer-controlled dosages of light to suit the amount of available, or ambient, light in the scene.

Making flash work for you

Whatever you might gain in terms of convenience by having a ready source of extra light built into the camera, you lose in terms of lighting subtlety. To make flash work for you, you need to exploit what limited control facilities your camera offers.

First, use the "slow-synch" mode if your camera offers it. This allows the ambient exposure to be relatively long, so that areas beyond the range of the flash can be recorded as well as possible, while the flash illuminates the foreground (*see below*). This not only softens the effect of the flash, it can also give mixed color temperatures – the cool color of the flash and the often warmer color of the ambient light – which can be eyecatching.

Second, try using a reflector on the shadow side of the subject. If angled correctly, it will pick up some light from the flash and bounce it into the shadows. Any light-colored material can be used as a reflector – a white sheet of paper or card, a white sheet, or a shirt. Professional photographers like to use a round, flexible reflector that can be twisted to a third of its full size. It is very compact, lightweight, and efficient, and it usually has two different surfaces – a gold side for warm-colored light and a matt side for softly diffused effects.

Third, an advanced option is to use slave flash. These are separate flash units equipped with sensors that trigger the flash when the master flash (built into or cabled directly to the camera) is detected. If you have a flash unit, then adding a slave unit is not expensive. However, you need to experiment with your camera to check if the synchronization of the multiple flash units is correct.

Flash limitations
Dusk in Istanbul, Turkey, and traditional musicians gather. The standard flash exposure used for this image lights only the foreground subjects and the rapid light fall-off, characteristic of small light sources, fails to reach even a short distance behind the first musician. Adding to the problems, camera exposure is not long enough for the low ambient, or available, light levels prevailing at the time. As a consequence, the background has been rendered black. This type of result is seldom attractive, nor does it display any sound photographic technique.

● Canon EOS-1n with 28–70 mm lens. ISO 100 film. Microtek 4000t scanner.

Effective technique
When illumination is low, make the most of what light is available rather than relying on electronic flash. Here, exposure was set for the sky: this required a shutter of ¼ sec, giving rise to the blurred parts of the image. At the same time, the flash was brief enough to "freeze" the soldier in the foreground, so he appears sharp. Utilizing all ambient light ensures that the distant part of the scene is not wholly underexposed – some color can even be seen in the background building. Compare this with the image in which flash provided all the illumination (*above left*).

Using any setup with more than one flash means trying out different levels of flash output to discover the best results. Start by setting the slave to its lowest power output, bearing in mind that the task of this unit is to relieve subject shadows, not act as the main light. Some models of camera are designed for multiple-flash photography.

Flash synchronization

Because the pulse of light from electronic flash is extremely brief, even when compared with the shortest shutter time, it is crucial that the shutter is fully open when the flash fires. Only then will the entire film area be exposed to the flash light reflected back from the subject. There is usually a limit to the shortest shutter time that synchronizes with the flash, often known as "x-synch". For most SLRs, this is between 1/60 and 1/250 sec. In some of the latest cameras, x-synch corresponds to the shortest available shutter time, which may be 1/8000 sec. To obtain this, however, you must use flash units dedicated to that particular camera model.

Flash exposure

All flash exposures consist of two separate processes occurring simultaneously. While the shutter is open, or the light sensor is receptive, light from the overall scene – the ambient light – produces one exposure. This ambient exposure takes on the color of the prevailing light, it exposes the background if sufficient, and it is longer than that of the flash itself.

The second exposure is in addition to the ambient one. The burst of light from a flash is extremely brief, possibly less than 1/10,000 sec (though studio flash may be as long as 1/200 sec) and its color is determined by the characteristics of the flash tube (which can be filtered for special effects).

The fact that there are two exposures means that it is necessary to balance them in order to produce good results. But it also allows you to make creative use of the process by, for example, allowing the flash exposure to freeze subject movement, while the longer ambient exposure produces blurred results.

Without flash
Bright, contrasty sunshine streaming in through large windows behind the subjects – a troupe of young singers dressed in traditional costume from Kyrgyzstan – produced a strongly backlit effect. Without the use of flash, the shadows would appear very dark, but in this case a wall behind the camera position reflected back some light from the windows to relieve the contrast a little, and so retain some subject details.

● Canon EOS-1n with 28–70 mm lens. ISO 100 film. Microtek 4000t scanner.

With flash
In this interpretation of the previous scene (*above left*), flash has been used. This produced enough light to fill most of the shadows. Now we can clearly see the girls' costumes, but note the shadows that still remain on the carpet. It is important to set the camera to expose the background correctly: since in this example it was very bright, a shutter time of 1/250 sec was needed. The f/number dictated by the exposure meter was set on the lens, and the flash was set to underexpose by 1 1/3 stops. This ensured that the foreground was exposed by both the flash and by the available window light.

Quick fix Electronic flash

Modern electronic flash units are versatile and convenient light sources, ideal for use when light levels are low (and the subject is relatively nearby), or when image contrast is high and you want to add a little fill-in illumination to the shadow areas. However, due to the intensity of their output as well as their limited range and covering power, obtaining naturalistic lighting effects and correct exposure can be problematic.

Problem

Common types of problem that are encountered when using electronic flash include overexposed results – particularly of the foreground parts of the image – and underexposed results – particularly of the image background. In addition, general underexposure of long-distance subject matter is very common, as is uneven lighting, in which the corners or foreground are less bright than the center of the image.

Analysis

Modern electronic flash units have their own light-sensitive sensor to automatically measure the light output from the flash or the amount of light reflecting back from the subject and reaching the film or camera sensor. As a result, they are as prone to error as any camera exposure meter. Furthermore, the light produced by a flash unit falls off very rapidly with distance (see *above right and p. 130*).

Overexposed flash-illuminated pictures are usually caused by positioning the flash too close to the subject or when the subject is the only element in an otherwise largely empty space.

Flash underexposure is caused by the unit having insufficient power to cover adequately the flash-to-subject distance. For example, no small flash unit can light an object that is more than about 33 ft (10 m) away, and even quite powerful flash units cannot adequately light an object that is more than about 100 ft (30 m) distant.

Uneven lighting is caused when the flash is unable to cover the angle of view of the lens – a problem most often experienced with wide-angles. And another problem occurs when an attached lens or lens accessory blocks the light from a camera-mounted flash.

Light fall-off

Light from a flash unit mounted on the camera falls off, or loses its effectiveness, very rapidly as distance increases. This is evident in this close-up image of a bride holding a bouquet of flowers. The subject's hands and the roses nearest the flash are brightly illuminated but even just a little bit back, the image is visibly darker. This is evident if you look at the back edge of the wedding dress, for example. The effect of this light fall-off can be greatly minimized by using a light source that covers a larger area – hence the very different lighting effect you get when using bounced flash (*opposite*).

● Nikon Coolpix 990.

Solution

For close-up work, reduce the power of the flash if possible. When photographing distant subjects in the dark – landscapes, for example, or at concerts, using flash is usually a waste of time and is best turned off. A better option is to use a long exposure and support the camera on a tripod or rest it on something stable, such as a wall or fence. With accessory flash units – not built-in types – you can place a diffuser over the flash window to help spread the light and so prevent darkened corners when using a wide-angle lens.

Bounced flash

Direct flash used at this close distance would produce a harshly lit subject and a shadowy background. In this shot, the flash was aimed at the wall opposite the child. In effect, the light source then becomes the wall, which reflects back a wide spread of light. Not only does this soften the quality of the light, it also reduces the rapid light fall-off characteristic of a small-sized source of light. But bounced flash is possible only if you use an auxiliary flash unit. Note, however, that the background is rather darker than ideal – to overcome this, there must be sufficient ambient light to mix with the flash illumination to provide correct exposure overall (*above right*).

● Olympus OM-1 with 50 mm f/1.4 lens. ISO 64 film. Microtek 4000t scanner.

Mixed lighting

The result of balancing flash with an exposure sufficient to register the ambient light indoors delivers results like this. The lighting is soft but the color balance is warmed by the ambient light. As well, the background is bright enough for it to appear quite natural. If a greater exposure had been given to the background, there would have been an increased risk of subject movement spoiling the image.

● Olympus OM-1 with 50 mm lens. ISO 100 film. Microtek 4000t scanner.

How to avoid the problem

The best way to obtain reliable results with flash is to experiment in different picture-taking situations. With a digital camera you can make exposures at different settings in a variety of situations to learn the effects of flash without wasting any film. Some flash units feature a modelling light, which flashes briefly to show you the effect of the light – this is a useful preview, but it can consume a good deal of power and is likely to disturb your subject.

Uneven light

On-camera flash typically delivers these unsatisfactory results. The lighting is uneven, the shapes the flash has illuminated look flat, and there are hard, harsh reflections on all shiny surfaces. In addition, the flash has created unpleasant shadows (note the shadow of the lip-brush on the background wood-work). Always be aware of any flat surfaces positioned behind your subject when using flash from the camera position.

● Pentax MX-5 with 35–70 mm lens. ISO 100 film. Nikon Coolscan LS-1000 scanner.

Studio flash

Plug-in flash units for the studio offer an unbeatable combination of high power, flexibility, and convenience. Modern flash units are extremely controllable, with small adjustments in light output being easily achieved. In addition, lighting effects are repeatable and color temperature is constant (*see p. 262*). However, the cost of these flash units is high, as are all the accessories you need to shape and modify the quality of the light output. Worse, many photographers are discouraged from using studio flash units because they perceive them as being difficult to use. In fact, the basics are easily mastered, as long as a few techniques are applied.

Digital advantages

Digital photographers have a great advantage over their film-based counterparts in being able to assess the result of a flash exposure immediately after it is made – either by observing the image on the camera's LCD screen or on a computer monitor. It can be a difficult task, however, to assess image quality on the type of small LCD screen found on the back of a typical digital camera. Therefore, if possible, it is always preferable to download the image onto a computer for assessment via a full-sized monitor. With many digital cameras, you can view images on the computer screen at the same time that you take them.

Types of equipment

For a range of photographic tasks – from still life to portraiture – a single flash unit will suffice, if it is combined with a large diffuser or soft box. Therefore, a starter kit comprising a single unit is a practical proposition. A second lighting unit is useful for adding highlights – a halo of light from behind, for example, or controlling background lighting or increasing overall light levels. You need to ensure, however, that the shutter of your digital camera will synchronize with the firing of the flash units – beware, not all models do. In addition, you will need a cable to connect the camera and flash, perhaps via an adaptor.

If you are using more than one flash they can be – and usually are – synchronized via "slave" sensors – units that detect the flash output from the cabled flash unit and trigger their own lights in response. You also need a camera model with an adjustable lens aperture, as this is your principal means of control over the quantity of flash exposure reaching the camera sensors.

Broad lighting

Young children can be demanding subjects if you have too fixed an end result in mind. Often, they are curious about all the equipment in a studio, they are very mobile, their concentration span is short, and they are difficult to direct. One approach is to position them against a plain background and set a broad lighting scheme – perhaps two soft-boxes, one on either side of the set. The wide spread of soft light allows your subjects to move about without you worrying around where shadows will fall.

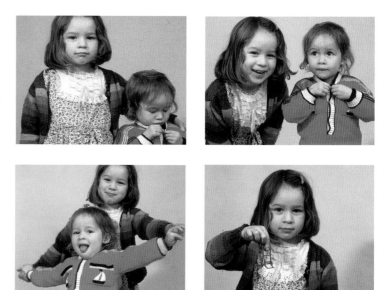

Building a lighting scheme

The following sequence of photographs (see *below and pp. 136–9*) illustrate the dramatic differences you can achieve by working with an extremely simple lighting arrangement and minimal equipment. A studio such as that used for these pictures could easily be set up in any spare room in your home, or you could assemble the equipment and dismantle it in a matter of minutes if you don't have the space for a full-time studio.

For all of the pictures, a single electronic flash head was used, fitted either with a bowl-shaped reflector or with a 3 ft (1 m) square soft box (a tent-like enclosure made of two layers of white nylon to diffuse and spread the light from the flash and so soften its quality).

In some shots a reflector, made of material coated with a metallic finish, was used to bounce light from the flash into subject shadows. And a cream-colored background was used throughout to help make comparisons easier.

Carefully analyze the images below and those following by looking not only at where the shadows fall but also by examining the quality of light making up the highlights. Note, too, the varying depth of color and changes in apparent contrast.

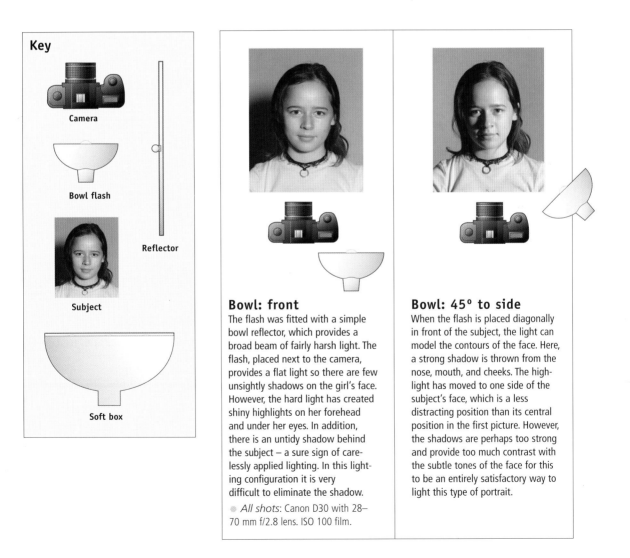

Key

Camera

Bowl flash

Reflector

Subject

Soft box

Bowl: front

The flash was fitted with a simple bowl reflector, which provides a broad beam of fairly harsh light. The flash, placed next to the camera, provides a flat light so there are few unsightly shadows on the girl's face. However, the hard light has created shiny highlights on her forehead and under her eyes. In addition, there is an untidy shadow behind the subject – a sure sign of carelessly applied lighting. In this lighting configuration it is very difficult to eliminate the shadow.

● *All shots*: Canon D30 with 28–70 mm f/2.8 lens. ISO 100 film.

Bowl: 45° to side

When the flash is placed diagonally in front of the subject, the light can model the contours of the face. Here, a strong shadow is thrown from the nose, mouth, and cheeks. The highlight has moved to one side of the subject's face, which is a less distracting position than its central position in the first picture. However, the shadows are perhaps too strong and provide too much contrast with the subtle tones of the face for this to be an entirely satisfactory way to light this type of portrait.

Studio flash continued

Inverse square law

If you double the distance between a light source and the surface that light falls on, brightness at the surface is not just halved. For a small, or "point," light source, without a reflector or lens for focusing output, doubling the distance reduces intensity by four times (by a factor of two squared). This is the inverse square law. Although commonly applied to studio and accessory flash lighting, the inverse square law gives inaccurate results since nearly all luminaires (sources of light) use reflectors or lenses, so light distribution is not even and equal in all directions.

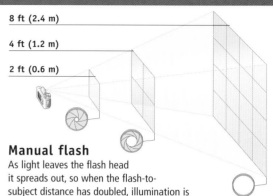

8 ft (2.4 m)

4 ft (1.2 m)

2 ft (0.6 m)

Manual flash
As light leaves the flash head it spreads out, so when the flash-to-subject distance has doubled, illumination is about a quarter of the original. Therefore, you control flash exposure through both distance and lens aperture.

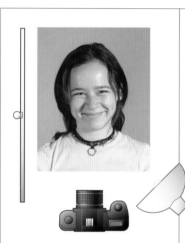

Bowl: 45° to side plus reflector
The addition of a reflector on the side of the subject's face, opposite the lamp, fills in the shadows, though not fully. Notice how the shadow under the chin is still visible, though it is not so dense that you cannot see full skin tone, and the clothes retain their shape. As a result, there is a good balance between shadows, which help define the form of the face, and mid-tones. However, look closely at the forehead and you will see two reflections – one caused by the reflector being placed too far forward of the face; the other caused by the lamp itself.

Bowl: 90° to side
With the lamp placed directly to one side of the subject, the shadows on the opposite side of her face become so deep that practically no detail is visible. As a result, the effect is dramatic and visually arresting. And notice how the texture of her clothes is beautifully rendered, with every thread visible. However, in conjunction with the lack of detail in the shadows, note that the highlights are also lacking in detail. This is due to the fact that the light-reading sensor in the camera is unable to retain information with the high dynamic range produced by the lighting.

Bowl: 90° to side plus reflector
A reflector should always be used with care. Here, it was introduced to bounce light back into the deep shadows thrown by the flash positioned directly to one side. However, the fill-in has only partially done its job, leaving a dark strip down the middle of the face due to the fact that it was placed directly opposite the lamp: a position further in front of the face would have improved the lighting effect. Other approaches include using a reflector that diffuses the light more strongly as well as varying the distance between the reflector and the subject.

Harsh shadows

Using a single camera-mounted flash is by far the most convenient lighting arrangement. However, effects are often harsh and unattractive. Here, a flash on the left of the camera has provided adequate illumination but it has also cast hard shadows behind the subject and from the pen she is holding. At the same time, the modeling effect on the face is flat, while the background appears too dark due to the rapid fall-off of light. To avoid these problems, you will either have to bounce the flash off an intervening surface or, better, use more than one lighting unit.

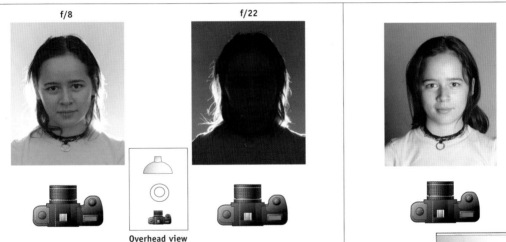

f/8 f/22

Overhead view

Soft box: front

Bowl: behind

This pair of images illustrates how a simple change in exposure setting can produce radically different lighting effects. In the darker image (*above right*), the flash was placed directly behind the subject: this creates an attractive halo of bright hair framing the head, but the sitter's face is all but obscured by heavy shadow. The lens aperture used for this image, like that of all the others in this set, was f/22. In the next image (*above left*), the lighting remained exactly the same, but the lens was opened up to f/8, which is a full 3 f-stops brighter than f/22. Note now that the face is correctly exposed. Increasing the level of exposure reveals the face because the wider aperture exploits indirect light from the flash – that which has been reflected from the studio's light-colored walls. You can refine this result further by using a black background, which would accentuate up the halo of light around the model's hair to a much greater degree.

Soft box: front

Compare this image with the first in the sequence (*p. 135*). The greater diffusion of light from a flash inside a soft box placed as near the camera as possible has produced an altogether more attractive lighting scheme. The shadow behind is diffused almost to the point of being a positive asset, and facial features are softer yet still clearly delineated. Note, too, that the catch-lights in the eyes are much larger than with the first bowl/reflector setup.

Studio flash continued

HINTS AND TIPS

If you are new to working with studio flash and accessories (*see pp. 46–9*), you might find it useful to bear the following points in mind:

● As a general rule, always use as few units as possible to achieve the desired lighting effects. Start with one light only and use reflectors to control the quality of the illumination reaching your subject. Only if this is insufficient should you consider adding extra lighting units to the scheme.

● Remember that it is easier to remove light than to add light. Using accessories, such as barn doors or snoots, you can easily control the fall of light and any shadows that are created as a result. However, an additional light immediately casts a set of new shadows.

● A reflector placed facing the main light, angled so that it bounces light into subject shadows, is usually a more effective solution than using another light source to reduce shadows.

● A large light source, such as an umbrella reflector or soft-box, produces softer light and more diffused shadows than a small light source.

● A small light source, such as a spotlight with a small bowl, produces harder light and sharper shadows than a large, diffuse light source.

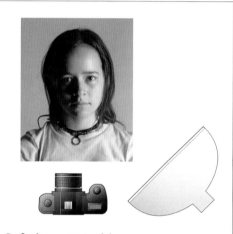

Soft box: 45° side

It is immediately clear that lighting from diagonally in front from a large, diffused source is a most versatile scheme. This arrangement is easy to control, with just small changes in the angle of the light producing a subtly differing feel to the quality of the illumination. The form of the face is clearly shown, shadows are not harsh, there is an attractively large catch-light, and the textures in the girl's top are well defined. There is also little problem with shadows falling behind the subject as the diagonal placement of the light throws them out of view of the lens. As a result, you can place the subject close to the background if required.

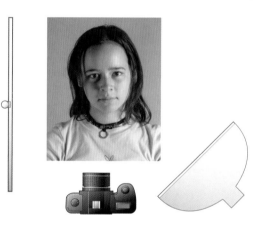

Soft box: 45° side plus reflector

Here, the reflector bounces light from the large source into the shadow region to create almost too soft a result. The lighting lacks drama and contrast and is somewhat similar to lighting directly from in front. The shadows from the lock of hair on the subject's right give away the fact that light is reaching the face from both sides. Note that the fill light from the reflector has almost completely removed the shadow under the chin – which is close to merging with the neck, thereby losing its shape – and is generally an effect to be avoided.

Mixed light sources

An aim of studio lighting can be to mimic the quality of daylight. In this scene, it was important that the table light appeared to be the main light source. The levels of daylight were inadequate to illuminate the dark-colored interior of the room, so a studio flash was directed at the ceiling behind the table. The reflected light was just enough to bring out important details in the setting without creating tell-tale hot spots in the glass-fronted pictures.

Soft box: 90° side

A large light source placed to the side of a face provides a strongly chiaroscuro effect, in which the distribution of light and dark areas define the image. So, in this scheme form is clearly molded yet details in the shadows are not wholly lost in the dark; nor are highlights "blown out," or featureless. This is a favorite arrangement for dramatic portraiture and mimics the effect of placing a portrait subject next to a window admitting bright yet diffused light. A dark background – instead of the light one used here – would help ensure that the viewer's attention is focused on the lighter side of the subject's face.

Overhead view

Soft box: behind

Placing a soft box directly behind the subject pointing back at the lens gives a camera image that looks unpromising. The light floods into the lens, making it very hard to discern the face. In addition, the veiling glare appears to destroy any image that you can see. In this situation, a lenshood – which stops side-lighting entering the lens – will not help at all. However, as a digital photographer, you should take the image even if it looks unpromising. It could be a revelation – highly unusual lighting schemes could make you look at your subject in new ways. Besides, you can always manipulate the image to reduce the worse effects of the glare.

3

A compendium of ideas

Inspiration

Stuck for an idea on what to photograph? Not really certain how to get started? Don't know how to finish? This chapter provides project concepts, subject areas, approaches, and ideas.

Reference material

Contained with this chapter is a library of material to refer to – to modify, redirect, condense, and use for your own purposes. It demonstrates that any idea is a good idea if you believe in it. The question is – how do you develop it and make the very best of it?

Hints and tips

Advice, suggestions, and strategies as well as numerous hints and tips on the practicalities of photography itself.

Starting projects

A project gives you something to concentrate on, something on which you can focus your ideas or around which you can define a goal. Committing yourself to a specific project can give you a purpose and help you develop your observational and technical skills. In addition, a project provides you with a measure against which you can determine your progress as a photographer.

One of the most common questions asked is how you come up with project ideas – and an often-made mistake is to think that some concept of global interest is needed. In fact, the most mundane subjects can be just as rewarding and – even more important – achievable.

An action plan

• It could be that your skills as a photographer could be put to use by some local community group. So, instead of giving money, you could provide photographs – perhaps with the idea of holding a local exhibition to raise funds.

• If you try to do too much too quickly you are heading for disappointment. For example, you want to digitize all the pictures in your family albums. Fine; but don't try to complete the project in a month.

• You have to be realistic about the money involved in carrying through a project, but pre-occupation with cost can freeze your enthusiasm, kill the sense of fun, and become, in itself, the cause of the waste of money.

• Nurturing a project idea is more about cooperation than coercion. You have to learn to work with the idiosyncrasies and character of the subject you have set your sights on. And doubts and misgivings are very common. If you find yourself inhibited or you are afraid to look silly, or if you think it's all been done before, then you may start to wonder what the point is. If so, then just bear in mind that you are doing this for yourself, for the fun of it. As long as you think it is worthwhile, why care what anyone else thinks?

Illuminating domesticity
This is the type of domestic scene that could easily pass unnoticed at home, unless your concentration is sharpened by having a project in mind. Yet, if you were to see the exact same scene on your travels, the simple fact that you were not in your familiar surroundings may make the light and balance of the complementary colors and the rhythm of the vertical or near-vertical lines immediately striking.

● Canon D30 with 17–35 mm lens.

Shadows
Strong light casting deep, well-defined shadows and the warm colors of the floor make for an abstract image. To ensure that the lit area was properly exposed, I took a spot reading from the bright area of floor, entirely ignoring the shadows.

● Canon D30 with 28–135 mm lens.

Juxtaposition

A monument to three wartime commandos in Scotland amusingly reflects the three benches erected for visitors to sit and enjoy the view. A long wait in a bitingly cold wind was rewarded when a spectacular burst of sunlight broke through a gap in the cloud-laden sky.

● Olympus OM-1n with 21 mm lens. ISO 25 film. Heidelberg Saphir Ultra II scanner.

Interior arrangements

The paraphernalia of a restaurant under construction produced a complex of lines and tones that caught my eye. The picture benefited from having the left-hand side slightly darkened to balance the darkness toward the top right of the image.

● Nikon Coolpix 990.

●TRY THIS

Make a list of objects you are familiar with. These can be as simple and ordinary as you like – dinner plates, for example, bus stops, drying clothes, or chairs. Do not prejudge the subject. If the idea comes to you, there is probably a good reason for it. Choose one subject and take some pictures on the theme: again, do not prejudge the results, just let the subject lead you. Be ready to be surprised. Don't think about what others will think of what you are doing. Don't worry about taking "great" pictures. Just respond to the subject – if it is not an obviously visual idea, then you might have to work a little harder to make it work as an image. Don't abandon the subject just because it initially seems unpromising.

Abstract imagery

Photography has the power to isolate a fragment of a scene and turn it into art, or to freeze shapes that momentarily take on a meaning far removed from their original intention. Or chance juxtapositions can be given significance as a result of your perception and the way you decide to frame and photograph the scene.

Close-ups and lighting

The easiest approach to abstracts is the close-up, as it emphasizes the graphic and removes the context. To achieve this, it is usually best to shoot square-on to the subject, as this frees the content from such distractions as receding space or shape changes due to projection distortion.

Longer focal length settings help to concentrate the visual field, but take care not to remove too much. It is advisable to take a variety of shots with differing compositions and from slightly different distances, as images used on screen or in print often have different demands made on them. For example, fine detail and texture are engrossing, but if the image is to be used small on a web page, then a broad sweep may work better. And since you will usually be shooting straight onto flat or two-dimensional subjects, you do not need great depth of field (*see pp. 84–7*). This is useful, as it is often crucial to keep images sharp throughout.

Inspirational posters

Torn billboards and posters offer one of the richest sources of everyday abstract imagery: the combination of random torn edges together with the layering of older posters offers rich visual possibilities. The trick is to avoid confusion and keep the image recognizable without being too obvious. The presence of recognizable elements always helps to locate the image and give it some sort of scale, as in the example here.

● Olympus OM-2n with 50 mm lens. ISO 64 film. Microtek 4000t scanner.

Found abstract

Here (*below*), the decaying roof surface at a busy railroad station must have been glanced at by thousands of commuters every day but seldom seen. Perhaps it is a simple expression of the process of aging, the origins of which can only be guessed.

● Pentax K2 with 50 mm lens. ISO 64 film. Microtek 4000t scanner.

Abstract imagery continued

Rust stains

Natural processes on the small scale often mimic larger-scale phenomena, and this can offer you another source of abstract imagery. The scratches on this steel door had corroded in the wet atmosphere of Hong Kong over the years to give rise to streaks of rust reminiscent of a series of waterfalls.

- Nikon F2 with 50 mm lens. ISO 64 film. Nikon 4000 scanner.

Peeling paintwork

While sheltering from wintry winds in the bleak railroad station that serves my university, I have often stared idly at the peeling paint. One day, however, an extra flake had fallen off and, suddenly, the wood grain that was revealed had taken on the appearance of a Polynesian-type sculpture, with just the suggestion of a face.

- Nikon Coolpix 990.

Copyright concerns

You may think that because a poster or other subject is in public view you can photograph it with impunity. The chances are, however, that you will be infringing someone's copyright. However, if you are taking the photograph for research or study, then perhaps not. To illustrate a school essay on advertising – you are probably in the clear. But if you use a recognizable and sizable portion of an image in public view as a significant part of another image that you go on to exhibit, publish, or sell, then in many countries you would be in breach of copyright. If you really want the image, then at least be aware of the potential legal situation. Note that sculptures, buildings, logos such as McDonald's arches, cars such as the Rolls Royce, the French TGV train, certain toys and, say, Disney characters – even the Lone Cypress tree in Pebble Beach, California – all enjoy a measure of copyright protection. You may never be pursued in court . . . but you could be (*see pp. 374–5*).

Buildings

The city environment provides endless photographic opportunities – the problem is not in finding subject matter, but in reducing it to a manageable scale.

Technical considerations

Although it is natural to reach for a wide-angle lens to photograph buildings, a wide-angle view is not always best. A carefully chosen narrower field of view can reveal more of a building and its surroundings. Working digitally, you can always stitch several shots to create a panorama (*see pp. 198–201*). Bear in mind, however, that this technique works best when the camera is tripod mounted, and that in many public buildings you need permission to use a tripod.

Avoid using lens attachments that are intended to increase the wide-angle or telephoto ability of the prime lens – these always worsen a lens's optical ability. Rather than use lens attachments, look for positions and angles that make best use of the focal lengths of your prime lens: if you need a larger image, try moving closer; for a broader view, shoot from farther back.

Privacy in public places

When shooting in a public space, such as the street, railroad station, or market-place, you are not likely to be invading people's privacy if they are included in the frame. However, you need to be sensitive to the fact that if you are photographing in a public place and you include people who happen to be in their private spaces – indoors by a window, say, or in their yard – the situation may be different. And people may be more suspicious of your motives if you are using a long lens. The whole notion of privacy varies from culture to culture; in some, photographing people in any circumstance – whether they are in a private or a public place – must be approached with tact.

High vantage point

A Hindu temple in Singapore, with its colorful depictions of deities, offers many photographic oportunities. By climbing up to a high vantage point, the temple could be photographed without pointing the camera upward. This shooting position also provided a contrasting background of modern office blocks.

● Canon D30 with 28–135 mm lens.

Buildings continued

Golden light
A street scene such as this (*above*) can be found in many cities, but the golden glow from a setting sun would flatter any view. These lighting effects are transient and you need to be at the right place at the right time. The best advice is always to carry a camera and be ready to take advantage of the unexpected.

● Canon F-1n with 200 mm lens. ISO 64 film. Microtek 4000t scanner.

Perspective is crucial
Tiny differences in perspective can make a huge difference to images of buildings. In this view of a mirror-clad building (*right*) in Leeds, England, every slight shift in the camera position produced a different set of reflections, and with each change a different impression of the building was presented.

● Nikon Coolpix 990.

Ideal conditions

Good weather and bright light are the best friends of architectural photography. Architects enjoy working with light and shadow, and modern buildings, in particular, come alive in good light. There will be moments at specific times of the year when light and shadow just seem to fall in all the most perfect places (*left*).

● Canon D30 with 28–135 mm lens.

Photographing clouds

Flying affords you an entirely novel perspective on the earth below. So, instead of watching the usual selection of in-flight movies, why not spend some of your time photographing the constantly changing pattern of clouds?

The ideal seat is by a window with a clear view unobstructed by the aircraft's wing. The best position is ahead of the engines; a view more from the rear is likely to suffer from the turbulence of gases ejected by the engines. On high-altitude flights it is not uncommon for windows to frost over for part of the time, so you will just have to wait for them to clear. You will need only a modest wide-angle or standard focal length to capture cloud effects: too wide a focal length and you will catch the sides of the windows; too long a focal length and the degradation in image quality due to the thickness of the window becomes apparent.

Wide-angle imagery

One disadvantage of working from an aircraft is the difficulty in using ultrawide-angle lenses to capture views, such as this (*below*), which was seen from ground level. A setting sun tries to break through a high layer of cloud while, lower down in the sky, heaped clouds sweeping around in lines are indicative of short-lived fine weather. The use of an inferior-quality wide-angle lens is apparent by the the appearance of slightly darkened corners, which are the result of light fall-off.

● Olympus OM-2n with 21 mm lens. ISO 64 film. Microtek 4000t scanner.

Health warning

Avoid looking directly at the sun – even at sunset when the sun is low – while waiting for it to burst through cloud cover. This is particularly the case if you are shooting in equatorial regions, where sunlight is often very strong. Even a fraction of a second's unprotected direct exposure can damage your eyes – especially if you are using a traditional single-lens reflex viewfinder. For sun-watching, a digital camera is ideal, as you can safely observe the fiery glow on its LCD screen. However, too long an exposure to the full effects of the sun can cause irreparable damage to a camera's photosensor.

Global view

Dawn is one of the best times to look for cloud images, whether you are on the ground or in the air. Here, high above the Earth, somewhere over the Pacific, a rain cloud (lower half of the picture) is building up, while the sun, just over the horizon, casts long shadows and mixes its pink tints with the blue to create shades of purple and mauve.

● Kodak DCS 520 with 28–80 mm lens.

Awkward angle

For this shot, I found an unoccupied seat at the very rear of the aircraft – from here, however, the hot gases and turbulence streaming out from the rear of the engines distorted part of the view. To avoid this, I tilted the camera to one side, causing the view to be at a somewhat awkward angle. Fortunately, aerial views, with no points of visual reference, are tolerant of this.

● Canon F-1n with 50 mm lens. ISO 100 film. Microtek 4000t scanner.

Documentary photography

The documentary uses of photography range from the most prosaic and practical – progress reports on building projects, for example – to the most altruistic and idealistic – such as recording the plight of endangered species or the effects of environmental pollution.

Useful digital features

Using even the most basic digital camera, you can take a picture of, say, an accident for insurance purposes or an item for auction and confirm instantly that it accurately records the features required for its purpose. Another advantage is that many digital cameras are nearly silent and inconspicuous in operation. This means that if you are an accepted part of an event, photography can proceed without anybody really noticing. This is further helped if your model has a swiveling lens or LCD screen, since you don't have to hold the camera up to your eye in order to shoot. If you use this technique, however, you will be holding the camera lower than usual, so you should therefore try to photograph from a higher viewpoint to compensate.

For formal documentary work, it is important that the digital image is not altered. Although a digital image is far easier than an analogue one to change, it is also easier to build into an image a feature that will prove this has happened. There are systems that conceal a code in the image that changes if the image is altered in even the minutest or most innocent of ways, such as a change in brightness or resolution. In addition, each image can be tagged with information about the date and time it was taken, increasing its value as a piece of documentary evidence. Various systems are available, and when a validation system is in operation you should expect the reading and writing of files to take longer than usual.

Potential digital drawbacks

Two major disadvantages experienced by digital photographers working in the field of social documentary are that many models have a slow response time when first turned on (*see p. 78*),

Photograph © John Curnow

and that those with LCD screens especially consume battery power at a very rapid rate.

In general, social documentary photography is characterized by long waits punctuated by short and sudden bursts of activity. Because of this, use the viewfinder – not the LCD screen – whenever possible in order to conserve battery power. This may give you enough power to keep the camera turned on and ready to respond instantly. You may also need to account for shutter lag with

Technical notes

John Curno took all the photographs shown on these pages using a Nikon Coolpix 950 digital camera with center-weighted metering. This metering system produces better results for black-and-white than fully automatic matrix or evaluative metering (*pp. 120–1 and 127–9*). Curno chose not to use his usual large- and medium-format, film-based cameras, opting instead for a digital camera to produce small, uncropped prints from a desktop ink-jet printer.

digital cameras. This is the delay between pressing the shutter and the picture actually being recorded. By anticipating the action, rather than responding to it, you can at least minimize this annoying drawback.

One man's vision

The affectionate and intimate images shown here and on the following two pages are part of John Curno's documentary work on the rural parish of Drewsteignton, Devon, in the southwest of England, where he lives. Curno is a much exhibited photographer, and his goal is to show through his images how the villagers are coping with the changes associated with the arrival of newcomers to the village. An aspect of this evolutionary change in the parish that particularly interests him is how modern technology allows the newcomers to choose a rural lifestyle, commuting only when necessary.

Documentary photography continued

Technical notes

Habitually using a wide-angle attachment on his digital camera means that Curno has to move in close to his subjects to achieve many of the portraits seen here. At times, he also uses a yellow-green filter over the camera lens. This type of filter is commonly used with black-and-white film cameras to help tonal rendition, and old habits die hard.

Photographs © John Curnow

Model-release form

This form is a legally binding agreement between subject and photographer allowing the photographer to use the picture without any further financial obligation or reference to the person depicted.

For the personal use of a photograph, it is generally not necessary to obtain the model's release; however, if an image is intended for commercial use it is advisable to obtain signed consent. A simple form of words is: "I permit the photos taken of me (subject's name) by (photographer's name) to be printed and published in any manner anywhere and at any time without limit." The consent form should also note the date the pictures were taken, the location, and include the signature and contact details for both the subject (or parent/guardian) and the photographer. Both parties should sign two copies – one is kept by the photographer, the other by the subject. In some countries, a consideration (the payment of a sum of money or the giving of a print) is required to make the contract binding.

Ecotourism

Every publicly funded animal reserve, national park, or nature preserve welcomes the type of activity that results in positive publicity of its aims. Thus, as a digital photographer, the technology at your command can turn you from a passive observer into an active contributor.

Aims and objectives

The likelihood is that you will have only limited time when you visit – a day probably, maybe two – so it is up to you to make the most of the opportunity. First, determine what the main attractions of the place are, and how you can best record them. Next, a little research beforehand will inform you of any recent developments that have taken place so you can decide whether or not they should be on your list of things to see. And don't neglect the people who work or live there – they may be rewarding subjects for your camera.

Digital photography wins over its traditional counterpart due to its versatility. You can use digital images as part of emails to illustrate a publicity campaign; as part of brochures within minutes of them being taken; and, of course, you can place them on a Web site publicizing the park or that of its work. In addition, many digital cameras allow you to include a sound-bite from the person you have photographed.

National parks in extremely remote or difficult locations may make a manual 35 mm camera a better choice than a digital type, as they tend to be more robust and less dependent on batteries.

Constant grooming

The Himba take great care with their appearance. Lost in conversation with other women of her tribe, this woman idly rearranges her intricate hairstyle unaware of the camera's presence. Taken from relatively close-up, the very long focal length threw a great deal of the background out of focus.

● Canon F1-n with 300 mm lens. ISO 100 film. Nikon LS-1000 scanner.

An outside eye

Mundane activity can appear exotic to outside eyes. For these women (*above*), a long walk is required just to get water. The day I took this shot there had been a lion attack on a cow near the village. In light of this, they decided it would be too dangerous to wait and make the trip at their preferred time of dusk.

● Canon F1-n with 300 mm lens. ISO 100 film. Nikon LS-1000 scanner.

Careful framing

The cool of dawn is the best time to milk the cows. An early start gave me a chance to combine portraiture with a record of an aspect of daily life. A wide-angle lens brought the subject elements together but I took care not to place the woman's face too close to the edge of the frame in order to avoid any distortion.

● Canon F1-n with 200 mm lens. ISO 100 film. Nikon LS-1000 scanner.

Ecotourism continued

Himba joke
At the water hole the girls of the village take a moment to relax and joke with each other. Framing the shot tightly cut out the glaring white light of the desert landscape.

● Canon F-1n with 300 mm lens. ISO 100 film. Nikon LS-1000 scanner.

Distant sunset
Long shadows from the distant hills darken the foreground while the sun turns the background a flaming orange.

● Canon F-1n with 300 mm lens plus x2 extender. ISO 100 film. Nikon LS-1000 scanner.

A professional approach

Even if the pictures you take are simply for your own enjoyment, a professional approach helps to ensure that you do not neglect to record some vital aspect of your visit or run out of film or memory cards.

● Bear in mind the basic storytelling elements of a picture story: the roads leading to and from the park help give your other images a context.

● Vary perspective and viewpoints as much as possible. Take close-ups as well as long views; wide-angle and telephoto shots.

● A choice of landscape- or portrait-format images gives you design flexibility if you ever want to produce publicity material.

● Take plenty of photographs whatever the conditions: you may be able improve the images (on the computer) even if the lighting or weather was less than perfect.

● If your digital camera can take short video sequences or voice recordings, don't neglect to use the facility.

● Take ample spare batteries and memory cards for a digital camera.

Close-up photography

Close-up photography used to require specialized equipment, but digital cameras have changed this. Not only is it common to be able to focus with the lens nearly touching the subject, the use of LCD screens giving a "through-the-lens" view allows all but the simplest models to focus close-up.

Points to consider

The main technical points to take into account when shooting close-up are:

● Depth of field is limited (*see pp. 84–7*), and it is all but impossible to include all of a subject within sharp focus. The best strategy is to focus critically on the most important part of the subject.

● Subject or camera movement is greatly magnified when working close-up. You will need to steady the camera and the subject to prevent blurred imagery. Flash, which delivers an extremely brief burst of light, can be used to reduce the effect of camera or subject movement.

● A reasonable working distance is needed with subjects such as birds or butterflies to avoid disturbing them. This requires the use of a long focal length – ideally, a 35efl of 180–200 mm.

● Automatic flash may be unable to respond quickly enough to light reflecting back from the subject, resulting in overexposure. To combat this, reduce flash exposure via the flash controls, set the flash to manual (*see right*), or cover the flash head with translucent material.

Close-up photography needs more care than when working at normal subject distances. To achieve the best results, you need a digital camera that allows apertures to be manually set and that has close-up focusing at the long end of the focal length range. Generally speaking, the cameras that feature these close-up-friendly facilities are the good-quality digital-SLR types.

Manual flash exposure

Using flash set to manual delivers the most accurate and reliable results when dealing with close-up subjects. You need to take four variables into account: the power of your flash; the working distance; the speed of your film (or sensitivity of your photosensor); and the effective lens aperture at the working distance. First, set your flash unit manually to low power – say, to ⅛ of maximum. Next, focus on an averagely reflective subject at a fixed distance from the camera – say, for example, 10 in (25 cm) away. Now make a series of exposures, changing the lens aperture each time, and carefully note all the settings used. Repeat this procedure at different subject distances and flash-output settings. Review the results on your LCD screen or after the film has been processed. You can then draw up a set of figures for different situations – such as ⅛ power at 10 in (25 cm) at a lens aperture of f/5.6, or ⅛ power at ⅓ in (1 cm) at f/8, and so on.

Safety first

Although this seal looks relaxed, I did not care to take the shot with an ordinary lens. In fact, I used a zoom set to 400 mm, and note how the shallow depth of field limits the zone of sharp focus. I decided that the snout and whiskers were the elements I wanted sharp and so focused specifically on them.

● Canon D30 with 100–400 mm lens.

Close-up photography continued

A sticky end

This spider (*left*) had clearly picked a perfect spot to spin her web: by the end of the day, so many flies were ensnared that the web was defined by the lines of tiny corpses. The shot was taken just as the sun went down, but I had to disable the flash, since any supplementary illumination would have destroyed the simplicity of the image and the atmosphere of the natural lighting.

● Nikon Coolpix 990.

Photomicrography

Extreme close-ups, as in this view of animal tissue (*right*), require a microscope. Modern, lightweight digital cameras are easy to link to laboratory microscopes as long as you have an adaptor tube and mounting system, which are readily available from many camera stores.

● Polaroid DMCS microscope camera.

Natural history

The most common subject for close-ups is plant life, and the features that recommend this image are the droplets of moisture clinging to the foliage. By observing the subject from various positions it was possible to see the reflected sparkles in the droplets change. But take care not to disturb the plants and disperse the water droplets by approaching too close.

● Nikon Coolpix 990.

Vacations

The challenge when photographing a vacation is to avoid the obvious while making a record of the events you may wish to remember in the years to come. Another challenge is to lift your images from the strictly personal – photos that are of interest only to friends and family – to a level where your images have a wider appeal.

Themes and subjects

One project idea that takes you away from the obvious monuments or museums could be something along the lines of street merchants or local cuisine. Depending on your own interests, you might find that pictures of street food brings back the memories of a place far more vividly than, say, the façade of some neoclassical public building. And by working digitally you have the ability to review an image as soon as you have taken it and decide whether or not another shot is needed.

Attitudes and approaches

It is simply good manners to take into account the sensitivities of the people in whose country you are traveling. It is their religion, customs, and attitudes to which you will be exposed, so treat your hosts' country with the same respect you would expect of tourists in your homeland. As a start, dress in a style that is appropriate to the cultural or social expectations of the country you are in. And don't insist on taking pictures of people if they wave you away or seem unhappy about it.

Local culture

Food shots can be colorful and memorable – food is an essential part of any vacation and negotiating a purchase can be part of the fun. But don't record only the food or some artistic arrangement of produce – including the vendors in the shot increases the challenge and can give rise to more interesting and livelier pictures.

 Minolta Dynax 7c with 28–85 mm lens. ISO 100 film. Nikon LS-1000 scanner.

Changing emphasis

Even when the weather is less than perfect, the observant can always find picture opportunities. In this view of downtown Auckland, New Zealand, rain from a storm beats on the windows of an observation tower. It is usual to focus on the distant view, but by concentrating on the raindrops the scene shifts, and suddenly there is a picture to be made.

● Canon D30 with 17–35 mm lens.

Securing your equipment

A potential problem on vacation is the tension that can exist between the vigilance necessary to take care of your equipment and the desire to relax and enjoy yourself. These points may help:

- In a hotel, make full use of any safe or security boxes that may be available. Sometimes these are provided in your room, sometimes at reception.
- Make sure you lock your luggage while you are out of your room.
- Set a battery-powered alarm (that beeps if it is moved) on your bags if you have to sleep during a long wait at a terminus or airport lounge.
- Stay in the best-quality accommodation you can afford – you are generally more at risk from theft in cheaper hotels or apartments.
- Use physical restraints (bolts or chains, if provided) to secure your door when you are in.
- Insure all your camera equipment and accessories before departure for their full replacement amount. Rates vary, so obtain two or three quotations.

Vacations continued

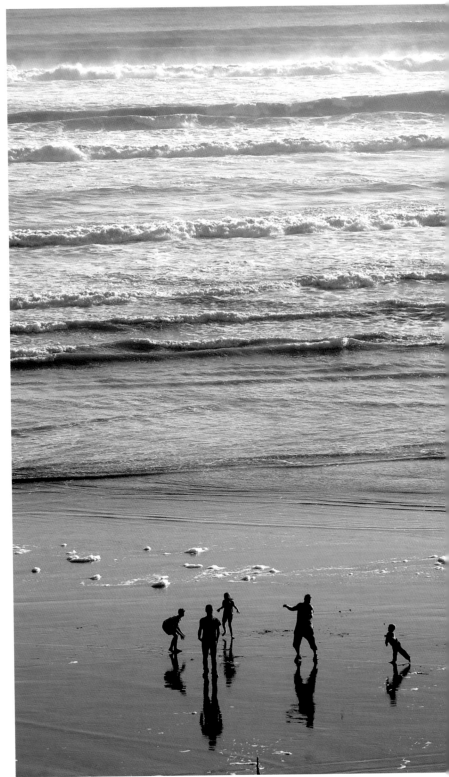

Ever ready

You may find interesting or strange images being created for you if you stay alert. When some villagers in Turkey borrowed my sunglasses, a child on his mother's arms wanted to try them on – and suddenly there was an image to be had (*above*). Tight framing left out the clues that would make the picture easier to read, making the image a little more intriguing.

● Leica R6 with 60 mm lens. ISO 400 film. Heidelberg Saphir Ultra II scanner.

Interpreting the ordinary

As the photographer, you may find yourself slightly apart as your search for pictures takes you away from the group. Here, walking up a hill from this beach in New Zealand rewarded me with a fine view of reflections of figures in the ebbing waters and wet sand.

● Canon D30 with 100– 400 mm lens.

Journeys and travel

What distinguishes a journey from a vacation is that on a journey it is the total trip, from beginning to end, that counts: in other words, the entire traveling experience supplies the challenge, and the fun, rather than just the destination.

Moving platforms

Photography from a car, bus, or train does not offer much opportunity for sharp, well-considered images. Nevertheless, it is worth taking the odd shot showing the countryside passing in a blur in order to record something of the experience of being there. It is better to try for a shot of a marvelous view than spend the rest of the journey wondering if you missed something special. And if it does not work, with a digital camera you can always delete the image.

For the best results when shooting from a moving platform, use a wide-angle lens, but avoid including too much of the foreground. The phenomenon of movement parallax means that the foreground appears to move much faster than objects in the distance, and it is impossible to render the foreground sharp – even at moderate road speeds. The use of an image-stabilized lens (*see p. 94*) can be of considerable help.

Remember that the windows in buses are often tinted – even if the view looks neutral in color, if it is slightly darker than clear glass it will surely tint your images. Digital cameras may fare better than film-based ones in this respect, since the automatically adjusted electronic white balance may be able to compensate for any tint.

Traveling companions

If you are traveling in a small group then you will almost certainly want to stop the vehicle whenever you see something promising. If your traveling companions are not sympathetic to your photography objectives – and even if they are – continually stopping and starting can become tiresome. You will, therefore, need to develop a sense of when something is really worth screeching to a halt in order to photograph.

Watch the changing views as you progress through the countryside to anticipate where a good viewpoint might be. However, bear in mind that what you see from, say, a bus or a four-wheel-drive vehicle is from a higher viewpoint than road level: this difference, though only small, can introduce an obstruction or cut off important foreground information.

Evocative imagery

Few things are more evocative of long distances than seeing the receding parallel lines of railroad tracks. With the foothills of the Tian Shan range in the background, these tracks offer a shortcut to the local people in Uzbekistan. You have to balance the need to show a long stretch of track with the size of the people on the line. Other pictures I took at about the same time showed the figures as being far too small to have much of an impact.

● Canon EOS-1n with 80–200 mm lens. ISO 100 film. Nikon LS-2000 scanner.

Journeys and travel continued

Vehicular interest

When you reach important stages in your journey, don't forget to include your most important companion – your means of transportation. Here, after two months on the road, on a beautiful day we reached Mount Ararat in Turkey. A wide-angle lens at minimum aperture captures the car on the road as well as the not-so-distant snow-capped mountain.

● Leica R6 with 21 mm lens. ISO 100 film. Microtek 4000t scanner.

From the air

Photographers travel the greatest distances by air, yet they photograph it the least. By staying alert, you can catch fleeting moments such as this – as the aircraft banked for its final approach, it caught a flash of sunlight reflected from a car down below. This brings the scene to life – and it could be a road you will be traveling on after touchdown.

● Canon D30 with 28–135 mm lens.

First things first

A large spring in the middle of nowhere (*right*) is irresistible after a hot, dusty day bumping along on the dirt roads that criss-cross the Kenyan savannah. But you have to resist the urge to jump in with all your clothes on – first you must grab your picture, remembering to get your transportation in view . . . then you can join the others.

● Canon F-1n with 20 mm lens. ISO 100 film. Microtek 4000t scanner.

Dunhuang dunes

A favorite spot for tourists visiting Dunhuang in Eastern China (after viewing the great grotto art) is to climb the giant sand dunes, from where a great sweep of countryside is visible. Rather than climb the dunes with everybody else, why not try for a different slant and be rewarded with a shot that is unique?

● Leica R6 with 28mm lens. ISO 100 film. Microtek 4000t scanner.

At home

It is a mistake to think you have to travel to foreign lands to find subject matter for your camera, when one of the richest veins of photography is in your own home. The secret lies in opening your eyes to the possibilities all around you.

Approaching the familiar

The trick is to carry a camera as you move around at home. The camera will remind you to keep alert, to look for a fresh approach to the ordinary and the familiar. For example, one day the sun may shine from precisely the right angle to light up a particular corner of your kitchen, or there may be one time of day when a reflection from a neighbor's window spotlights your bedroom dressing table. Resist the temptation to clean up: cluttered table tops, ruffled cushions, or discarded clothing can all help to evoke a specific mood.

Whether you work in color or in black and white affects the voice of your communication. Color can impart a documentary, objective tone, while black and white may mask some of the chaos most of us tend to live in, transforming clashing colors into harmonious monotones.

Indoors, light levels may be low, so think about using a tripod to steady the camera during long exposures – especially if you wish to set a small aperture to maximize depth of field (*see pp. 84–7*). With digital cameras, bear in mind that long exposures result in "noisy" pictures, though some models have a setting for removing this interference. Some cameras set a higher sensor "speed" when they detect low light levels: this also tends to increase noise (*see pp. 246–7*). But turn off the automatic flash unless you specifically want this type of lighting effect.

Once you begin to realize the potential that surrounds you, it may be that you start to see your immediate neighborhood in a different light, perhaps better appreciating the nature and character of your area. And this is excellent training for travel photography (*see pp. 165–7*).

Chance lighting

Only at rare times did the sun catch this dresser at precisely the right angle – fortunately, just after the children had added their personal decorative touches. Working in black and white helps to control the high subject contrast that often results from this type of directional lighting.

● Rolleiflex SL66 with 80 mm lens. ISO 125 film. Heidelberg Saphir Ultra II scanner.

Garden still life

A week of summer growth between the coils of a hose and a child's beads create a riot of texture and contrasting shape. But the coils of the hose and plants also organize the image into a satisfying rhythmic composition.

● Rolleiflex SL66 with 80 mm lens. ISO 125 film. Saphir Ultra II scanner.

Chair

This image was captured one morning before I had to rush off for an appointment. It was the only exposure I took, and it is not about precision of composition or arranging subject elements – it is simply an exercise in responding to the moment.

● Nikon F3 with 50 mm lens. ISO 125 film. Microtek 4000t scanner.

Children

The photography of children falls into two main areas of interest – images of family and friends or pictures taken when traveling abroad. We tend to photograph our own children, or children with whom we have some kind of relationship, in a very different way from children living in other cultures. The prime reason for this is that our approach to the "exotic" is one we are reluctant to apply to the familiar. For example, when abroad the fact that a child is dirty or is wearing ragged clothing may be the very features that attract our photographic interest. We may be proud to show this imagery highlighting the different and unfamiliar to friends or colleagues, yet we would be reluctant to show our own children in anything but a favorable, "sanitized" light.

A change of attitude

So the challenge is clear: we must find a way to bring the two approaches together, to show more honesty in the photography of our own children while showing more respect in our representation of children from other cultures. For example, when you are traveling you could try to learn about the games that children play: do they have rhyming games in Mongolia; do the children of the Philippines play "catch"; which version of soccer do they play on the beaches of Zanzibar? Another approach could be to show children from other cultures in roles that might be largely alien to our own – such as working in the fields or factories or active in religious observance.

In the end, by deepening our involvement, we increase both our understanding and our enjoyment. Such developments can give photography a most exciting and rewarding edge.

Selective view
Ostensibly this is a study of contrasts – between the baby's hands and that of his grandmother's; of colorful clothes against tanned skin – but this selective view also removes the viewer's gaze from the child's grubby face.

An even closer approach, to concentrate attention on, for example, the lower part of the image, might have been even more effective.
● Canon EOS-1n with 28–70 mm lens ISO 100 film. Microtek 4000t scanner.

A candid approach

A large fountain in hot weather is irresistible to young boys anywhere in the world. The problem here was trying to photograph them without them realizing – otherwise they would start playing for the camera. I mingled with the crowds, enjoying the sun, and waited for a suitable grouping and rare moment of relaxation. Then I raised my camera at the last moment and grabbed the shot.

● Canon EOS-1n with 80–200 mm lens. ISO 100 film. Microtek 4000t scanner.

Brief childhood

On the harsh steppes of Kazakhstan, children grow up quickly. Not only were these children in charge of a horse, they were also looking after a herd of cattle in winter weather that barely reached temperatures of -4° F (-20° C), even during daylight hours. This is a long way from a close-up picture of innocent young faces.

● Canon EOS-1n with 80–200 mm lens. ISO 100 film. Microtek 4000t scanner.

Children continued

Suitable framing

Without the stark framing, this would be a well-lit, uninteresting image. But the frame not only reveals the boys, it also gives us clues about where they live. With the hay just visible, this must be a farm. A second before shooting the standing boy's face was lost in shadow but I could not focus and shoot quickly enough.

● Canon EOS-1n with 200 mm lens. ISO 100 film. Nikon LS-2000.

● HINTS AND TIPS

Children can be a challenge in technical terms, as they are small, low down, and move quickly. They require stamina and fitness on the part of the photographer, as well as quick reflexes. You can help yourself by trying out these techniques:

● With very small children, work at a fixed distance: focus your lens manually to, say, 18 in (0.5 m) and keep your subjects in focus by leaning backward or forward as they move. Small children move very quickly but usually only over short distances. This method requires little effort and can be superior to relying on autofocus.

● When you first photograph a group of children, fire off a few shots in the first minute – they need to get used to the sound of the camera or light from the electronic flash, while you need to exploit their short attention span. Once they have heard the camera

working, they will soon lose interest and ignore you. If, however, you wait for them to settle before taking your first picture, they will be distracted by the noise.

● For professional photography of children, the best cameras to use are SLR-type digital models or manual film-based cameras. These give you more flexibility than ordinary digital cameras or autofocus compact types. You need the shortest possible shutter lag (the time interval between pressing the shutter and actually recording the picture) if you are not to miss out on the really spontaneous images.

● In low light, try using faster film or increasing the photosensor's sensitivity rather than setting the lens's maximum aperture. With non-professional lenses, you lose more image quality through using large apertures than from the grain given by higher-speed recording.

Landscapes

This is one of the most accommodating and the most challenging areas of photography. Of all subjects, the land simply lets you photograph it from any angle, at any time, and in any weather, but you must work to find the ideal viewpoint.

There are three essentials of landscape photography – place, time, and means – but the most crucial of all is place. And it will do you no good at all if you have an original approach to landscape in mind, but have not learned how to find just the right position from which to depict the place. To discover the perfect position you cannot rush at it, hoping it will be obvious once you get there. Once you see a view that is promising, you need to slow down completely – even put your camera away. Then just walk and look, walk a little more and look a little harder. That is all there is to it.

Foreground interest

One of the most effective techniques in landscape photography is to make confident use of features in the foreground. Here, in New Zealand, a spider's dew-laden web catches the early morning sun, and so frames the landscape beyond. By using a large aperture (small f/number) the depth of field was limited, so even in this wide-angle view the background is blurred and soft to blend into the mist.

● Canon D30 with 17–35 mm lens.

Polarizing filter

The hallmarks of a picture made through a polarizing filter are the deep blue of the skies and, if any water is visible, a lack of reflections. In this image of Samburu, Kenya, the dark stones at the bottom of the pool are clearly visible because the polarizing filter has removed reflections of the sky. As well, colors in the reeds were intensified because the filter removed the partial reflections that degrade color saturation.

● Canon F-1n with 20 mm lens. ISO 100 film. Microtek 4000t scanner.

Landscapes continued

Leading the eye

A landscape photograph does not need to feature the sky or be shot with a wide-angle lens. This scene in New Zealand was taken with a zoom lens set to a 35efl of 600 mm in order to lead the eye to the masses of variegated greens and the patterns of tree trunks. It is a scene that could easily be turned into a painting.

● Canon D30 with 100–400 mm lens.

Selective emphasis

The scene was simple enough and its promise was clear, but finding the right position to photograph this half-empty reservoir in Hong Kong took many minutes thanks to restrictions on access. As the day was dull, there was little choice about lighting, so I had to shift my attention to shape and the balancing of tonal masses.

● Nikon F2 with 135 mm lens. ISO 64 film. Microtek 4000t scanner.

Polarizing filters

One of the most popular, some would say essential, accessories for the landscape photographer is the polarizing filter. This is a neutrally dark glass filter on a rotating mount. When attached to the front of a lens pointing away from the sun, then rotated to a certain angle, the filter has the effect of making blue skies appear dark. This is because most of the light from a clear sky vibrates in a narrow range of angles: however, a polarizer passes light that is vibrating in one direction only and blocks all others. The polarizer is an effective way to reduce the luminance range of a scene, but it works most effectively when the sky is already blue (and so is darker than sky with diffused cloud), when it can cause overdarkening. This filter is best used on an SLR, where you can see any changes through the viewfinder. Modern polarizers should be of the circular polarizing type. Don't be tempted to use linear polarizing filters – although they are less expensive, they cannot be recommended for most modern cameras as they render autofocus and some metering systems inaccurate.

Dawn mist

Landscape photography may seem leisurely, but often you have to act quickly. Driving out of Auckland airport, New Zealand, just after dawn, this mist-shrouded scene presented itself. I knew that it would evaporate quickly, so I jumped out of the car and raced back down the road to record it. Just seconds later, the rising sun masked the delicate hues in the sky and the mist thinned.

● Canon D30 with 28–135 mm lens.

Mirrors

A moment's thought informs you that mirrors, other than being manufactured objects, can take the form of any reflective surface – metalwork in buildings, glass windows, or the shiny parts of cars. And any body of still water – from a puddle to a lake – will reflect the surrounding scene.

Practical concerns

One problem when photographing mirrors is that you can find yourself included in the image. Unless you are prepared to buy a specialized, and very expensive, shift lens (*see pp. 38–9*) – which allows you to stand to one side and then shift the lens to produce a "head-on" view – you will have to adopt an angled shooting position.

Another problem is that the depth of field required may need to extend from the near foreground to any distant view visible in the mirror. You could use the smallest lens aperture available, but on digital cameras this is often very limited. In addition, lens performance at the smallest aperture may fall below acceptable levels.

A digital approach is to take two images and fuse them later: take one of, say, the foreground and mirror frame at one focus setting; then take another, altering focus to obtain a sharp reflection. You may have to enlarge the reflected image slightly to make it fit perfectly in the mirror frame.

Making reflections disappear

You can make some reflections disappear by exploiting the fact that light reflected from most surfaces – but not metallic ones – becomes polarized. By attaching a polarizing filter to the lens and rotating the front element, some if not all reflections from, say, windows or water, will be removed. This technique is very valuable when photographing water when you want to see any fish that may be near the surface. Polarizing filters are also handy for improving the color saturation in a scene as they remove many of the partial reflections that reduce color brilliance.

Home farm
A backyard in Tokyo has taken on an esoteric appearance by including a mirror, which seems like the entrance to a parallel world. A short wait for the animals to arrange themselves was needed to complete the image.

● Leica M6 with 35 mm lens. ISO 400 film. Nikon Coolscan LS-2000 scanner.

Traffic mirror
You could entertain yourself by taking a series of pictures of the traffic mirrors used to help car drivers see around blind spots. This example, in Cambridge, England, was ringed with red spots, which glowed brightly when illuminated by the camera's flash.

● Nikon Coolpix 990.

Mirror mall
One of the disadvantages of digital cameras is their inability to take truly wide-angle shots. In this image of a shopping mall in New Zealand, I felt even the 17 mm lens, with its 104° field of view on a 35 mm camera was insufficient to convey the sense of unending virtual space caused by the narrow gap between precisely aligned mirror walls.

● Canon EOS-1n with 17–35 mm lens. ISO 100 film. Nikon Super Coolscan LS-4000 scanner.

Repeated imagery
The reflections of an office in the mirror-windows of another building offer many possibilities for the digital photographer – the image looks manipulated even before you have worked on it in the computer. Here, in Leeds, England, the new and the old in architecture come together but – apart from the photographer – it is not entirely clear who benefits from the union (*see also p. 148 for another treatment of this image*).

● Nikon Coolpix 990.

Nudes

The naked body has been a favorite subject with photographers from the very beginning, and all the techniques applicable to conventional photography apply equally when you are working digitally.

Technical considerations

The main objective is to control lighting contrast to ensure that the subtle transitions in tone that guide our perception of the human form are not lost in heavy shadows or empty highlights. The best way to ensure this is to use a single, simple light source – preferably one that is large and diffused. For example, hang a sheet over a window to diffuse in-coming daylight, or direct studio flash into an umbrella reflector. To lighten shadows, use a reflector, such as a white card, to direct extra light where it is needed.

Another approach is to soften the image. Generally, the rule is: the sharper the better. Too much sharp detail in images of the human form, however, tends to brings out minor skin features. Working digitally, you can always soften detail using filters and other techniques. Another softening technique is to throw the subject out of focus. However, in many digital cameras manual focus adjustment is limited.

Observing local laws

One of the most rewarding ways of photographing the nude is in the natural environment and in exotic locations. But while that beach in some far-off land may look empty, or that carefully selected desert oasis may seem private and secluded, you still need to take all reasonable precautions to ensure you are not observed by casual passersby and that you do not break local laws or upset local sensibilities.

If you are shooting in a country you do not know well, it is advisable to consult local tourist offices, local guides, or prominent local officials to find out what the law is and what reactions are likely to be.

But no matter whether you are photographing abroad or at home, if your model is someone you do not know well or is a young person, then you should work under the supervision of a chaperone – preferably a person who is known to and trusted by your model. This could save you from any misunderstandings that might arise at some point in the future.

Camera as observer

Formal posing sessions are not always necessary or even the best ways to work with a nude subject. You can ask the model to do a range of normal things, such as take a bath, dry, and dress, and the natural gestures that result can be far more intimate, revealing, and real than the most carefully constructed pose. Here the model, seen through a gauze of a netting, is simply pinning her hair on top of her head.

● Leica M6 with 35 mm lens. ISO 400 film. Nikon LS-2000 scanner.

Dawn light

A simple setup of mosquito netting and a bed lit by a rising sun provides a range of photographic opportunities. The warm-colored light from the early-morning sun has bathed the subject's body in a golden glow, while the light-diffusing quality of the intervening window keeps image contrast under control.

● Canon EOS-1n with 28–70 mm lens. ISO 100 film. Microtek 4000t scanner.

Diffused imagery

By focusing on the mosquito netting, the form of the figure was not only softened, skin tones have also blended with the color of the netting to produce an image in which texture and shape work harmoniously together. As the zoom was set to wide-angle, the widest aperture was needed to limit depth of field so that it did not extend to the figure. For this style of work, an SLR-type camera is invaluable, as you can make an approximate check on the depth of field in the viewfinder before shooting.

● Canon EOS-1n with 28–70 mm lens. ISO 100 film. Microtek 4000t scanner.

Nudes continued

Shifting viewpoint

The easiest place for nude photography is in the privacy of your own home, but bear in mind that too much clutter and detail in the surroundings will take attention away from your subject. You can reduce the effect of these distractions by your careful choice of viewpoint. A low viewpoint (*above left and left*) explores a composition dominated by lines resulting from the walls, blind, and the subject's own body. A high viewpoint (*above right*) ignores the room altogether and works with the body on the bed – here a pattern of light adds vital contrast without which this shot would lack tension.

● Canon D30 with 17–35 mm lens.

Bird's eye views

It is still a novelty to see pictures of familiar landmarks taken from the air or from the tops of tall buildings. The bird's eye view afforded by an elevated shooting position often produces images with no clear orientation – turning your head one way or another gives more or less the same view. However, choosing how to orient the camera, so that the resulting hard-edges of the picture frame relate to the picture content, is vital.

Technical considerations

The most effective focal lengths are in the mid- to wide-angle range – it is rare to use a long focal length, particularly from an aircraft due to the effects of vibration through the airframe and the problems associated with shooting through the thick windows.

A large aperture is the preferred setting, as this allows you to set the brief shutter times needed to prevent camera shake. However, the contrast-lowering effect of shooting through a large volume of air means that you will want to use your lens at its optimum aperture, to give the most contrasty image. Another measure for improving image contrast is to use a haze or UV (ultraviolet) filter. Exposure is generally straightforward as most scenes resolve into an average range of brightness. Slight underexposure with color transparency film helps increase color saturation and reduce the impact of haze.

Ideal times for aerial photography are early morning and early evening, when the sun is low and shadows long. When arranging a flight, ask for a pilot experienced in working with photographers. A good pilot knows how to bank at the right point to give you the best downward view.

Aerial spectacular
On long-haul flights it is easy to watch movies or sleep all the way, but then you miss out on views such as this – a river emptying into the sea while plumes of smoke are caught in the light of a setting sun. In this situation, when, because of the speed at which you are traveling, you have mere seconds before the lighting changes, measure exposure by taking a spot-reading of, say, the cloud of smoke. If your digital camera does not have this facility, try bracketing exposures instead.
● Canon D30 with 28–135 mm lens.

Bird's eye views continued

Proper context

Rather than aiming their boat straight downstream, which would have produced a boring image from my viewpoint, this young crew were rowing at an angle to the current. Their inexperience allowed me to frame the shot to show a distant slice of riverside development, and so give their boat a proper context.

● Nikon F60 with 28–200 mm lens. ISO 64 film.
Nikon LS-1000 scanner.

Appropriate view

Large-scale events – such as the massed runners in the Paris marathon (*right*), make an interesting composition when seen from a high viewpoint. I experimented with a view that showed the competitors running alongside the Seine River, but I prefer this shot in which each runner has his or her own space and is easily distinguished from the others.

● Canon EOS-1n with 28–70 mm lens. ISO 100 film. Microtek 4000t scanner.

Balcony view

Nearly overawed by the privilege of being invited into an ancient synagogue in Uzbekistan – a secular Muslim country – I almost failed to notice the balcony above my head (*right*). But having seen it, I knew I had to go up and view the service from above. Thus, I obtained this panoramic view of a holy place, but it is also a view that, sadly, makes obvious the diminished number of worshippers.

● Canon EOS-1n with 20 mm lens. ISO 100 film. Microtek 4000t scanner.

Optimum aperture

If you examine very carefully the quality of enlarged photographs from different lenses as you change the aperture from maximum (widest) to minimum (smallest), you will see a common pattern emerging. As you close the aperture down from maximum, lens performance improves, with images displaying more contrast and sharper and clearer details. Then, at a certain point, image quality drops off as you set yet smaller and smaller apertures. In other words, there is an aperture setting that gives optimum performance. Lower-quality lenses produce acceptable images only at this optimum aperture, while high-quality lenses produce acceptable images even at maximum aperture. The optimum aperture is commonly two or three stops smaller than maximum – in top-quality lenses, the optimum aperture may be as little as half a stop smaller than maximum.

Sports

Sports photographers were among the first to recognize the competitive edge digital technology could give them in the race to get pictures of dramatic moments into newspapers and magazines. With no film to process, images could be transmitted down the phone line directly to the picture desk. Minutes after a home run is scored, the image can be with a picture editor on the other side of the world.

Digital photography also offers advantages for the more casual sports photographer. You may, for example, be asked to make prints of winners and team lineups for friends or relatives – an easy task for digital cameras and ink-jet printers. Many sports clubs have their own website to attract new members and to keep fans informed of events, and images for these – from the Christmas party to the regional tournament – are always needed, and digital photography offers the easiest and least expensive way to provide them.

● TRY THIS

Sports photography does not have to be confined to the activity itself. A less-literal approach to the subject could, for example, lead you to document the fans – their faces and what they wear – or you could try making a record of what it is like behind the scenes – preparation for matches, the lives of the support staff, or what the event is like from a referee's perspective. By applying your imagination and knowledge of the sport, digital photography can open avenues of discovery about your favorite sport that might be closed to ordinary fans.

Behind the scenes
Photography of sports activity can include not only the highlights of the action but it can also give some sense of the hours of instruction needed to learn a skill. Here, a sensei, or teacher, demonstrates an arm lock in the repertoire of Goju-ryu-style karate.

● Canon EOS-1n with 28–105 mm lens. ISO 100 film. Nikon LS-2000 scanner.

Sports continued

Concentration

One of the difficulties with sports is that with so much happening in the background it can be hard to concentrate on the foreground action. Here, a busy background did not intrude into the main subject – a karate student being tested for tension – due to the exposure difference that allowed the background to be underexposed. In addition, the use of a large aperture limited depth of field to the foreground figures.

● Canon EOS-1n with 28–105 mm lens. ISO 100 film. Nikon LS-2000 scanner.

Know your sport

The better you know a sport the better able you will be to anticipate the action – you have to be almost as alert as those involved in the freestyle sparring taking place here. A blow can be delivered and retracted in a split second: not only do you have to respond, so does the camera – so you need to anticipate the action by small fractions of a second.

● Canon D30 with 80–200 mm lens.

Shoot what you need

Here, during freestyle sparring, the attacker has succeeded in momentarily trapping the right hand of his opponent. Unfortunately, in the next instant, the duellists turned and obscured the action. One advantage of a digital camera is that you can shoot as many action sequences as you need and later discard those that are useless without worrying about wasted film.

● Canon D30 with 80–20 mm lens.

Creative blur

Great sports photography is not just about showing the game. Only those who have taken part in a sport really know what it feels like, but we can use whatever photographic techniques that are available to us to show something of the spirit. A relatively long exposure – ¼ sec – blurs the action, but it takes many attempts to find an image that balances blur with discernible shape.

● Canon D30 with 80–200 mm lens.

● HINTS AND TIPS

The essence of the sports photograph lies in choosing the right moment to press the shutter. A split second represents the moment one tennis ace turns the tables on another or one misjudged tack separates the winner of the America's Cup from the also-rans. The strategy for sports photography is, therefore, constant vigilance to ensure you are at the right place at the right time:

● Allow for shutter lag: the time interval between pressing the shutter and actually capturing the image is usually at least $\frac{1}{10}$ sec but can be as long as $\frac{1}{4}$ sec.

● Keep safety in mind. In covering powered sports there is always an element of risk for anyone involved – particularly photographers, who are often given vantage points that are close to the action. Don't place yourself at risk unnecessarily and be guided by the track or event officials.

● Position yourself carefully. Try to view the event from a point at which you not only have a good view of the action, but also from where your target is not moving impossibly swiftly.

● Know your sport is the best advice. Use your expert knowledge to aid your photography. As a racetrack becomes worn down, for example, do the riders take a slightly different route around it? As the sun moves across the sky, do the players pass the ball from a different direction to avoid the glare? In dry conditions, do rally drivers take a corner faster than in the wet? Are you prepared for the changes?

Festivals

The key to successful photography at activities such as carnivals, festivals, or religious events is to undertake a little research beforehand.

Preparing for an event

If you are preparing to cover an outdoor event, get out and look over the route if you can a day or two beforehand to find likely shooting positions – in particular, look at where you might gain some extra height to allow you to shoot over the heads of the crowds that will be there on the day. A well-built, easily accessible brick wall might serve your needs; so might the second-floor window of a building overlooking the route (assuming you have permission to enter private property).

Preparation for an indoor event follows much the same routine. If possible, get to the venue in advance to familiarize yourself with the layout, bearing in mind that on the day the vast empty space before you now could be a seething mass of enthusiastic participants. It could be that there is a gallery, which would give you a vital height advantage on the day. If so, check with an official

if that area will be accessible and, if so, whether or not permission is required to enter it. In addition, pay special attention to where the windows are located – it is often better to shoot with the light coming from behind you so that the maximum possible illumination falls on the camera-facing side of your subjects.

Clearly you need to prepare your photographic resources carefully – during the middle of a festival is not the time to return to your hotel room for extra batteries. You will obviously bring ample supplies of film or memory cards so you do not have to return to base for supplies or to download images. An advantage of digital photography is that all images have the time they were taken embedded in the file, which makes it easy to reconstruct a sequence of events.

Position is all

To avoid getting only a back view of these "Roman soldiers" in Mexico City, I managed to secure a grandstand seat. For low-light shots, don't spoil the ambient lighting with flash: set a digital camera to high sensitivity, or use fast film.

● Nikon F2 with 50 mm lens. ISO 200 film. Nikon LS-1000 scanner.

Plain background
When you find an uncluttered background – here, a white-washed wall in Mexico City – stick to it. This composition is, however, a little tight: it would have been better if the man's hand had not been cut off, but my fixed focal length lens did not allow fine-tuning.

● Nikon F2 with 135 mm lens. ISO 200 film. Nikon LS-1000 scanner.

Amused onlookers
When covering a festival or public event, it is a mistake always to avoid taking the crowd along with the main action. Here, the normally stern-faced policemen could not help being amused by the parade of "criminals" in the Passion Play reenactment.

● Nikon F2 with 50 mm lens. ISO 200 film. Nikon LS-1000 scanner.

Festivals continued

Camera viewpoint

In any large-scale festivity there are always periods of waiting around and lining up – here to receive a blessing. The difficulty lies in catching a moment – amusing or revealing – or trying to obtain a striking composition. This shot (*left*), although striking, would have benefited from a slightly higher camera viewpoint or a greater concentration on a face.

● Nikon F2 with 135 mm lens. ISO 200 film. Microtek 4000t scanner.

Stamina

Even in extremely poor lighting conditions, there is always a chance something interesting will happen. For a brief time, this line of junior "penitents" (*above*) in the Passion Play is well-lit by weak sunlight. To catch such a moment, it is essential to be able to move around freely to take advantage of the situation. It is also important to stay alert: this moment occurred toward the end of 12 hours under a hot sun.

● Nikon F2 with 50 mm lens. ISO 200 film. Microtek 4000t scanner.

Urban views

The urban environment sets challenges for the photographer that are similar to those encountered by landscape photographers (*see pp. 173–5*). There is, for example, the overriding need to find the ideal viewpoint, sifting through a multiplicity of visual experiences to arrive at that single one that stands for them all. Then there is the importance of timing and lighting. In addition, whether you are working in a town or in the country, you have to choose between the wide vistas or recording a more detailed view of your subject.

Technical considerations

Technically there are differences between town and country photography. Pointing the lens a long way below or above the horizon in a landscape seldom causes obvious distortion effects, such as converging verticals, unless very upright trees are in view. In an urban setting, converging verticals are a constant challenge – whether to use them (easiest option), ignore them (seldom advisable), or correct them (requiring expensive equipment).

Depth of field is often a problem, too (*see pp. 84–7*). While country views may stretch from the medium distance into infinity, and so easily fall within normal depths of field, town views often stretch from very close to very distant.

Points of law

In most developed countries you will encounter few problems photographing in major cities, but you may need to exercise some care when working in some other parts of the world. It may be illegal to photograph certain government buildings, and railroad stations and bridges may also be out of bounds. In addition, some buildings may be protected by copyright or design rights: this is unlikely to cause a problem unless you wish to make commercial use of your photographs.

London Eye
Shooting at night and using London's slowly turning ferris wheel, the London Eye, as my platform posed a challenge. The simple strategy in a situation such as this is to take as many pictures as possible – with a digital camera, all unsharp images can be deleted.
● Nikon Coolpix 990.

Shooting at night

The tendency of all autoexposure systems is to over-expose urban night-time shots. As a result, street lights become too bright and the essential "feel" of a night scene is lost. It is best, first, to turn off the flash, and then to set your camera to manual and bracket a number of exposures, starting with a shutter speed of 1 sec. You will need to support your camera firmly, preferably on a tripod, to prevent camera shake. Note that digital cameras may produce "noisy" images with long exposures, in which blacks are degraded by lighter pixels. Some cameras offer a noise-reduction mode on long exposure, which you should turn on.

Urban views continued

Working around a subject

A simple exercise is to take an obvious landmark and then shoot as varied a set of views of it as possible. These images of the Sky Tower in Auckland, New Zealand, were all taken as I went about my business in that city. This shot (*above*), taken from a car, was very nearly missed – it is of such an ordinary scene, yet there is a rhythm in the multiple framing, a sense of a hidden story. In addition, its crisp colors make it a surprisingly rich picture. The passenger seat of a car makes a wonderful moving platform from which to work.

● Canon D30 with 28–135 mm lens.

Supplementary flash

Noticing these flowers first, I went over to photograph them only to find the tower unexpectedly in view. The flash on the camera illuminated the foreground flowers but not those a little farther away. The shadow visible on the bottom edge of the image was caused by the lens obstructing the light from the flash.

● Canon D30 with 17–35 mm lens.

Silhouette lighting

The silhouettes of trees in huge variety serve to frame the sleek, industrial lines of the distant tower (*above*). As the trees are represented by shape alone, they look very sharp – although depth of field in such views appears extensive, it is, in reality, an illusion of perception.

● Canon D30 with 28–135 mm lens.

Converging lines

Normally you would want to avoid pointing the camera steeply upward at buildings, as the strong convergence of normally parallel lines causes distortion. However, this can be exploited to create the sense of disorientation or of being towered over. Its effectiveness is increased in this view by avoiding any alignment between the picture frame and the sides of any buildings.

● Canon D30 with 17–35 mm lens.

Distant view

The Sky Tower is visible even an hour's ride away by hydrofoil. A strong tele-photo perspective – produced by the 35efl of a 560mm lens – leaps over the distance and appears to compress the space between the intervening islands. The haze has desaturated colors to give a nearly neutral gray.

● Canon D30 with 100–400 mm lens.

Natural history

Digital photography could have been designed for those interested in natural history. Of the many features that make this technology ideal for record-keeping, chief among them must be its automatic indexing of all images. At the very least, all digital cameras give a unique file name to every image captured, thus allowing pictures to be tied in to notes taken in the field. But many cameras record far more information: date, time, shutter and aperture setting, zoom lens setting, exposure compensation used, and so on. Some systems are even able to link in with GPS (Global Positioning System) instruments so that picture coordinates are automatically recorded.

Digital advantages

The sheer ease with which large amounts of data can be collected, downloaded onto a computer system, and catalogued is a huge bonus for digital camera users. For field work that does not call for first-class image detail, digital photography offers considerable advantages over film-based cameras. As long as you have the power to run a portable computer and your camera, you can produce as many images as you like without ever buying film or visiting a processing laboratory.

Digital cameras are by their nature easy to control electronically. You could, for example, set a camera to take images at relatively long intervals – say, once every hour – to reveal the transformation of a chrysalis into a butterfly or the opening of a flower. For this, however, you need main, not battery, power, and will probably need to set up a flash to ensure adequate and consistent lighting. Some cameras even charge the flash in advance so that it is fully powered in time for the exposure.

Afternoon light

Although your primary aim may be to document a scene or detailed feature, be aware that good lighting not only improves the visual qualities of any image, it may also bring out important new information. Earlier in the day, overhead lighting on this hill made the grass appear smooth and featureless. Toward evening, however, ridges caused by generations of sheep runs became evident in the low-angle light.

- Canon D30 with 100–400 mm lens.

Choose a natural history subject to photograph – any aspect of this wide area of study that interests you – and aim to document it as thoroughly as possible. It will be best if you approach this exercise methodically. Try to imagine you are documenting a new discovery of some type, and need to record every scrap of evidence. Start with overall views showing the subject and surroundings, depicted from a variety of angles. Then move in close to record each detail. Remember, you are not using up any film, so just take as many pictures as you need. You may surprise yourself by discovering any number of things you had never known or noticed before.

Looking at a single tree

For many, one of the most satisfying areas of photographic interest is the natural world, and one of the easiest subjects is plant life. Discipline and a systematic approach can bring you great satisfaction, deepening your pleasure both in photography and of the world around you. Here, a beautiful fir tree in New Zealand has been studied and recorded so that any expert could readily identify it – the cone, the organization of its branches, its bark, and its leaves are all unmissable clues. You could also add its habit (spreading, weeping, and so on) by recording the entire tree. For rigorous work you need to include some indication of scale by, for example, including a ruler with the cone and bark.

● Canon D30 with 28–135mm lens.

Panoramas

The basic concept of a panorama is that the recorded image encompasses more of a scene than you could see at the time without having to turn your head from one side to the other. In fact, to obtain a true panoramic view, the camera's lens must swing its view from one side to the other.

Visual clues

The giveaway visual clue to a panorama is that there is necessarily some distortion – if the panorama is taken with the camera pointing slightly upward or downward, then the horizon, or any other horizontal line, appears curved. Alternatively, if the camera is held parallel with the ground, objects positioned near the camera – usually those at the middle of the image – appear significantly larger than any objects that are more distant from the camera.

Landscape view

The landscape is the natural subject area for the panorama and it also presents the fewest technical problems. In addition, it can transform a dull day's photography into a breathtaking expanse of quiet tones and subtle shifts of color. Here, in Scotland, a still day creates a mirror-like expanse of water to reflect the fringing mountain, thus adding interest to an otherwise blank part of the scene. This image consists of six adjacent shots, and it was created using Photoshop Elements.

● Nikon Coolpix 990.

Digital options

In recent times, the concept of panoramas has been enlarged (confusingly) to include wide-angle shots that have had their top and bottom portions trimmed or cropped into a mailbox shape. As a result, images have a very long aspect ratio – which means that the width is much greater than the depth of the image. These pseudo-panoramas do not show the curvature of horizon or exaggerated distortion of image scale of true panoramas.

The digital photographer has a choice. Pseudo-panoramas can be created simply by cropping any wide-angle image – all you have to do is ensure that the image has sufficient reserve of detail to present credible sharpness after you have cropped it. Don't forget that a panorama can be oriented vertically as well as horizontally (*see pp. 88–9*).

True panoramas are almost as easy to create digitally. First, you take a number of overlapping images of a scene from, say, right to left or from top to bottom. Then, back at the computer, you can join all these individual views together using readily available software such as Spin Panorama, PhotoStitch, or Photoshop Elements. These software packages produce a final, new panoramic image without altering your original image files in any way (*see pp. 336–7*).

Unlikely subjects

You can experiment with component images (*left*) that deliberately do not match, in order to create a view of the scene with a rather puzzling perspective. The software may produce results you could not predict (*above*), which you can then crop to form a normal panoramic shape.

While the final picture is by no means an accurate record of the building, in Granada, Spain, it may give the viewer more of the sense of the architecture – of the never-ending curves and columns. This image was created using the PhotoStitch application.

● Nikon Coolpix 990.

Panoramas continued

Canal scene

The distortions in scale that are caused by swinging the view from one side to another, so that near objects are reproduced as being much larger than distant ones, can produce spectacular results. In this view, taken under a railroad bridge crossing a canal in Leeds, England, one end is reproduced as if it is the entire width of the image, while the other end takes up only a small portion of the center. The mirror calm of the canal water helps to produce a strong sense of symmetry, which is in opposition to the powerful shape of the wildly distorted bridge.

● Nikon Coolpix 990 with wide-angle attachment.

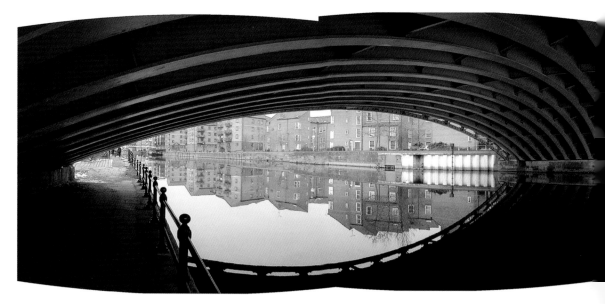

Rear nodal point

The image projected by a lens appears to come from a point in space: this is the rear nodal point. Rotate a lens horizontally around an axis through this point and features in the scene remain static even though the views change. A virtual reality head (*see right*) allows the axis of rotation to be set to that of the rear nodal point to give perfect overlaps between successive shots.

●HINTS AND TIPS

In order to obtain the best-quality panoramic images, you might find the following suggestions helpful:

● Secure the camera on a tripod and level it carefully.

● Use a so-called "virtual reality head": this allows you to adjust the centre of rotation of the camera so that the image does not move when you turn the camera. If you simply turn the camera for each shot, the edges of the images will not match properly.

● Set the camera to manual exposure and expose all the images at the same aperture and shutter speed settings. As far as you can, select an average exposure, one that will be suitable for the complete scene.

● Allow for an ample overlap between frames – at least a quarter of the image width to be safe.

● Set your lens's zoom to the middle of its range, between wide-angle and telephoto. This setting is likely to produce the most even illumination of the whole image field and also the least distortion.

● If possible, set the lens to a small (but not the smallest) aperture – say, f/11. Larger apertures result in unevenness of illumination, in which the image is fractionally darker away from the middle.

● Ensure that important detail – a distinctive building, for example – is in the middle of a shot, not an overlap.

Table setting
It can be fun to create panoramas of close-up views: here, a collection of views were blended together, playing with the pastel colors and repeated elliptical shapes (see also pp. 114-15).

● Nikon Coolpix 990.

Zoos

For most people, zoos offer the best chance to get up close to wild or exotic animals. Modern zoos in major cities are becoming less like animal theme parks and are now taking on the role of important centers for the study and preservation of wildlife and the development of models of animal care. You can see well-fed animals in something like their natural habitat, though generally with little room to roam or play.

A learning experience

For the photographer, zoos are useful places to practice some of the elements of wildlife photography before venturing into the field. You soon learn that you have to stay still and wait, sometimes for hours, for something to happen. After a while, you discover that if you set up at the right place at the right time, your wait for the right shot can be greatly shortened – and from this you learn the importance of knowing your animal, its habits, and its relationship with its environment. You also learn how most visitors to zoos, like tourists in nature reserves, are wholly insensitive to their surroundings, moving noisily, talking loudly, and failing to use their eyes. So the best times for your visits might be midweek, when zoos tend to be quiet, rather than on weekends. If you travel a lot, you might want to consider a photographic project on zoo architecture – which is virtually an art form in its own right – in addition to concentrating on the animals.

You can approach animal photography in zoos in various ways: the images shown here (*see right and overleaf*) mimic photography in the wild, with no signs of enclosures, cages, or members of the public allowed to intrude. An equally valid approach, however, is to emphasize the captivity and the isolation of the animals through your photography – it all depends on what you are trying to convey through your work.

It may be possible to gain privileged access to at least some of the animals by approaching the relevant keepers or the zoo director and offering free photographs for use in the zoo's publicity material or on its website.

The right moment
The ease of taking pictures of animals in zoos should not lull you into thinking it is easy to take effective images. As with animal photography in the wild, wait for the right moment, for a revealing insight in the animals' lives, or when the animals' features are clearly shown.
● Canon D30 with 100–400 mm lens.

Subject sharpness
The depth of field available when you are focusing on a nearby subject with a long focal length lens is limited. The advice for people pictures applies to animals, too: if you focus on the eyes, then lack of sharpness elsewhere is acceptable. In this portrait of a red panda, the eyes and whiskers are sharp but little else, yet the image overall gives the impression of being extremely sharp.
● Canon D30 with 100–400 mm lens.

The truth behind the image

You could explore the field of unconventional portraits: views of animals you could never expect to see in the wild – such as this polar bear swimming, apparently soaking up the sunshine with some degree of pleasure. Beware, however, of the mistake of attributing human emotions to animals – it is widely accepted that polar bears are very distressed by captivity in zoos.

● Nikon F2 with 135 mm lens. ISO 64 film. Microtek 4000t scanner.

Zoos continued

● HINTS AND TIPS

Zoo photography is technically straightforward, but these points may be worth noting:

● To minimize the appearance of wire barriers when photographing, use your longest focal length lens very close to the wire, and with the lens set at its maximum (widest) aperture. If you stop down the lens, any obstacle in view will be sharper and darker. However, be aware that even if a wire is not visible in the viewfinder or the preview screen, it may still show up as a very soft shadow in the resulting image.

● Check with an animal keeper before using flash in dark conditions to ensure that the animals will not be disturbed. Some cameras emit an infrared light to aid focusing in dim light – this may also disturb some animals. If so, turn this off or switch to manual focus.

● When using flash through a wire barrier, remember that the wires may cast unsightly shadows.

● When shooting through glass, place yourself at an angle to it. If you stand directly in front of the glass, the flash will bounce straight back at the camera.

Careful observation

Fast moving and constantly on the go, animals such as otters are very hard work to photograph, and you have to watch constantly with the camera ready at all times. Here, a digital camera puts you somewhat at a disadvantage compared to film-based cameras, as its high consumption of battery power limits its working time. Furthermore, shutter lag can present problems. The best solution is to observe the animals carefully and concentrate on the spot that seems to be a favorite with them – in the example here (*above*), it was these rocks where the otters regularly rested and sunned themselves. Focus the camera on this spot, set to manual – exposure and focusing – if possible. Setting the camera to manual helps to reduce shutter lag.

● Canon D30 with 100–400 mm lens.

An eye for detail

Zoos allow you to obtain animals portraits that would be difficult to take in the wild. However, to any knowledgeable eye, signs of captivity will be evident – even if the bars of the cage cannot be seen. Forests of tall trees are not typical of a lion's natural habitat, for example, nor is the fern at this lion's feet native to Africa.

● Canon D30 with 100–400 mm lens.

Record-keeping

Digital cameras have revolutionized record-keeping. Not only are they unencumbered by the need to process film, the amount of equipment required can be minimal (*see pp. 159–61*), and little or no physical materials are consumed. And once the information is recorded, you can send it around the world in an instant.

Applications

The everyday applications of digital technology are numerous. If you want to sell your car, just take a picture and email it to the advertiser with your details. For insurance, take images of your valuables and possessions, room by room, but keep the computer image files separate from the computer in case it is destroyed or stolen.

Digital photography is also useful if you need to transfer information. You may, for example, want an expert at the other end of the country to identify a document or object – emailing an image of it is quicker and easier than making the trip yourself or mailing it. And sometimes a quick response can save lives – a doctor giving advice via an email after seeing images sent in from the field by satellite phone, for example. And in some circumstances it is crucial to record the time, date, and a sequential number along with each digital image. This is invaluable for many types of scientific work, such as an archaeological excavation.

The combination of digital photography for making straightforward records with software for managing images makes it very easy to print out lists and notes to accompany images.

Reassembly
This fine sculpture from Sri Lanka is designed to protect a home from illness, but for transportation it needs to be disassembled into numerous small parts. A series of digital photographs quickly records the positions and orientations of every piece so that reassembly is both easy and accurate.
● Olympus C840L.

Color accuracy

If you have to produce an image of an object and maintaining color accuracy is crucial, you should include a color bar along with the subject. Such a bar only needs to be visible on the edge of the image and does not have to be an expensive, standard type. At its most basic, the colored subject divider tabs of a loose-leaf folder will do. The crucial factor is that you have the color bar on hand to compare with the printed image.

Good working practices

● Carefully preserve your backup copies, and always keep them separate from your working files.
● Lock your archive files to prevent accidental or malicious tampering, especially if the contents are crucial to your work. With Zip disks, this can be done electronically, using password protection. Otherwise, keep vulnerable disks physically secure, somewhere separate from the computer.

● Once your images number more than a few hundred, regularly print out a list of file names with notes about image content. You cannot hope to remember details of them all, and these notes will help.
● Use cataloguing software (*see pp. 232–3*) to keep track of pictures. This software makes it easy to print out indexes of pictures, which are easier to search through than scrolling down long lists of names on a monitor.

Art preview
Digital photography proved to be incredibly useful for the Russian artist of this picture. Being rather isolated in Kazakhstan, he photographed it and emailed the picture file to an expert gallery owner for an opinion on its value before committing to a sale. In this instance, it is not of crucial importance that the flash has lit the painting unevenly.

● Nikon Coolpix 880.

Identification
Even if jewellery is not very valuable, it may still be precious. One problem police encounter when they recover stolen goods is matching items with their rightful owners. If you have ink-jet prints of your possessions, it will be a great help to everybody concerned. But take care to keep the prints separate from the items they depict to prevent them being stolen along with the items they are recording.

● Nikon Coolpix 990.

Car for sale
If you are offering an item such as a car for sale, using a digital camera it is a matter of just a few seconds to take a picture of the item and email it to the newspaper, along with a full written description and your details, for inclusion in the paper's next issue.

● Ricoh RDC-2000.

Flat copying

The purpose of flat copying is to make a record of a print, map, or drawing. The easiest method is to scan the original, provided you have a scanner of sufficient size. If, however, the original is too large, you will have to take a photograph of it instead. There are three main considerations:

● The image must be geometrically undistorted and at a known reproduction ratio.

● Lighting must be even and exposure accurate.

● The color reproduction should match the colors of the original as closely as possible.

For accurate alignment of camera and original, a specialized copy stand is ideal, but a tripod can be used if you can ensure that the camera is exactly parallel to the original being copied. For the best results, use an SLR camera with a 35efl of a 50 or 55 mm macro lens. If using the zoom on a digital camera, set it to the middle of its range, as this is where distortion is likely to be minimal. The lighting should be arranged as shown in the diagram (*see right*), and to ensure color fidelity, reproduce a color bar or step wedge with the original. It is not necessary to use an expensive type – any set of standard colors is more useful than none.

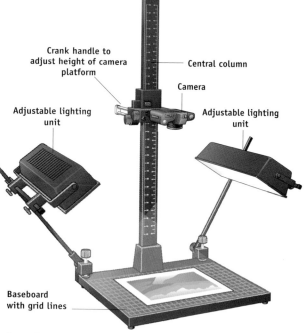

Crank handle to adjust height of camera platform

Central column

Camera

Adjustable lighting unit

Adjustable lighting unit

Baseboard with grid lines

Copying setup
The copying of flat documents, such as maps, artwork, drawings, and printed material, requires even lighting at a constant level, consistent color temperature, as well as a steady support for the camera, as shown in the copying setup here.

4

Radical conversions

Assessing resources

Photographs or prints are an invaluable resource for the digital photographer. Here you will see how to resurrect faded memories and incorporate them into current projects. And you can work with negatives at your desktop without the need for chemicals, running water, or a darkroom.

Secrets of scanning

This chapter tells you how to achieve first-class results with minimal effort – how to use a scanner, how to use scanners as cameras – and provides you with all you need to know about the intricacies of image resolution and different file formats.

Managing files and color

Here, the basics of color management and how to go about dealing with numerous image files are explained.

Help on hand

Quick-fix sections help you with any scanning problems you are likely to encounter, unravel your questions concerning resolution, and advise on what to do when scans are less than satisfactory.

Scanning: The basics

Scanning is the bridge taking film-based negatives and transparencies or printed images into the digital world. The process converts all color, brightness, and contrast information into digital data for your software to use. The quality of the scanner and the skill with which it is used are the key factors that determine the quality of the digital information and, hence, the quality of the image you have to work with (*see pp. 218–19*).

Scanning steps

You can think of scanning as a three-stage process:
- Gather together originals for the job at hand. You may have to make prints of family portraits, say, or collect images for your club's website.
- Next is the actual scanning. To do this, the scanner makes a prescan to allow you to check that the original is correctly oriented, or to set the scanner so that it scans only as much of the original as you want, or to set the final image size and resolution. You then make the real scan and save the result onto the computer's hard disk.
- The final stage is basic "housekeeping" – put your originals somewhere safe, somewhere you can readily find them again, and, if the work is critical, create a backup copy of the scans.

Basic procedures

To get the most from scanning, it is a good idea to follow some commonsense procedures designed to help streamline your working methods.
- Plan ahead – bring all your originals together before starting.
- If you have a lot of scans to make from a variety of different types of original, sort them out first. If, for example, you scan all black-and-white originals and then all color transparencies you will save a huge amount of time by not having to alter the scanner settings continually.
- Scan landscape-oriented images separately from portrait-oriented ones. This saves you having to rotate the scans. And you will minimize visits to dialog boxes if you classify originals by the final file size or resolution you want.
- If you are using a flatbed scanner, clean your scanner's glass plate before starting.
- Make sure originals are clean. Blow dust off with compressed air or a rubber puffer. Wipe prints carefully to remove fingerprints, dust, and fibers.

Setting up a scanner

Many scanners give excellent results with practically no adjustment at all. However, it pays to calibrate your scanner carefully right from the outset.

1 Obtain a standard target, such as that illustrated at right. The IT 8.7/1 is intended for use with color transparency film, and the IT 8.7/2 is for color prints. These targets may be supplied with your scanner; if not, a camera store may be able to order them. Alternatively, choose an original for scanning that is correctly exposed and contains a good range of colors and subject detail.

2 Make an initial scan using the machine's default settings – those set at the factory.

3 Check the image produced by the scan with the original. If necessary, make changes using the scanner driver's controls so that the scan matches the original. Some scanners require you to make these changes in the preview window. However, you need to be aware that on some scanners the preview image is not really an accurate representation of the final scan. You need to experiment with your particular equipment. For the best results, you also need to calibrate your monitor (*see pp. 228–31*).

4 Once you have a scan you are happy with, save or note the settings. Call it by the name of the film used – such as "Kodak Elite 100" or "Fuji Provia."

5 Repeat these steps with all the various types of film you scan – color negatives and transparencies use different scanner settings.

6 Then, for all subsequent scans, load the relevant saved settings as your starting point.

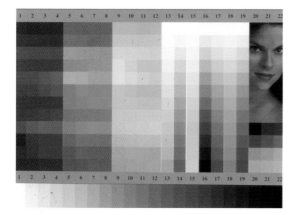

Scanners compared
Two high-quality scanners – a Nikon LS-2000 (*top*) and a Microtek 4000t (*above*) – can produce very different results from an identical standard target image. This demonstrates just how important it is to set up your scanner controls carefully.

● Align originals on the scanner as carefully as you can: realigning afterward may blur fine detail.
● Scan images to the lowest resolution you need. This gives you the smallest practicable file size, which, in turn, makes image manipulation faster, takes up less space on the hard disk or other storage media, and gives quicker screen handling.
● Use file names that are readily understood. A file name you choose today may seem obscure in a few months' time.
● When scanning, crop as much extraneous image as is sensible in order to keep file sizes small, but allow yourself room to maneuver in case you decide to crop further at some later stage.
● You may need to make your output image very slightly larger (say, an extra 5 percent all around) than the final size. This may be essential if, for example, you want your image to "bleed," or extend to the very edge of the paper so that no white border is visible.

Preview window
All scanners show a representation of the image in a preview window (*above*) prior to the final scan (*top*). This gives you a chance to make improvements before committing to a final scan. While it will save you time and effort later if you make the preview image as good as you can, bear in mind that it is only a general indication of the final scan. With some scanners, the preview may actually be rather inaccurate: if yours is one of these, you may need to experiment in order to learn how to compensate for its quirks.

Quick fix Computer problems

The rule to observe when your computer fails – and they all do at some stage – is: don't panic. Any glitch that falls short of actual physical damage can usually be solved without much effort. If, however, you suspect an electrical fault, turn off your equipment, remove the plug from the socket, and call for expert help.

The second rule is: make a detailed note of what you were doing at the time the failure occurred. For example, write down the software that was running, and the keys you were pressing.

Next, have a record of the version details of your computer and operating system, connected peripherals, as well as the software. This information will be asked for if you need to contact a technical helpline.

Troubleshooting

No computer system is safe from catastrophic failure, which is likely not to be your fault. But random attempts to deal with problems can make the situation worse. A full troubleshooting guide would run to thousands of pages – here, there is space to cover only a few of the most common problems. Work systematically through this guide, making notes as you proceed. If you need professional support, these notes could save you time.

How to avoid the problem

● An effective way to improve the stability and reliability of any computer system is to give it as much RAM as it can handle. For digital photography, 256 MB of RAM is the absolute minimum. Another improvement you can make is to have a large-capacity hard disk – 20 GB is not excessive.

● Save work regularly, and the more difficult the material you are working on, the more crucial it is to save as you go. Undeniably, large files can take a long time to save; but it will take a lot longer if you have to start all over again. If you end up with multiple versions of files, all at various stages of completion, you can delete unwanted ones at the end of your work session. At this point you should also make backup copies of everything that you might need to use again.

● Moving any connected hardware while a file is running can cause problems. Bumping into a computer while it is accessing the hard disk, could cause it to crash and, possibly, lose data. If the data is vital for the computer's operation, you may have to reinstall it or, worse, reinitialize the hard disk – this would mean losing all data held on that disk.

Problem	Analysis and solution
Error message is displayed on screen.	Conflict between software applications. Save open files if possible and then restart the application; otherwise restart the computer. If the message occurs on first use of scanner, reinstall scanner software.
After a period of normal working, the computer does not respond to keyboard or mouse actions.	Conflict between software causing a system freeze. Restart the computer and see if the problem recurs. If so, you may need to update software or operating system. Visit relevant websites to download updater utilities.
Application repeatedly stops working or causes the computer to crash.	Software conflict or shortage of memory. Run only one application at a time, if possible. With Mac OS computers, increase memory allocation or install more RAM. In Windows, install more RAM. If problems persist, there may be a conflict between the software and your computer's operating system and you may need to update the software. Visit relevant websites for updaters.

Problem	Analysis and solution
Computer crashes when you are multi-tasking.	Having the computer do more than one thing at a time may confuse it. Avoid multi-tasking – printing a job while saving a file, for example, and while this is going on, starting to surf the web.
Computer slows to a crawl.	In Windows, too many temporary files may be loaded. Clean out unwanted files – particularly in your internet browser folder. Unless you know what you are doing restrict yourself to files that have a .tmp suffix or a ~ prefix. In addition, make sure any software that was removed was properly uninstalled. In Mac OS, you may need to renew or rebuild the Desktop Folder. Use the TechTools utility or, during startup while the Extensions are loading, hold down the Apple (Command) and Option (Alt) keys simultaneously until the screen asks whether you are sure you want to rebuild the Desktop. When this appears, click "OK".
Computer takes too long to open files.	The hard disk may be full or very fragmented – large files split into smaller packets scattered over the hard disk. Clear the hard disk of unwanted files and de-fragment using the hard disk utility: before you run this utility, back-up your work. If you have two hard disks or large-capacity storage, copy all working files and then delete them (but not the system files) from the hard disk. Then copy back the working files afterward.
Unable to open a file.	A file has lost its association with the appropriate application. In Windows, if the file does have the correct suffix, change the file name adding, say, .jpg or .tif. In both Windows and Mac OS, start your application and then open the file from within it, using the File>Open dialog box.
Computer behaves erratically, performing unexpectedly or strangely, and may be losing data.	It may be infected with a virus. Obtain and run virus-checking and repair software to "disinfect" your computer. If the machine is seriously infected you may need to start the computer from its Startup or Emergency Disk – usually a floppy disk for Windows machines, a CD for modern Apple Macs. Alternatively, the motherboard battery may be nearly out of power. The battery keeps basic settings, such as passwords, system data, and date, in a special memory when the computer (an Apple Mac or Windows) is turned off. If that battery cannot keep the memory properly, the system becomes confused when searching for settings at startup. Replace the battery (usually a Lithium type similar to that used in cameras, but check the computer's data sheet for details): it should be a simple job.
You insert a disk or CD as usual but the computer will not recognize or mount it.	If the drive is attached by a cable, check that it is securely connected. If not: first, close down the computer in the normal way; make sure all connections are sound and that the drive is running; then restart the computer.

Using flatbed scanners

Flatbed scanners are intended primarily for two-dimensional artwork and printed material, but you can also use them with small, solid objects (*see pp. 220–1*). For scanning small-format film, such as 35mm, it is best to use a dedicated film scanner (*see pp. 216–17*): only the larger, costlier flatbed scanners are suitable for these miniature formats. You can satisfactorily scan medium-format and larger films on flatbed scanners, which makes them very versatile pieces of equipment.

Getting the best from your scanner

One way of thinking of what a scanner does is to regard it as a type of camera. Just as taking care when capturing an image via a camera increases your chances of a high-quality image, so careful scanning ensures that you have a good-quality digital image to manipulate – and it also cuts out unnecessary correction time on the computer.

- Keep the scanner's glass bed spotless. If you have a transparency adaptor, make sure that is also clean. Lint-free, microfiber cloths are available from camera stores or opticians to clean the glass without the risk of scratching it.
- Check that the colors you have seen on the prescan match those of the final scan.
- Be systematic about your filing and the names you give your images.
- Allow the scanner to warm up for at least five minutes before making your best-quality scans.
- If you are scanning, say, a large book, don't damage the hinge of the scanner lid by forcing it down. Use a heavy weight, such as another book, to hold down and flatten the original against the scanner's glass.
- Save your scanned images to the file format that is easiest for your software to access and use. It is a waste of your time having to change file formats more than is absolutely necessary.
- Line up any rectangular originals as carefully as you can on the scanner glass. Rotating the image after scanning in order to square it up (to correct a sloping horizon, for example) can significantly degrade image quality – especially of line art, such as black-and-white artwork.

Scanning photographic prints

There may be occasions when you get better results by, first, making a print in the darkroom from a negative and then scanning the print, rather than scanning the negative directly and working on that in the computer. Certain manipulations, such as the local contrast controls of burning-in and dodging, are often far easier to achieve in the darkroom than by manipulating a scanned image.

However, if the print intended for scanning has a glossy surface, take care to clean it carefully – every speck of dust, fiber, or loose hair will show up sharply on the resulting scan.

Scanning printed material

There is a wealth of printed material in general circulation, in books, magazines, posters, album covers, and so on, that appears ideal for scanning. But the likelihood is that most of it will be protected by copyright restrictions, and you are likely to be in breach of these restrictions if you scan such material without the copyright holder's written consent (*see pp. 374–5*).

However, in general, if you scan for the sole purpose of study or research, or you intend to make no commercial use of the material, then your actions will probably be exempted.

Scanning stamps and coins

Flatbed scanners are ideal pieces of equipment for making records of valuable items, such as stamp collections (*see opposite*) and coins. The main advantage that a scanner has over a conventional camera is that the scanner is capable of making very accurate records of objects with very little distortion. In addition, a scanner will record the real size of items extremely precisely, and this could be a crucially important consideration for some collectors.

Another factor you might want to consider is that the relatively low light-levels needed for scanning are less likely to harm the delicate coloring of, say, stamps than photographic tungsten lamps, which burn very bright and hot.

Hobbyists

Scanners are perfect for many hobbies, including stamp and coin collecting and autograph hunting, as well as for studies such as graphology. Scanners not only make precise 1:1 (life-size) copies, they also make excellent enlargements of, for example, the slight imperfections that can be so important to aficionados of some hobbies. The magnified view of these stamps (*left*) shows the enlarged "L" that distinguishes this batch.

● Heidelberg Saphir II scanner.

Starting from a print

Sunlight reflecting off these nurses' white uniforms created a contrasty negative. Working digitally, by scanning the original negative, would have meant losing the attractive graininess of the image. In this example, the negative was first printed conventionally, and the resulting print scanned. The digital equivalent was then worked on – principally by slightly warming up the image tones.

● Leica M6 with 35 mm lens. ISO 400 film, printed on Ilford Multigrade. Heidelberg Saphir II scanner.

Optical character recognition

If you scan text documents, such as letters or pages from a book, to create image files, you can edit them only as images. However, by using optical character recognition (OCR) software, which is often bundled with scanners, you can scan text documents to create word-processor files. This gives you the option of editing the text directly. For documents that are clearly printed, such as those from a laser printer, inexpensive OCR software is adequate. You will need a small piece of software to bridge the OCR with your scanner, which is usually available free from the scanner manufacturer's website. Once it is installed, operation is normally very simple, and you may be able to fax, print out, or save documents directly from the OCR application.

Using film scanners

Film scanners may seem highly specialized, but if your images are on photographic film – as nearly all are – a scanner designed for film is the best way to transform silver-based records into digital ones. In practice, you need the same organized and orderly approach as using any other scanner (*see pp. 210–11 and 214–15*).

● Since you will always be enlarging up from a small original, it is more important than ever to keep the system as free from dust as possible. A can of compressed air is invaluable for cleaning films (negatives or slides) before scanning them.

● Make sure you place the film in the scanner the correct way to save you having to rotate or flip the scanned image. This procedure can reduce image quality and so is best avoided.

● Think what you want to use your scan for. If you print a scan on a full 8½ x 11 in sheet you will find that it fills only a tiny part. The image scale should be set to, say, 600 percent to give an enlargement with an output height of some 6 in (15 cm).

Oversampling

Some scanners will read an original image more than once – a process called oversampling or multiple scanning – and then combine data so that differences are averaged. The more data samples that are obtained, the better. Oversampling has the effect of retaining genuine, repeatable information and – because unwanted data is random – it helps to create cleaner shadows. However, it does lengthen scanning times.

Even if your scanner does not offer a multiple scanning option, another strategy is available: making separate scans that are optimized for different tonal ranges. First, make a scan that is corrected for subject shadows; then make another, without any changes to cropping or image size, that is tonally optimized for subject highlights. Next, open up both scans and copy one onto the other before experimenting with blending modes and various opacity settings. For example, set the top layer to Screen with an opacity of 30 percent, or try Color Dodge mode with an opacity of 70

percent. Alternatively, try using Blending options, or use a mask to combine the two images.

Preparation

Once you have made a scan, it is good practice to turn your attention to tidying up the image. In most cases there will be portions of the scan you don't want – parts of the slide mount or film rebate, for example, or an extreme edge that could be removed. Bear in mind that although you may ignore unwanted parts of an image, they will still be taken into the calculations of, say, Levels or Color Balance. However, if you crop off all unwanted portions, you not only reduce the size of the image file, you also remove the extraneous data that may mislead the software.

Next, examine the image very carefully for sharpness and defects. It may be that the scanner failed to focus correctly. If so, rescan now, not after you have started work on the image. Then clean up any dust or particles. If you intend to manipulate the image heavily (*see pp. 256–7*), the best option may be to leave cleaning up to the end, as any even slight carelessness in the cleaning process may become very obvious (*see p. 246*).

Using a pro bureau

Most problems encountered with laboratories or bureaus originate from poor communication between the client and those carrying out the work. To get the best possible results from using a professional bureau, follow these guidelines:

● Give clear, written instructions, particularly if the job is more involved than normal film processing.

● Provide details of how you can be contacted if any problems arise.

● Plan ahead so that you don't collect work on a Friday – if there is a problem, you may then lose two days over the weekend.

● Allow at least the time that the bureau specifies as the standard turn-around period for the work. If you are in a hurry, you must expect to pay extra for a rapid service.

Original image

In the rush to capture this Parisian scene, I managed to underexpose the image, and the scan, as you can see, lacks contrast and color. All is not lost. First, you can scan to improve contrast and then again to add color back into the sky. Then, after opening both files, you need to explore Layers, Blending options, and Masking techniques.

● Olympus OM-1n with 90 mm lens. ISO 64 film. Nikon LS-2000 scanner.

Corrected image

To achieve this much-improved version of the original scene (*above left*), I manipulated the Blending options of the two images to allow the contrasty but darker regions of one image to show through, while retaining the lighter regions of the other image. A final Levels adjustment was then needed in order to improve image contrast overall.

Inferior scanner

A high-quality image scanned at 2,000 ppi on a costly but inferior scanner produces results that seem acceptable. There is detail here that can be improved, while overall tone and color can also be brought out.

● Hasselblad SWC with 38 mm lens. ISO 100 film. Nikon LS4500 scanner.

Superior scanner

The same original scanned on a top-quality scanner, also at 2,000 ppi, shows what can be done. Every detail in the original has been extracted; an enormous print could be made with no post-processing (apart from dust removal).

● Flextight II scanner.

Drum scanners

When you need the best possible image results – for example, if you are making scans for posters or other large-scale reproductions – then there is no substitute for a drum scanner.

This design of scanner uses completely different technology from desktop types. The original must be attached to a glass or acrylic drum, which spins at high speed while a laser beam scans the image. The sensor is a photo-multiplier tube (PMT), which, in principle, works like a night-vision scope to intensify the available light. Drum scanners achieve extremely high resolutions and record over a large dynamic range thanks to this PMT technology. But even at modest resolutions, they capture detail with a sharpness and depth of tone that puts desktop scanners in the shade. But the cost of these machines is high.

Quick fix Scan resolution

Often, one of the most important decisions you normally have to make when it comes to scanning an image is determining the most appropriate resolution to set.

Problem

When scanning, you may be tempted to set a low resolution in an attempt to keep file sizes as small as possible – especially if your computer has inadequate RAM or hard disk space is tight. If, however, you set too low a resolution figure, then the resulting image will look unsharp, image detail will be missing, or the image will appear pixelated.

Setting a higher resolution holds out the promise of higher-quality digital output, but if file sizes become too large, then there is a price to pay – images will take longer to scan, the resulting files will need more storage space, they will take longer to load or transmit, and they will need more memory to manipulate on screen. And files can grow very large, very quickly, when you start to work with multiple layers. Yet higher resolutions do not even guarantee better-quality results.

Analysis

Two approaches are possible. First, you could scan every image at the highest resolution you are ever likely to need, producing files of, say, 25–30 MB in size. You can then make copies, adapting image resolution to each task while copying. This saves you from having to scan an image each time you want to use it for a different job. This way of working uses a lot of data capacity, but it is a good solution for, say, a busy studio.

Alternatively, you scan specifically for the task at hand, and if a new use of the image calls for a higher or lower resolution, then you need to make a new scan. This is the most economical method of working if throughput is not particularly great.

Solution

Check image size The simplest method is to work by the size of the image file: use the table here (see right) as a guide for color images. For black-and-white images, use files a third of the size – instead of 1.9 MB for a

3 x 5 in (7.5 x 12.5 cm) print, use 0.6 MB. When you make the prescan and crop to the part of the scan that you want (see pp. 210–11), tell the scanner driver the size of the printout you want. The driver will then tell you the size of file you will obtain after scanning. If it is not right, simply change the resolution settings until you obtain approximately the file size suggested by the table.

Bear in mind that when you calculate the file size of an image, the size of the original is irrelevant. Whether you reduce a poster to fill a monitor screen or enlarge a postage stamp to fill the same area, the correct file size is exactly the same.

Calculate resolution The more rigorous approach is based on the fact that the number of pixels needed to be input from the scanner equals the total number of pixels needed for output. The calculation is as follows:

> input resolution = (size of output x output resolution)/size of original

Ensure that the size of output and size of original are in the same units – both inches or centimeters – then the input and output resolutions will be the same. Another formula giving the same result is the following:

> input resolution = percentage increase in size x output resolution

You may take the size of the output and the size of the original as one dimension – say, length. Suppose your original is 2 in long and the print you want is 10 in. If you need an output resolution of 300 lpi (lines per inch), then you need 300 x 10 pixels – a total of 3,000 pixels – for output. The input resolution must, therefore, be 3,000 divided by 2 in (the size of the original), which gives the required scanner resolution of 1,500 ppi (points per inch).

The key is to determine the correct output resolution.
● For ink-jets, use anything between 80 and 200 lpi, depending on paper quality.
● For screen-based work, use 72 dpi or 96 dpi.
● For reproduction in print, first determine the screen frequency – it is commonly 166 lpi for good-quality magazines and books but it can vary from 96 to 300 lpi. Then multiply the screen frequency by a "quality factor" of 1.5. For example, if the screen frequency used is 150 lpi, the output resolution required is 1.5 x 150 = 225 ppi.

Here are some examples to illustrate these principles. Note that although the final settings are in lines, pixels, or dots per inch, you can work the early parts of the

Screen shot – film scanner

A dialog box for a film scanner may ask for output sizes: the proportions of length to width is often set by cropping the image or it may be typed in. The resolution setting can also be entered by hand or by setting the scale and letting the software calculate resolution. A useful check is file size: high resolution (2,500 ppi) and 7 MB file size suggest the image is black and white.

Screen shot – flatbed scanner

Complicated-looking dialog boxes, such as the one here for a flatbed scanner, are usually not that difficult to use. Here, you must set an output ruling (166 lpi in this example) and the scaling is set to "Factor", which is indicated at 100 percent. From the dimensions of the frame for the cropping, the scanner calculates the rest, including the resolution – given here as 400 dpi. The expected file size is shown at the top of the box. These figures show the settings for the feather scan on page 221.

calculations using metric measurements if you wish:

1 Your original image is 35 mm long, and you want to make a print that is 250 mm long, and the assumption is that you using an ink-jet printer with an output resolution of 120 lpi.

Input resolution = (120 x 250)/35

\qquad = 30,000/35

\qquad = 857 pixels per inch

Since the original is 35 mm (1.4 in) long, there will be a total of 857 x 1.4 = 1,200 pixels on its long side.

2 Your original is 35 mm long and you want a scan of sufficient quality to be suitable for magazine reproduction up to 250 mm long. Working on the assumption that the magazine prints to a 150 lpi line screen, and with a quality factor of 1.5, the output resolution needed, therefore, is

\qquad 150 x 1.5 = 225 lpi.

Input resolution = (225 x 250)/35

\qquad = 56,250/35

\qquad = 1,607 pixels per inch or, say, 1,600 ppi

Since the original is 35 mm (1.4 in) long, there will be a total of 1,600 x 1.4 = 2,240 pixels on the long side of the image.

Determining file size

Look up the file size for the output you desire, then ensure the scanned file is about the same size by adjusting the dpi or resolution in the scanner driver.

Ink-jet print	3 x 5 in (7.5 x 12.5 cm)	1.9 MB
	4 x 6 in (10 x 15 cm)	2.7 MB
	8 x 10 in (20 x 25.5 cm)	5 MB
	8½ x 11 in (21 x 28 cm)	6.9 MB
	11 x 17 in (28 x 43 cm)	12.6 MB
Image for web page	480 x 320 pixels	0.45 MB
	600 x 400 pixels	0.7 MB
	768 x 512 pixels	1.12 MB
	960 x 640 pixels	1.75 MB
Book/ magazine printing	8½ x 11 in (21 x 28 cm)	18.6 MB
	8 x 10 in (20 x 25.5 cm)	13.6 MB
	5½ x 8½ in (14 x 21 cm)	9.3 MB
	5 x 7 in (12.5 x 17.5 cm)	6.7 MB

How to avoid the problem

Experiment with using the lowest resolutions you can manage that do not compromise the quality of the image. The exercise is most valuable when you are using an ink-jet printer. Working with the smallest possible files will help to save you both time

and money. Your work is likely to fall into a pattern after a while: keep a note of the settings that produce satisfactory results and reapply them to your new work. If you are outputting using commercial printers, ask them for their recommendations.

Using scanners as cameras

Since you can think of scanners as being a type of camera – indeed, professional digital cameras used in studios are essentially scanners built into the camera back – they can be used to make records of same-sized or enlarged views of small objects. It is even possible to use a desktop scanner outside, when shooting on location, say, by powering it from a car battery.

Scanning solid objects

You can scan anything that will fit on the scanning glass, but take care not to scratch or damage it in any way. Ideal subjects for scanning include essentially flat, nearly two-dimensional objects, such as dried leaves or flower petals, embroidery, textiles, textured papers, or wallpaper. But other small objects also scan very well: jewelry, sea shells, insects, seeds, or pebbles, for example. Food items such as rice, dried pasta, sugar grains, or cake decoration can also be interesting to try.

Being designed to record two-dimensional objects, flatbed scanners have only a limited depth of field (*see pp. 84–7*). As a result, only the parts of objects in contact with the glass will be sharp, but you can still experiment with other subjects – for example, you could try making a portrait by scanning a person's face. Interesting results are also possible if you don't flatten objects – the undulating shape of a leaf, for example, can look intriguing as it goes in and out of focus.

When scanning solid objects you will have to experiment with backgrounds. If you leave the scanner lid open, objects will be seen against a black background. If you need a white background, cover the object with white paper – but beware, the scanner may then pick up the texture of the paper and this can be difficult to remove later on. Try shining a light on the paper during the scan. This will brighten the background and so reduce the impact of any texture it may have.

If objects are semi-translucent, such as jewelry or lightweight silks and other fine textiles, you can try scanning them as if they were color transparencies – in other words, use the transparency adaptor of the scanner and then set the software to scan in transmission mode.

1 Feather
I first scanned this feather with the lid up, giving a black background. The feather was so flat, that covering it with paper would have added texture. I changed the background to white later on in Photoshop.

2 Shells
Next, I placed these shells on the glass and covered them with handmade paper. I then scanned them at full size with the tones adjusted for soft contrast and subtle color, and blurred the image a little.

3 First combination
This image comes from setting the feather layer to Difference. It exaggerated the differences between pixels on the two layers – a white pixel overlaying another white pixel is turned black.

Caring for your scanner

● Do not scan anything that is damp or wet, as water may enter the mechanism and corrode it.
● Take care to avoid damaging the glass bed with acid or grease from your fingers or colored food.
● Be extremely careful if you scan jewelry, pebbles, sea shells, or anything else that may scratch the glass.
● Don't force the scanner lid down on an object in an attempt to flatten it. You will strain the hinges, which are usually not very robust. Flatten objects, if necessary, before placing them on the scanner bed.

4 Final effect
The feather image, with its white background, was laid over the shells. I then experimented with the various Layer blending modes and found that Color Burn with the shells layer inverted (in other words, with tones reversed) gave the best result. To finish, I made some additional adjustments in Color Balance.

Layer mode
A seemingly complicated image can, in fact, be quite simple: two layers were used but, crucially, the one carrying the feather is smaller. Its layer blending mode was set to Color Burn, which reverses underlying tones. To soften its effect, opacity was reduced a little – from its 100 percent maximum to 87 percent.

File formats: A summary

Most types of data file are produced by application software to be used specifically by that software, and so there is only limited potential for interchange with other programs. However, image files are different, as they can be accessed and used by a range of programs. This is achieved by building them in widely recognized data-structures, or formats. The following are commonly supported.

TIFF

(Tag Image File Format) A method of storing image data, the best choice for images used in print reproduction, and a de facto standard. A bit-mapped or raster image file format supporting 24-bit color per pixel, with such data as dimensions and color look-up tables stored as a "tag" and added to the header of the data file. A variety of tag specifications give rise to many types of TIFF, leading to compatibility problems. The format can be compressed without loss (or losslessly) using LZW compression. This reduces file size by about half on average, but slightly slows down file

opening. It is always safe to compress TIFF files, although some bureaus may specify un-compressed files. The Windows suffix is .tif.

JPEG

(Joint Photographic Expert Group and pronounced "jay-peg") A format based on a data-compression technique that can reduce file sizes to as little as 10 percent of the original with only a slight loss of quality. This is the best choice for photographs intended for use on the internet. When files are saved as JPEGs you will be offered different levels of quality. For general use, a middle setting (5 or 6) is sufficient, as it gives very good reductions in file size without noticeable loss in image quality. A high setting of 9 or 10 is the level you should choose for high-quality work – the file size is still smaller than that possible with LZW compression and loss of quality is all but invisible. The Windows suffix is .jpg.

Photoshop

This is an application-native format that has become so widespread that it is now almost a standard. Photoshop supports color management, 48-bit color, and Photoshop layers. Many scanners will save directly to the Photoshop format, and the format used on other types of scanner may, in fact, be Photoshop, albeit under a different name. The Windows suffix is .psd.

GIF

(Graphic Interchange Format) A compressed file format designed for use over the internet, comprising a standard set of 216 colors. It is best for images with graphics – those with larger areas of even color – but not for photographic images with smooth tone transitions. It can be compressed losslessly using LZW algorithms. The Windows suffix is .gif.

PDF

(Portable Document Format) A file format native to Adobe Acrobat based on PostScript. It preserves the document text, typography, graphics, images,

"Save as" screen shot
Whenever you save a digital picture file you need to make a decision about which format to save it in. The safest choice is TIFF, which is very commonly recognized, but specific picture needs, perhaps for publication on a website for example, may demand that you use another type of format. You can use this dialogue box to change from one format to another. To preserve the original, save your new file under another name when choosing a different format.

and layout. There is no need to embed fonts. It can be read, but not edited, by Acrobat Reader. The Windows suffix is .pdf.

PhotoCD

Kodak's Photo Compact Disc is a format with a pyramidal structure that is used for transferring files from scanners onto CDs. The format supports compressed versions of each image stored at different resolutions – from 128 x 192 pixels to 2,048 x 6,144 pixels. The Pro version accepts resolutions up to 4,096 x 6,144 pixels. To open PhotoCD files you need the appropriate plug-in or filter in your software (this is best saved for further use as a TIFF or JPEG). The Windows suffix is .pcd. Don't confuse PhotoCD with PictureCD, which is more a service than a format.

PICT

(Macintosh Picture) This is a graphics format for Mac OS. It contains raster and vector information but is nominally limited to 72 dpi, being designed for screen images. PICT2 supports color to 24-bit depth, and it can be opened by very simple programs, such as SimpleText.

PNG

(Portable Network Graphics) A file format for losslessly compressed web images. It supports indexed-color, grayscale, and true-color images (up to 48 bits per pixel), plus one alpha channel, with sample bit depth of up to 16 bits. It is intended as a replacement for GIF and may well also replace TIFF on the web. However, it does not support CMYK color space.

JPEGs in detail

JPEG compression is efficient due to the fact that several distinct techniques are all brought to bear on the image file at the same time. Although it sounds complicated, thankfully modern computers and digital cameras have no problem handling the calculations. The technique, known as "jay-pegging," consists of three steps:

1 The Discrete Cosine Transform (DCT) orders data in blocks measuring 8 x 8 pixels, which creates the characteristic "blocky" structure you can see in close-up (*see right*). Blocks are converted from the "spatial domain" to the "frequency domain," which is analogous to presenting a graph of, say, a continuous curve as histograms that plot the frequency of occurrence of each value. This step compresses data, loses no detail, and identifies data that may be removed.

2 Matrix multiplication reorders the data for "quantization." It is here that you choose the quality setting of an image, balancing, on the one hand, your desire for small-sized files against, on the other, the loss of image quality.

3 In the final stage of jay-pegging, the results of the last manipulation are finally coded, using yet more lossless compression techniques.

JPEG artefacts

This close-up view of a JPEG-compressed image shows the blocks of 64 pixels that are created by the compression feature. This can create false textures and obscure detail, but on areas of even tone, or where image detail is small and patterned, such artifacts are not normally visible – even with very high levels of compression. Note how the pixels within a block are more similar to each other than to those of an adjacent block.

The effect of these compressions is that JPEG files can be reduced by 70 percent (or, reduced to just 30 percent of their original size) with nearly invisible image degradation; you still have a usable image even with a reduction of 90 percent. However, this is not enough for some applications, and so a new technology, known as JPEG2000, based on another way of coding data, offers greater file compression with even less loss of detail.

Quick fix Problems with scans

Scanning turns your film-based work into digital form, that you can work with in your computer. The quality of the digitization is crucial to the quality of everything you subsequently do with your images, so you can see that it is important to take considerable care at this stage of the process. You do not want to work at an image for days only to discover it was scanned at too low a resolution or that it has defects that are too deep to remove without undoing all your work.

Problem: File size is too small

The most common error is working on a file size that is too small for the intended task (see pp. 218–19 for details on how to calculate the optimum file size). Always check your image's file size before you do any work on it: you want it to be neither too large (as it will slow your work down unnecessarily), nor too small (as output quality will then be too low).

Solution

If you discover that the file size you are working on is too small for what you want to do with it, then you have no option other than rescanning and starting again. The quicker you come to this decision the less of your work you will have to redo.

Screen shot
The settings on this dialogue box are something you should never see in reality. They show that a small image of 3.2 MB in size is about to be enlarged to a normal page-size print. For the resolution required, however, the resulting file size will grow to more than 16 MB (shown in the top line) – five times larger than the original. With this level of interpolated enlargement, the result will show broken-up detail. It will be best to rescan the image to the required 16MB.

Problem: Newton's rings

When you place a film strip directly on the glass surface of your flatbed scanner, although you may not realize it you are also trapping a thin layer of air beneath the film. This layer of air acts like an oil film – of the type you often see on a road surface – that causes the light to split into rainbow-colored patterns, known as "Newton's rings." These colored distortions are extremely troublesome to remove from the image and it is best to keep them from occurring in the first place.

Solution

Avoid placing film strips directly on the scanner's glass surface. Most scanner manufacturers provide special holders for film strips or individual frames. If this is not the case with your machine, then make certain that the scanner is warmed up before starting – hot, dry air seems to reduce the incidence of Newton's rings.

Newton's rings
This film (only a portion of which is seen here) was scanned on a flatbed scanner because, having been produced by a panoramic camera, it was too long to fit into a normal film scanner. When held down by the scanner's lid, the trapped air created these tree-ring-like patterns (which have been slightly exaggerated for reproduction purposes). They are extremely difficult to remove as they cover a large area and are also colored.

Problem: Jitter and other artifacts

Before starting work on an image, examine it closely for signs of any features that are not part of the original. Even the most expensive scanners can introduce artifacts, or imperfections, such as tiny black dots in light areas. These may be so small that they are invisible at normal size; some other errors, however, such as jitter, or the uneven movement of the scanner head, cause defects that are obvious at normal print sizes (*see right*) – although they may be invisible at screen resolution. Defects may result from movement of the original during scanning – for example, if your book slips slightly, then the image will appear slightly stretched or smeared.

Solution

Rescanning on the same or on a better-quality scanner will solve the problem, unless the defect is due to the movement of the original.

Scanner jitter
A scan from an inexpensive scanner produced these streaks, which are due to the uneven movement of the head. The streaks have been exaggerated for reproduction purposes, but would be visible anyway when printed. Small areas could be improved by cloning, but essentially a better scanner is required.

Problem: Moiré from printed material

This problem arises when there is a clash between the regular pattern of the dots on the printed page of a book or magazine, say, and the regular raster pattern of the scanner. This conflict can cause a new pattern – known as a moiré pattern – to be superimposed over the image, usually with unsightly results.

Solution

There are several methods of dealing with moiré. You can rescan the original using a slightly different resolution setting, or you could try aligning the page slightly differently on the scanner's platen – just a small change of angle may be enough to do the trick. Some scanner software offers filters designed to remove, more or less successfully, such moiré patterns, but this is often at the cost of critically sharp image detail. Bear in mind that using sharpening filters (*see pp. 248–51*) may bring out a moiré pattern.

Moiré patterns
Just a small area of a photograph of a heron printed in a book was scanned for this example. You can readily see that the resulting image has picked up the array of halftone dots that make up the printed original. The pattern of these dots has clashed with the regular array of pixels, resulting in the creation of another pattern. Seen here, it gives the impression of looking at the scene through an intervening fence of chicken-wire.

Quick fix Problems with scans continued

Problem: Noisy shadows

Image "noise," or pixels with random values *(see pp. 46–7)*, are encountered in scanned images most frequently in the shadow regions of the image. In the example shown here *(see below)*, the dark areas should be black with smooth transitions to the lighter areas, but the speckled appearance shows a very noisy scan, which was produced by an inexpensive scanner.

Solution

Scans may be improved by increasing the overall brightness of the image, but that may be at the cost of losing highlight detail. If the shadows are of very high density – for example, those in high-definition transparency film – you may need to use a better-quality scanner.

Problem: Underexposure

You may have set the brightness level too low – often occurs as a result of compensating for a previous orig that was too bright. You may also have assessed the prescan with the monitor screen incorrectly adjusted. result is a scan with all the data skewed toward the shadow regions. An underexposed scan can, of course also result from an underexposed camera original.

Solution

Make a new scan. If the original is underexposed, improve it as far as possible at this stage rather than in post-scanner processing. It may help to scan at the highest bit-depth available (say, 36- or 48-bit), make t tonal corrections, and then convert to normal 24-bit.

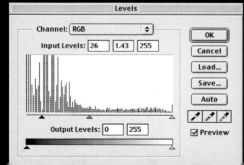

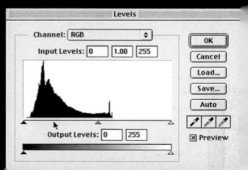

Quick fix Inaccurate printer colors

The basic problem of color reproduction is that monitors produce colors in a different way from printers. Bearing this in mind will avoid you harboring unrealistic expectations. You can see from any diagram comparing the color spaces enclosed by printers compared with the color space of monitors (*see p. 117*) that the deeper blues, greens, and reds seen on a monitor cannot be reproduced in print. These colors are the typical hues that are out-of-gamut for printers – in other words, cannot be printed.

Problem: Screen/printer colors don't match

If image colors look correct on the screen but not when they are printed, there is a failure of communication between your software, monitor, or printer. Assuming that your monitor, software, and printers are correctly set up, you may need to alter the printer's advanced settings or options. You can usually change color balance by dragging the sliders provided: change these by small increments, note the settings ("capture," or save, them if the facility is available), and then reprint. Repeat this procedure until you obtain the results you want.

Problem: Bright colors merge

You have over-saturated colors. Although they appear distinct on screen, they are out-of-gamut on the printer. As a result, what were different colors blend into one hue. Try to reduce saturation overall by, say, 10 percent a time until you start to see the separation of colors in the print. If this makes the other colors in the print too dull, try selecting the most vivid colors using, for example, Photoshop's Replace Color function, and then reduce the saturation of a limited range of colors. Color gamut of printers is usually largest if you use the best quality of glossy paper and the manufacturer's own inks. Change the paper if you are not using the best quality.

Problem: Weak colors with patterns

You have chosen a regular dither pattern. "Dithering" is a method of simulating a wide range of colors from a limited choice. For photographic images, you need a random dither pattern, while a regular one is better for business graphics (and it prints much faster, too). Choose random, or diffuse, dither in your printer driver options.

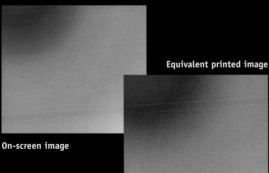

Equivalent printed image

On-screen image

Print brilliance
These images simulate the change you could see when printing out a highly saturated screen image on paper. The loss of depth and richness of color is dramatic when you compare them side by side in this fashion. Fortunately, most people looking at your prints will never see the screen image for comparison – as a result, they would accept the print on its own terms.

Dither patterns
What should be a smooth transition from pale blue to violet here appears banded and patterned. This is not because a small number of colors was used to simulate what really required hundreds of colors for accurate reproduction, but because the colors were ordered into regular patterns. If distribution were more random, the gradient would look much smoother.

Basic color management

Color management is a method of ensuring that the reproduction and display of color is as consistent as possible along the entire imaging chain. There are two key elements: first, the calibration of each item of equipment to ensure it is working to specification or to a known standard; second, the exchange of color profiles (a small piece of data) between key parts of the imaging chain, particularly between the image file and monitor, and between the monitor and output device, such as a printer. It is not necessary for you to work to industry standards, but if you work in a color-managed system on your own desktop, you will enjoy reliable, trouble-free image making.

First steps

The simplified procedure explained on these pages (*see also pp. 230–1*) will help you start a basic system. The key step is to calibrate your monitor – or make it comply with a standard. This does two things: first, it ensures your monitor is properly set up for brightness, color balance, and so on; second, this setup information is then used to characterize the monitor – in other words, a color profile (*see p. 368*) of the monitor is created that software, such as Photoshop, can use.

Apple Mac users can use the ColorSync utility, which is supplied as part of Mac OS, or Adobe Gamma, which is supplied with all versions of Photoshop, including free trial versions (*see opposite*). Once the calibration is completed, save it and use it as the monitor profile. During calibration, choose D50 as the white point and a gamma of 1.8. Note that using the software utilities relies on judgements made by eye.

In digital photography, the greatest difficulty in the control of color is that in many situations the photographer judges color balance by comparing two very different samples – for example, the image on a monitor screen and the same image printed out by, say, an ink-jet printer. Now, you would not be surprised to see differences in color reproduction from two printers – even if they were exactly the same model from the same manufacturer. So how much greater is the difference

between a monitor, which presents colors with glowing red, green, and blue phosphors, and a printer, which reproduces the same colors using dots of differently colored inks?

Manufacturing standards

It is an achievement to produce a print from an ink-jet printer that looks the same as one printed on, say, photographic paper or in a book. This can happen without any intervention from you if, for example, your scanner or digital camera was properly calibrated at the factory, your color settings for the printer were left untouched, and you printed without altering the image. This is so because the industry works to common standards and modern control of quality is extremely high.

Nonetheless, the weak link in this chain is the monitor: it is possible, despite an accurate print being produced by your printer, that the image on your monitor does not look correct. If you were to change the image until it did look right on screen, then it follows that the resulting print would be incorrect. This explains the central importance of calibrating your monitor. Fortunately, most of today's monitors are also built to extremely high standards of consistency, so the settings straight out of the box are often as good a starting point as any (*for further details on setting up your printer, see pp. 342–5*).

Soft proof

A monitor that is correctly calibrated is one that gives an accurate soft proof – in other words, it does not need to be printed out for confirmation. You should observe sensible precautions such as not shining a desk lamp onto the screen. If your work area is bright during the day but dark at night, you could use two profiles according to the brightness of the room. Finally, avoid using garish screen backgrounds with colored patterns or, indeed, backgrounds (also called desktop patterns or pictures) with any color at all. Expert image manipulators work on neutral and midtone gray backgrounds. Strong colors on your monitor's desktop could upset your color judgement.

Basic monitor calibration

Use the Adobe Gamma control panel or settings available on Macs and PCs. The first step in calibrating any monitor is to make the screen image as bright as possible, using the monitor controls. Then adjust the contrast, still using monitor controls, until you can just see alternate bars in the Brightness and Contrast strip near the top of the control panel. In the Gamma section, click on the dropdown window next to "Desired": for the Mac or the Windows default. Then adjust the slider above this so that the central square merges as well as possible with its striped frame. For the white point, set standard daylight of 5,000 K, although many experts use the 6,500 K, as this gives a more pleasant screen image. You are then ready to quit this panel, at which point you will be prompted to save the settings.

Color balance

If you uncheck the box "View Single Gamma Only," you will see three targets. This enables you to adjust color balance. Each of the central squares should merge into its background when the monitor is balanced neutrally with respect to color. It helps to squint when adjusting the sliders underneath (click on them one at a time with the mouse and hold down the mouse button as you drag the control) – it is particularly difficult to judge when the green merges best. If you are not sure what to do, you can click on "Assistant" and you will be guided. Note that for the resulting settings to be operational, you need to tell the computer that these settings are to be used – this is done in various control panels and in your image-manipulation software: consult your computer manuals for the latest instructions.

How often should you calibrate?

Professional users, whose work relies on consistency from day to day, should calibrate their monitors about once a week, or at least every month. Monitors should be recalibrated if moved (even a small distance), if new electrical equipment is installed nearby (due to the effect of magnetic fields), or following any changes to screen resolution or color depth. It follows that frequent changes to screen resolution are not recommended. Other equipment should be calibrated following any major change, such as when, for example, ink supplies are changed, a new type of paper is used, the printer is transported any distance from its normal position, or if the printer drivers are updated.

Screen image

Reflections on the screen or ambient lighting can affect your perception of screen color, problems that can be lessened by adding a side and top hood.

Basic color management continued

Step-by-step monitor calibration

1 Find the controls
In your operating system's control panel or settings folder you should be able to find the controls for your monitor. This is an example for the Mac OS, which takes you logically through the process, giving full explanations on the way. If you have a profile you can choose it from the list offered, or else click "Calibrate…" to check your monitor. It is usually best to create your own profile.

2 Monitor brightness
As with the Adobe Gamma control (*see p. 229*), you first need to make your monitor as bright as possible, then adjust the contrast to a standard defined by the dark target. You may find that your monitor is uncomfortable to look at when it is set to its brightest, but it will look better once you adjust the contrast.

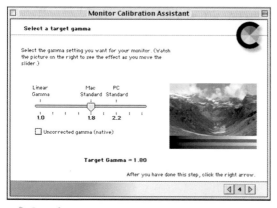

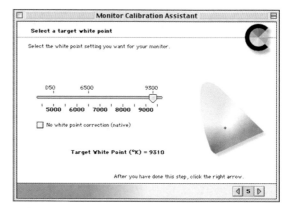

4 Setting screen gamma
The monitor's gamma should not be confused with photographic gamma: it is a correction factor that makes the screen darker as it increases. So the standard Mac gamma of 1.8 produces a brighter screen image than the 2.2 for Windows or PC machines, while the uncorrected gamma gives a very bright screen.

5 Setting the white point
The target white point establishes the overall color balance of the screen. The professional preference is 5,000 K, which is the equivalent of the color of white paper viewed under daylight – in other words, somewhat warm. When you first adjust this, the colors look quite unacceptable, but your eyes adjust in time. The setting of 9,300 K gives a bright, cool white, which is the easiest to work with, but not suitable for image manipulation.

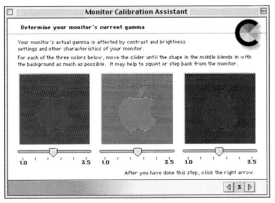

3 Color balance settings

The next dialogue box takes you to the color-balance settings. You need to merge the apple shapes into their backgrounds as well as you can using the slider controls under each panel. Half closing your eyes will help. It is important that you do all this against as dark or neutral a background as possible.

Warm white

This dialogue box shows the result of setting the target white point to a low setting of 4,500 K: whites are turned to a distinct yellow, with consequent distortion of all other color values.

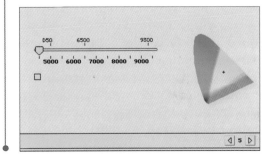

6 Save your settings

Finally, you need to save all the settings (which make up the profile). These can be saved with your image files, where it can be consulted by hardware such as another person's monitor. In this way, an image seen on your monitor will look the same on that other monitor, provided that it has been set up correctly. Remember to give the calibration a name, one you can easily identify. Including a date in the name is always a good idea.

Color unbalanced

If you send the color slider controls to extreme positions you obtain an extreme color balance: notice how the apple shapes are very distinct. The overall color is blue, naturally, when the red and green controls are set to their minimum settings and blue is maximized.

File management

Working with a conventional camera, you may return from a trip with, say, 20 rolls of film; some 700 images, an easily manageable number. The equivalent 700 files in digital photography may seem much more daunting.

File management

Folders in a computer file management are like paper folders – it is best not to keep too much in any one. If you have dozens of files in a folder it takes longer to find any one and your computer may slow down when it has to display them all.

Instead of keeping all working files in the same folder, start a new one for each project. And as a project grows, you can subdivide it into other folders by, say, date, country, or subject. For example, on an overseas trip you could create separate folders for each day's shoot: some days, there may be only a few shots; on a good day, dozens.

File naming

Digital cameras automatically give file names to each image. Make sure your camera gives a unique file name, even when you insert a new memory card. Note, some cameras, start from the beginning (for example, IMG_001.jpg, IMG_002.jpg, and so on) whenever you start a new card. If possible, turn this facility off on the camera so every image has a unique name.

For small to medium-sized collections, the most versatile system is to give a number and type for each disc: for example, CD 009 or Zip 034. Don't forget to use leading zeros, as system software will sort disc 100 ahead of disc 99. For large collections, you will need a more sophisticated cataloging system, such as by subject or project number.

Asset management

Not only will you produce innumerable digital files in a short time, you may produce lots of ink-jet prints. You should value all this work – after all you have put in a great deal of skill and time – so it makes sense to manage these assets. An essential part of good practice is to label or number all work – certainly the final prints. Note the file name for each print you make, as well as any details, such as printer settings. You might know right now which file the print came from, but is it likely you will be able to find it again in two or three years?

Keep your successful printouts carefully: store them in good-quality boxes, preferably the type made from acid-free cardboard produced for storing photographic prints. And you should always archive and backup your digital files.

			NZ B.fdb		
Filename	File Size	Last Modified	File Type Mac ▲		Volume
IMG_0378.JPG	1491K	14/4/01 6:17:46 pm	JPEG	G4 HD	
IMG_0379.JPG	1170K	14/4/01 6:21:46 pm	JPEG	G4 HD	
IMG_0380.JPG	1277K	14/4/01 6:21:54 pm	JPEG	G4 HD	
IMG_0381.JPG	1296K	14/4/01 6:22:14 pm	JPEG	G4 HD	
IMG_0382.JPG	1263K	14/4/01 6:22:18 pm	JPEG	G4 HD	
IMG_0383.JPG	1379K	14/4/01 6:22:20 pm	JPEG	G4 HD	
IMG_0384.JPG	1413K	14/4/01 6:24:02 pm	JPEG	G4 HD	
IMG_0385.JPG	1450K	14/4/01 6:24:04 pm	JPEG	G4 HD	
IMG_0386.JPG	987K	14/4/01 6:24:42 pm	JPEG	G4 HD	
IMG_0387.JPG	1460K	14/4/01 6:25:00 pm	JPEG	G4 HD	
IMG_0388.JPG	1059K	14/4/01 6:25:14 pm	JPEG	G4 HD	
IMG_0389.JPG	1133K	14/4/01 6:25:46 pm	JPEG	G4 HD	
IMG_0390.JPG	996K	14/4/01 6:25:58 pm	JPEG	G4 HD	
IMG_0391.JPG	1145K	14/4/01 6:26:00 pm	JPEG	G4 HD	
IMG_0392.JPG	1284K	14/4/01 6:27:16 pm	JPEG	G4 HD	
IMG_0393.JPG	1408K	14/4/01 6:27:36 pm	JPEG	G4 HD	
IMG_0394.JPG	1398K	14/4/01 6:27:58 pm	JPEG	G4 HD	

103 of 103

IMG_0384.JPG

Thumbnail Keywords Description

File lists

It is easy to find files when they are neatly listed, and you can change the order in which they are listed if you wish. Highlighting a file produces a little thumbnail picture to remind you of what it is. A text description of each file can also be created.

Archiving

The safest way to archive your digital files is to copy them onto a CD (Compact Disc), using a CD-writer. There are two types of writable CD: with a CD-R, you can write to it only once, but read from it as many times as you like; with a CD-RW, you can write to it many times as well as read from it as often as you like. In general, the most convenient and economical is the CD-R. CD-RW disks are not reliable and in order to write new data, you must erase the old, which can take a long time. With the CD-R, although it can be written to only once, it can take less than 5 minutes to write a full 650 MB load. For this, you need a fast CD-R writer, controlled from the computer (some computers have these installed internally), plus suitable "CD-burning" software (*see pp. 72–3*).

For more modest loads, you can copy your files onto magnetic media, such as Zip, Jaz, MO, or similar. These cost more than CDs to buy but you can reuse them over and over again, and accessing files is quicker than with a CD.

Backup software, which compresses your data to make more efficient use of space, can help you manage your files. However, you may find that accessing the backups – which has to be done through the software – is less convenient than keeping copies of the actual files.

You may consider keeping archives of early working or work-in-progress files, not just the final files. These may create useful records for historical reasons – in case of litigation over copyright, say. And sometimes ideas that do not fit one project may be useful for another, but you may not know this until months or years later.

Disorganized files

It is time consuming and difficult to look for a particular image when they are scattered around randomly like this, yet many digital photographers spoil their own enjoyment by working in this way.

Special software
One of the best ways to organize your images is by using cataloguing software. A relatively simple but fast-working example is FotoStation, illustrated here. Other applications worth considering are Cumulus, Portfolio, and ACDSee. Not only do all these programs help you to keep picture files organized, they can also create "contact prints," "slide" shows, and publish picture collections to the Web.

Cropping and rotation

Always make sure scanned images are correctly oriented – in other words, that left-to-right in the original is still left-to-right after scanning. This is seldom a problem with images taken with digital cameras, but when scanning a film original it is easy to place the negative or transparency the wrong way around – emulsion side either up or down, depending on your scanner – so that the scanned results become "flipped." Getting this right is crucially important if there is any writing or numbering in the image to prevent it from reversing, as in a mirror image.

Image cropping

The creative importance of cropping, to remove extraneous subject detail, is as crucial in digital photography as it is when working conventionally. But there is a vital difference, for not only does digital cropping reduce picture content, it also reduces file size. Bear in mind, however, that you should not crop to a specific resolution until the final stages of image processing, as "interpolation" may then be required (*see pp. 256–7*). This reduces picture quality, usually by causing a slight softening of detail. Image cropping without a change of resolution does not require interpolation.

In general, though, at the very least you will want to remove the border caused by, for example, inaccurate cropping when making the scan. This

area of white or black not only takes up valuable machine memory, it can also greatly distort tonal calculations, such as Levels (*see pp. 242–3*). If a border to the image is needed, you can always add it at a later stage using a range of different applications (*see p. 258*).

Image rotation

The horizon in an image is normally expected to run parallel with the top and bottom edges of the image. Any slight mistakes in aiming the camera, which is not an uncommon error when you are working quickly or your concentration slips, can be corrected by rotating the image before printing. With film-based photography, this correction is carried out in the darkroom during the printing stage. But since it is a strictly manual process you should not expect this type of correction to be an option available from the fully automatic printers found in minilabs.

In digital photography, however, rotation is a straightforward transformation, and in some software applications you can carry out the correction as part of the image-cropping process.

Note that any rotation that is not 90°, or a multiple of 90°, will need interpolation. Repeated rotation may cause image detail to blur, so it is best to decide exactly how much rotation is required, and then perform it all in a single step.

Fixed-size cropping

Some manipulation software, such as Photoshop, allows you to crop to a specific image size and to a specific output resolution – for example, 5 x 7 in (13 x 18 cm) at 225 dpi. This is useful because it combines two operations in one and is very convenient if you know the exact size of image needed – perhaps a picture for a newsletter. If so, enter the details in the boxes, together with the resolution. The crop area will then have the correct proportions, allowing you to adjust the overall size and position of the image for the crop you require. Cropping to a fixed size is useful for working rapidly through a batch of scans.

Crop Options screen shot
By clicking on "Fixed Target Size" you can crop to a specific size and resolution. This is a convenient way not only to change the image size but also to change the resolution of your image.

Color mode

Automatic Levels can lead to various results, depending on color mode. The initial RGB scan of this picture was dark and too warm in color (*above left*). Still in RGB (*p. 263*), the first correction was too bright (*above right*). This is because invoking Automatic Levels indiscriminately spreads values evenly in each channel. But after turning the image into LAB mode (*p. 275*), automatic correction produced a very accurate outcome (*right*).

● Canon EOS-1n with 80–200 mm lens. ISO 100 film. Microtek 4000t scanner.

⚠ Could not find the application program that created the document named "microtk settngs".

To open the document, select an alternate program, with or without translation:

- Photoshop® 6.0
- Adobe GoLive 5.0 with QuickTime translation
- Adobe Illustrator® 9.0
- Appearance
- Apple DVD Player with QuickTime translation
- CanoScan Toolbox

☑ Show only recommended choices

[Cancel] [Open]

"Could not find" screen shot

If you see this warning, or one like it, just look for the appropriate application on the list and click on it. If your application does not appear, do not panic: it is still in the computer. Start the application first, then try to open the file from within it.

Checking the image

- Check color mode. Some scanners produce LAB files or may have been incorrectly set. Most image-manipulation software works in 24-bit RGB color, and if the image is not in the correct mode many adjustments are not available or give odd results.
- Assess image sharpness. Are the colors clear and accurate? If not, you may have scanned it incorrectly or opened up a low-resolution version.
- Make sure there is no excess border to the image caused by inaccurate cropping during scanning (*see pp. 238–9*). If there is, remove it with the Crop tool. Unwanted black or white regions will distort tonal calculations.
- Check the file size. It should be adequate for your purposes but not much larger. If it is too small, you could work on it for hours only to discover that it is not suitable for the output size desired. If it is too large, you will waste time because all manipulations take longer than necessary to complete.

First steps

The usual way to open a file is to double-click on it; you place the cursor over the icon for the file and quickly click the mouse twice. The computer's operating system then checks to see what type of file it is and launches a suitable software application. This, though, is not the best way – the wrong software application may start up. The computer may also give a warning saying the file could not be opened (*see below right*). A better method is to start the application first and then open the file from within it. This often succeeds when files have lost their association with an application and so cannot be opened with a simple double-click.

Image sources

Certain sources of images, such as Photo CDs and images taken with professional Kodak cameras, should be opened from within the application recommended by the manufacturer. This is because the files may need to be uncompressed or otherwise processed to extract the best image quality before they are used.

Internet downloads

Images from an Internet site are usually in JPEG format (*see pp. 222–3*). If you expect to work on an image and then save it for extra treatment later on, it is good practice to perform a Save As on the file into a different format – for example, Photoshop or TIFF. Each time you save and close an image in JPEG, it is taken through the compression regimen – the file size may not reduce greatly, but quality progressively degrades.

Copyright and watermarks

Images from picture-agency CDs, the Web, or those on CDs given away with magazines may show a "watermark" – the company's or photographer's name – printed across the image. This prevents piracy and asserts the copyright holder's rights. Images may also be invisibly marked – although there is no printing overlaying the images, they resist all but the most destructive changes to the files and suitable software can readily detect the invisible identification watermark.

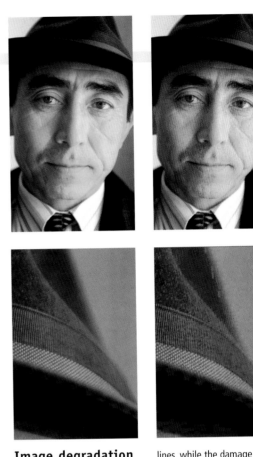

Image degradation
This original portrait (*top left*) was saved several times with maximum JPEG compression (*top right*). Used small like this, the image is acceptable but, in fact, the original is far better, with smoother tones and more accurate color. A close-up look at the original image (*above left*) shows continuous tones and unbroken lines, while the damage to the compressed version (*above right*) is obvious. A large print made from the JPEG image would simply not be acceptable.

● Canon EOS-1n with 28–70 mm lens. ISO 100 film. Microtek 4000t scanner.

The document "commex.vcf" could not be opened because the application program that created it could not be found.

Could not find a translation extension with appropriate translators.

OK

"Could not be opened" screen shot
If you see this warning box on your screen, or one like it, do not worry. You should be able to open the file from within an application. To do this, launch the application first and then try to open the file using the menu options provided.

5

All about image manipulation

Software insights

Filters, image effects, distortions, color control, manipulations, and much more – this chapter presents you with a detailed round-up of the spectrum of possibilities that modern image-manipulation software makes available to today's digital photographer.

Learning by example

Step-by-step guides and explanatory screen shots give precise information on how to achieve similar results using your own pictures. From burning-in and dodging to image sharpening, from darkroom effects such as Sabattier and hand-tinting to cross-processing and gum dichromates. Carefully written and designed to be accessible to the beginner, you will quickly discover how even simple techniques can produce advanced, eye-catching effects.

Help on hand

Quick-fix sections help you deal with poor subject detail and color, remove distracting subject elements, frame images, fix problem skies, and remove unwanted backgrounds.

Image size and memory

Reducing the size of an image by half reduces its file size by three-quarters. In this series, the size of the third-largest image is half that of the largest, but its file size is a quarter. The smallest image here has a file size a full 16 times smaller than the size of the original. This is why even a small crop can cause a significant saving in machine memory.

● Nikon Coolpix 990.

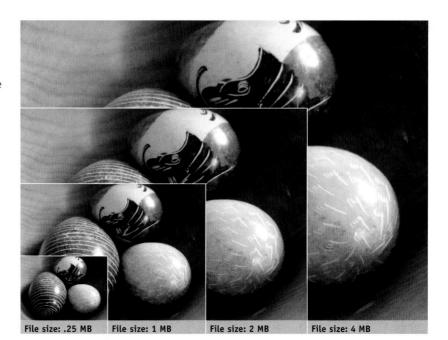

File size: .25 MB File size: 1 MB File size: 2 MB File size: 4 MB

Sloping horizon

A snatched shot taken with a wide-angle lens left the horizon with a slight but noticeable tilt, disturbing the serenity of the image. But by rotating a crop it is possible to correct the horizon, although, as you can see from the masked-off area (*above left*), you do have to sacrifice the marginal areas of the image. Some software allows you to give a precise figure for the rotation; others require you to do it by eye. Some scanner software gives you the facility to rotate the image while scanning.

● Canon EOS-1n with 17–35 mm lens. ISO 100 film. Microtek 4000t scanner.

Saving as you go

Adopt the habit of saving your working file as you proceed: press Command + S (Mac) or Control + S (PC) at regular intervals. It is easy to forget in the heat of the creative moment that the image on the monitor is only virtual – it exists just as long as the computer is on and functioning properly. If your file is large and what you are doing complicated, then the risks of a computer crash are increased (and the resulting loss of the work more grievous). A good rule to remember is that if your file is so large that making frequent saves is an inconvenient interruption, then you definitely should be doing it, inconvenient or not.

Quick fix Poor subject detail

Although in most picture-taking situations the aim is to produce the sharpest possible image, there are situations where blur is desirable.

Problem

Images lack overall "bite" and sharpness and subject detail is soft or low in contrast overall.

Analysis

Unsharp subject detail and low contrast can have many causes: a poor-quality lens; inaccurate focusing; subject movement; camera movement; dust or scratches on the lens; an intervening surface, such as a window; and over-magnification of the image.

Solution

One of the great advantages digital photography has over film-based photography is that unsharpness can, to varying extents, be reduced using image-processing techniques. The main one is unsharp masking (USM). This can be found on nearly all image-manipulation software: in Photoshop it is a filter; it is provided by software such as Extensis Intellihance; and the software drivers for many scanners also provide it. Some digital cameras also apply USM to images as they are being recorded (see pp. 248–51).

However, while USM can improve the appearance of an image, there are limits to how much subject information it can retrieve. In particular, unsharpness caused by movement usually shows little or no improvement with USM. At times, a simple increase in image contrast and color saturation can help to improve the appearance of image sharpness.

Turning the tables
Blurred, low-contrast images are not necessarily failures. This portrait was taken through a dusty, smeary window. The diffusion has not only softened all image contours, it has also reduced contrast and introduced some flare into the shadow areas. These are usually fatal image flaws, but if they appear in association with the right subject they can add a degree of character and atmosphere, rather than detract from picture content.
● Canon EOS-1n with 80–200 mm lens. ISO 100 film. Microtek 4000t scanner.

How to avoid the problem

● Keep the front surface of your lens and any lens filters clean. Replace scratched filters if necessary.

● Focus as precisely and carefully as possible.

● Release the shutter smoothly, in a single action. For longer hand-held exposures, take the picture as you breathe out, just before you start to breathe in.

● For long exposures, use a tripod or support the camera on some sort of informal, stable support, such as a table, window sill, wall, or a pile of books, to prevent camera movement.

● Experiment with your lens – some produce unsharp results when they are used very close-up, or at the extreme telephoto end of the zoom range.

Quick fix Poor subject color

If, despite your best efforts, subject color is disappointing, there is still a range of image-manipulation options to improve results.

Problem

Digital images are low in contrast, lack color brilliance, or are too dark. Problems most often occur in pictures taken in overcast or dull lighting conditions.

Analysis

Just like film-based cameras, digital cameras can get the exposure wrong. Digital "film" is, if anything, more difficult to expose correctly, and any slight error leads to poor subject color. Furthermore, high digital sensitivities are gained at the expense of poor color saturation; so, if the camera's sensitivity is increased to cope with low light levels, color results are, again, likely to be poor.

Overcast light tends to have a high blue content and the resulting bluish color cast can give dull, cold images.

Solution

An easy solution is to open the image in your image-manipulation software and apply Auto Levels (see pp. 242–3). This ensures that your image uses the full range of color values available and makes some corrections to color casts. Although quick, this can over-brighten an image or make it too contrasty.

Some software, such as Photo Soap, Digital Darkroom, and Extensis Intellihance, will analyze an image and apply automatic enhancement to, for example, concentrate on increasing the color content or correcting a color cast.

The handiest single control is the universally available Saturation (see pp. 254–5 and 260–3).

Problem...

...solution

Manipulation options

The original scan (*top*) is not only dull, it is also not an accurate representation of the original scene. However, Auto Levels has generally brightened up the image (*above*). Color saturation was increased using the Hue and Saturation control, and, finally, the USM filter was applied to help improve the definition of subject detail.

● Canon EOS-1n with 80–200 mm lens. ISO 100 film. Nikon Coolscan LS-1000 scanner.

How to avoid the problem

● In bright, contrasty lighting conditions it may help to underexpose by a small amount: set the camera override to -½ of a stop or -⅓ of a stop, depending on what the controls permit.

● Avoid taking pictures in dull and dark conditions. However, bright but partly overcast days usually provide the best color saturation. On overcast days, consider using a warm-up filter (a very light orange or pink color) over the camera lens.

● Avoid setting the camera to very high sensitivities – for example, film-speed equivalents of ISO 800 or above. And avoid using high-speed color film of any type in a conventional camera if color accuracy is crucial.

Levels

The Levels control shows a representation, in the form of a histogram, of the distribution of tone values of an image. Levels offers several powerful options for changing global tone distribution. The easiest thing to do is to click on the Auto Level button. This, however, works effectively in very few cases. What it does is take the darkest pixel to maximum black and the brightest pixel to maximum white, and spreads everything else evenly between them. This, however, may change the overall density of the image.

Another control that may be available is Output Level. This sets the maximum black or white points that can be produced by, say, a printer. Generally, by setting the white point to at least 5 less than the maximum (in other words, to about 250) you prevent the highlight areas in your output image from appearing totally blank. Setting the black point to at least 5 more than the minimum (in other words, to about 5) you will help to keep the shadow areas from looking overly heavy in your output image.

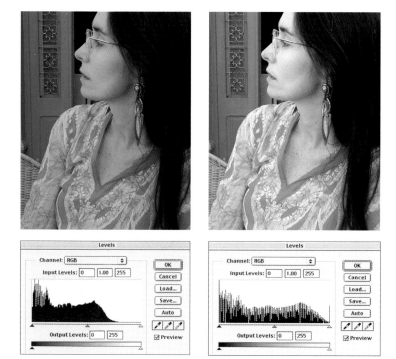

Auto Level

An underexposed image contains dark tones with few high-value ones (*far left*), confirmed in the Levels display (*bottom far left*). The gap on the right of the histogram indicates an absence of values lighter than three-quarter tone, with peak values falling in deep shadow. Applying Auto Level (*left*) spreads all available pixel values across the whole dynamic range. The new Levels display (*bottom left*) has a characteristic comblike structure, showing gaps in the color data. Auto Level not only brightens colors and increases contrast, it also causes a slight overall color shift.

● Kodak DC210.

How to read Levels

The Levels histogram gives an instant check on image quality – perhaps warning of a need to rescan.
● If all values across the range are filled with gentle peaks, the image is well exposed or well scanned.
● If the histogram shows mostly low values (weighted to the left), the image is overall low-key or dark; if values are mostly high (weighted to the right), the image is high-key or bright. These results are not necessarily undesirable.

● If you have a sharp peak toward one or other extreme, with few other values, you probably have an image that is over- or underexposed.
● If the histogram has several narrow vertical bars, the image is very deficient in color data or it is an indexed color file. Corrections may lead to unpredictable results.
● A comblike histogram indicates a poor image with many missing values and too many pixels of the same value. Such an image looks posterized (*see p. 264*).

Well-distributed tones

As you can see from this Levels histogram, a bright, well-exposed image fills all the available range of pixels, with no gaps. Since the image contains many light tones, there are more pixels lighter than mid-tone, so the peak of the histogram lies to the right of center. This image would tolerate a lot of manipulation thanks to the richness of color data it contains.

● Kodak DCS315 with 28–70 mm lens.

Deficient color data

An image with only a limited color range, such as this still-life composition, can be turned into a very small file by saving it as an indexed color file (p. 271). In fact, just 55 colors were sufficient to represent this scene with hardly any loss of subject information. However, the comblike Levels histogram associated with it indicates just how sparse the available color data was. Any work on the image to alter its colors or tonality, or the application of filter effects that alter its color data, would certainly show up artifacts and produce unpredictable results.

● Nikon Coolpix 990.

Histogram display

The histogram for this image shows mid-tones dominated by yellow and blue with large amounts of red in mid- to light tones, consistent with the strong orange color of the shirt. This display is from the FotoStation application, which displays histograms for each RGB separation in the corresponding color.

Burning-in and dodging

Two techniques used in film-based and digital photography for manipulating the local density of an image are known as burning-in and dodging.

Controlling density

Burning-in increases the density in the area of the image being worked on, while dodging reduces it. Both techniques have the effect of changing the tonal reproduction of the original either to correct errors in the initial exposure or to create a visual effect. For example, the highlights and shadows of both film and digital images are low in contrast, and to counteract this you can burn in and dodge

to bring out what shadow and highlight detail does exist by increasing local image contrast.

The same techniques can be used in order to reduce contrast – to darken highlight areas, for example – to bring them tonally closer to image mid-tones. An often-used application of this in conventional photography is burning-in areas of sky when printing to darken them. Increasing the sky exposure (while shading, or dodging, the rest of the print) not only helps differentiate sky and cloud tonally, it also helps to match the sky tones to those of the foreground.

Digital techniques

In digital photography, burning-in and dodging are easily achieved using the tools available in all image-manipulation software. Working digitally you can be as precise as you like – down to the individual pixel, if necessary. And the area treated can be between 1 and 100 percent of the image area, nominated by the Marquee or Lasso tool.

A drawback of working digitally, however, is that when manipulating large areas results are often patchy and uneven, while working on large area in the darkroom is easy.

Working digitally, some applications allow you to set the tool for the shadows, mid-tones, or high-lights alone. Carefully choosing the tonal range to be manipulated helps avoid telltale signs of clumsy burning-in and dodging. Corresponding techniques, available in Photoshop and some other professional software packages, are known as Color Dodge and Color Burn painting modes.

Color Dodge is not only able to brighten up the image, it also pushes up image contrast as you apply the "paint." In addition, if you set a color other than white, you simultaneously tint the areas being brightened. Color Burn has similar effects – darkening and increasing image contrast.

Correcting exposure

Taken on a bright winter afternoon, the camera's meter was fooled by the sudden appearance of the sun within the picture area, causing it to underexpose the scene (*above left*). This situation can be rescued using the Dodging tool set to work on the high-lights areas alone. However, to produce the corrected image shown here (*above right*), the Paintbrush tool was chosen and set to Color Dodge. By using the brush in this mode, set to a mid-gray color and with lowered opacity (for example, 50 per-cent), you will obtain more rapid results with less tendency to burn out subject details. As an optional way of working, paint onto a new layer set to Color Dodge mode.

● Nikon Coolpix 990, set to black and white mode.

Correcting color balance

Looking at the original image (*above left*), the temptation to burn in the foreground and some of the background in order to "bring out" the sheep is irresistible. Brief applications of the Burn tool on the foreground (set to mid-tone at 10 percent) and background hills, plus the Dodge tool on the sheep (set to highlight at 5 percent) produced an image (*left*) that was very similar to the scene as it appeared at the actual time of shooting.

● Nikon Coolpix 990.

●HINTS AND TIPS

● Apply dodging and burning-in techniques with a light touch. Start off by using a light pressure or a low strength of effect – say, 10 percent or less – and then build up to the strength the image requires.

● When burning-in image highlights or bright areas, set the tool to burn in the shadows or mid-tones. Do not set it to burn in the highlights.

● When burning-in mid-tones or shadows, set the tool at a very light pressure to burn in the highlights or mid-tones. Do not set it to burn in the shadows.

● When dodging mid-tones, set the tool at very light pressure to dodge the highlights or mid-tones. Do not set it to dodge the shadows.

● When dodging shadows, set the tool to dodge the highlights. Do not set it to dodge the shadows.

● Use soft-edged or feathered Brush tools to achieve more realistic tonal results.

Dust and noise

Two factors that can impair image quality are dust and noise. Dust results when material, such as hairs, debris, and grit, lands on the film of a conventional camera or photosensor of a digital camera. Noise, usually seen as pixels not related to adjacent pixels, arises from the intrinsic properties of the photosensor of a scanner or digital camera.

You can reduce noise using digital filters only if the noise has a much higher frequency than the image detail itself – in other words, if the specks are much smaller than the image detail. If this is not the case, then applying a filter will smudge image information along with the noise signals.

Dust can be a serious problem with the design of SLR digital cameras, since debris on the photosensing surface will be sharply recorded on every image. In a film-based camera, a trapped hair may cast a shadow at the edge of the frame until it dislodges, or specks of dust will affect only the frame of film they land on.

Dust-removal options

Some film scanners provide "dust-removal" features to mask the damage caused by dust, and replace the resulting gaps in the image with pixels similar to those adjacent to the problem areas. These can work well, although some may disturb the film's grain structure, while others work only on color film. In addition, you will probably still have to remove some specks manually or repair the gaps left by any automatic dust-removal process.

Avoid using the dust-removal filters provided in image-manipulation software – these almost always destroy fine detail along with the specks. However, these same filters can be used effectively to smooth out the roughness caused by noise.

Cloning

The key image repair technique is cloning, or "rubber-stamping," and consists of two steps. Initially you define the source for the clone – usually

Removing dust
The first example presented here (*top left*) shows an image that has been produced by a scanner with no dust-removal facility. Applying the Dust and Scratch filter to the image removes many specks (*above left*), but larger ones remain and, worse, a great deal of detail has been

lost. The final image (*above*) is the result of removing dust by hand-cloning, using a Brush with a diameter four times that of most of the specks. It was set to Aligned and the cloned area was adjacent to the source. You sometimes have to choose a new source and change the alignment in order to avoid cloning

wrong parts of the image. Although laborious to carry out, manual cloning best preserves image detail.
● Microtek 4000t scanner.

Noisy image

Poor noise-suppression circuitry and an exposure of ⅛ sec gave rise to this "noisy" image. Long exposures increase the chance of stray signals, which increase noise in an image.

● Kodak DCS 315 with 28–70 mm lens.

Screen shots

Examining the different channels (*above*) showed that the noisiest was the green one. This was selected and Gaussian Blur applied (*top*). The radius setting was adjusted to balance blurring of the specks while retaining overall sharpness.

Smoother but softer

The resulting image offers smoother tones – especially skin tones – but the cost is visible in reduced sharpness of the orchids. You could select the red and blue channels to apply Unsharp Masking to improve the appearance of the flowers.

done by holding down the Alt (Option) key while clicking on the image. This source is then copied to the part of the image you next click on. In most software you can set whether all samples are taken from around the original source area or whether the source stays at the same relative distance to the clone – in other words, whether it remains aligned to the source. Some applications, such as Corel Painter, allow you to invert, distort, or otherwise transform the cloned image compared with the source. If you have a Wacom graphics tablet, then use the PenDuster component of the PenTools software. This quickly and effectively removes dust and hairs using a special type of cloning that replaces the dust with pixels from the area immediately adjacent to the problem area.

Noise in detail

In this close-up view of an image, it is clear there is more noise, or random pixels (seen as specks and unevenness of tone), in the darker areas than in the brighter ones. Compare the blue shadow area, for example, with the white plate. This is because noise in the photosensor is normally drowned out by higher signals, such as those generated by strong light.

● Kodak DC210.

●HINTS AND TIPS

● Clone with the tool set to maximum pressure, or 100 percent – lighter pressure produces a smudged or soft-looking clone.

● In even-toned areas, use a soft-edged or feathered Brush as the cloning tool. In areas with fine detail, use a sharp-edge Brush instead.

● You do not always have to eliminate specks of dust – reducing their size or contrast may be sufficient to disguise them.

● Work systematically from a cleaned area into areas with specks, or you may find yourself cloning dust specks, thereby compounding the problem.

● If cloning gives an overly smoothed-out look, introduce some noise to make it look more realistic. Select the area for treatment and then apply the Noise filter.

Sharpening

The ease with which modern image-manipulation software can make a soft image appear sharp is almost magical. Although software cannot add to the amount of information contained in an image, it can put whatever information is there to the best possible use. Edges, for example, can be given more clarity and definition by improving local contrast.

Digitally, sharpen effects are true filters, as they hold back some components and selectively let others through. A Sharpen filter is, in reality, a "high-pass" filter – it allows high-frequency image information to pass while holding back low-frequency information.

Unsharp masking

The most versatile method of image sharpening is to use unsharp masking (USM). This takes a grid of pixels and increases edge definition without introducing too many artifacts. The difficulty with USM is knowing which values to set (*see examples on these page and those following*).

Like any manipulation effect, it is possible to overdo sharpening. In general, assess image sharpness at the actual pixel level, so that each image pixel corresponds to a pixel on the monitor. Any other view is interpolated (*see pp. 256–7*) and edges are softened, or anti-aliased, which makes sharpness impossible to assess properly.

As general guidance, for images intended for print reproduction, the screen image should look very slightly oversharpened – so that artifacts (such as halos or bright fringes) are just visible. For on-screen use, however, sharpen images only until they look right on the screen.

Sharpening makes deep image changes that cannot easily be undone. Therefore, it is generally best to leave sharpening to last in any sequence of image manipulations, except for combining different layers. However, if you are working on a scan that has many dust specks and other, similar types of fault, you should expect the final sharpening to reveal more fine defects, so be prepared for another round of dust removal using cloning (*see pp. 246–7*).

Undersharpening

In images containing large amounts of fine detail, such as this scene taken in Uzbekistan, applying a modest strength of USM filtering (55) and a large radius (22), with a threshold set at 11 does little for the image. There is a modest uplift in sharpness, but this is due more to an overall increase in contrast rather than any other effect.

Oversharpening

The maximum strength setting used for this version results in oversharpening – it is still usable and is arguably a good setting if you intend to print on poor-quality paper. The same setting applied to the Kashgar image (*pp. 250–1*) would simply bring out all the film grain – a technique for increasing noise in the image.

Ideal setting

The best settings for images with fine detail is high strength with a small radius and a very low threshold: here, strength was 222, the radius was 2, and the threshold was kept at 0. Details are all well defined and if large-size prints are wanted, details are crisper than those obtained with sharpening using a larger radius setting.

Sharpening continued

Original image
This photograph of the main town square in Kashgar, Xinjiang, China, has large areas of smooth tone with little fine detail, and it would clearly benefit from the effects of image sharpening.

● Leica R6 with 21 mm lens. ISO 50 film.

Using an advanced Photoshop technique for image sharpening, first mask off areas (such as a face) to be protected from oversharpening and any associated increase in defects. Next, produce a duplicate layer of the background and set it to Soft Light mode. This increases contrast overall. Then apply the High-Pass filter (found under the Filter menu in Other > High Pass). Increasing the radius strengthens the effect (passes higher frequencies, or more detail). You can now enter Quick Mask mode or add a layer mask to control which areas of the image will be sharpened by the High-Pass filter. This method is also effective for sharpening an image overall and can be controlled by direct settings and by opacity. However, the preview window in the dialog box does not give an accurate view because it samples only the top layer.

Unsharp Mask

OK

Cancel

☑ Preview

□ 100% ⊞

Amount: 222 %

Radius: 2 pixels

Threshold: 0 levels

Oversharpening
If you increase the sharpening effect (222 in this version) and reduce the threshold (0), but reduce the radius to 2, virtually everything in the image increases in sharpness. The result is that film grain and fine detail are sharpened to an undesirable extent. Compare the result of these settings with that of an image that contains a mass of fine detail (*p. 248*).

Sharpening areas of tone

A moderate amount of sharpening (55) and a relatively wide radius for the filter to act on (22) improves sharpness where there is subject detail, without bringing out film grain or unwanted information, such as in the subject's skintones. A threshold setting of 11 prevents the filter from breaking up smooth tonal transitions, as the sharpening effect operates only on pixels differing in brightness by more than 11 units.

Extreme settings

This version results from maximum amount and radius settings. The effect is extreme, but a threshold of 32 controls coloration. Even so, the image has highly saturated colors and brilliant contrast. In addition, film grain is emphasized. The random appearance of film grain gives more attractive results than the regular structure of a digital image, so if you want to use this effect introduce image noise first.

Blurring

Blur can be introduced by lowering contrast to give boundaries a less-distinct outline. This is the opposite of sharpening (*see pp. 248–51*). Paradoxically, blurring can make images look sharper, for if you throw a background out of focus, then any detail in front looks sharper in comparison.

Blur options

Blur effects are seldom effective if applied to the whole image, since they often fail to respond to the picture's content and character. The Median Blur and Dust and Scratches filters produce an effect like looking through clear, moving water. For some subjects this is appropriate, but for blur with some clarity, other methods are better. One approach depends on the dataloss caused by interpolation (*see pp. 256–7*) when reducing file sizes. First, increase the image size by, say, 300 percent, using Resampling, and then reduce it to its original size. Check its appearance and repeat if necessary. This does take time, but it can give well-detailed, softly blurred results. A quicker, though less-adaptive, method is to reduce the file size, and then increase it, repeating this step as necessary.

Selective blur

Although you will not often want to blur an image in its entirety, selective blurring, and thus the softening of subject detail, can be extremely useful on occasion. To take one example, the blurred areas of an image could become the perfect background for typography – perhaps on a web page – as the wording would then be easier to read. Another example could be to introduce digital selective blur to simulate the appearance of using a special effects, soft-focus lens filter. This type of glass filter is designed to soften all but a central region of the image in order to help concentrate the viewer's attention on a particular feature. In the example shown here – an informal portrait of a traveler on a ferry on the Danube River, Hungary – the high-contrast sunlight and the sharpness of background detail was softened to match the girl's handsome features.

● Canon D30 with 100–400 mm lens.

Original image
In this unworked scan (*left*), you can see that the original image was critically sharp, and minor defects, such as freckles on the subject's skin, were very obvious.

- Kodak DC315 with 28–70 mm lens.

Interpolated file
The appearance of the subject's skin was softened in this example (*right*) by reducing the file to a quarter of its original size and then increasing it a total of four times.

Gaussian Blur filter
This version of the original image is the result of applying a Gaussian Blur filter with a setting of 5. It is, as you can see, fuzzy rather than soft and is, pictorially, not a very convincing result.

Median filter
This option, introducing Median blur, bears a strong family resemblance to the effects of the Dust and Scratches filter (*right*). As you can see from the dialog box, a radius of 36 pixels was selected, and results are now becoming more useful.

Dust and Scratches filter
This version is the result of applying the Dust and Scratches filter with a radius of 40 pixels and a threshold level of 4.

Quick fix Image distractions

Unless there is a fundamental problem with your image, most minor distractions can be removed, or at least be minimized, using digital techniques.

Problem

While concentrating on your subject it is easy not to notice distracting objects in the picture area. This could be something minor, such as a discarded food wrapper, but out-of-focus highlights can also be a problem.

Analysis

The small viewfinders of many cameras make it difficult to see much subject detail. Furthermore, though something is distant and looks out of focus, it may still be within the depth of field of your lens (see pp. 84–7). At other times, you simply cannot avoid including, say, telephone wires in the background of a scene.

Solution

You may not need to remove a distraction completely – simply reducing the difference between it and adjacent areas may be enough. The usual way to achieve this is with cloning – duplicating part of an image and placing it into another part (see pp. 326–31). For example, blue sky can be easily cloned onto wires crossing it, as long as you are careful to use areas that match in brightness and

hue. If you clone from as close to the distraction as possible, this should not be too much of a problem.

You could also try desaturating the background: select the main subject and invert the selection; or select the background and lower saturation using the Color Saturation control. You could also paint over the background using the Saturation or Sponge tool set to desaturate.

Another method is to blur the background. Select the main subject and invert the selection, or select the background directly, and apply a Blur filter (see pp. 252–3). Select a narrow feather edge to retain sharpness in the subject's outline. Choose carefully or, when Blur is applied, the selected region will be left with a distinct margin. Try different settings, keeping in mind the image's output size – small images need more blur than large ones.

How to avoid the problem

Check the viewfinder image carefully before shooting. This is easier with an SLR camera, which is why most professionals use them. Long focal length lenses (or zoom settings) reduce depth of field and tend to blur backgrounds. And, if appropriate to the subject, use a lower viewpoint and look upward to increase the amount of nondistracting sky.

Problem...

...solution

Foreground distraction
An old man photographed in Greece shows me a picture of his sons. As he leans over the balcony, the clothespins in front of his chin prove impossible to avoid.

Cloning
Luckily, in this example there was enough of the man's skin tone visible to give a convincing reconstruction. To do this the skin part of the image was used to clone areas of color over the

Problem... ...solution

Background distractions

In the chaos of a young child's room, it is neither possible nor desirable to remove all the distractions, but toning them down would help to emphasize the main subject.

● Bronica SQ-A with 40 mm lens. ISO 64 film. Heidelberg Saphir II scanner.

Desaturated background

Applying Desaturate to the background, turning all the colors into gray has helped separate the girl from the numerous objects surrounding her. A large, soft-edged Brush tool was chosen and the printing mode was set to desaturation at 100 percent.

Problem... ...solution

Selective blur

Despite using a large aperture, a wide-angle lens setting still produced more depth of field than I wanted in this example (*above left*). To reduce the intrusive sharpness of the trees, I used the Gaussian Blur filter set to a radius of 9 pixels (*right*). First, I selected the figure with a feathering of 5 and then inverted this selection in order to apply the Gaussian Blur to the background alone (*above right*).

● Canon EOS-1n with 17–35 mm lens. ISO 100 film. Nikon Coolscan 4000 scanner.

Image size and distortion

Working digitally, it is common to change image size prior to printing. In practice, you will probably set only a small range of sizes – from postcard to small poster – but available sizes vary enormously. While size changes are usually uniform across the image, they can be nonuniform and radically transform the shape of the picture.

Why distort?

You may want to distort an image to make it fit a specific area, for humorous effect, or to vary the usual rectangular shape for visual impact. Images with faces or other very familiar shapes often don't make the best subjects for this type of treatment, as the shape change focuses attention on the distortion itself rather than on the role of the image in the design.

On rare occasions, you may wish to squeeze or expand an image to fit into a specific space but don't wish to crop. The easiest way to achieve this effect is to resize the image without maintaining the same ratio of depth to width.

The Transform tool is often used to resize images or, occasionally, to distort their shape before placing them into a montage or other composition. But it can also be used to solve a common photographic problem – projection distortion that occurs when the camera is not held square to a building, painting, or some other geometrically regular subject. When this occurs, the film plane is not parallel to the subject, and one side of the film is inevitably nearer the subject than the other. As a result, the near part of the film receives a somewhat larger image than the far part, and image shape is skewed (*see p. 259*).

The digital solution to this problem is simple – a combination of cropping, allowing for losses at the corners if you have to rotate the image, followed by a controlled distortion of the entire image. This technique requires "interpolation" (*see opposite*) – a calculation of the addition or removal of pixel values based on the values of existing ones – and, therefore, you have to accept an irretrievable loss of image information.

Destructive interpolation

The original landscape-format image of a flower and straplike leaves (*above*) was contracted on one axis only; so while depth remained the same, width was reduced to a third. This crams all the information into a narrow area and distorts the content of the image (*right*).

If, however, you decided to restore this image's original shape, it would not be as sharp as it originally was because the distortion is a destructive interpolation and involves the irretrievable loss of image information.

● Nikon Coolpix 990.

Comic effects

An image already distorted as a result of being shot from a very low camera angle has been taken to comic extremes to emphasize the subject's waving hand (*right*). Though sometimes amusing, such imagery needs to be used sparingly. The upper part of the image was widened by about 50 percent and the lower part was reduced by approximately the same amount. The resulting empty areas were then cropped off, as indicated by the white area on the screen (*above*).

● Leica R6 with 70–210 mm lens. ISO 50 film. Microtek 4000t scanner.

What is interpolation?

Interpolation is a mathematical discipline vital to processes ranging from satellite surveys to machine vision (the recognition of license plates on speeding cars, for example). In digital photography, three methods of interpolation are used to alter image size.

"**Nearest neighbor**" simply takes adjacent values and copies them for new pixels. This gives rough results with continuous-tone images but it is the best way for bit-map line graphics (those with only black or white pixels).

"**Bilinear interpolation**" looks at the four pixels to the top, bottom, and sides of the central pixel and calculates new values by averaging the four. This method gives smoother-looking results.

"**Bicubic interpolation**" looks at all eight neighbouring pixels and computes a weighted average to give the best results. However, this method requires more computing power.

Image Size	
Pixel Dimensions: 7M	
Width: 1396 pixels	OK
Height: 1752 pixels	Cancel
	Auto...
Document Size:	
Width: 49.25 cm	
Height: 61.81 cm	
Resolution: 72 pixels/inch	
☑ Constrain Proport	Nearest Neighbor
☑ Resample Image:	Bilinear ✓ Bicubic

Image Size screen shot

If you have the professional image-manipulation software package Photoshop, you have the option of choosing your default interpolation method from the general application preferences menu, or you can override the default for each resizing operation using the Image Size dialogue box (*above*).

Quick fix Image framing

Don't allow your images to become unnecessarily constrained by the sides of the camera viewfinder or the regular borders of your printing paper. There are creative options available to you.

Problem

The precise and clear-cut rectangular outlines around images can not only become boring, sometimes they are simply not appropriate – for example, on a web site page where the rest of the design is informal. What is needed is some kind of controlled way of introducing some variety to the way you frame your images.

Analysis

In the majority of situations, producing images with clean borders is the most appropriate method of presentation. But with the less-formal space of a web page, a looser, vignetted frame might be a better option. On occasion, a picture frame can also be used to crop an image without actually losing any crucial subject matter.

Solution

Scan textures and shapes that you would like to use as frames and simply drop them onto the margins of your images. Many software applications offer simple frame types, which you can easily apply to any image and at any size. Specialized plug-ins, such as Extensis Photoframe, simplify the process of applying frames and provide you with numerous, customizable framing options.

How to avoid the problem

The need to create picture frames usually arises from the desire to improve an image that has not been ideally composed. Nobody thinks about picture frames when looking at a truly arresting photograph. Inspect your pictures carefully, checking the image right to the edges. Tilting the camera when shooting creates a different style of framing, or simply crop off image elements you don't need.

Framing option 1
The first option applies a geometric frame in which it partially reverses the underlying tones of the image. It is effective in hiding unwanted details in the top left of the image, but its outline is perhaps too hard in contrast with the soft lines of the subject's body.

Framing option 2
The simplest frame is often the best – here it is like looking through a cleared area of fogged glass. The color of the frame should be chosen to tone in with the image. However, you should also consider the background color: on this black page, the contrast is too high whereas against a white page or an on-screen background, the nude figure

Framing option 3
Here a painterly effect is combined with a frame that reverses both hue and tone (a Difference mode). By carefully adjusting the opacity of the frame, the colors were toned down to match that of the main image. Finally, the frame was rotated so that the main axis nude figure runs across the diagonal, leading the eye from the thigh to her just-revealed breast

Quick fix Converging parallels

While the brain largely compensates for visual distortions – so, in effect, you see what you expect to see – the camera faithfully records them all.

Problem

Images showing subjects with prominent straight lines, such as the sides of a building, appear uncomfortable when printed or viewed on screen because the lines appear to converge. Regular shapes may also appear sheared or squashed (*see also p. 108*).

Analysis

The change in size of different parts of the image is due to changes of magnification – different parts of the recorded scene are being reproduced at different scales. This occurs because of changes in distance between the camera and various parts of the subject. For example, when you look through the viewfinder at a building from street level, its top is farther away than its base – a fact that is emphasized by pointing the camera upward to include the whole structure. As a result, the more distant parts appear to be smaller than the closer parts.

Solution

Select the whole image and, using the Distortion or Transformation tool, pull the image into shape. If there are changes in magnification in two planes, both will converge, and so you will need to compensate for both.

How to avoid the problem

● Choose your shooting position with care and try to compose the image in order to keep any lines that are centrally positioned as vertical as possible. In addition, look to maintain symmetry on each side of the middle of the picture.

● Rather than pointing the camera upward, to include the upper parts of a building or some other tall structure, look for an elevated shooting position. This way, you may be able to keep the camera parallel with the subject and so minimize differences in scale between various parts of the subject as they are recorded by the camera

1 Verticals converge
Shooting from ground level with the camera angled upward caused the scene to appear to tilt backward.

2 Image manipulation
Stretching the lower left-hand corner of the image using the Distortion tool produces a realistic effect.

3 Verticals corrected
The corrected image looks better and corresponds more closely to the way the scene looked in reality.

Color balancing

All image-manipulation software allows you to adjust the overall color of an image. Most also offers Levels and Curves control. In powerful software, such as Photoshop, you have separate tools for controlling an image's hue and saturation, as well as others for replacing specified colors.

Color Balance control

This control makes global changes to the standard primary or secondary hues in an image. In some software, you can restrict the changes to shadows, highlights, or mid-tones. This control is useful for making quick changes to an image that has, for example, been affected by an overall color cast.

Levels control

Using this control, you can alter color balance by separately adjusting the Level in each color channel. It is similar to the Color Balance control but it gives you greater control over brightness. The great advantage of using Levels is that, in most software, settings can be saved and reapplied to other images.

Curves control

This controls the tonal reproduction of image brightness values, represented by a curve running from the lightest to darkest values. It can do everything the Levels control can, but with more precise location of where changes in tonal value occur. By carefully manipulating the curves in separate color channels you can change the color balance to counteract irregularities in color reproduction in both film-based and digital originals. For example, you can decrease the blue content of shadows, to remove cold-looking tones, while leaving the rest of the image's color balance untouched (*for more details, see pp. 266–70*).

Warm white point
The original picture of a simple still-life (*above left*) has reproduced with the strong orange cast that is characteristic of images lit by domestic incandescent lamps. The corrected image (*above right*), was produced using using Color Balance. It is still warm in tone because a fully corrected image would look cold and unnatural.
- Nikon Coolpix 990.

White point

A quick method of working when you wish to color correct an image is by deciding which part of the picture you want to be the white point – that part you want to be seen as pure white. You then use the Highlight Dropper tool, which is commonly available in image-manipulation software as well as part of scanner drivers, to select that area. If the white point needs to be corrected, the whole image will change in tonality (it is said to be mapped to the new white point) to reflect the fact that your selected area is now the "official" pure white point. This, like all color-correction methods, works only if the image has no strong color cast. If it has, then more drastic measures may be needed.

Color adjustments

With some types of software you can control the hue and saturation levels of a picture file globally and by waveband. In Photoshop, for example, the Hue control shifts all colors or a band of colors (for example, reds or cyans) around the color wheel (*see p. 111*). You can also select colors directly from the image. The Saturation control increases color purity by decreasing its gray/white content.

The Lightness control is useful for improving poor scans and digital pictures (*see also see pp. 218–19 and 275*).

Original image

This original image has not been corrected in any way, and it accurately reproduces the flat illumination of a solidly cloudy sky.

⬤ Nikon Coolpix 990.

Replace Color control

This replaces one hue, within a "fuzziness" setting or waveband, with another. Select the colors in the image you wish to change by sampling the image with the Dropper tool, and then transform that part via the Hue and Saturation dialogue box (*see p. 263*). By setting a small fuzziness factor – the top slider in the dialogue box – you select only those pixels very similar in color to the original; a large fuzziness setting selects relatively dissimilar pixels. It is best to accumulate small changes by repeatedly applying this control. Replace Color is good for strengthening colors printers have trouble with (yellows and purples), or toning down colors they overdo (reds). Film, monitors, or prints reproduce less than a third of the colors perceived by our eyes. But although we can distinguish very slight errors in reproduction when comparing samples side by side, we cannot

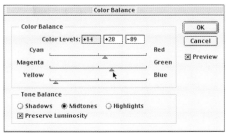

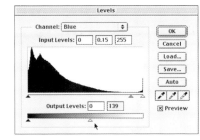

Color Balance control

Strong changes brought about via the Color Balance control, mainly by increasing yellow in the mid-tones – which is the lowest slider in the dialogue box here – make the scene look as if it has been lit by an early evening sun.

Levels control

A golden tone has been introduced to the image here by forcefully lowering the blue channel in the Levels control – the middle slider beneath the histogram – thus allowing red and green to figure more strongly. Red and green additively produce yellow, and this color now dominates the highlights of the image.

Color adjustments continued

remember colors with anything like the same degree of precision. In addition, we remember some colors better than others.

Color balancing in photography is, therefore, usually not about achieving perfect reproduction but about controlling the process so that the output is not only accurate, given the medium used, but that it is also pleasing to the eye.

What is color balance?

In the context of color, "balance" does not refer to harmony or equality, but neutrality. A scene that is color balanced is one in which the illuminating light offers all hues in equal proportion: in other words, the illumination is white and not tinted with color. Thus, a scene can be full of blues or greens yet still be color balanced, while another scene with a well-judged combination of secondary colors may look harmonious, but may not be color balanced at all.

The aim of color balancing is to produce an image that appears as if it were illuminated by white light, achieved by adjusting the white point (*see p. 260*). However, there are different standards

for white light, and so there are different white points. For example, it would not look natural to correct an indoor scene lit by domestic lamps in order to make it look like daylight; rather, a warm-toned white point is called for instead. However, in a scene containing brilliant colors, a cool-toned white point is more acceptable (giving colors like that from a bright Mediterranean sky). A color balance that is slightly warmer than neutral is generally preferred by most viewers.

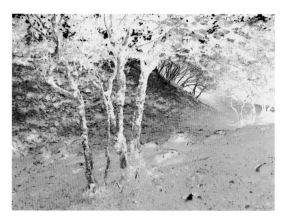

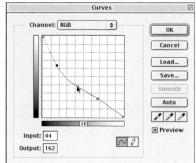

Color temperature

The color temperature of light has, in fact, nothing to do with temperature as we traditionally think of it; instead, color temperature is measured by correlating it to the color changes undergone by an object as it is heated. Experience tells us that cooler objects, such as candles or domestic lights, produce a reddish light, whereas hotter objects, such as tungsten lamps, produce more of a blue/white light.

The color temperature of light is measured in degrees Kelvin, and a white that is relatively yellow in coloration might be around 6,000 K, while a white that is more blue in content might be, say, 9,500 K.

While color slide film must be balanced to a specific white point, digital cameras can vary their white point dynamically, according to changing needs of the situation.

Curves control
A simple inversion of color and tone leaves dark shadows looking empty and blank. Manipulating tonal reproduction via the Curves dialogue box, however, gives you more control, allowing you to put color into these otherwise empty deep shadows (the bright areas after inversion). In the

dialogue box here you can see how the curve runs top left to bottom right – the reverse of usual – and the other adjustments that were made to improve density in the image's mid-tones.

Working in RGB

The most intuitive color mode to work in is RGB. It is easy to understand that any color is a mixture of different amounts of red, green, or blue, and that areas of an image where full amounts of all three colors are present give you white. The other modes, such as LAB and CMYK, have their uses, but it is best to avoid using them unless you have a specific effect in mind you want to achieve. When you are producing image files to be printed out onto paper, you may think you should supply your images as CMYK, since this is how they will be printed. However, unless you have the specific data or separation tables supplied by the processors, it is preferable to allow the printers to make the conversions themselves. In addition, CMYK files are larger than their RGB equivalents and so are far less convenient to handle.

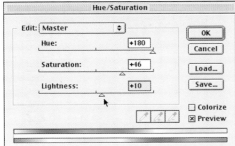

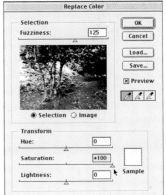

Hue and Saturation control

Here, in this dialogue box you can see that image hue has been changed to an extreme value, and this change has been supported by improvements in saturation and lightness in order to produce good tonal balance. Smaller changes in image hue may be effective for adjusting color balance. Bear in mind that colors such as purples look brighter and deeper on a monitor than in print because of limitations in the printer's color gamut (*pp. 117 and 342–5*).

Replace Color control

Four passes of the Replace Color control were made to create an image that is now very different from that originally captured (*p. 261*). The dialogue box here shows the location of the colors selected in the small preview window, and the controls are the same as those found in the Hue and Saturation dialogue box (*above left*), which allow you to bring about powerful changes of color. However, for Hue and Saturation to have an effect, the selected values must indeed have color. If they are gray, then only the lightness control has an effect.

Quick fix Manipulation "problems"

There are many difficulties to overcome for those new to digital photography that arise primarily from the nature of the medium in use. When the software will not respond to commands, for example, or when the results are not as you expected them to be, it may seem as if you have encountered a problem. But, in fact, these could be the result of the software doing exactly what you have asked of it, not realizing that you mean something different. The following are all common examples of DAMNS – Do what I Mean, Not what I Say.

Screen clash

An image that features a fine, regular texture has a raster, or regular array of detail, that can clash with the raster of the monitor on which it is being displayed. This screen clash is seen as inconsistent patterns of dark and light, which appear at some magnifications and disappear or change at others. The printed image, however, is not affected but the appearance of this pattern on the screen can be alarming. These two screen images show the same image at different degrees of magnification, and the differences in the appearance of the patterns are readily apparent.

Posterization

As a result of applying a curve (*pp. 266–70*) that has greatly distorted image tones, the limited color information contained in the image – a gradation from dark to light (*see the original image on p. 260*) – has been separated out, or posterized, into an eye-catching composition consisting of distinct bands of colors.

● Nikon coolpix 990.

Poor scan

A scan can look too dark with incorrect color balance and yet, after some work, yield an acceptable image if it contains enough data to accommodate the changes. This scan is fine for a newsletter or for publishing on a website, but its weak colors, lack of shadow detail, and poor sharpness all disqualify it for critical work.

● Ricoh RDC-5000.

Problem	Cause and solution
The file opens in your image-manipulation software but you cannot seem to do anything with it, or some options in your menus are grayed-out and not available.	Your scanner may have produced a 16-bit grayscale, 36-bit or 48-bit image file. Change the image mode to 8-bit grayscale or 24-bit color.
When applying filters or making tonal changes from dialogue boxes, nothing seems to happen.	You may have selected a small image area by mistake and all the changes are being applied only to that area. Deselect by using the relevant keyboard or menu command and try the procedure once more.
The software seems to be running slower and slower, taking longer and longer to perform even the simplest tasks.	The computer's memory is being strained or the clipboard (temporary memory) is full from a large "copy" or "cut-and-paste". Empty the clipboard directly if you can. If not, select a tiny image area and copy it. If your software has a history palette or multiple undos, purge the history palette or empty the undo buffer. If these measures don't help, save the image, quit the program, and reboot the computer.
When making some dramatic changes to the image using the Curves control, what were smooth areas of color become banded or layered in appearance.	The image has become posterized – smooth transitions are now sudden and stepped because there is insufficient color information to fill in the gaps created by the drastic color changes (see *opposite*). If possible, work in 48-bit color. But be aware that the resulting file will be large.
Whatever you do to the image, it is impossible to achieve good color balance.	You may be working with a very poor scan containing limited color information. Look at Levels to check if this is so. If Levels indicates there is good information, you may have a scan of a color negative. The way to tell is if you invert the colors, the image then has an overall orange cast. Cancel the cast with its complementary color and proceed with your corrections.
The image on the screen appears to be overlaid with bands of dark and light that disappear when the size of the image is changed, and reappear in a different form at other image sizes.	You are experiencing screenclash effects between a fine pattern in the image (a herring-bone pattern in textiles, say, or dots from an illustration scanned from a book) and the raster pattern of the monitor. It is unlikely to show up in a print, but you will need to check (see *opposite*). More importantly, if the pattern shows up at the size you wish to use for a website, you may need to change the image size or blur it slightly.
You cannot save toned image in any of the usual color formats.	A duotone or tritone is not a color image but a gray-scale image with extra channels. Change the image mode to color and then save in TIFF or JPEG.
The preview image looks nothing like the final image.	You have an indexed color image. Changes may appear to take but alter the proxy screen image only. Change to 24-bit RGB color and try again.

Curves

The Curves control found in image-manipulation software may remind some photographers of the characteristic curves published for films. This is a graph that shows the density of sensitized material that will result from being exposed to specific intensities of light. In fact, there are similarities, but equally important are the differences. Both are effectively transfer functions: they describe how one variable (the input either of color value or of the amount of light) produces another variable (the output or density of silver in the image).

The principal difference is that when it comes to image-manipulation software the curve is always a 45° line at the beginning. This shows that the output is exactly the same as the input. However, unlike the film curve, you can manipulate this directly by clicking on and dragging the curve or by redrawing the curve yourself. In this way, you force light tones to become dark, mid-tones to become light, and with all the other variations in between. In addition, you may change the curve of each color channel separately.

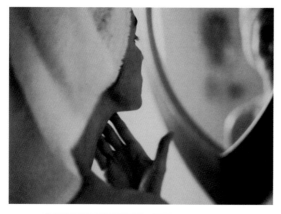

Original image and curve

Since the original negative was slightly underexposed, the image from the scan is tonally rather lifeless. You cannot tell anything about exposure by looking at the curve in the screen shot (*above*) because it describes how one tone is output as another. As nothing has been changed, when it first appears the line is a straight 45°, mapping black to black, mid-tone to mid-tone, and white to white. It is not like a film characteristic curve, which actually describes how film is responding to light and its processing.

- Mamiya 645 with 80 mm lens. ISO 400 film. Heidelberg Saphir II scanner.

Boosting the mid-tones

The bow-shaped curve displayed here subtly boosts the mid-tone range of the image, as you can see in the resulting image (*top*). But the price paid is evident in the quarter-tones, where details in the shadows and the details in the highlights are both slightly darkened. The result is an image with, overall, more tonal liveliness – note, too, that the outline of the subject's face has been clarified. With some image-manipulation software, you have the option of nudging the position of the curve by clicking on the section you want to move and then pressing the arrow keys up or down to alter its shape.

What the Curves control does

The Curves control is a very powerful tool indeed and can produce visual results that are impossible to achieve in any other way. By employing less extreme curves you can improve tones in, for example, the shadow areas while leaving the mid-tones and highlights as they were originally recorded. And by altering curves separately by color channel, you have unprecedented control over an image's color balance. More importantly, the color changes brought about via the Curves control can be so smooth that the new colors blend seamlessly with those of the original.

In general, the subjects that react best to the application of extreme Curve settings are those with simple outlines and large, obvious features. You can try endless experiments with Curves, particularly if you start using different curve shapes in each channel. The examples following (*see pp. 268–70*) show the scope of applying simpler modifications to the master curve , thereby changing all channels at the same time.

Emphasizing the highlights

The scan's flat, dynamic range suggests that it could make an effective high-key image by changing the curve to remove the black tones (the left-hand end of the curve in the screen shot is not on black but is raised to dark gray) and mapping many highlight tones to white (the top of the curve is level with the maximum for nearly a third of the tonal range). The result is that the input mid-tone is set to give highlights with detail. Very small changes to the curve can have a large effect on the image, so if you want to adjust overall brightness, it is easier to commit to the curve and then use Levels to adjust brightness (*pp. 242–3*).

Emphasizing the shadows

The versatility of the original image is evident here, as now it can be seen working as an effective low-key picture. The mood of the picture is heavier and a little brooding, and it has lost its fashion-conscious atmosphere in favor of more filmic overtones. The curve shown in the screen shot has been adjusted not simply to darken the image overall (the right-hand end has been lowered to the mid-tone so that the brightest part of the picture is no brighter than normal mid-tone). In addition, the slight increase in the slope of the curve improves contrast at the lower mid-tone level to preserve some shadow detail. This is crucial, as too many blank areas would look unattractive.

Curves continued

Original image

The image you select for manipulating Curves does not have to be of the highest quality, but it should offer a simple shape or outline, such as this church. In addition, the range of colors can be limited – as you can see below, dramatic colors will be created when you apply Curves with unusual or extreme shapes.

● Sanyo VPC-3000.

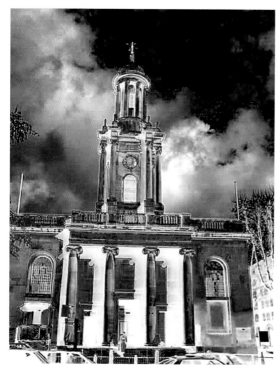

Reversing dark tones

A U-shaped curve reverses all tones darker than mid-tone and forces rapid changes to occur – an increase in image contrast, for example. The deep shadows in the church become light areas, giving a negative type of effect, but the clouds have darkened and greatly increased in color content. The effect of using this shape curve is similar to the darkroom Sabattier effect, when exposed film or paper is briefly re-exposed to white light during development.

Reversing light tones

An arc-shaped curve reverses the original's lighter tones, giving the effect shown here. Although it looks unusual, it is not as strange as reversing dark tones (*left*). Note that the curve's peak does not reach the top of the range – the height of the arc was reduced to avoid creating overbright white areas. The color of the building changes as the red-green color in the normal image was removed by the reversal, allowing the blue range to make its mark.

Tone/color reversal

Applying an M-shaped curve plays havoc with our normal understanding of what a color image should look like. Not only are the tones reversed as a result, but areas with dominant color whose tones have been reversed will also take on a color that is complementary to their own. And since parts of the tonal range are reversed and others are not, the result is a variegated spread of colors.

Using small files

When working on smaller image files, the results on the image of applying extreme curves become increasingly unpredictable due to gaps in the color data the software has to work with. When a W-shaped curve is applied, the picture becomes rather garish – an effect emphasized by the theatricality of the black sky. You can also see how some picture areas have sharply defined colors while others have smooth transitions, due to variations in the pixel structure of JPEGs (pp. 222–3).

Curves continued

Posterized effects

By applying a shape of curve that exhibits more peaks, such as that here, less of the image is reversed to dark tones. Although, as you can see in the resulting image, this produces a much brighter image overall, the many steep parts of the curve cause an effect something like that of posterization – the posterlike separation of colors into clearly segregated bands without the usual color transitions (*p. 264*). This in large part contributes to the broken-up texture of the picture. If you wanted to refine this style of image to a greater degree, then it might be best, after applying the Curve control, to bring the Dodge, Burn, and Saturation tools to bear in order to clean up small areas of the picture. Such an area in the example shown here might be the distracting appearance of the black cloud looming ominously behind the church tower.

Keyboard shortcut

When you are experimenting with the Curves control to discover the range of possible effects offered by your particular software, you may not have to start from scratch each time. In many image-manipulation applications, including Photoshop, if you press a key, such as Alt or Options, while accessing the tool, it will open with the last used settings in place. With extreme Curves invoked, very small changes can have a marked effect on the image. Experiments such as these are all part of the fun.

Bit-depth and color

The bit-depth of a color file tells you how finely a piece of equipment can recognize or reproduce colors. It is a measure of resolution. Modern film scanners work to 24-bit RGB depth, or better (8 bits x 3 channels gives 24 bits). This means, in theory, that each channel is divided up into 256 equally spaced steps, which is the minimum requirement for good-quality reproduction. The total number of colors, if all combinations could be realized, is in the region of 16.8 million.

Higher resolution

Increasingly, we are finding that 24-bit does not measure up to our expectations – tones are not smooth enough and there is insufficient data to allow for dramatic changes in tones or colors. This is why, when applying curves with very steep slopes, the image breaks up into separate blocks of color. Better-quality scanners can work in 36-bit depth or more – even when images are down-sampled back to 24-bit, results are better than if the scanner had worked in 24-bit. Some scanners even provide 48-bit RGB files, but there are very few image-manipulation software packages that can use them. Even the professional application Photoshop is limited in its ability to manipulate 48-bit files. But results are worth the extra effort, as images exhibit far smoother tones and fewer problems when Levels or Curves tools are used.

File size

Once the image is ready for use, you may find that very few colors are needed to reproduce it. A picture of a lion among sun-dried grass stems on a dusty plain will have very few colors, for example. Because of this, you may be able to use a small palette of colors and greatly reduce file size.

Some software allows images to be stored as "index color." This enables image colors to be mapped onto a limited palette of colors – the advantage being that the change from full 24-bit RGB to an index reduces the file size by two-thirds. Reducing the color palette or bit-depth should be the last change to the image as the information you lose is irrecoverable.

Color bit-depth and image quality
When seen in full color (*top*), this image of colored pens is vibrant and rich, but is the next image (*middle*), which contains a mere 100 colors, significantly poorer in quality? Yet this index color image is only a third of the size of the full-color original. As the color palette is reduced still further, to just 20 colors (*above*), the image is dramatically inferior. However, since this change does not reduce file size any further, there is no point in limiting the color palette beyond what is necessary.

● Nikon F-80 with 70–180 mm lens. Nikon LS-2000 scanner.

Color into black and white

Creating a black-and-white picture from a color original allows you to change the shot's emphasis. For example, a portrait may be marred by strongly colored objects in view, or your subjects may be wearing clashing colored clothing. Seen in black and white, the emphasis in these pictures is skewed more toward shape and form.

The translation process

A black-and-white image is not a direct translation of colors into grayscale (a range of neutral tones ranging from white to black) in which all colors are accurately represented – many films favor blues, for example, and record them as being lighter than greens.

When a digital camera or image-manipulation software translates a color image, it refers to a built-in table for the conversion. Professional software assumes you want to print the result and so makes the conversion according to a regime appropriate for certain types of printing press and paper. Other software simply turns the three color channels into gray values before combining them – in the main giving dull, murky results.

There are, however, better ways of converting to black and white, depending on the software you have. But before you start experimenting, make sure you make a copy of your file and work on that rather than the original. Bear in mind that conversions to black and white loses color data that is impossible to reconstruct.

Before you print

After you have desaturated the image (*see box below*), and despite its gray appearance, it is still a color picture. So, unless it is to be printed on a four-color press, you should now convert it to grayscale to reduce its file size. If, however, the image is to be printed in a magazine or book, remember to reconvert it to color – either RGB or CMYK. Otherwise it will be printed solely with black ink, giving very poor reproduction.

Four-color black

In color reproduction, if all four inks (cyan, magenta, yellow, and black) are used, the result is a rich, deep black. It is not necessary to lay down full amounts of each ink to achieve this, but a mixture of all four inks (called four-color black) gives excellent results when reproducing photographs on the printed page. Varying the ratio of colors enables subtle shifts of image tone.

Desaturation

All image-manipulation software has a command that increases or decreases color saturation, or intensity. If you completely desaturate a color image, you remove the color data to give just a grayscale. However, despite appearances, it is still a color image and looks gray only because every pixel has its red, green, and blue information in balance. Because of this, the information is self-canceling and the color disappears. If, though, you select different colors to desaturate, you can change the balance of tones. Converting the image to grayscale at this point gives you a different result from a straight conversion, since the colors that you first desaturate become lighter than they otherwise would have been.

Saturation screen shot
With the color image open you can access the Saturation control and drag the slider to minimum color. This gives a gray image with full color information. In some software you can desaturate the image using keystrokes instead (such as Shift+Option+U in Photoshop, for example).

Color saturation

While the original color image is full of light and life, the colors could be seen as detracting from the core of the image – the contrasts of the textures of the water, sand, and stones. This is purely a subjective interpretation, as is often the case when making judgments about images.

● Leica M6 with 90 mm f/2 lens. ISO 64 film. Microtek 4000t scanner.

Color desaturation

By removing all the colors using the Saturation control to give an image composed of grays, the essentials of the image emerge. The Burn and Dodge tools (*pp. 244–5*) were used to bring out tonal contrasts – darkening the lower portion of the picture with the Burn tool, while bringing out the sparkling water with the Dodge tool.

Overcoming distracting color

The color of the shirt in the original image (*above left*) detracts from the calm and quiet dignity of the subject. However, a straight desaturation of the image (*above middle*) leaves the whites and pattern contrast too apparent, so the shirt still represents a distraction.

However, by reducing the white point (*above right and below*), the pure white areas have been eliminated. This has the effect of softening image contrast overall and so toning down the impact of the shirt. As a result, however, some light was lost from the subject's face, but this was returned with a few touches of the Dodge tool to bring out the catchlights in his eyes and the light areas on his face.

● Nikon F2 with 50 mm f/l.4 lens. ISO 64 film. Nikon LS-1000 scanner.

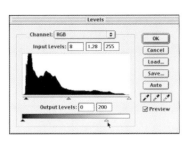

Levels screen shot

With the desaturated image open, move the white point slider in the Levels dialogue box to force the brightest pixels to be about a fifth less bright: in other words, to have a value no greater than 200.

Color into black and white continued

Channel extraction

Since a color image consists of three grayscale channels, the easiest way to convert the color to grayscale is to choose, or extract, one of these and abandon the others. This process is known as "channel extraction," but it is available only as part of more professional software packages.

When you view the image on the monitor normally, all three color channels are superimposed on each other. However, if you look at them one channel at a time, your software may display the image as being all one color – perhaps as reds of different brightnesses, for example, or as a range of gray tones, according to the software preferences you have set. If your software gives you the option, choose to view the channels as gray (by selecting this from the preferences or options menu). Then, simply by viewing each channel,

you can choose the one you like best. Now when you convert to grayscale, the software should act on the selected channel alone, converting it to gray.

Some software may allow you to select two channels to convert to gray, thus allowing you a great deal of experimentation with the image's appearance. In general, the channels that convert best are the green, especially from digital cameras, because the green channel is effectively the luminance channel, and the red, which often gives bright, eye-catching results.

Another method, available in the popular Photoshop program, is to use Split Channels to produce three separate images. With this, you save the image you like and abandon the others. Note, however, that this operation cannot be undone – the extracted file is a true grayscale, and is just a third the size of the original file.

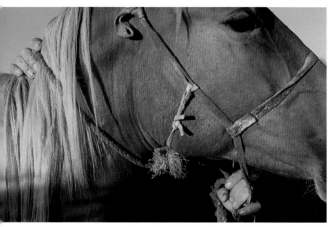

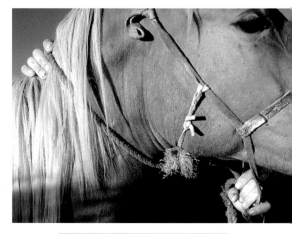

Red-channel extraction

While the colors of the original image are sumptuous (*above left*), black and white seemed to offer more promise (*above right*). It is clear that the sky should be dark against the mane and cradling hand, so the green and blue channels (*right*) offered no promise. Neither did the

lightness channel (*opposite*), as it distributes tonal information too evenly. The red channel, however, presented the blues as dark and the brown of the horse as light. So, with the red channel extracted, no extra work was needed.

● Canon F-1n with 135 mm f/2 lens. ISO 100 film. Microtek 4000t scanner.

Channels screen shot

If your software allows, select color channels one at a time to preview the effects of extraction. Turn off the color if the software shows channels in their corresponding colors.

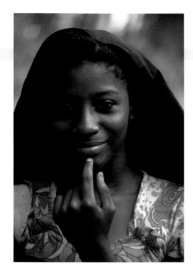

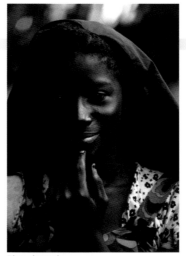

Blue channel

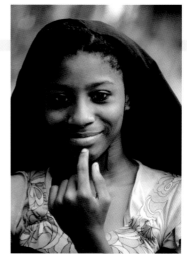

Red channel

Green channel

Lab (with Lightness channel extracted)

Comparing channels

The three grayscale images that make up the original color image (*top left*), photographed in Kenya, can be seen in the Channels screen shot (*above*). An image from the blue channel alone is very dark because there is little blue in the image. In contrast, the red channel is too light and seems to make the girl's face look insubstantial, while the dress is nearly white because of its high red content. The green channel is, overall, the best balanced since it carries much of the detail information. As a final experiment, the color image was converted from RGB to Lab mode and the Lightness channel extracted (*right*) – the other two carry hardly any detail information. The advantage of this approach is that, given a well-balanced original, it needs no further manipulation.

● Canon F-1n with 135 mm f/2 lens. ISO 100 film. Microtek 4000t scanner.

Lab mode

When you convert a color image image to LAB, or Lab mode, the L channel carries the lightness information, which contains the main tonal details about the image. Using software such as Photoshop, you can select the L channel and manipulate it with Levels or Curves. With the L channel selected, you can now convert to grayscale and the software will use only the data in that channel. If your software gives you this option, you will come to appreciate

the control you have over an image's final appearance, and results are also likely to be sharper than if you had extracted another of the channels to work on. The extracted file is a true grayscale, and so is only a third the size of the original color file.

Color into black and white continued

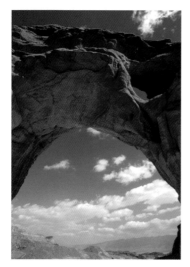

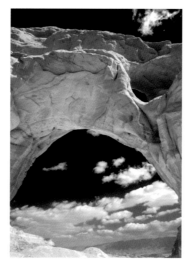

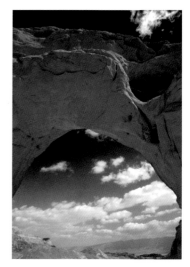

Original image
A simple conversion of this image could make colors look lifeless – a problem avoided by using the Channel Mixer control (*below*).

● Canon F-1n with 20 mm lens. ISO 100 film. Microtek 4000t scanner.

Working in RGB mode
In RGB, the blue channel was reduced, making the sky dark, and the red was increased to compensate. Results of using these settings are contrasty and dramatic, but the foreground is too bright.

Working in CMYK mode
With the original image translated into CMYK mode, results are noticeably softer than those achieved via the Channel Mixer in RGB mode.

Channel Mixer control

A colored filter used in black-and-white photography looks a certain color because it transmits only its own color waveband of light. Thus, a yellow filter looks yellow because it blocks non-yellow light. If you then use this filter to take a picture (making the appropriate exposure compensation), yellows in the resulting image are white and the other colors look relatively dark.

Lens filters are limited by the waveband transmissions built into each piece of glass, irrespective of the needs of the subject. But using the Channel Mixer tool you can choose from, in effect, an infinite range of filters until you find the ideal one for each subject.

Using this tool, you can now decide how to convert a color image to grayscale – making greens brighter in preference to reds, for example, or making blues dark relative to greens. Depending on your image software, you may also be able to work in RGB or CMYK (*see above*), the two methods producing different results.

Channel Mixer screen shot
With the control set to monochrome, the result is gray. If one channel is set to 100 percent, and the others at 0, you are effectively extracting that channel. This is more powerful than channel extraction (*pp. 274–5*).

If you set the control to Preview you can see the image change as you alter the settings. For landscapes, increase the green channel by a large margin and correct overall density by decreasing the red and blue channels. Channel mixing is useful for ensuring that reds, which are dominant in color images, are rendered brighter than greens.

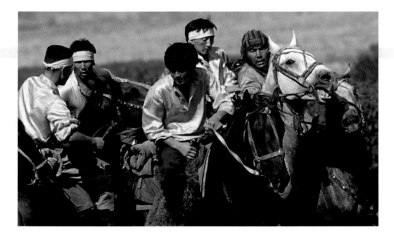

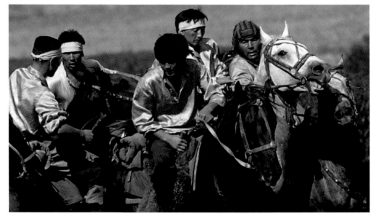

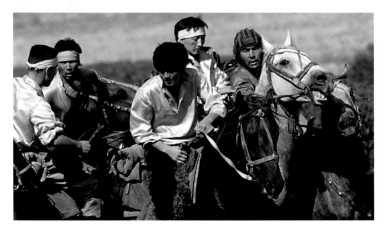

Separating tones

Starting with this color image (*top left*), a standard grayscale conversion gives acceptable results (*middle left*), but channel mixing separates out the tones more effectively, particular in shadow areas (*bottom left*). The settings required were complicated, and arrived at by trial and error (*screen shot above*). The work done reduces the need for further processing of the image, but if you want to refine the results further, a channel-mixed image makes such techniques as burning-in and dodging (*pp. 244–5*) easier to apply, since, as you can see, the shadows on the shirts are far more open and susceptible to local density control.

● Canon EOS-1n with 300 mm lens. ISO 100 film. Microtek 4000t scanner.

●TRY THIS

To help learn how to isolate colors using the tools available in your software, start by selecting a bright, multicolored image – perhaps a collection of fruit, a flower stand, or something similar. Working on a copy of the image, now decide which color you wish to emphasize by making it light after conversion to grayscale. Use Color Balance, Replace Color, Hue and Saturation, or Channel Mixer tools to obtain the required result. If your first try does not work, return to the image and try a series of new settings. When you have a result you are happy with, note the settings. Use this information to replace another color in the image, and see if you can get to the desired result more quickly than the first time.

Duotones

Much of the art of traditional black-and-white printing lies in making the most of the limited tonal range inherent in the printing paper. A common tactic is to imply a wider tonal range than really exists by making the print contrasty. This suggests that shadows are really deep while highlights are truly bright. The success of this depends on the subtleties of tonal gradation between these extremes. A further technique is to tone the print, adding color to the neutral gray image areas.

Modern digital printers have opened up the possibilities for toning well beyond that possible in the darkroom. The range of hues is virtually unlimited as you can simulate all those that can be created with the four-color (or more) process.

Creating a duotone

Starting with an image, even a color one, first turn the file into a grayscale (*see pp. 272–7*) using, in Photoshop, the Image > Mode menu. This permanently deletes color information, so you need to work on a copy file. Similar results can be obtained in the Sepia Tone effect, a menu option in almost all image-manipulation applications.

Now that you have a grayscale image you can enter the Duotone mode, where you have a choice of custom work or loading one of the preset duotones. If you are not familiar with the process, use the Duotone Presets (usually found in the "Goodies" folder of Photoshop). Double-click on any one to see the result.

Simple duotones
This view of Prague (*left*) has been rendered in tones reminiscent of a by-gone era. After turning the image to grayscale, two inks were used for the duotone, neither of them black. This gave a light, low-contrast image characteristic of an old postcard.

● Canon F-1n with 135 mm lens. ISO 64 film. Nikon Coolscan 4000 scanner.

Duotone Options screen shot
The curve for the blue ink (*above*) was lifted in the highlights in order to put a light bluish tone into the bright parts of the image and also to help increase the density of the shadow areas.

Clicking on the colored square in the dialogue box (*see opposite*) changes the color of the second "ink." Bright red could give an effect of gold toning; dark brown, a sepia-toned effect. This is a powerful feature – in an instant you can vary the toning effects on any image without any of the mess and expense of mixing chemicals associated with the darkroom equivalent.

If you click on the lower of the graph symbols, a curve appears that tells you how the second ink is being used, and by manipulating the curve you can change its effect. You could, for example, choose to place a lot of second ink in the highlights, in which case all the upper tones will be tinted. Or you may decide to create a wavy curve,

in which case the result will be an image that looks somewhat posterized (*see p. 264*).

In version 5 and later editions of Photoshop, you can choose Previews. This updates the image without changing the file, allowing you to see and evaluate the effects in advance.

You need to bear in mind that a duotone is likely to be saved in the native file format (the software's own format). This means that to print it you may first have to convert it into a standard RGB or CMYK TIFF file, so that the combination of black and colored inks you specified for the duotone can be simulated by the colored inks of the printer. This is the case whether you output on an ink-jet printer or a four-color press.

Retaining subject detail

In this original image (*above*), there was so much atmosphere it was a pity to lose the color. But the resulting duotone, with a green second ink, has its own charms (*above right*). To reduce

overall contrast and allow the green ink to come through, it was necessary to reduce the black ink considerably – as shown by the Duotone Curve dialogue box (*right*).

● Nikon FG with 70–210 mm lens. ISO 64 film. Nikon Coolscan 4000 scanner.

Duotone Curve and Color Picker screen shots

The low position of the end of the curve in the dialogue box (*above*) indicates a low density of black, but the kinks in the curve were introduced to increase shadow contrast and

retain subject detail. The lifted end of the curve shows that there are no real whites: the lightest part still retains nearly 14 percent of ink, as shown in the top box labeled "0:" in the Duotone Curve dialogue box.

Tritones and quadtones

The addition of one or more inks to a duotone (*see pp. 278–9*) adds extra layers of subtlety to an image. Using most image-manipulation software, you will have tritone or quadtone boxes offering additional inks and curves for you to apply.

Bear in mind that with the extra inks on offer you can produce tinted highlights or you can hint at colors in the shadows that are not present in the mid-tones, and in this way create more tonal separation. But there is no substitute for experimenting by applying different curves and colors, as this is the best way to learn how to use this powerful control. As a starting point, try using color contrasts by applying third and fourth inks in small amounts. Or, if you want a graphic-art type of effect, try curves that have sharp peaks.

One technical reason for using a quadtone is to help ensure accurate color reproduction. While not guaranteeing results, the chances of an accurate four-color black are greatly increased by specifying a quadtone in which the colors used are the standard cyan, magenta, yellow, and black of the printing process.

You can save curves and sets of colors and apply them to other grayscale images. When you find a combination that appeals to you, save it for future use in a library of your favorite settings.

Original image
Starting with this view of the city of Granada, in southern Spain (*above*), I first made a copy file of the original to work on. Then, using the copy file, I removed all the color information to make a grayscale, before deciding on which inks to apply.

● Nikon Coolpix 990.

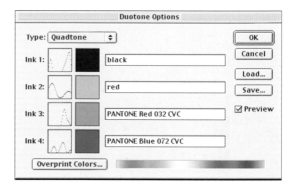

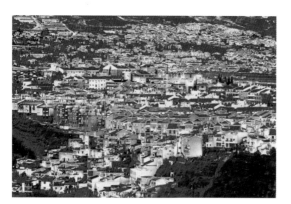

Quadtone
For this image, black has been assigned to the dark featureless shadows, green to those shadows that still retain details, and blue to the lower and mid-tones. This is shown by the peaks in the graphs next to each color ink in the Duotone Options dialogue box (*above right*). Adjusting the heights of the peaks changes the strength of the colors.

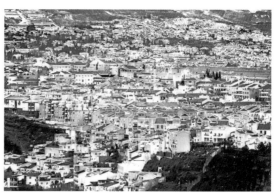

Tritone
Assigning different-colored inks to specific tonal densities in the image produces visual effects that are very difficult to achieve in any other way. In this tritone version of the scene, the fourth (blue) color has been switched off, and the result is a brighter, lighter image compared with the quadtone (*above left*).

Sepia tones

With digital technology you can bring about image changes with more control than is possible in a darkroom. A prime example of this is the digital equivalent of sepia toning – the low-contrast, nineteenth-century technique that gives warm, brown image tone with no blacks or whites.

Old prints lack contrast due to the film's recording properties and the makeup of the print's emulsion. The softness is likely due to the lens, while the brown tone is down to the print being treated with a thiocarbamide compound.

Some digital cameras produce "sepia-toning," if correctly set, and various image-manipulation applications will also give these effects with just a single command, though with little control.

For controlled results, first convert your grayscale image to RGB color mode. Once in RGB, desaturate the image. Invoke the Levels command (*see pp. 242–3*) and make the image lighter and grayer and then remove the blacks and whites.

Now you can add color. The easiest way to do this is by using Color Balance (*see p. 260*) to increase the red and yellow. Or use the Variations command (if available) to add red, yellow, and possibly a little blue to produce a brown that you find suits the content of your image.

Another option is to work with a grayscale image in Duotone mode to add a brown or dark orange as the second ink. Using Photoshop, this provides the most subtle effects.

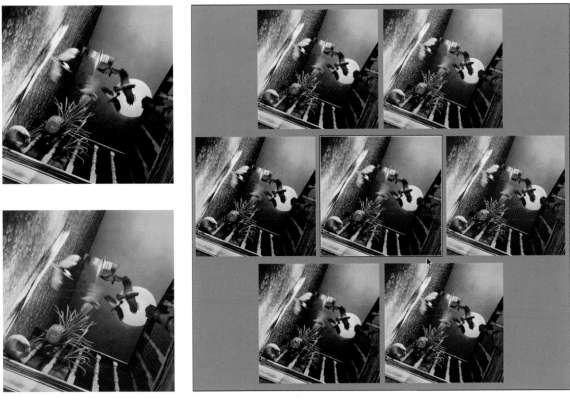

Using Variations
There are several ways to add overall color to the type of interior view shown here. Although subject content is strong, the black-and-white version (*top left*) lacks atmosphere. The multi-image Variations dialogue box (*right*), an option available in most image-manipulation software packages, presents several versions of the toned original from which to choose. By clicking on one (*shown outlined in the dialogue box above*), you turn it into the image of choice, and you can then compare it against the original. To arrive at the final sepia-toned image (*bottom far left*), the Levels control was used to reduce shadow density and so produce a flatter contrast.

● Rolleiflex SL66 with 50 mm lens. ISO 125 film. Heidelberg Saphir II scanner.

Sabattier effect

When a partially developed print is briefly re-exposed to white light, some of the tone values are reversed. Although developed areas of the print are desensitized to light, partially undeveloped areas are still capable of being fogged. If these are then allowed to develop normally, they will darken. As the doctor and scientist who discovered this effect, Frenchman Armand Sabattier (1834–1910), described this process as "pseudo-solarization," it has become incorrectly known as "solarization" – which is, in fact, the reversal of image tones due to extreme overexposure.

Digital advantages

For the traditional darkroom worker, the Sabattier effect is notoriously time-consuming and difficult to control – it is all too easy to spend an entire morning making a dozen or more prints, none of which looks remotely like the one you might be trying to copy. Using digital image-manipulation techniques, however, this type of uncertainty is a thing of the past.

The first step is to make a copy of your original image to work on and convert that file to a grayscale (*see pp. 272–7*). Choose an image that has fairly simple outlines and bold shapes – images with fine or intricate details are not really suitable as the tone reversal tends to confuse their appearance. You can also work with a desaturated color image if you wish.

There are several digital techniques that allow you to simulate the Sabattier effect. One way of proceeding, if you have software that offers Layers and Modes (*see pp. 314–19*), is to duplicate the lower, original layer into a second layer. You then apply the Exclusion Layer mode, and adjust the tone of the image by altering the Curves or Levels for either layer.

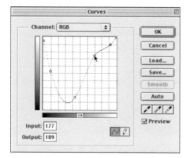

Working in black and white
Images with strong shapes (*top*) are ideal for the Sabattier treatment, since the changing tonal values only obscure images with fine detail. To obtain the partial reversal of tones shown here (*above*), a U-shaped curve was applied, which caused the shadows to lighten. The narrow halo on some shapes are a by-product of the Curves and they are also reminiscent of the Sabattier effect induced in the darkroom, known as Mackie lines.

● Rolleiflex SL66 with 50 mm lens. ISO 125 film. Heidelberg Saphir II scanner.

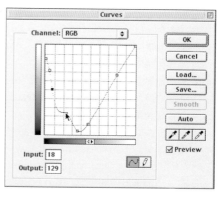

Working in color

Working digitally, you can take the Sabattier effect further than is possible in the darkroom. By starting with a slightly colored image, you will end up with results displaying partially reversed hues. In this landscape, taken in Oxfordshire, England, the grayscale print was warmed using the Color Balance control to add yellow and red. On applying a U-shaped curve to this image, the highlights to mid-tones remained as they were, but the darker tones reversed — not only in tone but also in color, as you can see here (*right*). An arch-shaped curve would produce the opposite effects.

● Nikon F2 with 135 mm lens. ISO 400 film. Nikon Coolscan 4000 scanner.

Using Curves

The most controllable and powerful way of working is to invoke the Curves control and draw a valley-shaped curve, with a more-or-less pronounced hollow in the middle (*top right*). By introducing small irregularities in the curve's shape you create surprising tonal changes — thus putting back into the process some of the unpredictability and charm of the original darkroom technique. The advantage of working with Curves is that you can save them and then apply them to any other image you wish. The Sabattier effect will also work with color images, but as with the tones, the colors become reversed as well. If you want to avoid the hues becoming reversed, change the image to Lab mode (*see p. 275*), and then apply the "Sabattier" curve only to the L channel.

Gum dichromates

A gum dichromate is a flat colorization of a grayscale image; in the process, however, the tonal range tends to become compressed. Gum dichromates have had a popular following for most of the history of photography – they are relatively inexpensive and tolerant of processing variations, they are an accessible way to add color to black-and-white images, and the technique is a rapid route to effects that look painterly. However, the process is also rather messy and results unpredictable, so most darkroom workers soon tire of it. Fortunately, once you know the look of a typical gum dichromate, you can easily reproduce it digitally without having to handle dyes and a range of sticky substances.

The digital method is very straightforward. Images with clean outlines and subjects without strong "memory colors" – flesh tones or green vegetables, for example, that everybody recognizes – are the easiest to work with. Start by selecting the areas you want to color using the Lasso or Magic Wand tool. Next, choose a color from the Palette or Color Picker and fill your selection using the Bucket or Fill tool with the Colorize mode set. Working this way ensures that colors are added to the existing pixels, rather than replacing them. The main point to bear in mind is that you should keep colors muted by choosing lighter, more pastel shades rather than deep, saturated hues – it is easy to create too many brilliant colors.

Another approach is to work in Layers, with a top layer filled with color and the mode set to Color or Colorize. This colors the entire image, so you will need to apply some masking (*see pp. 320–1*) to remove colors from certain areas (Photoshop versions 6 and above do this automatically). Another layer filled with a different color and different masks will apply colors to other parts of the image. If you want to lower the color effect overall, use the opacity setting. In fact, this method is the exact digital counterpart of the darkroom process.

Adding texture
The original picture (*above left*) shows a place set aside for quiet contemplation in a cemetery in Hong Kong, and it has the clean, strong lines that work so well for dichromatic effects. Areas of the image were roughly selected and colored in to produce the inaccuracies that are typical of darkroom-produced dichromates. After adjusting the colors, a texture was laid on the image to simulate the fibrous nature of a dichromate made the traditional way. The Texturizer filter of Photoshop was used twice at high settings, and then the Blur More filter was applied once in order to soften the texture a little.

● Rolleiflex SL66 with 80 mm lens. ISO 125 film. Heidelberg Saphir II scanner.

Subtle covers

The colors of the room background, the bed itself, and the bed covers that were recorded in the original picture (*above left*) were each separately selected and then filled with the Colorize mode set. The resulting image, with its eye-catching blocks of pastel shades (*above right*) accurately imitates an old-style gum dichromate print.

● Mamiya 645 ProTL with 80 mm lens. ISO 400 film. Heidelberg Saphir II scanner.

Color and opacity

This negative print (*left*) was made from an instant black-and-white slide film. It was scanned to RGB and areas roughly selected with the Lasso tool, set to a feather or blended edge of 22. Color was filled into each selection, using Color mode (in Photoshop 6, Fill Layer mode) set to Color. This colorizes the underlying layer at differing opacities. Different selections were filled with color and adjusted so that they balanced well to give the final image (*below*).

● Canon F-1n with 50 mm lens. ISO 80 film. Heidelberg Saphir II scanner.

Split toning

Toning is a traditional darkroom technique – or workroom technique, as darkness is not essential for the process. Here, the image-forming silver in the processed print is replaced by other metals or compounds to produce a new image tone.

The exact tone resulting from this process depends, in part, on the chemical or metal used and, in part, on the size of the particles produced by the process. Some so-called toners simply divide the silver particles into tinier fragments in order to produce their effect. Where there is variation in the size of particles, the image takes on variations in tone – from red to brown, for example, or from black to silvery gray. This variation in tone is known as split toning and is caused by the toning process proceeding at different rates. These

Using the Color Balance control

Images with well-separated tones, such as this misty mountain view, respond best to split toning. To add blue to the blank, white highlights of the mist, an adjustment layer for Color Balance was created. The Highlight Ratio button was clicked and a lot of blue then added. Another adjustment layer was then created, but this time the tone balance was limited to the shadows.

The Preserve Luminosity box was left unchecked in order to weaken the strong corrections given: the screen shot (*above*) shows that maximum yellow and red were set. While this gives a satisfactory result, it can be refined further in some software packages (*right*).

● Canon F-1n with 80–200 mm lens. ISO 100 film. Nikon Coolscan 4000 scanner.

Blending Options

This is part of the Blending Options box from Photoshop. The color bars show which pixels from the lower and which from the upper layer will show in the final image. With the sliders set as here, there is partial show-through – enabling a smooth transition between the blended and unblended image areas. For this layer, the underlying area shows through the dark blue pixels. In addition, a wide partial blend was indicated for all channels, allowing much of the light blue to show over the dark, reddish tones.

rates are dependent on the density of silver in the original image.

This, perhaps, gives you a clue about how the effect can be simulated digitally in the computer – by manipulating duotone or tritone curves (*see pp. 278–80*) you can lay two or more colors on the image, the effects of which will be taken up according to image density.

Another method is to use Color Balance (*see p. 260*), a command that is available in all image-manipulation software. This is easiest to effect in software that allows you to adjust the Color Balance control independently for highlights, mid-tones, and shadows. If your software does not allow this, you will have to use Curves, working in each color channel separately (*see pp. 266–70*).

Using Tritone
The Tritone part of the Duotone Options dialogue box for the final image shows a normal curve for the first, orange-brown, color. The second, blue, color is boosted to darken the mid-tones, while the third color, another blue, supports the first blue. Without the addition of this third color, the mid-tones would look a little too weak and lack visual impact.

Using Color Balance
Highlighting the similarity in shape between the tree reflected in the store window and the lamps within in the original image (*top left*) was the aim here. At first, two colors – brown and blue – were used, but it was hard to create sufficient contrast between the dark and light areas. To help overcome this problem, another blue was added to boost the dark areas, as shown in the Duotone Options dialogue box (*above left*) – the blue plus brown giving deep purple. Color Balance (*above right*) was shifted to help shadow saturation, and the lamps were also dodged a little to prevent them from being rendered too dark.

● Leica M6 with 35 mm lens. ISO 400 film. Nikon Coolscan 4000 scanner.

Sun prints

By the end of the eighteenth century it was known that if objects were placed on specially treated paper and left out in sunshine, a "sun print" of the object could be recorded. Later, prints were made in the same way, by placing negatives in contact with special printing paper. This paper did not need developer as the image became visible as a result of the exposure. The image was then fixed or, in later versions, the paper incorporated toning salts so that the image colored as it was exposed.

Typical tonalities were rich and vibrant golden browns and yellows, even oranges and purples.

Developer-incorporated papers today are not intended for printing: standard fixers erase the image and the low quantity of silver used gives poor image quality.

Fortunately, in the computer you can re-create the tonalities of sun prints easily and conveniently. As well, you are not limited to using large-format negatives or even black-and-white originals. The

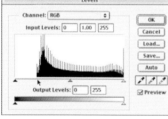

Sun print colors
While the black-and-white original captures the mood of the scene (*top*), it loses the golden light so magical at the time. A new Layer was applied to the image (scanned from the original) and filled with yellow, with Blending mode set to Color Burn. This had the effect of increasing contrast and color saturation. However, the yellow looked too artificial, so I changed it for golden orange. Though better, contrast was still too high. To counter this, next I lightened it overall by reducing the black output, resulting in the Levels display here (*above*). The copper-red tones of the final image (*above right*) are typical of toned sun prints.

● Mamiya RB67 with 65 mm lens. ISO 125 film. Heidelberg Saphir Ultra II scanner.

Layers screen shot
The Layers dialog box (*left*) shows that the upper layer (scanned from the original black-and-white image) has been filled with an orange color and that no mask has been applied anywhere to the image. Using these settings, the color is made to extend fully and evenly over the whole of the picture area. The Blending mode selected is Color Burn, which intensifies both the tone and color by darkening tonal values and increasing color saturation. If you want to reduce the intensity of the color effect, then it is a simple matter to reduce the opacity from the 100 percent value that has been set here, seen in the top right-hand panel of the box.

basic technique is first to take any grayscale image, or desaturate a colored image to grayscale (*see pp. 272–7*). The easiest route is next to create a layer above the image and fill it with color. Set the Layer mode to Color Burn (to intensify colors) or Color Mode (to add color values to the underlying layer according to its – the receiving layer's – brightness). Note that as you do this, images easily fall outside the printer's gamut – the colors seen on the monitor are outside the range that the printer can reproduce (*see p. 117*). You can experiment endlessly until you obtain the precise rich, warm tonal response. For a convincing effect, however, it is vital that both the highlights and shadows take on the color cast.

Because this simulated sun-print effect extends evenly over the entire image, you can apply it to virtually any type of subject. Landscapes and still-life studies, or images of buildings can all benefit from this treatment.

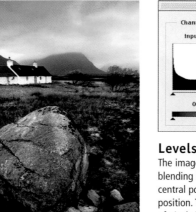

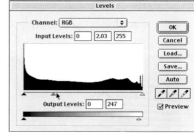

Levels screen shot
The image was lightened, under the top blending layer, in Levels by dragging the central pointer to the left of its default position. This forces a greater proportion of pixels in the image to be brighter than mid-tone, so increasing the overall brightness of the picture.

Color and tone
For this view of an attractively located Scottish bothy (a hut or mountain shelter) in a wild and remote region of the Highlands, an even warmer color than that used opposite was applied to the original black-and-white image (*above left*) using Color Burn. This mixing mode not only adds strong color, it also greatly increases image contrast. Although the first effort (*above*) resulted in the correct color, this was simply too intense and it also had that heaviness of tone that is characteristics of applying the Color Burn mode. Making a simple adjustment in Levels lightens the image overall (*left*) without allowing any white areas to appear. It is typical of sun prints that there is no real white visible anywhere in the image.

● Olympus OM-2n with 21 mm lens. ISO 25 film. Heidelberg Saphir Ultra II scanner.

Hand tinting

Ever since the early days of photography, the hand coloring of black-and-white prints has been considered an art form, with its own palette of "permitted" tones. And because of the undeniable skill required by practitioners, the process tends not to be for the faint-hearted – the slightest mishap could cost you the entire print.

Working digitally

However, hand coloring in the digital domain is very different. It allows you risk-free experimentation, no commitment to interim results, and, of course, it is an entirely mess-free process.

This said, there are still some points you need to consider. Many photographers make the mistake of painting directly onto their image with the Brush tool set to Normal. This never works well because you are switching the pixel values of your image directly into the Brush color. You may then try painting into a layer, but this does not help much either. Even if you change the opacity percentage in an attempt to make the effect more subtle, it still appears as if the color has replaced the image. What you need to do instead is add the color values, still using the Brush tool but to the grayscale values of the image, without changing

Color combinations

To suit the strong shapes of the original (*top*), equally strong colors were called for. You can work with any combination of colors, and it is worth experimenting – not only will some combinations look better, some will print more effectively than others. Bear in mind that a blank area will not accept color if the Color or Blending mode is set to Colorize. To give white areas density, go to the Levels control and drag the white pointer to eliminate pure white pixels. Once the pixels have some density, they have the ability to pick up color. To give black areas color, reduce the amount of black, again via Levels control. Although the "paint" is applied liberally (*above left*), note in the finished print (*above*) that color does not show up in the totally black areas.

● Rolleiflex SL66 with 80 mm lens. ISO 125 film. Heidelberg Saphir II scanner.

the luminance value of the pixels. That is the job of the Color or Colorize mode.

There are two ways of proceeding. The way most like painting is to set the Brush to Color and then paint away. The second is to create a new layer set to Color above the image, and paint into it. This makes it possible to erase errors without damaging the underlying image. If you find it easier, add strong colors to see what you are doing and then reduce the opacity afterward.

Pastel shades are often out-of-gamut with color printers and monitors, so you may need to work with barely visible subtleties for the printed result to look soft enough. As yet, the porcelain-like textured finish of a good-quality, hand-colored print is beyond the ability of ink-jets. The careful use of papers with tinted bases can help the effect, as the paper's tints will then narrow the dynamic range and soften contrast.

Painted layer

When tinting an image, you can apply the paint quite freely – as you can see in this image of the painted layer that lies above the base image. However, for a realistic final effect you need to use a range of colors to give variety. Unlike using real paints on a print, you can easily erase any unwanted mistakes and repaint the layer as often as you wish.

Reduced opacity

The springtime foliage deep within an old wood (*above*) was emphasized by a great deal of detailed dodging (*pp. 244–5*) to lighten individual leaves. In order to introduce some color into the scene, a new layer was created and its Blending mode was set to Color – this means that only areas with density are able to pick up color (*above right*). The paint was then applied to this layer. Finally, the opacity of the layer was reduced to 40 percent for the final image (*right*) to allow the quality of the foliage to show through the color overlay.

● Nikon 601 with 20–35 mm lens. ISO 400 film. Nikon LS-2000 scanner.

Cross-processing

Of the numerous unorthodox ways to process color film, perhaps the most popular is developing transparencies in chemicals designed for color negatives. Second is processing color negatives in chemicals designed for color transparency film.

Cross-processing techniques make fundamental and irreversible changes to the film, so there is much to be said for simulating the effects using digital image-manipulation techniques. There is a further advantage to working digitally. Color negative film is overlaid with an orange-colored mask whose job it is to correct inherent deficiencies in the color separation or filtering process during exposure. Before the final print can be made, this mask has to be replaced or neutralized.

Color negative film to transparencies

Results from this type of cross-processing have flat tones and muted colors due to the fact that color negative film is low in contrast and transparency processing chemicals compress highlights. Color is also unpredictable, resulting in color balance in the highlights being different from that in the lower mid-tones and shadows.

Digitally, the Curves control is the best way to simulate this effect, though don't be alarmed if

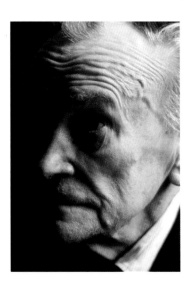

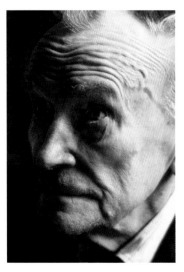

Processing negatives as transparencies

The flattening out of image contrast and the semblance of color toning that results from processing color negative film in chemicals intended for transparencies can become an interesting portraiture effect. By applying different curves to each color channel (*above*), the color balance was shifted away from the red (*above left*) toward the yellow-green coloration that is typical of this form of cross-processing (*left*). Note the posterization beginning to become

apparent in the shadow areas around the subject's eyes. This is due to the original image being shot on high-speed film. The curves that are given here are for your guidance only: you can start with these but you are likely to want to adjust them, particularly the master RGB curve, to suit the particular images you are working on.

● Canon F-1n with 135 mm lens. ISO 1000 film. Nikon LS-4000 scanner.

your image goes too dark or light – you can adjust overall brightness later. Another possible image outcome is posterization (*see p. 264*). If you find this effect unattractive, then the scan may be of insufficient quality. If so, your only option is to rescan the original image, possibly to a higher bit-depth (*see p. 271*).

From transparencies to color negatives

Results from processing transparencies as color negatives are often contrasty, with color shifts toward cyan. They also have an open tonality, often with highlights reproducing as featureless white. This occurs because of the need to print inherently high-contrast transparencies on paper meant for the lower contrast of color negatives.

The best way to create this digitally is to manipulate the separate channels in the Curves control. When you have a set of curves that work, you can save and reapply them to any image.

If you find it hard to concentrate on the overall lightness of the image while juggling with different channels, leave overall density to the end and work just on the colors and contrast. Once you are satisfied with these, call up the Levels control (*see pp. 242–3*) to adjust overall brightness.

Processing transparencies as negatives

The high-contrast effect that results from cross-processing color transparency film in color negative chemicals works with subjects that have strong outlines and punchy colors (*above left*). By applying the set of curves shown here (*right*), the result is brilliant color and the type of washed-out highlights typical of this form of cross-processing (*above right*). As the highlight areas are tonally balanced by the full shadows and strong colors, they are more acceptable than in an image with a normal tonal range. The curves are given here are for your guidance only: you can start with these but you are likely to want to adjust them, particularly the master RGB curve, to suit your particular images.

● Canon EOS-1n with 80–200 mm lens. ISO 100 film. Nikon Coolscan 4000 scanner.

Tints from color originals

It is not necessary for color images to be strongly colored in order to have impact. You can, for example, use desaturated hues – those that contain more gray than actual color – to make more subtle color statements. In addition, selectively removing color from a composition can be a useful device for reducing the impact of unwanted distractions within a scene (*see pp. 254–5*).

For global reductions in color, you need only turn on the Color Saturation control, often linked with other color controls, such as Hue, in order to reduce saturation or increase gray. By selecting a defined area, you can limit desaturation effects to just that part.

Working procedure

While working, it may be helpful to look away from the screen for each change, since the eye finds it difficult to assess continuous changes in color with any degree of accuracy. If you watch the changes occur, you may overshoot the point that you really want and then have to return to it. The resulting shuffling backward and forward can be confusing. Furthermore, a picture often looks as if it has "died on its feet" when you first remove

the color if you do it suddenly – look at the image again after a second or two, and you may see it in a more objective light.

For extra control, all image-manipulation software has a Desaturation tool. This is a brush tool, the effect of which is to remove all color evenly as it is "brushed" over the pixels. Work with quite large settings – but not 100 percent – in order to remove color quickly while still retaining some control and finesse.

Another way of obtaining tints of color from your original is to select by color or range of colors. If you increase the saturation of certain colors, leaving the others unchanged, and then desaturate globally, the highly saturated colors will retain more color than the rest of the image, which will appear gray in comparison.

Bear in mind that many pixels will contain some of the color you are working on, even if they appear to be of a different hue. Because of this, it may not be possible to be highly selective and work only over a narrow waveband. The program Photoshop allows you to make a narrow selection: you can use Replace Color as well as the waveband limiter in Hue and Saturation.

Global desaturation

To produce a selective desaturation of the original (*above left*), taken in Samarkand, Uzbekistan, the whole image was slightly desaturated, while ensuring that some color was retained in the apples and hands (*above right*). The process was paused so that the apples and hands could be selected, and then the selection was inverted, with a large feathering setting of 22.

This was easier to do than selecting everything apart from the hands and apples. Desaturation was again applied, but this time just to the selected area.

● Leica R5 with 28 mm lens. ISO 50 film. Nikon Coolscan LS-1000 scanner.

Selective color

The original shot of a park in Kyrgyzstan (*above left*) was too colorful for the mood I wanted to convey. In preparation for a selective desaturation based on color-band, I first increased the blues to maximum saturation in one action. Then I opened the Saturation control again and boosted yellows (in order to retain some color in the leaves on the ground and the distant trees in the final image). The result of these two increases in saturation produced a rather gaudy interpretation (*above right*). Normally, a 40 percent global desaturation would remove practically all visible color, but when that was applied to the prepared image, the strengthened colors can still be seen while others, such as greens, were removed (*right*).

● Canon EOS-1n with 17–35 mm lens. ISO 100 film. Nikon LS-2000 scanner.

Partial desaturation

The best way to desaturate the original image here (*above left*) was to use the Desaturation tool (also known as Sponge in the Desaturation mode), as it allowed the effects to be built up gradually and for precise strokes to be applied. Although the intention was to desaturate the trees completely, in order to emphasize the glorious colors of the women's clothes, as the strokes were applied it become clear that just a partial removal and toning down of the green would be more effective (*above right*). The image was finished off with a little burning-in to tone down the white clothing.

● Leica R5 with 70–210 mm lens. ISO 50 film. Nikon LS-1000 scanner.

Quick fix Problem skies

A common problem with views taking in both sky and land is accommodating the exposure requirements of both – a correctly exposed sky leads to a dark foreground, or a correctly exposed foreground gives a featureless, burned-out sky.

Problem

Skies in pictures are too bright, with little or no detail and lacking color. This has the effect of disturbing the tonal balance of the image.

Analysis

The luminance range can be enormous outside. Even on an overcast day, the sky can be 7 stops brighter than the shadows. This greatly exceeds the capacity of all but the most advanced scanning backs.

Solution

If an area of sky is too light in a scan from a negative (black and white or color), it is best to make a darkroom print and burn the sky in manually (see pp. 244–5). Then you can scan this corrected print if further manipulations are required. Digital solutions will be of no help if the sky presents plain white pixels devoid of subject information. For small overbright areas, you can use the Burn-in tool, set to darken shadows or mid-tones, at very low pressure.

Don't set it to darken highlights or the result will be unattractive smudges of gray.

Another method is to add a layer, if your software allows, with the Layer mode set to Darken or Luminosity (which preserves colors better). You can then apply dark colors where you want the underlying image darker. The quickest method to cover large areas is to add a Gradient Fill – this is equivalent to using a graduated filter over the camera lens, but it is somewhat indiscriminate.

A more complicated method requires some planning. You take two identically framed images – one exposed for the shadows, the other for the highlights. This is best done in a computer, where it is a simple matter of superimposing the two images with a Gradient Mask.

How to avoid the problem

Graduated filters attached to the camera lens are as useful in digital as traditional photography – their greater density toward the top reduces exposure compared with the lower part of the filter, so helping to even out exposure differences between sky and foreground. It is worth bearing in mind that some exposure difference between the land and sky is visually very acceptable.

1 Gradient Fill
Areas of overbright highlight, as in the sky of this landscape, can be corrected using Gradient Fill. This mimics the effect of a graduated filter used on the camera lens.
● Nikon Coolpix 990.

2 Layers screen shot
First, a new layer was created and the Layer mode set to Darken. This darkens lighter pixels but not those already dark. A graduated dark blue was then applied to the top corners with medium opacity.

3 Final effect
This digital treatment does not increase graininess, as conventional burning-in would do, but note how local darkening lowers overall image brightness. Further adjustments to brighten the lake are possible.

1 Masking overlays

The basis of this technique is to take two identically framed images – one exposed for the sky (*top*), the other exposed for the foreground (*above*) – and then composite them using a gradient or graduated mask to blend them smoothly. You need image-manipulation software that works with Layers and Masks (*pp. 316–21*). This is easy for digital photographers but if you shoot on film, you can scan an original twice (once for highlights, once for shadows), ensuring the two are the same size, and copy one over to the other.

● Canon D30 with 100–400 mm lens.

2 Making a gradient mask

Next, using Layers control you have to create a gradient mask, which allows you to blend one image smoothly into the other (*top*). Notice that this entire image is slightly transparent: in other words, the whole image is masked but there is heavier masking in the lower half, as you can see in the dialog box (*above*). The overall effect of applying this mask is that the lower image will show through the top layer.

3 Final effect

Blending the two exposures and the mask produces an image that is closer to the visual experience than either original shot. This is because our eyes adjust when viewing a scene, with the pupil opening slightly when we look at darker areas and closing slightly when focusing on bright areas. A camera cannot adjust like this (although certain professional digital cameras can partly compensate). Image-manipulation techniques can thus help overcome limitations of the film.

Filter effects

One of the alluring features of working digitally is being able to create, at the touch of a button, fantastic visual effects. These range from the dazzling to the ridiculous. However, while filter effects can impress, they are often solutions looking for visual problems. Experienced digital workers use filters only when they have a definite objective in mind.

Special filter effects are most useful when judiciously used with standard operations, where they lift an image into the extraordinary. However, not all filters are obvious or give strange results: some, such as Unsharp Masking, are essential tools.

The variety of different filter effects can be bewildering at first glance, so it may be helpful to classify them into broad categories.

Sharpness and Blur filters These affect the image, or selected areas, uniformly (*see pp. 248–53*). They work at the edges of image detail to increase differences at these boundaries (sharpening) or decrease differences (softening or blurring).

Distortion filters These change the shape of the image – either overall or small portions of it. These can be very tricky to control and need to be used with care (*see pp. 100 and 300*).

Art Materials and Brushstroke filters These filters aim to simulate such effects as charcoal drawing or painting brushstrokes by using image information and combining it with effects based on mimicking real artists' materials. With these may be grouped filters that are designed to break

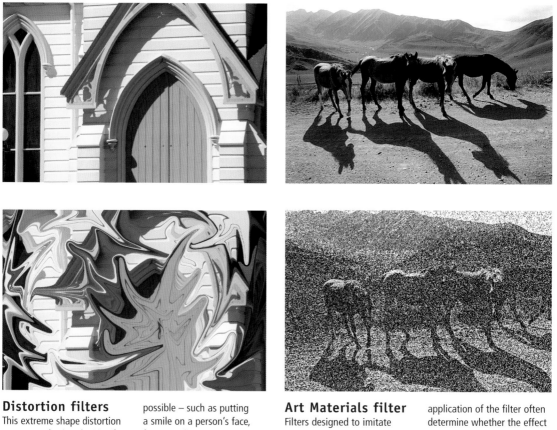

Distortion filters
This extreme shape distortion was created using the Liquify filter in Photoshop. The effects can be extreme and cartoon-like in appearance. However, delicate distortions are also possible – such as putting a smile on a person's face, for example.
- Canon D30 with 28–135 mm lens.

Art Materials filter
Filters designed to imitate artists' techniques are readily available, and can be effective when applied to appropriate imagery. Adjustments to tone, color, and sharpness after application of the filter often determine whether the effect is a success or failure.
- Canon EOS-1n with 28–80 mm lens. ISO 100 film. Nikon LS-1000 scanner.

up the image into blocks or which add "noise" (*see pp. 246–7 and 303*).

Stylizing filters These use geometric shapes to build up the image, or else they base the new image on features, such as edges, of the original (*see p. 305*).

Texturizing filters These filters (*see p. 307*) are similar to Rendering filters in three-dimensional modeling programs. For example, lighting effects simulate a light shining on the image, and by altering the "surface" of the image, the light appears to give the image a texture. These filters make heavy demands on the computer and you may find large files cannot be processed if the machine does not have enough RAM.

Using filters

● Practice on small files when experimenting with filter effects.

● Try the same filter on different styles of image to discover which filters work best on particular types of imagery.

● Filters often work best if applied to selected areas.

● Repeated applications of a filter can lead to unpredictable results.

● You usually need to adjust contrast and brightness after applying a filter.

● Reduce the image to its final size on screen to check the effect of filters.

Stylizing filters
These filters take their cue from geometric shapes, applying them to images to create mosaic-like effects. Dramatic, three-dimensional effects, such as Extrude, are also possible. They usually need images that feature clear shapes and strong colors to work on.

● Canon F-1n with 20 mm lens. ISO 100 film. Nikon LS-1000 scanner.

Texturizing filters
Texturizing filters, or the very similar Rendering filters, provide a range of challenging effects for digital photographers. The computer, too, is likely to be challenged by them, since they all soak up a great deal of computing power.

● Canon F-1n with 80–200 mm lens. ISO 100 film. Nikon LS-1000 scanner.

Filter effects continued

Distortion filters

In essence, Distortion filters work by changing the position of a pixel in an image by moving its value onto another pixel while leaving the original color and brightness information intact. The key point here is that the distance the pixel value is moved depends on its original position.

The effects of the filters can be applied over small, repeated grids, such as in the Glass Distortion, or globally, as in the Pinch filter effect. These filters change the inherent shape of objects in ways that are simply impossible to imitate using any type of conventional treatments, such as the special effects filters used on the camera lens or in a traditional darkroom.

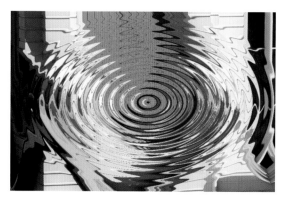

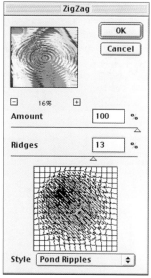

ZigZag (ripples)

This Distortions filter makes an image look as if it is a reflection in a pond. With any Distortion filter, it is vital to be able to control the degree of the effect (*above*). For an animation, you can increase the effect progressively, adding more ridges and saving separate images (later to be the animation "frames") for each step.

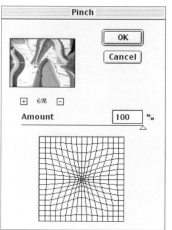

Pinch

This filter acts as if the image is on a rubber mat being squeezed or stretched. It compresses the "mat" toward the center with most effect away from the diagonals. When lightly applied to a limited area, the filter is useful for subtle shape changes of small features. You can also experiment with rotating the whole canvas before applying the filter. Try rotating the image a little and applying the filter; then repeat with another small rotation. If any distortion is not enough, reapply the effect to strengthen it.

RAM problems

Rendering and Distortion filters use large amounts of RAM. If you run low, try distorting the image one channel at a time. However, if the image is not full of information, or suffers from noise, the effects of this method may not be the same as a single, simultaneous application. If you run out of RAM with other operations, try reducing the image file size a little at a time until you can perform the operation. Rendered images seldom need the resolution of an unblemished one, so you can resize images without worrying about loss of detail.

Polar Coordinates

This filter performs some very complicated mathematics in order to show how an image might look if it were projected onto a globe. Notice how the vertical lines in the church have been mapped into circular lines, as if the original image (*p. 298*) had been a map in two-dimensions of a three-dimensional globe, and the filter has returned the image to what would have been its original appearance. However, since the original image was not corrected for projection distortions, the filtered image appears to be strongly distorted.

Glass

Looking at an object through a refracting medium, such as glass, causes distortion. This filter imitates different types of glass, which you can nominate, as well as the size and strength of the effect. One way of using this filter is to duplicate the image on another layer, apply the effect, and then merge it with the original.

Filter effects continued

Smart Blur

With this filter you can specify a radius that sets how far the filter searches for dissimilar pixels to blur. In addition, you can set a threshold that determines how different the pixels' values should be before they are blended. In short, the filter can be set to leave the edges but blur lower-contrast detail. You can also set a mode for the entire selection or for the edges of color transitions. Where there is significant contrast, Edge Only gives black and white edges; Overlay Edge gives white.

Spherize

This filter produces a simple distortion, making the image look as if seen through a water droplet. With high settings (*above*) the effect is not obviously useful, but when applied with a light touch it can be used for correcting lens distortions, such as those introduced by lens attachments. Try applying the filter to small sections of the image at a time – the effects on images that have clear lines can be visually very intriguing.

●TRY THIS

The best way to learn about digital filters is to work systematically through them, using a variety of images each time. Start by selecting three different color images. One should have a single, strong shape, such as a leaf or a silhouette of a church. Another should have lots of detail – perhaps a landscape full of trees. The third test image should feature strong colors arranged in a pattern, which could be abstract. Resize the images to about 1MB and save them with a new file name. Now try the different filters you have available on each one and make notes of which types of filter work best with each type of image.

Art Materials filters

Filters that imitate the effects of artists' materials can be very rewarding. Different software packages approach this class of filter with varying degrees of success – ultimately, a filter that applies its effects in an indiscriminate manner across an image is not as versatile as building up effects by hand. However, they do provide quick solutions: the trick is in selecting the right type of image to work on. Choose those with simple outlines and clear shapes that do not rely on intricate details.

Crosshatch

This filter is often more effective when it is applied to black and white images, as it mimics the strokes used by artists to cover an area in tone. You need to experiment with different settings for length of stroke and other features (*above*). You have a choice of applying another filter to improve the Art Materials filter's appearance or to change the image to a black and white. Another option with an image such as the one here, is to print it onto highly textured paper. If you select the right paper stock, the interaction of the crosshatched strokes and the texture of the paper can create a very real impression of an artist's work.

Plastic Wrap

Filters can produce a metallic effect by creating neutral highlight areas accompanied by shadow regions. This is called Plastic Wrap in Photoshop, and by varying (in particular) Highlight Strength (*above*) with Detail set to follow the image outlines, the resulting image looks as if it has been printed and embossed onto a metal plate. If the shininess is too hard, however, image noise can increase as a result.

Filter effects continued

Spatter

The Spatter filter imitates an oil painting in which color has been applied with a broad-bristle brush. Starting with an image that has very clear outlines is essential. To improve the simulation of the work of a real artist, you can increase the saturation of colors, as well as add a little unexpected color to uniform areas. As an artist is unlikely to leave any canvas bare, you may need to clone some strokes into any white, empty areas.

Cutout

This filter uses areas of flat color to produce an effect similar to a woodcut. It reduces an image to its bare essentials and is useful when quick, graphics-like effects are called for. "No. of Levels" in the dialog box refers to the number of different grayscale steps per channel. If you choose a high figure, there are more colors, and this reduces the effect of the graphic simplification of detail.

High Pass

This filter, in the Corel Painter application, produces a very surprising result when it is applied. The original image was too dark and it also lacked color saturation, but with a little extra work the final result (*left*) has certain attractive, painterly qualities. The lesson to be learned here is that even if you know, or think you know, what a filter will do to an image, it is still worth taking the time to experiment – sometimes you will be surprised. "High Pass" is a technical term describing a filter that passes subject detail, or high frequency information.

Stylizing filters

This class of filter uses image color data from the original to build up blocks of color, or the location of image edges, as the basis for producing graphics-like effects. It is always best to check the appearance of the image at the final size it will be viewed – some effects may look eyecatching when they are seen at large screen magnifications but they are subsequently lost when printed out at their final size. Beware of options such as Find Edges. These have alluring effects that seem to improve any image to which they are applied, but are popular to the point of being a cliché.

Mosaic

The filter produces pixellated-like images. It creates a representation of what an image would look like if you were to reduce its resolution considerably, and then enlarge it back up to the required size. In fact, it makes a lot of sense to work in just this way, as the resulting image will then be just a tiny fraction of its original file size. However, when using the filter, you can preview the results more easily. To further improve the effect of a low-quality image, you can posterize the colors, thus reducing the number of colors used in the image.

Crystallize

This simple filter averages out the color under irregular, polygonal areas and gives each polygon a uniform hue. The size of polygons can be varied to match the output size (*above*). Some applications may call this filter effect Mosaic or Tessellation: the idea is that there are no gaps between the blocks of color, which fully cover the image. With filters of this type, you may need to reduce the density of black areas of the image if they predomi-nate. Not only can you work with very low-resolution images, you may, indeed, achieve better results if you do. One experiment worth trying is to compare the effects of the filter on the same image at both high and low resolutions.

Filter effects continued

Emboss

This filter emphasizes image outlines while leaving all other details a neutral gray. The outlines are then shown as if they are an embossed surface lit from the side. If you wish to obtain the best from this filter, experiment with the controls offered, which adjust not only the strength of the effect but also the direction from which the light appears to come.

Glowing Edges

The Glowing Edges filter builds on the Find Edges filter by adding a solarization effect. This partially reverses image tones and produces a neonlike glow around image borders. As a result, images are always dark and benefit from being lightened after the filter has been applied. "Edge Width" in the dialog box (*above*) preserves the original image outlines if it is kept to low figures.

Working with filters

● When trying filters, use small files. Those 1 MB or smaller speed up all operations. Larger files of the same image, however, may give slightly different results.

● Make a careful note of any filter settings you try that produce effects you like.

● Avoid running other applications or performing tasks such as printing or internet operations while using filters, as these slow down your machine.

● A filter once used is likely to run faster the next time (on modern computers it will have been stored in the RAM cache), so it may be easier to keep a few small images open and apply the same filter to each to try it out, rather than try a different filter each time.

● Incorporate the figures of settings you like to use by including them in the file name ("tree glow 2 6 5", for example).

Texturizing or plug-in filters
Filters that work on original image data and change both its color values and pixel position can sometimes have weird and wonderful effects. These can be said to be rendering filters as they apply a combination of surface texture and lighting properties – like the rendering processes in three-dimensional modeling programs used to create backgrounds for computer games.

Many filters designed to work within software applications, such as Photoshop or Painter, fall into the same category. They plug into these existing, larger applications, and it can take many hours of trial and error to learn how to use them effectively. Plug-in effects are readily available as web downloads; in addition, they are frequently offered on a free trial basis with digital photography and computing magazines (*see also pp. 392–3 and 396–7 for further information*).

Lens Flare
This filter imitates the effect of a bright light source flaring into the camera lens. Plug-in collections that give a full range of effects are available, though software such as Photoshop has only basic controls. The dialog box here shows just three types of effect, corresponding to different lenses, and a flare-strength control. You can also change the position of the "light source." Although it appears to be a simple filter, it makes considerable demands on the computer, so you need ample RAM.

Stained Glass
This filter combines the effects of an Art Materials filter with Texture and Lighting filters. You need to choose the color of the borders with care: an inappropriate one will ruin the effect of the changes. As this and similar filters, such as Mosaic, greatly simplify color data as well as reduce detail, you can save images as very small JPEG files without worrying about loss of quality.

Filter effects continued

Clouds (via levels)

The Clouds filter reverses color values in a non-uniform way. The result of applying this filter is difficult to predict, but on images with plain, clear outlines it can be dramatic. If you apply the filter, then reduce its opacity over the original image, you can produce a very passable imitation of a badly faded color print. As well, you can apply the filter twice (*top*) and darken with Levels (*top and above*) to elaborate the effect – or even more times to explore stranger and stranger effects (*below*).

PhotoGroove

The PhotoGroove is a plug-in filter from the Extensis Phototools set, and it is useful for giving images a highly customizable border – as if they were wrapped over a box cover. Not only can you vary the width and height of the border, the profile of the border's shape can also be precisely drawn (*above*). The border design here suggests a metallic box on which the image has been printed (*top*).

Multiple clouds

Applying filters more than once can give rise to unpredictable results. Here, the colors are far removed from those of the original, while the sharpening effect on image contours was unexpected.

Fractal explorer

This filter, part of the range of KPT plug-in filters, delivers a bewildering array of options that operate together to produce millions of visually challenging combinations.

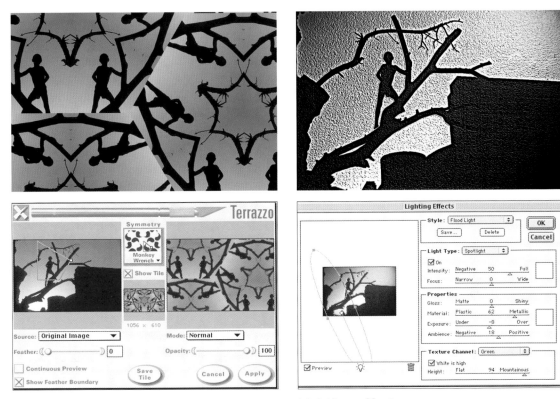

Terrazzo

The Terrazzo plug-in filter from Xaos Tools is a very efficient shortcut to some striking graphics effects. Quick and easy to use, it is able to turn the most mundane images into stunning patterns. It works rather like a kaleidoscope, in which you can control, to a fine degree, the number and placement of the mirrors. The filter acts on a nominated part of the image – here the boy in the tree – and the resulting render, or tile, is repeated until the whole image area is filled.

Lighting effects

The dialog box for this filter looks complicated (*above*), but it is worth persevering with. The filter allows you to apply different shapes and qualities of light, varying its color and position, and applying simple textures. The filter takes some time to work, due to the calculations needed, but the preview image is accurate and you can try different settings before you commit to one. It is easy to get lost, so make notes of setting combinations you like before moving on to a new one. For this effect (*top*), the settings have increased contrast and made the image look as if it is printed on a textured, metallic surface with a strong light from the lower left.

Behind the scenes

Image filters are groups of repeated mathematical operations. Some work by operating on small parts of an image at a time; others need to "see" the entire image at once. For example, the USM filter looks at blocks of up to 200 pixels square at a time, while Rendering loads the entire image into memory. A simple filter effect to understand is Mosaic. The filter takes a group of pixels, according to the size you set, and calculates their average value by adding them all and dividing by the number of pixels. It then gives all the pixels in the group the same value, so the pixels appear greatly enlarged. The filter then moves to the next set of pixels and repeats the operation. Most Mosaic filters can work on small image segments at a time, but some need to operate on the entire image for each calculation. These latter types require a great deal of computer memory and calculating power. Add all of these operations together and you obtain the pixelated effect of the Mosaic filter.

Selecting pixels

There are two ways of limiting the action of an image-manipulation effect: using a tool that applies the effect locally (a Dodge tool or Brush, for example); or selecting an image area and applying the effect just to those pixels.

Making a selection

One method is to select every pixel contained within an area defined using, say, the Lasso or Marquee tool: these pixels can be of any value or color. In this case, the pixels are said to be contiguous. Or you can select pixels from across the image that are the same as or similar to a color you specify, using a tool often called the Magic Wand. Since there may be gaps between these areas, this selection is said to be noncontiguous.

A crucial aspect of selection is that you can partially select a pixel near the edge of a selection in order to "feather" the effect. This creates a gradual transition across the boundary from pixels that are fully selected through those that are partially selected to those that are unselected, thus smoothing out the image-manipulation changes.

The effect of selecting a local, defined set of pixels for the changes to work on has an effect similar to that of masking (*see pp. 320–1*). But there are important differences. First, a selection is a temporary mask – it disappears as soon as you click outside a selected area. Second, in software with Layers, the selection applies only to the layer that is active or chosen. Third, with some software, you can copy and move selected pixels – something that cannot be done with a mask.

Some advanced software provides two different types of image data – bitmap and vector. If so, you need to use different tools to make selections. When you select pixels, you can also create selections using the Pen or Shape tools to give precise outlines called paths. A path is a vector shape that contains no pixels.

Original image
This cropped view of a church in New Zealand shows the original, unmanipulated image. The change I wanted to make here was to the windows, which looked too dark in contrast to the color of the boarded exterior.
● Canon D30 with 28–135 mm lens.

Making a selection
Using Photoshop's Lasso, with a feathering width set to 11 pixels, I selected the dark glass within the window frames. To start a new area to be selected, hold down the Command key (for Macs) or the Control key (for PCs) – the selected area is defined by moving dashes, known as "marching ants." When the Levels command is invoked, settings are applied only to the selections.

Final effect
In some circumstances, the somewhat uneven result of using the Lasso selection can produce more realism than a perfectly clean selection would give. The dark areas remaining toward the bottom of the right-hand windows correspond to the area omitted from the selection in the previous image (*above left*).

●HINTS AND TIPS

● Learn about the different ways of making a selection – some are obvious, such as the Lasso or Marquee tool, but your software may have other less-obvious methods, such as Color Range in Photoshop, which selects a band of colors according to the sample you choose.

● Use feathered selections unless you are confident you do not need to blur the boundaries. A moderate width of around 10 pixels is a good start for most images. But adjust the feathering to suit the task – for a vignetted effect, use very wide feathering, but if you are trying to separate an object from its background, then very little feathering produces the cleanest results. Set the feathering before making a selection.

● Note that the feathering of a selection tends to smooth out the outline: sudden changes in the direction of the boundary are rounded off. For example, a wide feathering setting on a rectangular selection will give it radiused corners.

● The selected area is marked by a graphic device called "marching ants" – a broken line that looks like a column of ants trekking across your monitor screen: it can be very distracting. On many applications you can turn this off or hide it without losing the selection: it is worth learning how to hide the "ants."

● In most software, after you have made an initial selection you can add to or subtract from it by using the selection tool and holding down an appropriate key. Learning the method provided by your software will save you the time and effort of having to start the selection process all over again every time you want to make a change.

● Examine your selection at high magnification for any fragments left with unnatural-looking edges. Clean these up using an Eraser tool or Blur tool.

● Making selections is easier to control with a graphics tablet (*see p. 72*) than with a mouse.

Original image
The brilliant red leaves of this Japanese maple seem to invite being separated out from their background. However, any selection methods based on outlining with a tool would obviously demand a maddening amount of painstaking effort. You could use the Magic Wand tool, but a control such as the Color Range control (*right*) is far more powerful and adaptable.

Color Range screen shot
In its implementation in Photoshop, you can add to the colors selected via the Eye-dropper tool by using the plus sign; or by clicking the eye-dropper tool with a minus sign (beneath the "Save" button), however, you can refine the colors selected. The Fuzziness slider also controls the range of colors selected: a medium-high setting, such as that shown, ensures that you take in pixels at the edge of the leaves, which will not be fully red.

Manipulated image
Having set the parameters in the Color Range dialog box (*above left*), clicking "OK" selects the colors – in this case, just the red leaves. By inverting the selection, you then erase all but the red leaves, leaving you with a result like that shown here. Such an image can be stored in your library to be composited into another image or used as a lively background in another composition.

Quick fix Removing backgrounds

One of the most common image-manipulation tasks is to eliminate a background. There are two main methods: one is to remove the background directly by erasing it (time-consuming); the other is to hide it under a mask.

Problem

The main problem is how to separate a foreground object from its background while retaining fine edge detail, such as hair, or maintain the transparency of a wine glass and retain shadows and blurred edges.

Analysis

Almost all edges in images are slightly soft or fuzzy – it is more the transitions in color and brightness that define edges. If a transition is more sudden and more obvious than other transitions in the locality, it is seen as an edge. If you select the foreground in such a way as to make all its edges sharp and well defined, it will appear artificial and "cut-out." However, much depends on the final size of the foreground: if it is to be used small and hidden by a lot of other detail, you can afford a little inaccuracy in the selection. If not, you must work more carefully.

Solution

Make selections with edge transitions that are appropriate to the subject being extracted. The usual selection methods – Lasso or Magic Wand – are sufficient most of the time, but complicated subjects will need specialist tools, such as Corel KnockOut, Extensis Mask Professional, or the Extract Image command in Photoshop.

How to avoid the problem

With objects you expect to separate out, it is best to work with a plain backdrop. However, while a white or black background is preferable to a varied one, even better is a colored ground. The aim is to choose a color that does not appear anywhere on the subject – if your subject is blond, has tanned skin, and is wearing yellow, a blue backdrop is perfect. Also, avoid using rimlighting, since this imparts a light-colored fringe to the subject. In addition, avoid subject-movement blur and try to keep an extended depth of field so that any detail, such as hair behind the subject's head, is not soft or fuzzy.

Low tolerance

With simple tasks, such as removing the sky from this image, the Magic Wand or similar tool, which selects pixels according to their color and is available in almost all image-manipulation software, is quick to use. It has just one control – the tolerance – which allows you to set the range of colors to be selected. If you set too low a tolerance (here the setting was 22) you obtain a result in which only a part of the sky is selected, seen by the marching ants occupying just the right-hand portion of the sky and small, isolated groups.

● Nikon Coolpix 990.

Removing the sky

Adjusting the tolerance setting in small, incremental steps allows you to see when you have captured just the right area to be removed. Then, pressing "OK" removes your selection. The edges of the selection may be hard to see in a small image, but are clearly visible on a large monitor screen.

High tolerance

If you set too high a tolerance, you will capture parts of the building where it meets the sky. Here, notice the result of setting a large feathering (111 pixels) to the selection – pixels a long way to either side of a target pixel are chosen. As a result, the selection is smoothed out and the boundary is very fuzzy.

Original image

This original image of a young Afghan girl, who is an expert carpet weaver, shows her taking to the ▪ to dance. Unfortunately, the distracting background ▪ not add to the image as a whole.
▪anon EOS-1n with 80–200 mm lens. Microtek 4000t scanner.

2 Defining fore- and background

Using Corel KnockOut, I first drew inside the girl's outline to define the foreground and then outside her outline to define the background. The region between the two outlines comprises the transition area that allows soft boundaries to be smoothly masked.

Making the mask

Using the information from the previous step, a mask ▪eated. The mask outlines the foreground while hiding ▪ackground: the black shows the hidden area and the ▪e where the image will be allowed to show through.

4 Knocking out the background

Now, while the mask hides part of the image on its own layer, it does not affect images on another layer (*below left*). Therefore, if you place an image behind the mask, you will see that image appear.

Layers screen shot

The Layers dialog box shows the little girl and the ▪ciated mask lying over the introduced image. ▪use the mask was produced by extracting the girl, ▪original background is gone, waiting for a new ▪round image to be introduced

6 Masked combination

The background was lightened to tone in with the colors of the girl. The mask has preserved the softness of the girl's outline, and now she appears to be dancing in front of the wall-hanging. An extra refinement may be to soften the background so that it appears less sharp

Layers and channels

The "layers" metaphor is fundamental to many software applications, such as desktop publishing, video animation, and digital photography. The idea is that images are "laid" on top of each other, though the order is interchangeable. Think of layers as a stack of acetate sheets with images; where the layer is transparent, you see through to the one below. However, not all software layers have the same resolution, start with the same number of channels, or have the same image mode. The final image depends on how layers blend or merge when they are "flattened," or combined, for final output. Before then, however, they allow you to make changes without altering the original data, while each remains independent of the others.

Color as layers

A point to grasp is that the basic color image is composed of red, green, and blue layers – normally called channels. In essence, the terms "layers" and "channels" are interchangeable. Masks, too, are channels, since they work with a layer to affect the appearance of an underlying layer.

By analogy, if you see a face through a layer of misted glass it looks soft or diffused. Now, if you clean off part of the glass, the portion of face lying directly under the cleaned-off area becomes clearly visible, without being obscured as under other parts of the glass. So the glass is a layer over the underlying layer – the face – and by doing something to part of it, but not the whole, you have applied a mask, which is in effect another layer.

Using layers

The main use for layers (also known as "objects" or "floaters" in some applications) is to arrange composite images – those made up of two or more separately obtained images. You can place images on top of one another – varying the order in which they lie; duplicate smaller images and place them around the canvas to create a new image; or change the size of the individual components or distort them at will. At the same time, the ways in which one layer interacts or blends with the underlying layer – known as the blend modes – can also be altered. Finally, you can control the transparency or opacity of the layers, too – from high opacity for full effect (or low transparency), to barely visible, when you set a high transparency (or low opacity).

Original 1
The dreamy spires of Cambridge University in England offer the clean clarity of shape and line that are ideal for work with superimposing images. The actively clouded sky also adds variety without too much detail. Prior to use, the image had its colors strengthened by increasing saturation and the towers were straightened so that they did not lean backward.
● Nikon Coolpix 990.

Original 2
The outline of wintry trees in France provides fascinatingly complicated silhouettes for the image worker. Shot on an overcast day, the sky was too even to be interesting for this exercise, so a rainbow-colored gradient was applied across the whole image. Finally, colors were strengthened and the outline of the trees sharpened to improve their graphic impact.
● Canon 10D.

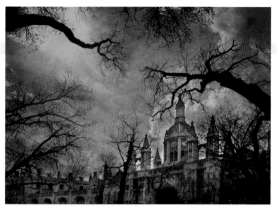

Normal

The Normal blend is often ignored but it is a proper blending mode – provided you lower the opacity of the top layer below 100 percent, the lower layer then becomes progressively more visible. Here, the top layer at 50 percent shows that a useful blend is possible – one that cannot be replicated by other blend modes – and it does not matter which is the topmost image.

Multiply

This mode is the digital equivalent of sandwiching two color slides – densities multiply and the image darkens. Here, the upper layer was reduced to 60 percent opacity to keep the trees from turning black. Multiply mode can be used for recovering images that are too light (overexposed slides or underexposed negatives). First, duplicate the image into another layer and then set this new layer to Multiply.

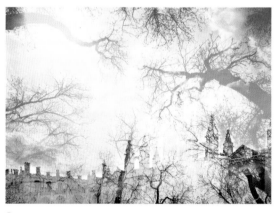

Screen

Adding together the lightness of corresponding pixels is like projecting one slide from a projector onto the projected image of another slide – the result is always a lighter image. By reducing the opacity of the top layer, you control image darkness. This mode is useful for lightening an overly dark image (the opposite of Multiply). Simply duplicate the image onto another layer and set the top to Screen, then adjust opacity.

Overlay

This mode is able to mix colors evenly from both layers, and is very responsive to changes in opacity. It works by screening light areas in the upper layer onto the lower and by multiplying dark areas of the upper layer onto the lower, which is the opposite effect of Hard Light (*p. 316*). At lowered opacities, its effect is similar to that of the Normal blend but with more intense colors. It is useful for adding textures to an image.

Layers and channels continued

Soft Light

Soft Light blending darkens or lightens image colors, depending on the blend color. The effect is similar to shining a diffused spotlight on the image. Now, painting with pure black or white produces a distinctly darker or lighter area but does not result in pure black or white. This is a very effective way of making local tonal adjustments. It is a softer, and generally more useful version of the Hard Light blending mode.

Hard Light

This mode is similar to Soft Light: it darkens image color if the blend layer is dark, and lightens it if the blend is light, but with greater contrast. It simulates the contrasty projection of the image onto another image. It is generally less useful than Soft Light but can prove valuable for increasing local contrast – particularly if applied as a painted color at very low pressures and lowered opacity.

Blending modes

Interactions between layers are tricky to learn, since their precise effect depends on the value of a pixel on the source (or blend, or upper) layer compared with the corresponding pixel on the destination (or lower) layer. The most often-used method is simply to try them out one by one (hold the shift key down and press "+" or "-" to step through the menu) until the effect looks attractive. This can distract from your initial vision by offering effects you had not thought of – but that is part of the fun of working with powerful software. With experience you will get to know the Blend modes that are most pleasing and plan your images with them in mind.

One key point to remember is that the effectiveness of a mode may depend to a great extent on the opacity set on the source layer – sometimes a small change in opacity turns a garish result into one that is visually persuasive. So if you find an effect that does not look quite right, change the opacity to see what effect this has.

Of the many blend modes available in such software as Adobe Photoshop or Corel Painter, some of the most useful are:

● **Soft Light** This offers a useful approach for making tonal adjustments (see above).

● **Color** Adds color to the receiving layer without changing its brightness or luminance – useful for coloring in grayscale images (see pp. 322–3).

● **Difference** This produces dramatic effects by reversing tones and colors.

● **Color Burn/Dodge** Useful for greatly increasing contrast and color saturation or, at lower opacities, making global changes in tone and exposure (see opposite).

Other modes are shown here (see pp. 315–19).

- Normal
 Dissolve

 Darken
 Multiply
 Color Burn
 Linear Burn

 Lighten
 Screen
 Color Dodge
 Linear Dodge

 Overlay
 Soft Light
 Hard Light
 Vivid Light
 Linear Light
 Pin Light

 Difference
 Exclusion

Interaction modes

The different ways in which layers can interact also apply to other situations, such as painting, fading a command, and cloning. Experience with different effects helps you to previsualize effects.

Color Dodge

At first glance, Color Dodge appears like Screen mode (*p. 315*) in that it brightens the image, but its effect is more dramatic. Black in the upper layer has no effect on the receiving layer, but all other colors will tint the underlying colors as well as increasing color saturation and brightness. This mode is useful when you want to create strong, graphic results. Note that when you change the order of the images you get markedly different effects.

Color Burn

This blend mode produces very strong effects as it increases color saturation and contrast. At the same time, it produces darkened images by replacing lighter underlying pixels with darker top pixels. Be aware that both Color Burn and Color Dodge modes often produce colors that are so extreme they cannot be printed – in other words, they are out-of-gamut for printers (*see p. 117*).

Darken

The Darken mode applies only darker pixels from the top layer to the bottom layer. Here, the black branches of the trees overshadow anything that lies under them, showing the importance of using clear but interesting shapes. This mode does not strongly change colors. If, for example, there is no difference between the corresponding pixels on the top and bottom layers, there is no change – so this mode cannot be used to darken an image (*but see Multiply, p. 315*).

Difference

The Difference mode is one of the most useful for giving dramatic and usable effects, since it reverses tones and colors at the same time – the greater the difference between corresponding pixels, the brighter the result will be. Notice how the dark forms of the trees are rendered in the negative, while the blues of the sky turn to magenta. Therefore, where top and bottom pixels are identical, the result is black, and if one is white and the other black, the result is white.

Layers and channels continued

Exclusion

Exclusion is a softer version of Difference mode (*p. 317*): it returns gray to pixels with medium-strong colors, rather than strengthening the colors. A useful variant is to duplicate the top layer and apply Exclusion to the duplicate layer – now topmost. This creates an appearance similar to the Sabattier effect (*pp. 282–3*).

Hue

In this mode the colors of the top layer are combined with the saturation and brightness (luminosity) values of the lower layer. The result can be a strong toning effect, as seen here, or it can be weak, depending on the images used. It is worth comparing the effect of this mode with that of the Color mode (*below*).

Saturation

Here, the saturation of the underlying layer is changed to that of the corresponding pixel in the top, or source, layer. Where saturation is high, the lower image returns a richer color. It is useful where you wish to define a shape using richer or weaker colors: create a top layer with the shape you want and change saturation only within the shape, then apply Saturation mode.

Color

Both hue and saturation of the upper layer are transferred to the lower layer, while the luminosity of the receiving layer is kept. This mode simulates the hand-tinting effect of black and white prints. Note that the receiving layer does not have to be turned to a grayscale image for this mode to be effective. Compare this with Hue mode (*above*).

Luminosity

This blend mode is a variant of Hue and Color: this time, the luminosity of the top layer is kept while the color and saturation of the underlying layer are applied. It is always worth trying the layers in different orders when working with these modes, particularly with this group consisting of Hue, Color, and Luminosity. In this image, reducing the opacity of the top layer produces a soft, appealing image, in contrast to the more high-contrast result when both layers are left at full strength.

Vivid Light
This both burns and dodges: lighter blend colors decrease contrast and lighten the receiving layer (dodges), while darker ones increase contrast and darken the lower color.

Pin Light
Blend colors lighten or darken the underlying layer according to the blend color and underlying color. The results are tricky to predict, but visually appealing effects are often produced.

Linear Burn
The receiving colors are darkened to match the blend color. This burns or darkens the image without increase in contrast. The strong darkening effect is best tempered through opacity control.

Linear Light
Similar to Vivid Light, this burns or dodges in response to the blend color by changing brightness. Its effect is to increase contrast – as darker colors are darkened, lighter ones are lightened.

Linear Dodge
Similar to Color Dodge (*p. 317*), this blend mode brightens the base or receiving layer to match that of the blend layer, thus blends with black produce no change. It is an effective way of brightening an image to a high-key effect but has a tendency to produce too much blank white.

Lighten
This mode chooses the lighter of the two colors being blended as the result of the combination. This blend tends to flatten or reduce contrast, but it is effective at producing pastel tones. Images that originally have subtle tones respond very well to this mode.

Masks

Masks allow you to isolate areas of an image from color changes or filter effects applied to the rest of the image. Unlike real-life masks, digital types are very versatile: you can, for example, alter a mask's opacity so that its effects taper off allowing you to see more or less clearly through it. Using image-manipulation software you can alter a mask until you are satisfied with it and then save it for reuse. When you do so, you create what are known as "alpha channels," which can be converted back to selections. Technically, masks are 8-bit grayscale channels – just like the channels representing the colors – so you can edit them using the usual array of painting and editing tools.

If your software does not offer masks, don't worry – it is possible to carry out a good deal of work by the use of selections. But remember that selections are inclusive – they show what will be included in a change; masks work the opposite way, by excluding pixels from an applied effect.

Software takes two approaches to creating masks. First is Photoshop's Quick-mask, which gives direct control and allows you to see the effect of any transitional zones. Or, you can create a selection that is turned into a mask. This is quick, but transitional zones cannot be assessed.

Quick-mask

In Photoshop and Photoshop Elements you hit the Q key to enter Quick-mask mode. You then paint on the layer and hit Q again to exit, but in the process, you turn the painted area into a selection. You can also invert your selection (select the pixels you did not first select) – sometimes it is easier to select an area such as bright sky behind a silhouette by selecting the silhouette and then inverting the selection. You then turn the selection into a mask by adding a layer mask.

The layer mask makes all the underlying pixels disappear, unless you tell it to leave some alone. When applying a layer mask, you can choose to mask the selected area or mask all but the selected area. The advantage of Quick-mask is that it is often easier to judge the effect of the painted area than it is to make many selections. It also means that an accidental click of the mouse outside a selection does not cancel your work – it simply adds to the mask. Use Quick-masking when you have many elements to mask out at once.

Turning selections into masks

Some methods of selecting pixels have already been discussed (*see pp. 310–11*). If you need a

Using quick mask

1 Bottom layer
Quick-mask, or any method where you "paint" the mask is best when you are not attempting to enclose a clearly defined shape, such as a person's silhouette. It is best first to place the image that will be revealed under the mask – in this example, it is an Islamic painting.

2 Creating the mask
Next, the mask is applied to the main leaves in this negative image. The red color shows where the freehand masking will be created. When it is turned into a mask, this is the area that will allow the base image to show through.

sharp-edged selection whose scale you can change without losing crispness of line, then you need to create a clipping path.

Although almost anything you can do with masks you can do with selections, it is convenient to turn a selection into a mask as it is then easier to store and reuse – even for other images. It is good practice to turn any selection you make into a mask (just in case you wish to reuse it), particularly if it took a long time to create.

Alpha channels

Alpha channels are selections stored as masks in the form of grayscale images. The convention is that fully selected areas appear white, non-selected areas are shown black, while partially selected areas appear as proportionate shades of gray. In effect, an alpha channel is just like a color channel, but instead of providing color it hides some pixels and allows others to be visible. An alpha channel can be turned into a selection by "loading" the selection for that channel. The term "alpha" refers to a variable in an equation defining the blending of one layer with another.

Limiting filter effects
Here (*top*), the mask has been applied to "protect" the child's face from the effect of the Stylize/Extrude filter. Note that when you turn the painted area into the selection, the mask would be applied only to that selection, so you have to invert the selection to take in everything but the face. When the filter was applied (*above*), it worked only on the pixels that were not protected.

3 Quick-mask Layers screen shot
This dialogue box shows that the painting forms the bottom layer (but not the background, as masks cannot be applied to the background). The top layer consists of the grass and, to the right, the mask is also shown.

4 Final effect
You can move the underlying image around until you are happy with the results – in other words, when the most effective areas are showing through within the areas defined by the masking.

Grayscale and color

The usual way to obtain grayscale images – those with no color information – is by making a scan of existing artwork. Even if the artwork contains color, you can still scan into grayscale, which, incidentally, will usually speed up scanning. Or you can scan in full color and then drop the color data to make a grayscale (*see pp. 272–7*).

If the artwork consists of sharp black-and-white lines then you will need to take extra care with the scanning if you hope to maintain the crispness of the contours, and you will also need a high resolution setting on your scanner. Should you wish to scan into bitmap (an image in only black or white), then you should set the highest possible resolution. This is because you lose the antialiasing effect provided by the intermediate tones and, therefore, need the highest possible resolution to avoid stair-stepping or jagged-edged ("jaggies") artifacts. This applies particularly to originals with subtleties of shape and form. Unfortunately, when you use the highest resolution required to capture the fine details, you will also pick up all the defects in the paper which we normally ignore. Do not be tempted to remove them by raising the contrast of the image as you will destroy detail in the writing. Instead, use cloning tools to remove the defects (*see pp. 326–31*).

(*see pp. 272–7*). ... (*see pp. 326–31*).

● HINTS AND TIPS

● Remove dust specks and other defects carefully before combining a grayscale with other images. These defects can be hard to spot but they can become very evident in certain layer blend modes.
● You can control the effect of certain blends by changing the opacity of either top (blending) or bottom (source) layers – not just of the uppermost layer.
● For best results, avoid increasing the size of a component image by a large amount once it is layered with another image. Rescan if necessary – otherwise the mix of sharp and unsharp images that results will look unprofessional.

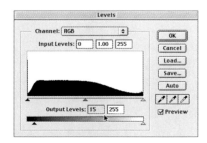

Output densities
If your image has large, completely black areas, you need to take special care when printing or the paper may become saturated with ink. Reduce the output levels in the Levels control, or equivalent, in your software.

Choosing the color component
When I was considering which color picture to combine with the grayscale image (*above right*) I looked for a subject that was soft in contrast and contained lots of texture. In order to combine the two images, the grayscale component must be turned to full-color.

The grayscale component
I scanned the original graphite drawing as a grayscale image with the background kept gray rather than white. This was essential as I intended to add color to the whole image, and pure white would not be colored.

A change of mood

Simply by using a different image to add color to the grayscale, as done here, you can very quickly achieve a totally different feel and atmosphere. As the donor image was pastel in tone, it was placed at 100 percent.

Colored drawing

By laying the colored image over the grayscale and setting the Layer mode to Color, you effectively add color to the drawing without overriding the underlying tones. You will need to adjust both the opacity of the top layer as well as the tonal quality of both layers to obtain exactly the right effect. If the receiving (lower) layer is darker, it takes on more color; if the donor (top) layer is of higher opacity, it places more color into the lower layer. Here the opacity was reduced to 85 percent in order to soften the colors.

Difference mode

For a totally different type of toning effect for grayscale images, try applying the top layer in Difference mode (p. 318). This mode, as always, produces dramatic effects. By reducing the opacity, or strength, of the mode in the Layers dialogue box to just 35 percent (above right), an intriguingly rich texture has been added to the drawing (above left). The image in the color layer was moved sideways to ensure that any distracting details were not located on the face.

Text effects

Typefaces, also known as letter-forms or fonts, can be treated in many unique ways using image-manipulation software. Letters can be made to flame up, for example, dissolve into clouds, recede and blur into the distance, or appear transparent over another image – the possibilities are truly unlimited. All image-manipulation applications offer at least a basic range of effects, but if they also accept Photoshop-compliant plug-ins, you can greatly extend your repertoire.

Note, however, that text can sit uncomfortably with image pixels. The reason is that type is best digitally encoded as "vector graphics", whereas photographic images are best encoded as "bitmap graphics" (*see below*). Nearly always, the text would have to be turned from vector into a set of bit-mapped pixels, resulting in a loss of clarity and sharpness. As a consequence, as you increase the size of an image that incorporates text, the letter-forms quickly start to look ragged, with poorly defined outlines. More than anywhere else in image manipulation, if you work with text always work at the full output size – and avoid altering the image size after applying text to the image.

Bitmap and vector graphics

There are two classes of graphic image. Digital cameras all produce a bitmap type of image, also called a raster image, which is based on a grid of data (the colored pixels). Each pixel is placed in a specific location and given a color value. Image manipulation is all about altering pixels, and so such images are resolution-dependent – that is, they start with a fixed number of pixels and thus a change in image size alters the amount of detail that is available.

Vector graphics, also known as object-oriented images, are described according to their geometric basics – lines, circles, and so on – with their location, together with operations such as stroke (to draw a line) or fill (to cover an enclosed area with color). Vector graphics are said to be resolution-independent – that is, they can be scaled to any size and printed at any resolution without losing sharpness, and so can always use the output device's highest resolution.

Vectors are best for describing text as well as graphics such as company logos, and are created by graphics software such as Macromedia FreeHand, Corel Draw, or Adobe Illustrator. You may discover that the more complicated letter-forms, such as those with scrolls or long loops, may not print properly in your printer: if so, you may need to install special software to interpret the vector information, called a PostScript RIP (Raster Image Processor).

Display type
If you wish to add type effects to a face it is advisable to start with a chunky display type such as Postino Italic shown here, with its vertical scale increased to stretch its height. With a color chosen to contrast with the rest of the image, the effect is unat-tractive and garish, but it is easy to read at any size.

Drop shadow
By asking the image-manipulation software to create a drop shadow, you make the letters appear as if they are floating above the image. The overall effect is of a poster. The color of the type was toned down to that of a tint of white: any light tint of white is likely to be an effective and safe choice of color for type.

It is always best to check the typeface at full size by printing it out. Check again if you change the face: even at the same point size, different typefaces vary considerably in legibility. Consider, too, the following points:

● Use typefaces with narrow lines where they contrast well with the background; faces with broad shapes should be used where the contrast is less obvious.

● You can use typefaces with narrow outlines if you create effects that separate the text from the underlying image, such as with drop shadows.

● Use typefaces with broad lines if you want to use them for masking or to allow images to show through.

● Avoid faces with narrow serifs – the little extensions to the end of a stroke in a letter – as these are easily lost into the underlying image. In addition, avoid letterforms with hollow strokes or those made up of double strokes for the same reason.

● Use only small amounts of text when combining it with images – at best a heading and at most a short block of text; but avoid using more than 50 words.

Inner shadow
Here, an inner shadow in pink has been applied with a high level of noise, so creating the appearance of rough texture. Drop shadows have been retained, but note that the "light" can be made to come from different directions.

Text warp
Distortion of text can be effective for drawing the viewer's attention. Here, the text has been warped as if it is a waving flag. In addition, various stroke and inner glow effects were applied to make the type look metallic.

Graduated overlay
Another way of making the type lively is to make the color appear graduated. Here, colors move between yellow and orange. The gradient chosen was sloped so that it runs across the type at an angle. With these effects you can produce comicbook effects that used to have to be laboriously hand-painted.

Eye Candy's Fire
Plug-in software can bring very powerful effects to type. Here, with the type area of the image selected, Eye Candy's Fire filter was applied to make the words look as if they are going up in flames. You can adjust all the important parameters of the effect – such as the size of the flames, their angle, and their colors.

Cloning techniques

Cloning is the process of copying, repeating, or duplicating pixels from one part of an image, or taking pixels from another image, and placing them on another part of the image. First, you sample, or select, an area that is to be the source of the clone and then, second, apply that selected area where it is needed. This is a basic tool in image manipulation, and you will find yourself constantly turning to it whenever you need, say, to replace a dust speck in the sky of an image with an adjacent bit of sky, or remove stray hairs from a face by cloning nearby skin texture over them.

This is only the start, however. Such cloning makes an exact copy of the pixels, but you can go much further. Some applications, such as Corel Painter, allow you to invert, distort, and otherwise transform the cloned image compared to the source you took it from.

Original image
An unsightly tarred area of road left by repairs marred this street scene in Prague. All it will take is a few moments to bring about a transformation.

History palette
The screen shot of the History palette shows the many individual cloning steps that were necessary to bring about the required transformation.

Manipulated image
The result is not perfect as it has none of the careful radial pattern of the original, but it is far preferable to the original image. It was finished off by applying an Unsharp Masking filter plus a few tonal adjustments.

●HINTS AND TIPS

The following points may help you avoid some of the more obvious cloning pitfalls:
- Clone with the tool set to maximum (100 percent). Less than this will produce a soft-looking clone.
- In areas with even tones, use a soft-edged, or feathered Brush as the cloning tool; in areas of fine detail, use a sharp-edge-Brush.
- Work systematically, perhaps from left to right, from a cleaned area into areas with specks – or else you may be cloning dust specks themselves.
- If your cloning produces an unnaturally smooth-looking area, you may need to introduce some noise to make it look more natural: select the area to be worked on and then apply the Noise filter.
- You can reduce the tendency of cloning to produce smooth areas by reducing the spacing setting. Most digital Brushes are set so that they apply "paint" in overlapping dabs – typically, each dab is separated by a quarter of the diameter of the brush. Your software may allow you to change settings to that of zero spacing.
- If you expect to apply extreme tonal changes to an image using, say, Curves settings, apply the Curves before cloning. Extreme tonalities can reveal cloning by showing boundaries between cloned and uncloned areas.

Original image

Suppose you wished to remove the lamp on the far left of this image to show an uninterrupted area of sky. You could use the cloning tool to do this, but it would be a lot of work and there would be a danger of leaving the sky's tones unnaturally smoothed out in appearance.

1 Marquee tool

The Marquee tool was set to a feather of 10 pixels (to blur its border) and placed near the lamp to be removed to ensure a smooth transition in sky tones.

2 Removing the lamp

By applying the Marquee tool, you can see here in this image how the cloned area of sky is replacing the lamp. Further cloning of sky was needed in order to smooth out differences in tone and make the new sky area look completely natural.

3 Looking at details

The final removal of the lamp was done with a smaller Marquee area, with its feather set to zero (as sharp as possible). Finally, the lamp behind the one removed was restored by carefully cloning from visible parts of the lamp

4 Cleaned-up result

As a finishing touch, a small area of cloud was cloned over the top of the lamp and its lid was darkened to match the others left on the pier.

Cloning techniques continued

Special cloning

In most software, there are two main ways of applying a clone. The basic method is what is now known as nonaligned, or normal: the first area you sample is inserted to each new spot the Brush tool is applied to. The other cloning method keeps a constant spatial relationship between the point sampled and the first place the sample is applied – in other words, an offset is maintained so that the clone is aligned to the source point.

However, software such as Corel Painter offers as many as nine other ways of aligning the clone to the source. You can distort, shear, rotate, mirror, scale up or down, and so on. The procedure is more complicated than with normal cloning because you need to define the original scale and position prior to applying the clone. You first set the reference points in the source image, then set the transformation points – this can be either in the original image or in a new document. It is this latter feature which gives Painter's cloning tools tremendous power.

One interesting feature is that as the cloned image is being built up, it can become itself the source of the cloning process. Even after long acquaintance with these features, they have the power to surprise and delight.

As with all cloning experiments, you should work only on a copy of the original image. And since some transformations require huge computing power, you need to allocate maximum RAM to the software.

Original images
Both of these originals (*left*) were taken in New Zealand. Note that images do not have to be the same size or shape for cloning to take place, but look for originals with strong, simple shapes. Sharpness and color were improved prior to the cloning: increasing sharpness after cloning can exaggerate the patches of cloned material.

Manipulated images
The originals were first cloned into a new file, but with added textures and overlaid with different layers. The first image (*below*) is intended to give a modern feel to the Chinese character "good fortune"; the other (*right*) has been given a crackle texture.

Original image

Any original image can be cloned onto itself to make complexes of line and form. Starting with an image with clear-cut lines and simple colors, such as this, special cloning techniques can make images that are difficult to produce in any other way.

Original image

Very interesting results can be achieved by cloning an ordinary, everyday object into a new document.

Rotation and scale

Cloning with rotation and scale calls for two points to be set to define the source and a corresponding two points to determine the clone. By experimenting with different positions of the source and clone points, you can create a wide range of effects: here the boy appears to be spinning into an abyss.

Bilinear transformation

Here, bilinear transformation was used to bring about this transformation. This technique warps the image according to the relative positions of the reference points set. By experimenting with the positions of the clone points, a totally unexpected shape was produced from a simple picture of an orange shirt.

Perspective tiling

Here, the boy was cloned with perspective tiling applied twice to different parts of the image. This requires four points to be set as the source, and four for the clone. By switching around the positions of the reference points, wild perspective distortions are produced, which could have come from a sci-fi comic.

Dust removal

PenDuster is a component of the PenTools software, which comes bundled with the Wacom graphics tablet. It is an excellent tool for neatly and effectively removing dust and hairs, and it employs a special type of cloning technique that replaces the dust with pixels from immediately adjacent areas. So useful is this feature for the digital photographer that it alone is worth the purchase price of a small Wacom tablet.

Cloning techniques continued

Natural media cloning

Many of the filter effects for image manipulation (*see pp. 298–309*) take photographs into the realm of painting and the textures of fine art materials. Filters operate on the whole image simultaneously with overall control possible only over the strength of effect, and no local control at all. Very different effects result, however, if you lay down the strokes yourself.

Don't be afraid if you think you are not artistic: the beauty of working digitally is that if you are not happy with the results, you can step backward to undo the work and start again. You can experiment for as long as you like until the result is to your satisfaction. And don't think you are being "amateurish" if it takes hours: professionals will confess that it can take them days before they achieve results they are content with.

All digital image-manipulation software offers art material effects as special "paints" with which Brushes may be loaded. The difference is that instead of simply loading a Brush with color, it is loaded with instructions – to vary color or intensity as the stroke progresses, to add texture to it or "dilute" the color as if you were mixing water in, and so on. The brush color can be based on the colors of an underlying or source image, so offering you a shortcut to a radical modification of the original. You can turn a sharp digital image into a soft watercolor, a colorful abstraction into a

Jerusalem 1

Once I had settled on an image I wanted to use, I started to experiment with the Curves setting to see what would happen if I set a very distorted value (*pp. 266–70*). The result that seemed to have the best potential turned the image into a metallic rendering, something like a weathered painting. The trick in this mode of working is knowing when to stop: you can work endlessly trying out different effects. Remember to save promising-looking images as you go so that you can assess them in the cold light of day.

Jerusalem 2

Only those images that have clear outlines and distinct features will survive the detail-destroying aspects caused by applying brush strokes. Here, impressionist-like strokes were applied – taking their color from the original picture, the strokes build up a new image by cloning, or copying, from one image into another. At the same time, the strokes were set to respond to the underlying texture of the paper. You can experiment with different settings and directions of "painting" as often as you like.

vibrant "oil painting" with strong strokes of color and the texture of a bristly brush.

The reason for working with a low-resolution file is that it is smaller and the effects you apply will, therefore, appear on screen much faster than with a large file. It makes the whole system much more responsive to your brush. As you will be obliterating any fine detail anyway, it is not necessary to keep all the image data. Reduce the source file resolution to at least half the normal for the output you envisage. But when you are happy with your work, change resolution back to normal, in order to avoid pixelation (*see pp. 346–7*).

Many people prefer using a graphics tablet (*see p. 72*) rather than a mouse for this way of working.

The graphics tablet and pen responds to many levels of pressure, speed of stroke, and even to the angle of the pen, thus making for livelier, more natural-looking and varied strokes.

HINTS AND TIPS

For the most effective results you will find it easiest to work when:

● The source offers clear outlines and strong shapes: fine details, such as that of grass or hair or facial features, are generally lost.
● The source image has areas of strong color.
● The source image does not have extensive areas of black or of white.
● The source image is relatively low resolution.

Applying art effects

Powerful software, such as Painter, offers a bewildering choice of effects to experiment with, but you will probably find that you regularly use only a fraction of the range available. The transformation from the original image of a chest of drawers seen in the screen shot panel (*upper left*) to that rendered in Natural Media (*lower right*) took less than an hour to achieve, yet suggested many other treatments on the way.

Image before and after

The shadows in the original (*top*) were replaced by textures from a drawing on rough-textured paper, which were applied using a Brush tool. Parts of the image were cloned into other areas and tonally adjusted for balance.

Image hose

The normal process of digital painting is to change the values of a group of pixels all at once – if you are applying a certain magenta color, then all the pixels lying around the middle of a brush stroke are turned to that shade of magenta. By the same token, you could replace one group of pixels with another group, which could make up an image. This is the principle behind the image hose – as the Brush tool is applied, images are laid down rather than pixels made to change color. The best known example of the implementation is in Corel Painter. In this, the size, orientation, and distribution (whether images are trailed along the brush stroke or scattered around) can all be varied.

Preparations

Unlike other Brush tools, you need to prepare an image hose with a range of images, or you can use a library of images already created. For this, digital photography is ideal, as you can easily capture images – which can be very low-resolution files – for use in the image hose. The next stage involves some calculation and planning, but once done, you have made up tremendously powerful tools for creative work.

The images you "paint" with are without limit: you could also create and apply textures – also known as a texture stamp – or you can paint with moths and houses, as shown here.

Village original
Ten component images of a village make up this image hose. Each is a small part of a larger whole and at slightly varying scales so that when applied randomly the buildings look somewhat jumbled.

Moth original
The component images of this image hose are all the same apart from their orientation, so that when they are randomly applied they appear to be flitting around in different directions.

Ferns original
The components of the ferns Brush used in the final image (*opposite*) can be seen here. Each fern is an individual image that is held in a collection, or nozzle. As you paint with the ferns Brush, the software selects one fern at a time to lay on the image. Ferns can be set to be chosen at random or according to the speed, direction, or pressure of the stroke. And as the Brush is made larger, so the ferns increase in size.

1 Adding clouds

To start off the process of manufacturing this fantasy landscape, I first created a gradient of blue to represent the sky against which the image hose loaded with clouds could be applied.

2 Building elements

As foreground objects overlap those in the background, I first laid down the small buildings to represent the far distance, using a small Brush size for the image hose. By increasing the Brush size, larger "foreground" buildings could then be laid down.

3 Establishing the middle ground

Distant vegetation, such as trees in the village, were laid with a small Brush, with the Brush size increasing to represent plants that are supposed to look closer to the viewer.

4 Developing the foreground

A few stones were next deposited in the foreground, then the nearest plants were laid – but I took care not to use too many examples to prevent this area becoming cluttered in appearance.

5 Moths in the sky

Finally, as a fantasy touch, a stream of moths was created – again starting with small ones in the distance, growing larger as they approach the viewer's position.

6 Final image

Finally, a few flowers were added to reduce the blankness of the wall in the middle ground.

Photomosaics

Since digital pictures are composed of an array of individual pixels, it is only a short step to making up an image from an array of individual pictures. This is the principle behind photomosaics: you can replace an image's pixels with tiny individual images, like the tiles of a traditional mosaic.

Preparation

As with an image hose (*see pp. 332–3*) you need to prepare images with which to create the mosaic. The small "mosaic pieces" may be tiny versions of the larger one or different images. Photomosaic software treats individual pictures as if they are pixels, looking for best matches between the density and color of the small images to the pixel of the larger image that is to be replaced.

Photomosaic software usually provides libraries of mosaic pieces for you to work with, but it is more fun to create your own. However, the large numbers of images needed means that this can be a long-winded process. Advanced users can create batch processing sets to automate the process of rendering files into the specific pixel dimensions needed for the mosaic pieces. Other sources are the thumbnails (small files) found in some collections of royalty-free CDs.

Composite photomosaic
The original image was relatively complicated, but its clear lines and shapes, as well as the repeated elements it contained, made it a suitable candidate for photomosaic techniques. By selecting a small size for the mosaic "tiles" the resulting image still, overall, retains many details, but with an added richness of texture that invites closer inspection. The close-up view of the photomosaic (*below*) shows an intriguing mixture of images. Varying the component images is one way to produce an entirely different feeling to the image, while still retaining the outlines of the originals.

●HINTS AND TIPS

When thinking of producing a photomosaic, bear the following points in mind:

- Provide a wide range of images from which to make up the mosaic pieces.
- Remember that smaller mosaic pieces produce finer, more detailed photomosaics.
- Use subjects with very clear or recognizable out-lines; avoid complicated subjects lacking clear outlines as the process destroys all but the largest details.
- Bear in mind that if you create images in which a high level of detail is replaced with large mosaics, the resulting files will be very large.
- The rendering process that creates the photomosaic can take some time for your machine to handle.

High-key photomosaic
The large, even spread of tones presents a challenge to photomosaic software, as identical images next to each other must be avoided, or else false patterns are created. However, the photomosaic has superimposed an attractive texture over the image. The close-up view (*below*) is richly rewarding.

Image stitching

Panoramic views can be created by "stitching," or overlaying, images side-by-side (*see pp. 198–9*). Essentially, a sequence of images is taken from one side of the scene to the other (or from the top to the bottom). The individual images are then overlapped to create a seamless composite.

You do not need specialist software to achieve panoramas if the original shots are taken with care. You simply create a long canvas and drop the images in, overlapping them. However, small errors in framing can make this a slow process due to the need to blend the overlaps to hide the seams.

Appropriate software

Specialist panoramic software makes connecting component shots far easier, especially if they were inexpertly taken. The available software packages take different approaches. Some try to match overlaps automatically and blend shots together by blurring the overlaps. Results look crude but are effective for low-resolution use. Other software recognizes if the overlaps are not matching (which results from a camera not being mounted on a tripod) and tries to accommodate the problem – some by distorting the image, others by trying to correct perspective. Many digital cameras are supplied with panorama-creation software.

For more unusual effects, experiment with placing incongruous images together, or deliberately distort the perspective or overlaps so that the components clash instead of blend. There is a great deal of interesting new work still to be done.

Photographs © Louise Ang

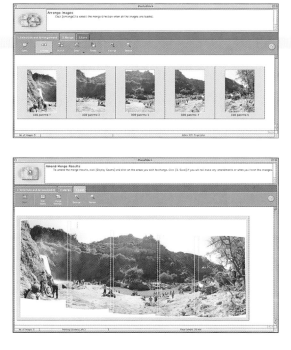

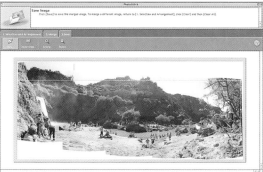

- Beware that a panorama resulting from, say, six average-size images will be a very large file: reduce the size of the component images first in order not to stretch your computer's capacity.
- If you want to create a panorama that covers half the horizon or more, it may be better to stitch it in stages: three or four images at a time, then stitch the resulting panoramas. Keep an eye on the image size.
- Place all the component images together into one folder: some software will not be able to access images if they are in different folders.

Assembly

To start the assembly (*left*), move the component images into a single folder where the software can access them. With some software, you will be able to move images around to change their order, while in others you will have to open the images in the correct order. To merge the images, the software may need extra instructions, such as the equivalent focal length of the lens used.

● Nikon Coolpix 990.

Final version

The component images show very generous overlaps, which make it easier for the software to create smooth blends. Once the component images are all combined on the same canvas you can use the facilities offered by the particular software to blend and disguise the overlaps to create a seamless, single image (*below*). Once you are happy with your work, save the file as a TIFF, not as a JPEG, for best-quality results.

6
The output adventure

Publishing your results

Output to paper, making books, printing to film, or uploading images to the web – this chapter tells you exactly how to do it. With enough information to help you attain professional-quality output, but only with as much technical detail as you really need, this is your guide to reliable, high-quality, and satisfying output, time after time.

Help on hand

Quick-fix sections help you to diagnose and fix printer problems as well as anticipate and avoid potential web-related problems.

Hobby or career?

A unique coverage of subjects such as careers in digital photography, setting up and running a business, putting together a portfolio, mounting an exhibition, guidance for disabled photographers, as well as copyright matters.

Further information

A highly accessible and authoritative glossary, numerous hardware- and software-related resources, and suggestions for further reading.

Image software

All software consists of thousands, sometimes millions, of instructions, which tell the computer what do when it receives commands from you, from software such as scanner drivers, or from attached equipment, such as a modem. Image-manipulation software is a specialized set of instructions for working on images and, as such, numbers among the most complicated and powerful software generally available. In practice, what matters is not exactly how the software works, but how to make it work effectively and efficiently for you. Here are some hints and suggestions:

● Keep referring to the instruction manual: it makes little sense when you first read it, but after you have used the software for a while, you will start to see the light. A good software manual is worth reading even if you think you know the program, as the more subtle tricks it can teach you will be easier to understand once you are familiar with the main features of the software.
● Use the keyboard shortcuts: all good software, particularly programs for Windows, offers execution of commands from the keyboard. Using as many of these as possible saves time and effort and is healthier, putting less strain on your wrist controlling the mouse. One of the reasons for Photoshop's popularity is that it is easy to set up time-saving shortcuts. At the very least you should never need to use the mouse to initiate a save, print, or to close a file.
● Quit other applications you do not need: image-manipulation software is highly processor-intensive (it takes up all the time and attention of the central processing unit). So, to have other software – such as a word processor or an internet browser – running at the same time can seriously slow down image manipulation operations.
● Use the highest resolution available on your monitor: this forces the palettes and associated labels to be as small as possible, reducing clutter on the screen and thereby giving you more room to work with images. A screen resolution setting of 1,024 should be the very minimum; most monitor screens can be set to 1,280, some to as high as

1,600. The symbols may appear too small initially, but you will get used to them – and the bonus is that the image-manipulation software will be much easier to use.

Some of the questions frequently asked about software are considered next.

When is software worth updating?

If you can do all you want to with your current software, it is not worth updating. Even if you think you need the new features, consider carefully: the new version may need more memory, run more slowly, behave slightly differently, and be unstable – in addition to costing you for the upgrade. You may also have to invest time in learning the new features. The best applications in their respective fields are mature products that are difficult to improve. Many "improvements" simply bloat the application with extra features.

Why is some software so expensive?

The cost of software comes from not only the obvious, such as the cost of the CD, instruction book, packaging, marketing, and development, but professional software may need proprietary technologies to implement some features – for which licenses have to be paid. Nonetheless, the market-leader applications can charge a premium, safe in the knowledge that they cannot be neglected for long. The advantage of using your own copy of an application, apart from the legalities involved, is that you can then obtain upgrades and technical support direct from the manufacturer, without trying to pretend to be someone else.

Should I wait before buying the newest software?

Yes: all new software has errors, or bugs in it, which are usually fixed by updates – for example, version 6.0.1 repairs bugs in version 6.0 – which often appear within weeks of the initial introduction. Wait for these to settle down before purchasing your software and you will save yourself a good deal of time and trauma.

Is it worth getting the best software?

The best software is that which has the features you need (but no more) and which is easy to use. Photoshop has by far the fullest featureset but is expensive and takes a long time to learn. Photo-Paint, Picture Publisher, Photoshop Elements, and Paint Shop Pro are relatively full-featured applications, much cheaper than Photoshop, and easier to learn. Simpler applications, such as PhotoImpact, PhotoSuite, and PhotoDeluxe, have basic feature sets and are correspondingly easy to use (*see pp. 396–7 for websites for software*).

Why should I reinstall software?

After some use, your application may become unstable and crash frequently or give rise to error messages. Software components may become corrupted or, if they are in a faulty portion of a hard disk, give rise to errors when read. The easiest solution is to reinstall the whole application. Advanced users may run a disk-repair utility before reinstallation; other users may omit this. It is worth moving Preferences and Settings files that you have evolved over time to prevent them being overwritten by default settings – see your software manual for the names of folders where these are kept within your system. When the application is reinstalled, you can move your personal settings back to their correct folder.

Is Mac and Windows software different?

There are few practical differences when standard applications, such as Photoshop and Quark XPress, are written for either the Mac OS or Windows operating systems. Most keyboard commands are the same, except that Control in Windows is usually Command in the Mac, and of course the interface looks a little different. However, some applications are available only for Windows or for Mac OS: you should confirm availability. Furthermore, you should check whether the software you want will run with the operating system you have – for example, if you are still using Mac OS 8.5 you would not be able to run many modern applications.

What are viruses?

Viruses, worms, Trojan horses, and the like are all small applications written in the same language as full applications. What distinguishes these applications is that they are designed to be destructive – to erase files or change settings, to confuse the computer – or they may be harmless but generate disturbing effects, such as making all the text on a page appear to fall into a heap at the bottom of the screen. Viruses are distinguished by being able to make copies of themselves, for example, onto a disk introduced into the computer, so they can install themselves on another computer. Computers running Windows are far more vulnerable than Apple Mac computers – with tens of thousands have been known to infect Windows, but only a few hundred for Macs. If you have any information of value on your computer, you should install virus-protection software and regularly update it, especially if you are a Windows user.

Norton AntiVirus

Are downloads from the internet safe?

Software downloads from commercial sites should be perfectly safe from viruses and other destructive software. If, however, you download from sites specializing in cheap, pirated software, then you are running a risk because you do not know exactly what you are copying onto your computer until it arrives and installs itself. By then it is too late to resist any infection. Bear in mind that you may have to turn off virus-protection software before installing an application.

Proofing and printing

It is an exciting moment. You have worked for hours at your computer, using all your know-how to create an image that looks just the way you want it, and now you are ready to print. You take a deep breath and press the button to send the file to the printer. If, then, the printer produces satisfactory results for most images, without any intervention on your part or setting up, you are lucky (make sure you note the settings in the printer driver for future reference). Unfortunately, the experience for many digital photographers is that the results of printing will be disappointing.

An important point is that mismatch between the monitor image and the printer is not, in the first instance, caused by any malfunctioning of your printer or monitor. The basic problem is that the monitor produces colors by emitting a mix of red, green, and blue light, while a print reflects a mix of light to produce the colors you perceive. These fundamentally different ways of producing color lead to a difference in gamut, which is the range of colors which can be produced by a device (*see p. 117*).

There are two main approaches open to you. You can adjust the image to compensate for the differences between what you see on screen and the resulting print, then print again and again, repeating the process until the print is satisfactory. This is not only unscientific, but the adjustments apply only to one image. The best way is to use software such as Photoshop, which offers color-management facilities.

Printing with color management

To use color management for printing, you must first calibrate your monitor (*see pp. 228–31*). Note, too, that for the highest reliability, settings will apply only for the paper and inks with which you make the test. The basic idea is that you will first specify the source color space containing the colors you want to send to your printer – those that typically relate to your monitor. Second, you specify the color space of the printer, usually tied to

the material being used. This gives the software the information it needs in order to make the necessary conversions.

A typical task is to proof an image currently in the monitor RGB space as it will appear on an offset printer (a commercial machine). The source color space uses the soft-proof profile while your printer profile is the printer space. The following description details the steps for Photoshop.

First choose File > Print Options and select "Show More Options," then "Color Management." For Source Space, select "Document" to reproduce colors as interpreted by the profile currently assigned to the image. Select "Proof" to reproduce document colors as interpreted by the current proof profile. Under Print Space, choose the profile that matches the color space of your printer to

Color settings

The dialog box controlling color settings looks complex, and careful attention is needed to make full sense of it. However, there are many guides – such as those provided in printer and software manuals – which should help you master it. The crucial point to keep in mind is that,

unless you are producing work to be printed by a commercial press for a mass market, you need not worry about these settings. You can get by without touching them: however, if you can control them, it is then far easier to obtain reliably good prints from your desktop printer.

Printer settings

A driver that complies with the ColorSync protocol for color management will offer a dialogue such as that shown here. The Source Space is the color space or profile for the image: here I have specified a commercially defined standard, which defines an RGB space in a way that is opti- mized for print. The Print Space is not only that of the printer but of the paper and print quality being set. "Perceptual" has been cho- sen for the Intent, or preference for color conversions of colors that fall out of gamut, as that is most likely to give a photographi- cally acceptable print.

What is PostScript?

This is the most important of a range of programming languages that describe text and graphics on a page. PostScript breaks the most complex text and graphics into elementary components such as lines or dots and into basic operations such as "stroke" (to draw a line) or "translate" (to turn a component). When a printer receives a PostScript file it has to interpret it in order to turn these commands into the correct output on the page. This can be done with software in the computer's operating system or through specialist PostScript RIPs (Raster Image Processors). Using a PostScript RIP is the best way of making sure that complicated graphics and text are properly printed out on the page.

Fantasy colors

When you produce highly manipulated images, even a large error in color accuracy is unlikely to damage the effectiveness of the image, since most viewers will not ever know what the right colors were supposed to be. Of course, for the sake of artistic integrity, you will strive to produce the exact color you have in your mind's eye, but the impact of images such as that shown here, with its artificial colors and fantasy content, does not depend on precise color reproduction.

Proofing and printing continued

print using that printer space or else select "Same As Source" to print using the original source profile.

If you have an ink-jet printer, select "Printer Color Management" to send all the color data that is needed for the printer's driver to manage the colors. (Those using a PostScript printer should follow the instructions that are supplied with their PostScript RIP software.) Finally, under "Print Space," choose a suitable "rendering intent" (*see below*).

You are now ready to print, but before proceeding any further check that:

● You are using the same type of paper as that intended for the final output.

● You are using the correct side of the paper.

● There is a good supply of ink (check the level using the printer's controls).

● Your image has been sized to the correct output dimensions.

Previewing

The key to efficient printing practice is to employ soft-proofing as much as possible – that is, checking and confirming everything you can on the monitor screen before committing the image to

Textile color
For accurate records of valuable artifacts, such as this piece of textile (*above*), precise color control is essential. Reds are visually very impor- tant but deep reds can vary considerably between monitor image and paper output. The subtle variations in deep tone are easily lost if a printout is too dark.

What are rendering intents?

Converting from one color space to another involves an adjustment to accommodate the gamut of the destination color space. The rendering intent determines the rules for adjusting source colors to destination gamut: those that fall outside the gamut may be ignored or they may be adjusted to preserve the original range of visual relationships. Printers that are ColorSync-compliant will offer a choice of rendering intents that determine the way in which the color is reproduced.

● Perceptual (or image or photorealistic) aims to preserve the visual relationship between colors in a way that appears natural to the human eye, although value (in other words, brightness) may change. It is most suitable for photographic images.

● Saturation (or graphics or vivid) aims to create

vivid color at the expense of color accuracy. It preserves relative saturation so hues may shift. This is suitable for business graphics, where the presence of bright, saturated colors may be important.

● Absolute Colorimetric leaves colors that fall inside the destination gamut unchanged. This intent aims to maintain color accuracy at the expense of preserving relationships between colors (as two colors different in the source space – usually out-of-gamut – may be mapped to the same color in the destination space).

● Relative Colorimetric is similar to Absolute Colorimetric but it compares the white or black point of the source color space to that of the destination color space in order to shift all colors in proportion. It is suitable for photographic images provided that you first select "Use Black Point Compensation."

print. If you have implemented the color management suggested in this book (*see pp. 260–3*), the onscreen image should be very similar to the print you obtain. If, though, images are to be printed on a four-color (CMYK) press, set the destination printer or printer profile to that of a standard to which it conforms.

The first check is the output size: most image applications and print drivers will show a preview of the size and/or position of the image on the page before printing it out. If you are not sure of what you are doing, it is best always to invoke print preview to check – the print preview here (*see below*), from Photoshop, shows an image that is too large, while the screen shot (*see bottom*), from an Epson driver, shows an image enlarged 300 percent to make better use of the page. Printer drivers should warn you if the image size is too great to be printed without cropping.

Original image
All digital images are virtual and thus have no dimensions until they are sized for output, with a suitable output resolution. Ideally, there are sufficient pixels in the image for the combination of output resolution and output size, otherwise interpolation (*pp. 256–7*) is needed to increase resolution.

Photoshop print preview
Some software provides a quick way to check the print size in relation to the paper size set for the printer. Here (*right*) is Photoshop's way of displaying it. The corners of the image fall outside the paper as can be seen by the diagonals not meeting the corners of the white rectangle, which pops up when you click on a bar at the bottom of the frame: the image is clearly far too large for the paper.

Print options preview
This screen shot (*left*), taken from a printer driver, shows how a printer expects to produce a given file. The image has been enlarged by 300 per cent to make better use of the paper and has been centered (ensure your image has sufficient data to print at this enlargement). Note how the preview shows the image on paper and that it provides you with handy functions, such as being able to position the image as well as choose units of measurement. Modern printers can place an image with great and repeatable precision.

Output to paper

One great advantage of ink-jet printers is that they can print on a wide variety of surfaces. In fact, some desktop models will print on anything from fine paper to thin cardboard.

For the digital photographer, there are three main types of paper available. Most papers are a bright white or a near-white base tint, but some art materials may be closer to cream.

Paper types

Office stationery is suitable for letters, notes, or drafts of designs. Quality is low by photographic standards and printed images cannot be high in resolution or color saturation. Ink-jet paper described as 360 dpi or 720 dpi is a good compromise between quality and cost for many purposes.

Near-photographic quality is suitable for final printouts or proofs for mass printing. These papers range from ultra-glossy or smooth to the slightly textured surface of glossy photographic paper. Paper thickness varies from very thin (suitable for pasting in a presentation album) to the thickness of good-quality photographic paper. Image quality can be the best a printer can deliver

with excellent sharpness and color saturation. However, paper and ink costs may be high.

Art papers are suitable for presentation prints or for special effects and include materials such as handmade papers, watercolor papers, or papers with hessian or canvaslike surfaces. With these papers, it is not necessary to use high-resolution images or large files that are full of detail.

Paper qualities

If you want to experiment with different papers, ensure that the paper does not easily shred and damage your machine and clog the nozzles of the ink-jet cartridge. If using flimsy papers, it is a good idea to support them on thin cardboard or a more rigid piece of paper of the same size or slightly larger. The problem with paper not designed for ink-jets is that the ink either spreads too much on contact or else it pools and fails to dry.

Dye-sublimation printers will print only on specially designed paper – indeed some printers will even refuse to print at all when offered the wrong type of paper. Laser printers are designed only for office stationery and so there is little point in using other types of paper.

Crucial color

Not only does the blue of this scene test the evenness of printing, it also tests color accuracy. Very slight shifts away from blue will make the image look unbalanced in color and distract the viewer's attention from the relaxed, sun-filled scene. In fact, blue ranks with skin tones as the most important of colors that must be correctly printed, or else the foundation of an image will be seen as unsound.

● Canon EOS-1n with 80–200 mm lens. ISO 100 film. Nikon LS-2000 scanner.

Dark subjects

The blacker a color image, the more ink will be needed to print it. If your subject is full of very dark areas, such as this scene, the paper could easily be overloaded with ink. The ink may then pool if it is not absorbed and the paper could buckle or become corrugated. To minimize this problem, use the best quality paper and tone down the maximum of black as much as possible by reducing the black output level in the Levels control.

● Canon EOS-1n with 80–200 mm lens. ISO 100 film. Nikon LS-2000 scanner.

● **TRY THIS**

To determine the minimum resolution that gives acceptable results on your printer, you need to make a series of test prints with the same image printed to the same size but saved to different resolutions. Start by printing out a good quality image of about 10 x 8 in (25 x 20 cm) at a resolution of 300 dpi – its file size is about 18 MB. Now reduce resolution to 200 dpi (the file size will get smaller but the output size should be the same) and print the file, using the same paper as for the first print. Repeat with resolutions at 100 dpi and 50 dpi. Compare your results and you might be pleasantly surprised: depending on the paper and printer, files with low output resolution can print to virtually the same quality as much higher-resolution files. With low-quality or art materials, you can set very low resolutions and obtain results that are indistinguishable from high-resolution files. In fact, low resolutions can sometimes give better results, especially if you want brighter colors.

Even tones

Subjects with large expanses of even and subtly shifting tone present a challenge to ink-jet printers in terms of preventing gaps and uneven-ness in coverage. However, in this image of a frozen lake in a Kazakh winter, the challenge is not so great as the color is nearly gray, which means that the printer will print from all its ink reservoirs. If there is only one color, most often the blues of skies, you are more likely to see uneven ink coverage.

● Canon EOS-1n with 80–200 mm lens. ISO 100 film. Nikon LS-2000 scanner.

Quick fix Printer problems

A great deal of computation is needed before your printer can translate the image on screen or captured in a digital camera into a print. Not only must the pixel data be translated to individual dots or sets of dots of color, that translation must ensure the final print is sized correctly for the page and turned the right way. The real surprise is that people do not experience more printer problems than they do. But it is true that everybody reports having some problems with printers. This table may help you solve the more commonly encountered glitches.

Troubleshooting

The commonest causes of problems with the printer are often the easiest to deal with. As a routine response to problems, check that the power cord and printer cable are securely inserted at both ends, check that your printer has not run out of ink, and make sure that the paper is properly inserted, with nothing jammed inside.

Problem	Cause and solution
Prints show poor quality – dull colors or unsharp results.	If you run the self-check or diagnostic test for the printer and nothing appears to be mechanically at fault, then the cause is a user setting. You may have set an economy or high-speed printing mode. If so, set a high-quality mode. You may be using a low-quality paper or one unsuitable for the printer, or you could be using the wrong side of the paper: change the paper and see what happens. You may be using an uncertified ink cartridge instead of the manufacturer's: use the manufacturer's own brand.
Prints do not match the image seen on the monitor.	Your printer and monitor are not calibrated. Go through the calibration steps (*see pp. 228–31*). Your image may contain very little color data: check the image using Levels – rescanning may be necessary.
A large file was printed really small.	File size does not alone determine printed size. Change the output dimensions using the Image Size dialog box.
An image does not fully print, with one or more edges missing.	Output size is larger than the printable area of the printer – most printers cannot print to the edge of the paper. Reduce the output or print size of the image in the Image Size dialog box and try again.
The printer works very slowly when it is printing images.	You may have asked the printer to do something complicated, such as print a complex graphic, text overlaying an image, or a picture in landscape format. If your graphic has paths, simplify them. If your image has many layers, flatten the image prior to printing. To print landscape-format pictures, turn the picture to one side using your image-manipulation software prior to printing. If you set the factor or magnification to any figure other than 100 percent, the printer is burdened with resizing the entire image. Change the image size using image-manipulation software before printing.

Out of memory
This close up of a printout shows the printer making a start, then suddenly printing lines instead of the image. The cause was a shortage of memory available to the printer driver: when that was increased, the problem disappeared.

Unsuitable paper
An attempt to print on normal photographic paper produced this result: the ink has not been absorbed into the paper and individual droplets have pooled together taking many hours, if not days, to dry.

Garbled print
It is easy to send the wrong message down the wrong port. This was the result of trying to send a facsimile message to the printer – it does its best to interpret the signals.

Streaky prints
The result of a very poor-quality printer working on low-quality paper is an output image that is streaky, uneven, and wholly unacceptable. Cleaning the nozzles may improve matters to a degree.

Problem	Cause and solution
The printer works slowly even when printing text.	You have set the printer to a high-quality setting, such as high resolution or fine, or the high-speed or economy mode has been turned off, or you have set the printer to unidirectional or to print on high-quality (photorealistic) paper. Check and reset the printer to high-speed, bidirectional, and reduce the resolution or choose a normal or standard paper.
The computer crashes or slows to a crawl during printing.	You do not have sufficient RAM to do more than one thing at a time. For Mac OS, turn off background printing. For Windows, wait until printing is over. For both platforms: obtain and install more RAM into the computer.
The printer cannot be found or nothing happens when "OK" is pressed at the printer dialog box.	You may have a conflict – this is probably the case if this problem occurs just after you install a new scanner, mouse, or the like. Reinstall the printer driver software. Ensure you have the latest drivers for the USB ports: download them from the manufacturer's website. Owners of early iMac computers should ensure they have the latest iMac Update (find Mac OS ROM and check the version).
Prints appear smudged, with colors bleeding into each other.	The paper is damp, you have made settings for the wrong paper type, or there may be ink on the printer's rollers. Store paper in dry conditions inside its original wrappings. Check the settings against the paper type. Clean the rolls using a cloth and run the printer cleaner sheets, which are supplied by the manufacturer, through the printer.
The printer produces random lines or crashes the computer.	The system is lacking memory. With a Mac OS, turn off background printing and restart the printer; with Windows, don't try to do anything on the machine while the printer is working.

Quick fix printer problems continued

Problem	Cause and solution
The print is missing lines or there are gaps.	The printer head nozzles have almost certainly become blocked with ink or the printer head may need to be recalibrated. Clean the nozzles using the driver utilities supplied with the printer and try to print again. You may need to repeat the cleaning cycle three or more times to solve the problem. Run the calibration utility in order to realign the print heads. Blocked printer nozzles are less likely to occur if you use the manufacturer's own brand of ink cartridges.
The print suddenly changes color part of the way through.	Either one of the colors in the ink cartridge has run out or it has become blocked during printing. Clean the nozzles using the driver utilities and try to print again. You may need to repeat the cleaning cycle three or four times to solve the problem.
The printer produces garbled text.	You may have connected the printer to the wrong computer port or you may have tried to use the printer port to send a file, fax, or similar. This problem can also occur if you have aborted a print operation some time earlier. If so, turn the printer off, wait for a few seconds, turn the printer back on, and try the operation again. With Windows machines, check that the spool or print manager has no jobs waiting to be processed. If there are any, delete them and start again.
The printer fails to print text accurately – for example, it leaves off the tail, or descender, of letters such as "p," "q," or "g," or leaves out overlapping items in images.	The printer driver has been unable to rasterize complicated shapes or multiple image layers. Simplify the image by flattening it – in other words, combining all the layers into one – before trying to print the job again. If this does not work, you will need to install a software PostScript RIP (Raster Image Processor), but note that not all printers will print to a PostScript RIP (see p. 324).
Printer produces banded lines in areas of even tone.	The paper transport is not properly synchronized with the printhead. This could be a fundamental fault of the printer. If this is not the case, try changing the weight of paper being used or the thickness setting (usually achieved by adjusting a lever on the printer). You could also try adding noise (see pp. 246–7) to the image, using image-manipulation software, to disguise the unevenness of tone.
Details in prints appear soft and blurred and colors are dull – all despite printing at high resolution and on good-quality paper.	You may be using the wrong side of the paper. Most ink-jet papers have a good, receiving side and a support side: it may be difficult to feel the difference in texture if the paper is not highly glossy or to see the difference in whiteness under household lighting if the paper is textured. Manufacturers often pack their paper with the receiving side facing the back of the pack or there may be a mark faintly printed on the support side.

Quick fix Web page problems

It is rare to come across a Web page that does precisely what is expected of it by the designer or the client, and shows users everything meant to be on the screen and when it is meant to appear.

In the available space, the list below is by no means comprehensive, but it does at least cover some of the more major problems that are frequently encountered.

Problem	Cause and solution
The browser cannot find your Web page.	The most likely cause is that you have placed the Web page in the wrong folder or directory on the server – check with your ISP (Internet Service Provider) or WPP (Web Presence Provider). Another possible cause is that your home page is incorrectly identified – the convention varies, so check with your Provider – the home page is usually called index.html.
Your Web page appears incorrectly.	If you produced the Web page by writing HTML code directly, it is likely you made a small typing error. Check the spelling of every tag and attribute. If a section of a page is missing you may have failed to close quotation marks (" – and – ") or angle brackets (< – and – >) and these must always occur in pairs. If a single element is missing, then you probably gave the wrong path or location for that element or else gave the incorrect suffix or extension to the item. An incorrect extension is one that is not recognized at all or which is wrongly associated with the file – for example, .jpg used with a GIF file. If formatting is applied to a large mass of text, you probably forgot to provide the closing tag.
The browser displays your HTML code.	The browser has not recognized your document as containing HTML code. If some of your pages did not carry the .htm or .html suffix or carried an incorrect suffix, such as .doc or .txt (as easily occurs if you used a word-processor program to create the code), then the browser may display the raw code. All HTML documents should start with the tag <HTML> and close with the end tag </HTML>; if not, a browser may not recognize it as HTML, even if the file carries the correct suffix.
Pictures are missing.	The browser cannot find the images where it was told to look. Check that file names in the HTML document match exactly with the file names of the images and that the names carry the correct suffix. If any images are in PNG format, earlier browsers may not recognize the format. If the images are very large or high-resolution, the browser may have insufficient memory to display them.
Pictures take too long to download.	The pictures may be too large. Reduce the file size with compression and by reducing the number of colors. The phone or other connection may be slow or when traffic is heavy (when many people are logged on), data transfer rates are reduced. Try logging on at quieter times of the day.

Creating your own book

One of the most satisfying activities for the digital photographer is to be able create a book. It is said that everyone has a book in them – it may be as modest as the record of a memorable trip to some exotic location or a memento of a beloved pet; or it could be grander project, such as a history of your town or a document campaigning for the preservation of a historic building or an area of ancient woodland. If you know what you want to do, you have already met the first key requirement for a successful book – having a vision.

There are many ways to approach the task. In essence there are four main steps – but that does not mean that you take the first step and then proceed to the next in some sort of orderly sequence: it is a feature of modern digital technology that all steps tend to overlap and merge with each other.

The first step is the acquisition stage: here, you make all the necessary contacts prior to creating the pictures, gather information, and organize all your material. Second, you design the page, deciding how to place the material on the page (this need not be as daunting as it sounds). Third, you go into production – you print out the pages, bind them, and put a cover on them. Finally, you publish the results.

Acquisition

The best way to start and then to proceed is the same: keep your vision of the book in mind as you go about making the pictures and gathering information. The effort of concentrating your mind on your goal can have a wonderful effect on your photography – you will feel directed and the photographs will almost make themselves for you. Think about which picture will go on the cover and what type of picture you want to see at the very end the book. Will you depict only objects and locations, or do you need some portraits and group pictures as well? Will you work in color or in black and white – or, indeed, both? Do you need to research archives for historical views or to gather information about deceased people? With digital photography, it is easy to copy documents by, for example, scanning them – a deed of sale or a birth or marriage certificate – which will lend authenticity to the book you are planning. And start a project folder in which you list tasks, note contact details, jot down ideas, and so on.

With digital photography it is all so easy, and it costs you nothing, to be experimental and stretch the boundaries of what you do. Your action points might be:

Sort your pictures
As you build up a collection of pictures for your book, look at them frequently – image-management software such as Extensis Portfolio or FotoStation is convenient for this, since you can view all the images at once at a small size. It is also rewarding to watch the collection become steadily larger, more comprehensive in scope, and more relevant to the content of your book project.

Title or heading

- Keep a project folder
- Keep photographing
- Collect visual materials
- Experiment with unusual views and try out new associations of ideas.

Design

You might think that you should start designing your book and putting it together only once you have all your material. That is a mistake: it is better to start pulling the book together very soon after the first two or three sessions of photography. When you have some preliminary idea of what the book will look like, you will find it even easier to photograph or to select the most appropriate pictures to fit into the right spaces.

Books differ from pamphlets in that they have a definable underlying structure. You can choose to ignore the usual "rules," but experience tells us that if a book is built around a skeleton on which all the elements – the pictures, text, and graphics – are arranged, it is easier for the reader to enjoy the content. The key points are:

Start and finish Have a front and back cover and a title page, and it may also help to have a contents page that lists the main topics and where to find

them. Remember to design the book in such a way that it is appropriate to the culture of your readers – reading right to left for some Middle Eastern languages, for example.

Orientation and dimensions How large will your book be and will it be upright or landscape format, or square? Remember that most printers cannot print to the edge of the paper, so you may need to trim off excess if, for example, you want pictures to "bleed" off the page. If all your pictures are landscape format, it may be a shame to place them on pages that are narrower than they are deep. And while the square format is tempting, it uses – some may say wastes – a lot of space. One approach is to use an A3 printer to produce a book somewhat smaller than A4 – this way you can print two pages of the book at a time.

Book grid Your book will look more organized and professional if there is some regularity and predictability in the positioning of items on the page, such as headings and page numbers, blocks of text and captioning, and the tops of pictures or other illustrations – against which the occasional surprise positioning of a design element will keep readers interested (*a classic grid is shown above*).

Creating your own book continued

Consider the possibility that you might want to publish the book on the internet – can the design be adapted easily to suit the format imposed by the Web page?

Picture flow Plan how your pictures will run so that there is some continuity and a sense of story-telling. Classically, you might start off with overall views, move quickly to close-up portraits and old documents, show some interior shots and objects, and finish off with some stunning landscapes. Of course, you can be more bold, starting with abstracts that tease and intrigue before offering the main – perhaps informative – part of the book, and round off with some challenging images.

Set up a system Keep all the materials – your pictures, documents, and so on – in one box; keep all scans in the same folder and keep a backup of all your digital files in a safe place somewhere well away from the computer.

This may seem a daunting list of aims, but if you approach it one step at a time and without rushing, the book will evolve steadily under your control. Your action points might be:

● Decide on the size of the book and the number of pages. In addition, decide how many copies you need and the budget you have: if you want 30 or fewer copies or a total of a few hundred pages, you can probably do it all on your desktop printer.

Bindings

Many convenient and inexpensive ways of binding books are available today. Plastic combs are not expensive and are widely available, but they are not very attractive. Wire spiral binding gives neat results provided you have a good number of pages – say, at least 50. Perfect binding applies glue to the spine edge of the pages: this is effective but the books do not open flat and the binding may not be very durable. The strongest method is the traditional one of stitching pages with thread and pasting the pages between stiff covers, but it is very costly.

● Work out a simple printing plan to allow for the book to be bound (*see opposite*).
● Start sketching a layout of the book in a rough, freehand form.
● Work out which typeface you wish to use: you will need to use easily readable faces for the main text, reserving more elaborate ones for headings. It is best to avoid using more than three different faces on a page.
● Write the words. Text blocks can be short, and if you are not confident about writing, just keep to the facts.
● Decide on the software you will use for laying out the book. Learn how to use a new program in good time before going into production.
● Look at other books to find the style of design and layout you like and learn from them.
● Consider the method for binding the pages: most methods require you to send your work to a specialist supplier. Spiral binding is neat, inexpensive, yet can be stylish. Plastic comb binding is very inexpensive but neither durable nor neat. Perfect binding – in which pages are glued together at the "spine" – is neat but not strong. Metal stapling of folded sheets can be perfectly acceptable.

If this is your first try, do not be too self-critical: it is better to produce something that is of an acceptable standard than to try to produce something that is perfect and fail to achieve anything at all. Furthermore, it is much easier to change a design once you have printed it out – and when you have something printed out, it is also much easier to see the merits of what you have done.

Production

Once you have some confidence in your design you can start a trial output, or proof. Unless you know what you are doing, do not be tempted to save paper by printing out files at reduced size. But you can save money, time, and ink by out-putting onto stationery-quality paper using a low-quality or high-speed setting for the printer.

If you decide to try your hand at page imposi-tion, you will need a printer that will print on

Imposition

The term "imposition" describes a method of printing pages on large sheets of paper so that when they are folded and trimmed together, the pages fall in the correct order. Four methods are shown here. It may seem confusing, but it is worth trying if you are serious about producing your own books. Even if your book is short, if it has been professionally imposed it will feel more like a "real" book than one in which each page is a separate sheet of paper.

4-page to view, work and turn

8-page to view, work and turn

8-page to view, work and tumble

12-page booklet to view, 3 parallel folds

both sides of the paper as well as paper that is designed to receive ink on both sides. Some printers have an accessory called a duplex unit: the printer prints consecutive pairs of pages on both sides of one sheet. Some printer drivers also allow two pages to be printed on the same sheet.

As you print out your work, the urge to make small changes may be irresistible. Well, why not? The beauty of producing your own book is that you can refine and refine further until you are perfectly happy with the result. It is good practice, however, to save the changes to a new file – you may change your mind after a few printings and if the original file is untouched it is easy to return to that earlier version.

Once you organize the output pages, you can have them bound into single volumes or books. Do not forget to produce the covers as well: these could be made of a heavier stock (paper) than the pages inside the book.

Publication

For the private publisher, publication may be as simple as giving out copies of your book to your friends or interested parties. If you hold a party to celebrate publication, it may be useful to have a few big prints of your pictures on display.

Having your book published

Despite the growth of the World Wide Web, book publishing is still very active and there is a continuing demand for books. In general, books that concentrate on the work of a photographer are rare, and devoted to those who have made a reputation in the gallery or art world or through work for magazines. If you want to show off your work but are relatively unknown, you will probably have to publish the book yourself. Should you present your images in an interesting and relevant context, however, you will greatly increase your chances of finding a publisher.

For instance, you may love taking pictures of dogs. But a book consisting simply of canine mug shots is not likely to excite a publisher. However, a book on dog care illustrated with creatively innovative pictures can, for the right publisher, be a prospect. A book of clouds and sky images may be picturesque but not particularly targeted, while one that illustrates a subject such as the joys of flying, taking in meteorology and aviation navigation, might have that clear focus, and a very specific market, that could appeal to the right publisher.

Permanence: Ink and paper

The two main factors governing the permanence of photographic images are the characteristics of the materials used and the storage conditions. Both of the main components of the materials – the ink that makes up the image and the substrate, or supporting layer – are important.

For the ink to be stable, its colors must be fast and not fade in light or when exposed to the normal range of chemicals in the atmosphere. For the paper to be stable: it should be neutral and "buffered" (able to remain neutral when attacked with a small amount of acidic chemicals); it should not depend on volatile chemicals for its color or physical state; and it should not discolor with exposure to light.

When colors fade, one is likely to fade more rapidly than others, which quickly becomes obvious as a color shift. Black and white materials do not suffer from color shift, so appear more stable. Inks based on pigments (materials that are themselves colored) are more permanent than dyes (dissolved pigments that give color to materials).

The substrate may be a source of impermanence: papers fade or become brittle; the layer of plastic used to cover paper may crack and peel apart, taking the image with it; or the plastic itself may discolor.

The careful design of storage conditions can ensure that even highly unstable images are preserved, but these may not be practical. Ideally, images should be stored in chilled conditions – nearly at freezing point – with low humidity and in total darkness. To ensure the best color stability, exposure to light and chemicals should be kept to a minimum, and storage temperatures and humidity should also be as low as is practical. In normal room conditions, most materials will last several years, but if you keep pictures in a kitchen or bathroom, you can expect the life expectancy of your prints to be much reduced.

Faded print
With half the print shielded, the exposed half faded after only one week's constant exposure to bright sunlight. Since some colors are more fast, or resistant to fading, than others, there will be a color shift in addition to an overall loss of density.

Archival storage

Digital photographers have two strategies for the archival storage of images. The first is to store images in the form of prints in the best possible conditions – specifically, in total darkness, low humidity, chilled (to temperatures close to freezing point) with slow air circulation in archivally safe containers. These containers – boxes made from museum board – should emit no chemicals or radiation, be pH neutral (neither acidic nor alkaline), and, preferably, incorporate a buffer (a substance that helps maintain chemical neutrality). These conditions are ideal for any silver-based or gelatin-based film or print.

The alternative strategy is to store images as computer files in archivally safe media. The current preferred option is the MO (magneto-optical) disk, but nobody really knows how long they will last. Next down are media such as CDs or DVDs, which are, in turn, more durable than magnetic media such as tapes or hard-disks. But you can never be sure: a fungus found in hot, humid conditions has developed a taste for CDs, rendering them useless.

Poster-sized printing

It can be a thrill to see your images enlarged to poster size. The subject of the poster does not have to be unusual – sometimes the simplest image is the most effective – and the digital file from which it is output may not even need to be of the highest resolution. This is because large prints tend to be viewed from a distance, in which case finely rendered detail is not necessarily an issue.

Preparing a print

There are two main approaches to outputting prints larger than A3, the maximum that can be comfortably printed on a desktop printer. The first is the simplest: you use an oversized ink-jet printer. These range from freestanding machines somewhat larger than desktop printers to monsters capable of printing on the entire side of a bus. These are far too expensive for the average digital photographer to own, so you need to take your file to a bureau. Before you prepare your file, ask the bureau for its preferred format (usually RGB TIFF uncompressed) and which type of media it accepts – all will take a CD-ROM and most will accept Zips as well as MO (magneto-optical) disks. You also need to check the resolution the bureau prefers, and you should adjust the file to the output size you require (although some bureaus do that for you).

There are different printers that produce prints appropriate to different markets. The Iris printer, for example, produces the very highest quality on a variety of papers for art and fine-art exhibition purposes. Ink-jet printers, manufactured by, for example, Hewlett-Packard or Epson, generally produce good-quality prints intended for commercial display and trade exhibitions.

The other approach is a hybrid one, based on the digital manipulation of true photographic materials. Your file is used to control a laser that exposes a roll of photographic paper. This is then processed in normal color-processing chemicals to produce a photographic print. Many offline printing services use the same method to produce small photographic prints from digital image files. The results can be extremely effective and look very much like traditional photographic images from start to finish. Another advantage to this method is that relatively small image files can produce excellent results – 20 MB of detail may be sufficient for a print of A2 size. A variant of the hybrid approach is to use the digital file to create a color negative, which is then processed and used to make large color prints. This method is the preferred route if you wish to make many copies of the same image.

Tiling a printout

One way to make prints larger than your printer can print is to output the image in sections, or tiles, which you then put together. This is straightforward in a desktop publishing application such as QuarkXPress: you simply create a large document size, set up the page for the available paper dimensions, and tell the software to print out each section on the paper supplied. You can then trim the prints to remove the overlaps and butt the joins together to produce a seamless, large-size image. For those occasions when economy is important and critical image quality is not required, tiling is worth considering.

Tiling option
Modern printers work with great precision and consistency, so it is possible to combine tiles almost seamlessly. Use heavier-weight papers, plastic, or filmlike material to help retain shape. Then the overlaps need be only sufficient to allow you to trim off the excess and butt up the images together before fixing.

How the internet works

The most extensive and wide-ranging part of the wave of digital technologies that has changed the lives of many people on this planet is the internet and its associated resource – the World Wide Web.

The internet

The important part of the word internet is "net": in essence, it is an intricate network of computers that are all connected to each other on a global scale via the international telephone system. Some computers, known as servers, control the traffic and manage the flow of information between individual computers, like the one sitting on your desk, which are known as clients. Servers are run by a wide range of organizations – from national bodies to universities and research centers, as well as Internet Service Providers (ISPs). Most members of the public connect to the internet through their ISP's server computers, whereas students or research staff might connect through their institutions' servers. Whichever route is taken, the method is the same: when you try to enter the system, or log on, the server checks your identity and password before providing you with a connection. If you pass, the server then looks at the address you have requested and determines how best to connect you, often by linking up with another server.

Whenever you send or receive an email, you are also using the internet – exploiting the connections between servers, which try to find the best route for the email's journey.

The World Wide Web

In short, the internet consists mostly of computer hardware components and of the myriad network connections between them. Now, the World Wide Web consists of essentially the information that is stored on the internet, which is organized and arranged in a form that you can see on screen when you use an internet browser, such as Opera, Navigator, or Explorer. From one Web site you can visit many others, and since most Web sites are linked to at least one other, in theory it may be possible to visit all Web sites just by following links through other sites. The Web is, therefore, effectively one huge, global book – often referred to as a hypertext document – in which millions and millions of pages are linked so that you can view them in any order you choose. Another analogy is to regard the Web as a vast library that is always open, allowing you to access its documents at any time. However, just like in some libraries, certain parts of the Web may have restricted access – in order to obtain its specialist and potentially valuable information you must be a subscriber who has the necessary password that allows you to enter the restricted area.

Connecting to the internet

This is the sequence of events that occurs when you visit a Web site. Your computer first launches your browser application and, if you are connecting from home, dials up your Internet Service Provider (or, if you are on an organization's network, it checks in to the network's server). When a connection is made, security checks are conducted against your user name (to make sure you are

What is a modem?

The most common way to connect a computer to the telephone system is through a modem, or MOdulator-DEModulator. It is a device that converts computer signals into a series noises that can be transmitted by a telephone. Equally, it translates the sequence of noises – chirps, whistles, and so on – into electrical signals that can be used by the computer. The reliance on sounds severely limits the rate at which data can be transmitted. This technology is rapidly being superseded by digital methods, such as ISDN and ADSL.

known to the organization or ISP), and then your request to visit a Web site, given by the URL or address, such as www.dk.com, is taken up. The server searches its registers or database or sends a request to another server to find the location of the Web site, and then connects with the server on which the Web site is hosted. (A Web site is hosted on a particular server when its files are stored on that server's computers.) Once your server has made a connection with the Web site's server, it requests the pages you ask for. The Web site's server then sends the required files down: you receive them when they are passed on from your ISP's or organization's server – this is how the server can control your access to particular sites and monitor your activities on the Web. As your browser application receives the files – the words, images, sounds, or animations – it builds the pages up, one component at a time.

When you click on a feature on the page – for example, to go to another part of the site – you are sending a message saying you want more files to be downloaded. This message goes to your server, which passes it on to the Web site's server, which responds by locating the necessary files, and then sends them on to you. If hundreds of people around the world are visiting the same site, they may all need the same files at about the same time. Servers for popular sites can be kept busy responding to thousands of requests a minute – and do not forget, the server may also host other Web sites.

How Web browsers work

While the exact workings of the internet and the workings of vast store of information and sheer data of the World Wide Web may not be of importance to the typical internet surfer, understanding the browser software can be useful. First, how do browsers work? Internet browsers, such as Netscape Navigator and Microsoft Internet Explorer, are essentially interpreters of a computer language called HTML or Hypertext Markup Language. Marking-up is the process of turning simple text documents into formatted text with underlinings, bold lettering, and so on. HTML

also tells the browsers where to place any graphic elements and pictures. In short, browsers are similar to any word-processing application that takes a stream of data and converts it into text with headings, bold letters, and other elaborations.

To make efficient use of browsers, you need to apply the usual rules:
- Avoid having other software applications running at the same time.
- Give the browser plenty of memory.
- Whenever possible, use keyboard shortcuts to access the browser's functions and become familiar with the key-plus-mouse combinations for much-used functions such as going back, downloading text, and so on.
- If you can, turn off unnecessary computer features, such as animations of logos.
- Browsers are easily available – some are free and some are part of an ISP's service. But remember to keep your browser software up-to-date – although earlier versions will work fine, they may not support the latest features, such as virtual reality, complicated formatting, or animated elements.

What are cookies?

You may not realize it but your browser may be storing a great deal of information about the sites you visit. One place to keep this information is in the historical record of the pages you looked at, kept in the History section of a browser. Another place is the folder in which "cookies" are kept.

Cookies are small text files sent to you by a Web site – they can record facts based on information that you yourself provided – such as your name and contact details – and your actions on the site. When you next visit the site, cookies are sent back to the Web site, which can then identify you – your preferred page, perhaps, security details, when you last visited, and so on. If you do not like telling a Web site so much about yourself, you can set your browser to refuse to accept cookies or, better, to ask you before any cookies are accepted. For many purposes, such as internet banking and e-commerce, you need cookies or the site's security systems will not recognize you.

Pictures on the Web

As a producer of pages for the Web, your goal should be to create lively, dynamic, and interesting material as the means of engaging a wider audience. To do this, everything reaching the screen should do so quickly and smoothly. When working with images, the main problem is how small you can make image files, to minimize download times, while ensuring image quality is up to scratch.

Fortunately, the practice is to cater to people with small monitors and less capable computers. The assumption is a screen size of not larger than 15 in (38 cm) – usually measured on the diagonal – which, allowing for the browser, means that full-size images are at best not larger than about 640 x 480 pixels in size. The other control that reduces the size of the image is file compression – a way of coding the information so that it takes up less room than it would otherwise. You can do this in two ways: you can sacrifice some information in the search for the tiniest file (lossy compression, which gives the highest compression); or you sacrifice no information and put up instead with a somewhat larger file (lossless compression).

For internet use, the two most widely used formats are JPEG and GIF. Both formats use lossy compression (*see pp. 222–3*). JPEG is generally best for photographic images in which there is a good deal of fine detail, gradual tonal transitions with few areas of even color, and a rich variety of color. GIF, as its name, Graphic Interchange Format, suggests, is designed for graphics: large

areas of even tone and color with few fine details and a limited palette of colors. The PNG formats can be also used but are not supported by all Web browsers: PNG is better than GIF for the same, graphic, images.

Preparation
There are three main steps in preparing images for use on Web pages or sending via the internet: evaluation, resizing, and conversion (*see p. 351*).

Evaluation Assess the image quality and content. If it is photographic, you can convert it to JPEG; if it is a graphic, with few subtle color gradations, you can convert to GIF. Also check brightness and color – adjust both so that the image will be an acceptable compromise when viewed on both Apple Mac and Windows monitors: the higher monitor gamma (2.2) of Windows and domestic television screens delivers a significantly darker image than Apple monitors (gamma of 1.8).

Resizing Change the size of copies (not original files) of the images to the viewing size intended, so that the size of files is no larger than is needed for the screen layout. Images may be tiny, perhaps 10 x 10 pixels (for use as buttons), or large, perhaps 360 x 240 pixels (to show off your work). Images to be used as backgrounds do not have to be large, as the browser will repeat a small tile until it fills the screen. In assessing how large the

Optimizing your pictures on the internet

You will want Web surfers who access your site to receive your images quickly on their screens and to have the best experience of your images the system permits. Here are some hints for optimizing your images on the internet:

● Use Progressive JPEG if you can. This presents a low-resolution image first and gradually improves it as the file is downloaded. The idea is that it gives the viewer something to watch while waiting for the full-resolution image to appear.

● Use the WIDTH and HEIGHT attributes to force a small image to be shown on screen at a larger size than the actual image size.

● Use lower resolution color – for example, indexed-color files are much smaller than full-color equivalents. An indexed-color file uses only a limited palette of colors (typically 256 colors or fewer), and you would be surprised how acceptable many images look when they are reproduced even with only 60 or so colors (*see p. 271*).

Original

JPEG compression

JPEG compression

With minimum JPEG compression you get maximum quality. In fact, at the highest magnification it is very hard to see any loss in detail but at the magnification shown here you can make out, with careful examination, a very slight smoothing of detail in the right-hand image compared with the original on the left. The cost, of course, is that the file is compressed from nearly 7 MB to about half the size, 3.7 MB.

Original

Minimum quality

Quality setting

At the minimum quality setting, the file size is pared down to an impressive 100 K from 7 MB – just 2 percent of the original size, a reduction of nearly 50 times – and the download time has dropped to an acceptable 16 seconds. The loss of image quality is more evident: notice how the grain in the original (*far left*) has been smoothed out and the girl's arm is altered, with slightly exaggerated borders. But when it is used at its normal size on screen, it is a perfectly acceptable image.

Original

Medium quality

Medium quality

With a medium-quality setting, here showing a different part of the same image, there is a substantial and useful reduction in file size – from nearly 7 MB to just 265 K – some 20 times smaller, or 5 percent of the original file size. The download time is accordingly reduced from over 15 minutes to 50 seconds. This latter figure is still uncomfortably long and the image quality is arguable better than needed for viewing on screen, while being just adequate for printing at postcard size.

Pictures on the Web continued

image should be, keep in mind that the larger the image, the longer it takes to download.

Conversion Convert images to the correct Web format: image files should be JPEG or GIF, possibly PNG, but not TIFF. In the process, you will be faced with the choice of image compression ratios. For most purposes, it is best to set a compression slightly greater than you would like (the image is degraded just a little more than you would wish). Chances are that visitors to your site will not know your images and will tolerate a slight loss of detail. But they will appreciate not having to wait long for your images to appear. Part of image conversion is to ensure that image files are correctly named, with their appropriate suffix.

On-line printing

If you have only the occasional need to print or to make a poster-sized print (see p. 357), you can always consider using an on-line printing facility. To take advantage of this, you simply send your image file or mail your film to an internet-based service, together with your credit card details to cover the processing and handling costs. Most of these services allow you to set up your own album or folder in which to keep your images, saving you from having to resend images if you need a repeat printing. Since new services are always being added, and some others may go out of business, it is probably best to use a service that is based in your own country.

Original

GIF 256 colors

GIF 256 colors
This image shows that even when you restrict what looks like a scene with many colors to just 256 colors, you can obtain a very passable reproduction (p. 271). The view shows an enlarged portion of the image – very little quality loss is visible. The file size is about a quarter smaller than the original (far left) – 840 K instead of 3.4 MB.

GIF color table
The colors used to reproduce the image are displayed in this table (left) – also known as a color look-up table. Here, colors are displayed in order of popularity – the color most used is a near-black, followed by four pale blues, and so on.

PNG color table
The color look-up table for PNG (right) shows all the colors that can be reliably reproduced across the Web. Only 136 of the 256 colors available were actually used for the image.

Original

GIF 32 colors

GIF 32 colors

Even when using a mere 32 colors to create the image (*near left*), quality loss is not that apparent, apart from an increase in graininess in the sky. Note that the file size is some 10 percent smaller than the original (*far left*) – a level of compression not equal to that of a JPEG file at the medium-quality setting, yet giving inferior image quality.

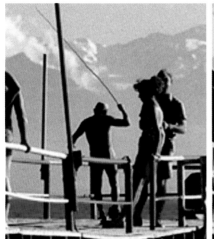

Original

GIF 4 colors

GIF 4 colors

By setting the GIF to use only four colors, a graphic image results (*near left*). This is a useful way of creating posterized effects – an effect in which the colors used to reproduce an image are drastically reduced in number.

Original

PNG version

PNG version

The PNG format set to use Web-safe colors – those that can be reliably reproduced, regardless of browser software – produces inferior results (*near left*). The sky is mottled yet the file size is only reduced to a quarter of the original (*far left*).

Getting started

With the vast quantity of information available it is relatively easy to find out all you need to know about all the many aspects of digital photography: there are videos that guide you step-by-step, CD-ROMs with interactive lessons, and, of course, there are numerous books, some of which you will find listed in Further Reading (*see pp. 398–9*). There are also many sources of information on the internet – although these may vary in both quality and depth, most of them should at least be up-to-date. The best way to learn from these sources is usually to have a specific task to complete: having a clear direction in mind often greatly speeds up your learning, rather than just picking up on unrelated snippets of information.

Another option to help you get started is to attend a course. Many are available, but the best courses for most people are those that offer intensive or on-campus study. These are often run as summer schools in which you immerse yourself in a completely "digital" environment. Such courses will enable you to concentrate on problem-solving, and being able to ask for help from experts at the immediate time that you need clarification can greatly accelerate the learning process. However, if you do not have the equipment to continue at the same level once you return home, you may quickly forget all you have learned. To make the most of immersion teaching, you need to continue using your newly acquired skills. To check if an intensive or residential course is suitable for you, ask these questions when you speak to the administrator or when you read through the prospectus:

● Does the tuition include all materials, such as ink-jet paper and removable media?
● Will there be printed information to take home and keep?
● Which software will be taught?
● Which computer platform will be used?
● Do students have individual computers to work on or will you have to share?
● What standard is expected at the start; what standard is to be attained by the end?
● What are the qualifications of tutors?

You will gain most from any course if you first thoroughly prepare yourself. Having a project or two in mind to work on prevents your mind going blank when you are asked what you would like to achieve. And take along some image files or a scrapbook of pictures to use or to scan in. The best way to learn how to use computer software is to have a real task to complete – this might be a poster for a community event in which you are involved in, making a greeting card, or producing a brochure for a company.

Courses and degrees

If you want more in-depth training and a broader educational approach to the subject of digital photography and image manipulation, then some type of higher or further education courses at a

Enrolling in a course

To help ensure that you enroll in the course of your choice, consider the following points:
● Plan ahead: most courses accept applications and conduct interviews only at certain times of the year.
● Prepare a portfolio (*see p. 369*).
● Read up: if the course contains elements you are not familiar with, such as art history, media theory, and so on, check that you are interested in them before applying. Furthermore, if you know what the course objectives are, you will then know that what you want to do is in line with what the institution wants to achieve. This is important for you – and it is likely to impress the interviewer.
● Check on any entrance requirements: some institutions will require that you have met certain educational requirements before you are considered. You may need to attend a refresher course or complete certain prerequisites before starting the course.
● Plan your finances: attending a course affects your ability to earn and can itself be a financial drain. Calculate the cost of tuition, then add the materials, equipment, and travel costs to your living expenses to determine how much you need to put aside.

Getting started continued

college may be a good idea. It is also a good place to meet other like-minded individuals – over a period of a few years you can make lasting friends and valuable contacts – such a course of study also makes it far easier to share interests and solve problems.

In some countries you may need a degree to obtain a license to work professionally – in which case completing a formal course is a necessity. In the English-speaking world, qualifications are seldom a prerequisite for professional practice unless you wish, for example, to teach digital photography in college. Indeed, formal qualifications may even be discouraged in some sectors of practice. Don't be afraid to ask local professionals for their advice – most will remember their own initial struggles and will be prepared to help others.

If undertaking a college-based course is not possible, then you may want to consider some type of correspondence course. In these, you communicate with your instructor by mail or, more likely today, email, working with printed materials or from a website. Correspondence courses enable you to be flexible about your rate of progress and when you work, but it can be a lonely process: you may have no contact with fellow students or teaching staff beyond brief summer seminars.

Multiskilling

Digital photography is just one expression of an enormous growth in employment and career opportunities based on new technologies that has taken place over the last few years. One important feature of these recent developments is that the need to have multiple skills makes it relatively easy for competent digital photographers to transfer to print publication, or for people talented in the field of, for example, page design, to transfer their skills to internet-based work.

Careers in digital photography

Working as a digital photographer does not limit you to the glamorous areas of fashion, advertising, photojournalism, or celebrity portraiture. Many varied and satisfying ways of doing what you

enjoy and earning a living are available.

Those, for example, who have some sort of special interest – archaeology, perhaps, or architecture, music, and animals – may find work with institutions relevant to their interests, such as museums, heritage preservation organizations, humane societies, and so on. In such an environment, a likely job description will require not only photographic skills, but also an enthusiasm for and knowledge of the subject. Other career opportunities could take you in the direction of becoming an in-house photographer for specialized magazines – those covering an industry or particular sport, such as sailing, fishing, or biking. If you like working with animals, you might want to consider offering a photographic service to pet owners by taking their animals' portraits in an inventive and creative way (*see pp. 184–6*).

Those who enjoy photography may also find work in the background to other activities – for example, as technicians in laboratories, manufacturers, or universities. This type of work often has the advantage of letting you do the things you enjoy – perhaps scanning and then the digital manipulation of pictures – without the stresses associated with working as an independent professional photographer. At the same time, you may enjoy access to the type of equipment that only large organizations can afford – astronomical telescopes or electron microscopes, for example.

Another burgeoning area of photographic interest is in the field of scientific and medical imaging. This ranges from remote satellites sensing to unraveling the secrets of the atom. The work is highly technical but could perfectly suit those with physics or medical degrees who have an interest in both digital photography and aspects of computer technology.

Those with the requisite depth of knowledge and industry experience can also find a welcome in teaching and training institutions: it is widely recognized in many countries that high-technology industries and service providers are being held back by a skills shortage. If you are an experienced photographer or a designer who has developed a

professional grasp of key applications – including Adobe Photoshop, Quark XPress (for designing pages), web-authoring software such as Macromedia Flash, Dreamweaver, or Adobe GoLive, or vector-based graphics software such as Adobe Illustrator or Macromedia FreeHand – then there are many opportunities for training the thousands of people who need to learn how to use these computer programs.

Finally, the digital photographer is but a step away from working with time-based media, such as animations, video, and web-based animations. In fact, Photoshop was originally invented to clean up images for the film industry, and today the distinction between software for stills images and software for moving images is becoming increasingly blurred, especially with the internet carrying more and more moving imagery.

Another dimension of time-based media is multimedia production, whether for computer games, websites, or educational presentations. All of these career applications have an enormous appetite for well-taken pictures that display a careful judgment of tonality and color.

Career advice

The key requirement for a career in digital photography today is versatility: having a wide range of skills covering diverse fields and the willingness to apply them to different and sometimes untried ends. You need to be competent in photography – to understand lighting, exposure, composition, and the nature of the recording medium. You need to be comfortable with computers, to work with varying pieces of hardware to get the most out of them: the more extensive your technical experience the easier it will be to solve production problems. And you need an understanding of how images work in contemporary society and the wider cultural context in which they operate. A base in visual and contemporary culture with an awareness of art history are great assets.

Needless to say, you have to be competent with software. This means more than being able to use standard software; you have to be able to obtain the results you want effortlessly and rapidly so that your thinking and creative processes are not hampered by imperfect knowledge or lack of experience. All professional imaging artists use only a fraction of the capabilities of their software – just as photographers use a very limited range of films and equipment – but their command of what they use is so fluent that the software becomes almost an extension of their thinking. Much of today's professional work is the creation of a visual solution to a conceptual or communication problem, so it helps to understand how to translate abstract concepts into an attractive, eye-catching image.

And because operating professionally means working successfully in a commercial environment, you need some business sense, or at least access to good advice, as well as a desire to act professionally – to commit yourself to working to the highest standards, to work honestly, and to take your commitments, such as meeting deadlines, seriously.

Digital photographers may, therefore, have graphics, illustration, design, or photography backgrounds. While the list of skills may seem demanding, the good news is that the need is growing much faster than supply. Anybody who offers technical skills combined with artistry, creativity, and business acumen will be kept busy.

Turning professional

Having the right attitude and doing your homework are essential if you are thinking of turning professional. Here is a basic checklist of points to consider before taking the plunge:

● Be positive, decide what you really want to do , and decide that you are going to do it.

● Be prepared to start small, with work you may not want to do long-term, to gain experience, build confidence, and provide the capital reserves to take you in the direction you really want to go.

● Check out the competition – you want to be a portrait photographer and there are already two other others in your area.

● Decide in advance what to charge for particular types of work – it is embarrassing to be asked

Getting started continued

"How much will it cost?" when you cannot give a quick answer.

● Consider a loan to finance your start-up: this means preparing a business plan (*see below*).

● Check any legal and local regulations: are you allowed to operate a business on your property; do you have to insure against third-party claims?

● Check your supply lines: can you get materials quickly or rent equipment if you need something more specialized than you already own?

● Raise your profile: make sure local newspapers and magazines know you are in business.

● Prepare a portfolio (*see opposite*) – potential clients will want to see what you can do – and other advertising, such as a website or posters for your local library and meeting places.

● Consider joining a professional organization or your local Chamber of Commerce to network with others.

Preparing a business plan

A business plan makes you consider whether you have a viable prospect. It makes you think about what you want to do and if you have the means to do it, in terms of money and management skills. Just as important, a business plan demonstrates to your bank manager or accountant that you should be taken seriously. It is no exaggeration to say that merely possessing a well-presented, clearly articulated business plan takes you halfway to acquiring the financing your business might need.

The business plan is a report: it summarizes your goals and objectives while honestly presenting your strengths and weaknesses. It should assess the competition and market to arrive at an honest appraisal of your chances of success. The plan also presents a cashflow forecast of how your business will develop over the first two years or so.

A typical cashflow will show that in the early months more money will be spent than income is earned. As the business becomes established, income increases while overhead (rent, heating, utilities) remain steady: your business is starting to make money. But at predictable times during the year – when insurance need renewing, per-

haps – there will be heavy costs, and these might coincide with times when business is slow. By figuring this out, you know when to expect a few tricky months and can warn the bank in advance. This confirms your financial competence and makes it easier to obtain short-term loans or an extended overdraft. The cashflow will also show when an injection of extra cash may be needed to take on more people or invest in new equipment.

All banks give advice or literature on writing a business plan and constructing cashflow forecasts. These may be alien concepts, but you should keep in mind that they are essentially works of fiction – they mix a good deal of fact with the potential and the probable. They should not, however, be works of fantasy, which combine the improbable with the potential. Finally, bear in mind that as your work develops it may move away from the projected business plan. But with it written, at least you know you are changing direction. A business plan is a map – drawn by you – by which you can plot your future.

Keeping records

Good records are essential for a well-run business, minimizing the time involved in completing tax returns, dealing with the bank, or setting prices for particular types of work. Get into the habit of keeping all your receipts. Try to make a brief note of the phone calls you make and receive, and keep a log of projects you work on. In addition, keep a note on everything you are paid. Good records keep you on the right side of the tax inspector. They also put you in a good position if you are ever involved in litigation – you can refer to your notes and give times and dates on what was discussed and agreed upon. Good records will also lower your accountancy costs. Accurate financial records enable you to regulate your cashflow and the resulting soundness of your financial affairs will also lower bank and other finance charges.

Creating a portfolio

A portfolio is a selection of your best work brought together to show to a potential client or employer. "Selection" means be selective – only show the type of material that maximizes your chances of getting the work. "Best" obviously means that you select only from the work you are confident in, pleased with, and wish to be known for. And when you present your portfolio it should be part of a carefully thought-out process. Consider everything – from the way you dress to the words you use, the way you mount your prints to the style of your business cards – so that you make exactly the right impression.

When you create and present your portfolio, bear in mind the following points:
● Show the kind of work that you want to be commissioned to photograph: don't show a range of portraits if you want to shoot gardens.
● Show work that is appropriate: if you know the client is interested in seeing fashion shots, show off your portraiture. A lack of fashion shots in your portfolio may not be too much of a disadvantage – but certainly don't show interiors.

● Show enough to make it clear you are talented and capable, but no more: showing too many images may demonstrate a lack of confidence and poor judgment.
● Talk about your images or explain the thinking behind them only as much as you are invited to: talking too much about your work could, again, suggest a lack of confidence.
● Allow the people reviewing your work to look through it at their own pace. Most professionals sort pictures very rapidly – pausing for perhaps barely a second on each image. This can be very disconcerting if you are not used to it.
● Dress appropriately. If your client is in media you may generally dress more informally than when meeting a financial or corporate client. Awareness of dress codes is not about conformity; it is about understanding the needs of clients.
● Be polite. You may be rejected today, but you may want to return another day or approach a different part of the company.
● Leave contact information – preferably a good-quality picture or print, or at least a business card.

Methods of presentation

Unmounted prints
This is the cheapest method but can be recommended only for very informal presentations. Prints easily become damaged when they are handled.

Mounted prints
Still relatively inexpensive, but prints do receive some protection. They may need to be mounted on window-matts (cards with window apertures to reveal the image) for best protection. Being bulky and heavy, oversized mounts (larger than 11 x 17 in) are not popular with commissioners. Generally, it is best to mount prints singly rather than in groups.

Mounted color transparencies
Inexpensive and you can show many images at once, but you may need a lightbox and magnifier. You could load a selection of transparencies in a slide carousel if you know the client has a projector. This is very convenient and popular in some countries.

Large-format transparencies
This is costly but most impressive: the system makes even small-sized original transparencies look good. Robust but can be heavy, and easy to view even without a lightbox, this is a favorite method of presentation in advertising and commercial photography.

CD-ROM
A very cheap and reliable medium if you have the right equipment. It allows you to show your images in the best light and is excellent for distribution as it is easily posted. The assumption is, however, that the recipient has a CD-ROM player in the computer.

Website
Very inexpensive and relatively easy to set up (*see pp. 358–61*). Allows anyone 24-hour access anywhere in the world to view your pictures. It assumes that clients have internet access and are sufficiently interested in your work to look for your site.

Building up your business

Your goal as a photographer is to provide a service for potential clients: in short, people will offer you work if you give them what they want. To that end, you need to bring all your photographic skill, inventiveness, flexibility, and professionalism to bear on the task, as well as honesty and as much charm as you can muster under what will sometimes be very trying circumstances. The qualities that help you attract business in the first place are the same ones that help you retain and build up your client base.

Promotion and marketing

One of the keys to building a successful business is good communication. To start with, clients must be able to find you, and to find you they must first know about you. This is the task of promotion and marketing. Start small – perhaps by placing advertisements locally in community newspapers and magazines, cards or posters in store windows or library noticeboards, even distributing leaflets to homes and businesses in your neighbourhood. Visit local businesses and leave contact details – preferably a promotional card featuring a picture of yours. If there is any interest, be prepared to show your portfolio (*see p. 369*): pay particular attention to businesses that are likely to be visually more aware, such as architects, real estate brokers, interior designers, landscape architects, and, of course, local publications. Remember, there is no shame in starting by visiting homes to take pictures of babies before making your move on the competitive world of celebrity portraits; hone your skills on interiors of homes for sale or flower arrangements before tackling a multinational's annual report. And the web is an increasingly important place for self-promotion, and a natural choice for the digital photographer. A web presence has to be supported by targeted marketing, however, such as mailings of your photographic calling card or sending out CD-ROMs of work.

Once you have made contact with potential clients, you then need to enter into discussions with them to help bring about a successful conclusion to the exercise.

What is a contract?

A contract creates legal relations between two parties in which one offers to complete some work or service and the other party accepts an obligation or liability to pay for that work or service. The contract may not have to be a formal legal document: an exchange of letters, even a conversation, may be sufficient to form a contract and, with it, corresponding legal obligations (depending on local law: ask your lawyer if you are not sure). However, in general, both parties must want to enter into a relationship. This may carry with it conditions that both sides agree to. In addition, a contract is generally legally binding only if it is possible to carry it out, is not illegal, and is not frustrated by circumstances beyond the control of either party. Many photographers do not realize that when they are commissioned to complete work to a particular specification, they are legally bound to do so: artistic license and freedom of expression do not come into the debate. By the same token, if a client commissions a photographer to take 10 portraits, to ask in addition for shots of the building is to vary the contract. It is reasonable for other terms, such as payment, to be renegotiated. An important issue is who retains copyright on a commission: in some countries, national law allows copyright to be assigned from the creator to the commissioner, but in other countries copyright is held to be an inalienable right of the artist and cannot be assigned to anybody else.

Clarity

Be specific (not "as soon as possible," but "within five working days"); be precise (not "color film," but "Ektachrome ESW 100, 120 format"); be honest (not "of course I can do it" when you don't really know, but "I'll shoot a free test and you can see how it works.").

Honesty

Evaluate your skills objectively. You can take risks and push yourself, but don't let others down – in the end you only damage yourself. If you don't like something – perhaps an element of the com-

mission is dangerous or unethical – then say so (and the sooner the better).

Repetition

Summarize the conclusions after any discussion has taken place; summarize and agree on the action points; repeat and agree on the schedule with everybody concerned; and repeat and agree on all task allocations and responsibilities.

Follow-up

Construct a paper trail with a written or emailed note after all meetings. Record phone conversations pertinent to a commission, particularly if detailed changes are being discussed. Keep records of what you do, why you're doing it, and how much it is costing you. If, right from the beginning, you make a habit of keeping good records, even with small jobs, you will be able to cope better with the larger ones.

Legality

Introduce into the discussion anything to do with copyright, licensing, or other legal aspects of the commission that may concern you as soon as they become relevant. Doing this will add to, rather than detract from, the air of professionalism you project. And more often than not, the client will be pleased to know about any possible legal complications at the earliest possible point.

Finances

Talk about money – fees, day rates, equipment rental charges, and any associated charges that will affect the final bill – early on. You will not seem greedy by doing this; you will look more professional. And if you don't think the money is right, then say so. If the finances are going to be a sticking point, then the sooner you know about it the better.

Repeat business

Clients will appreciate any sign of your involvement in the project over and above that engendered by the fee. For example, suggesting new approaches to the task, offering additional shots that were not specified, or trying out different angles or a more interesting and creative approach all represent "added value" from the client's point of view while, in fact, costing you very little.

Calculating your day rate

The basic day rate is your benchmark for survival: it measures the average cashflow (*see p. 369*) you need to keep going. After all, the fees you charge must at least pay for your survival. If you hit the rate, you can survive, but your profits will be minimal.

The first step is to add up your living expenses, including your rent or mortgage, the cost of any loans or leasing contracts, utilities and food bills, and business overhead, such as insurance, interest payments, car and travel expenses, and so on. These are the expenses you must meet before you can move into profit. Don't forget to add depreciation of capital items, such as your camera equipment and car: you will need money to pay for their replacement.

The next step is less objective – you need to evaluate how many chargeable days you wish for and can reasonably expect to work in a year. Be realistic, so allow yourself vacations, days off for illness, and other days on which you may not be earning any money but you will still be working – going to meetings, for example, or researching new projects, and taking your portfolio around. A figure of between 100–150 non-chargeable days per annum is not an unreasonable figure.

Now, simply divide the figure for total costs by the number of chargeable days. Many photographers making this calculation arrive at a much higher figure than they expected. To this, of course, must be added your profit element, without which a business cannot grow and improve. An alternative approach, having worked out how much you need a year, is to divide the figure by the day rate you think the local market will bear: that will tell you how many chargeable days you need to work.

Mounting an exhibition

After spending some time taking photographs and accumulating images, the urge to show your work to people beyond your immediate circle of family and friends may start to grow and gnaw at you. The first thing you must do is banish from your mind any doubts that your work is not good enough to show to the wider public. An exhibition is exactly that: you make an exhibit of yourself. People will not laugh, but they may admire. If you have the drive and the ambition, then you should start planning now – you cannot start this process too early.

Turning a dream into reality

You may feel that you are not ready to mount an exhibition just yet. If so, then perhaps you had better start the task of building up a library of suitable images. At some point in the future you will know you have the right material and that the time is right.

Now try to imagine in your mind's eye what the show will look like: visualize how you would light it, how you will position your images for maximum impact, how to sequence photographs to create a particular atmosphere, and create a flow of meaning or narrative. Picture to yourself the size of the prints, how they will glow in the light.

Selling prints

Remember that silver-based prints will continue, for a long time yet, to sell for higher prices than any digital-produced print. Here are some hints for ensuring good, continuing relations with your buyers.

● Don't make unsubstantiated claims about the permanence of printed images.

● Give people advice about how to care for the prints, such as not storing them in humid conditions or where they will be exposed to bright sunlight.

● Never exceed the run when you offer limited-edition prints – produce the specific, guaranteed number, and not one more.

● Print on the best-quality paper you can afford or that recommended by the printer manufacturer.

This will help to focus your mind and guide your energies as well as act as a spur to your picture- or printmaking. Here are some other pointers you might want to consider:

● Choose your venue well in advance, as most of the better-known galleries are under a lot of pressure and have to plan their schedules at least a year in advance. Other galleries may call quarterly or semiannual committee meetings to decide what to show in the coming period. At the other end of the scale, venues such as a local library or a neighborhood community center may be prepared to show work on very short notice. In any event, you will want to give yourself the time necessary for your plans to mature and to give the venue the opportunity to tie something in to the exhibition, such as a concert or lecture (depending on the subject matter of your imagery).

● Choose your venue creatively. Any public space could be a potential exhibition venue – indeed, some seemingly improbable spaces may be more suitable for some types of work than a "proper" gallery. Bear in mind that the very presence of your work will transform the space into a "gallery," whether it is in an office cafeteria, a shopping mall, or a town square.

● Budget with your brains, not your heart. Put on the best show you can afford, not one that costs more than you can afford. The point of an exhibition is to win over a wider audience for your work, not to bankrupt you or to force you to call in financial favors that you might need at some time in the future to further your photographic endeavors.

● Once you have decided on the space you want to use and have received all the necessary permission, produce drawings of the layout of the entire venue. This will also involve you in making little thumbnail sketches of your prints in their correct hanging order: it is easier to visualize the effectiveness of picture order this way.

Timing

Mounting an exhibition requires very careful planning on many different levels if you want your show to look professional, so don't leave any

Drawing up a budget

When budgeting for the costs of an exhibition, take into account not only your direct photographic expenses but also the range of support services. These include the costs of electricians to light your work, picture-framing, public-liability insurance, the building (or hiring) of "flats" to break up the exhibition space and provide extra surfaces on which to hang your work. Here are some cost categories to consider:

● Direct photographic costs – including making prints or slide duplication if projected images form part of your show.

● Indirect photographic costs – including retouching, mounting, frame-making, and the hire of equipment, such as projectors.

● Gallery costs – including venue hire, deposits against damage or breakages, and the hiring of flats or similar.

● Publicity – including the cost of producing and mailing out invitations, advertising in trade or local journals or newspapers, as well as the production of an exhibition catalogue.

● Insurance – budget for the costs of insuring your work, public liability, and damage to the venue.

● And don't forget – no matter what your final budget figure is, there will always be out-of pocket expenses you cannot identify beforehand. At the last minute, for example, you might decide you want flowers for the opening night. So, as a precaution, add a 15 per cent contingency to the final budget figure.

important carpentry, electrical, picture-framing or similar work to, say, a long weekend or vacation period when you might not be able to gain access to key personnel should something go critically wrong. And you should always count on the fact that something will go wrong.

Looking at sponsorship

One way to offset some of the costs of mounting an exhibition is by sponsorship. The key to success is persuading a potential sponsor that the likely benefits from the relationship will flow both ways. It is obvious that you will benefit from the deal by being offered free film, the use of equipment you might not otherwise be able to afford perhaps, or complementary or discounted printmaking, but what do the other parties get?

The best approach to sponsorship involves you persuading potential benefactors that by making equipment or services available to you they will receive some boost to their business or that their public profile will be somehow enhanced by the association. It could be that, for example, sponsoring individuals, companies, or organizations will receive coverage in trade journals or newspapers as a result of their help.

As a rule, it is always easier to obtain services or products than it is cash. Printing materials, exhibition space, scanning, processing, even food and beverages for the opening night are all possible, but cash is unlikely. And remember to make your approach in plenty of time – organizations have budgets to maintain and once sponsorship allocations have been made, often there may be nothing left until the next financial year.

Finally, even if the answer from a potential sponsor is "no," you can still ask for something that may be even more valuable – information. So ask for suggestions about which other companies or organizations might be interested in helping.

An exhibition is your chance to get your work known by a wider audience, so make full use of the opportunity if it arises by telling everybody you know about it, and encouraging them to spread the word to their contacts.

Finally, mounting a photographic exhibition brings together many different people and skills. They are your sponsors just as much as any commercial contributor, so always take the trouble to acknowledge their invaluable help and contributions, for without them your show might never have gotten off the drawing board.

Copyright concerns

Copyright is a fascinating subject, and it is one that, due to the rise of digital media and information technology in particular, is becoming even more pertinent. Different traditions of copyright law in different countries lead to varieties not only in the detail but also in the entire approach to this subject. This renders the area of copyright a potential minefield for the unwary, especially since it is so dependent on national boundaries and international relations.

Rather than attempt to produce the impossible – a brief summary of copyright law and traditions that would be accurate in most places in the world – the following are some frequently asked questions and their answers, which have a wide applicability. However, you should always seek professional advice if you are not sure what your rights are or how you should proceed. But you probably will not need to hire a lawyer, as many professional organizations are willing to provide basic copyright law advice to members of the public who come to them for help. Another source of help is the internet (*see pp. 358–9*).

Do I have to register in order to receive copyright protection?

No, you do not. Copyright in works of art – which includes writing, photographs, and digital images – arises as the work is created. In more than 140 countries in the world, no formal registration is needed to receive basic legal protection.

Can I protect copyright of my images once they are on the web?

Not directly. This is because you cannot control who has access to your website. Make sure you read the small print if you are using free web space. You may be asked to assign copyright to the web server or service provider. Do not proceed if you are not happy with this condition.

Can I be prosecuted for any images I place on the web?

Yes, you can. If your pictures breach local laws – for example, those to do with decency, pornography, or the incitement of religious or racial hatred, or if they feature illegal organizations – and if you live within the jurisdiction of those laws, you may be liable to prosecution. Alternatively, your Internet Service Provider (ISP) may be ordered to remove them.

Do I have to declare that I own copyright by stamping a print or signing a form?

In most countries, no. Copyright protection is not usually subject to any formality, such as registration, deposit, or notice. It helps, however, to assert your ownership of copyright clearly – at least placing "© YOUR NAME" – on the back of a print or discreetly within an image on the web, such as in the lower-right-hand corner.

Is it wrong to scan images from books and magazines?

Technically, yes you are in the wrong. Copying copyright material (images or text) by scanning

Can I prevent my ideas from being stolen?

There is no copyright protection covering ideas to do with picture essays, for example, or magazine features or books. The easiest way to protect your concept is by offering your ideas in strict confidence. That is, your ideas are given to publishers or editors only on the condition that they will not reveal your ideas to any third party without your authorization. Your idea must have the necessary quality of confidentiality – that is, you have not shared the information with more than a few confidants – and the idea is not something that is widely known. The most unambiguous approach to this issue is to require your publisher or the commissioning editor to sign a non-disclosure agreement – a written guarantee. However, this may be an unduly commercial-strength approach. You may preface your discussions with a "this is confidential" statement. If the person does not accept the burden of confidentiality, you should not proceed.

from published sources does place you in breach of copyright law in most countries. However, in many countries you are allowed certain exceptions – for example, if you do it for the purposes of study or research, for the purposes of criticism or review, or to provide copy for the visually impaired. Bear in mind, though, that these exceptions vary greatly from country to country.

What is a watermark?

It is information, such as a copyright notice or your name and address, that is incorporated deep in the data of an image file. The watermark is usually visible but it may be designed to be invisible. In either case, watermarks are designed so that they cannot be removed without destroying the image itself.

If I sell a print, is the buyer allowed to reproduce the image?

No – you have sold only the physical item, which is the print itself. By selling a print, you grant no rights apart from the basic property right of ownership of the piece of paper – and an implied right to display it for the buyer's personal, private enjoyment. The buyer should not copy, alter, publish, exhibit, broadcast, or otherwise make use of that image without your permission.

What are royalty-free images?

These are images that you pay a fee to obtain in the first instance, but then you do not have to pay any extra if you use them – even for commercial purposes. With some companies, however, certain categories of commercial use, such as advertising or packaging, may attract further payments. Royalty-free images usually come on CDs but they may also be downloaded from a website.

How is it possible for images to be issued completely free?

Free images found on the internet can be an inexpensive way for companies to attract you to visit their site. You can then download these images for your own use, but if you wish to make

money from them, you are expected and trusted to make a payment. This fee is usually relatively small, however, so you are encouraged to behave honestly and not exploit the system.

Does somebody own the copyright of an image if that person pays for the film or the equipment rental?

In most countries, the answer is no. In some countries, if you are employed as a photographer then it is your employer who retains copyright in any material you produce; in others, however, it is the photographer who retains the copyright. In any circumstance, the basic position can be overridden by a local contract made between the photographer and the other party prior to the work being undertaken.

If I manipulate someone else's image, so that it is completely changed and is all my own work, do I then own the copyright in the new image?

No. You need to bear in mind that you were infringing on copyright in the first place by making the copy. And then, altering the image is a further breach of copyright. Besides, the new image is not fully your work: arguably, it is derived from the copy. If you then claim authorship, you could be guilty of yet another breach – this time, of a moral right to ownership.

Surely it is all right to copy just a small part of an image – for instance, part of the sky area or some other minor detail?

The copyright laws in most countries allow for "incidental" or "accidental" copying. If you take an insignificant part of an image, perhaps nobody will object, but it is arguable that your action in choosing that particular part of an image renders it significant. If this is accepted, then it could be argued that you are in breach. If it makes no real difference where you obtain a piece of sky, then try to take it from a free source (see p. 394).

Shopping for equipment

Purchasing all the equipment needed for digital photography can be either bewilderingly off-putting or delightfully full of new things to learn. There is undoubtedly a lot to consider, but if you are not lucky enough to have a knowledgeable friend to help, don't worry. There is a great amount of information available out there – much of it free and not all of it dependent on internet access.

Where to look for help

Large retailers are a good starting place in the search for information, as many produce catalogs with basic definitions and helpful advice, in addition to equipment specifications and prices. There are also several magazines on digital photography and, if you have internet access, there is much up-to-date information, technical details, and more-or-less objective reviews. Note, however, that information on the internet may be as biased or as objective as advice given by a friend. And can you be certain that the reviewer has sufficient depth and breadth of knowledge and experience of the equipment under review?

Similar issues apply to specialty magazines: some journalists may be only a little further ahead of you on the learning curve. Added to this, magazines can also come under pressure to find good features in products and to play down evidence of poor performance. Be especially wary of reviewers who never find anything to criticize and give high ratings to all equipment tested.

Buying on-line

Contrary to much of the bad press associated with internet shopping, buying on-line can be a more secure route than ordering by telephone mail-order. It can also be cheaper due to the discounts offered by many retailers to web-based customers. However, there are some sensible precautions you should take:
- Ensure the site promises secure transactions.
- Buy only low-cost items on-line when dealing with an unknown company, or simply to start with, until you are more confident in the system.
- If possible, use a credit card that guarantees against the fraudulent use of your details when shopping on the internet.
- Make sure you take a note of the transaction references or print out a copy of any orders you make on-line.
- Don't leave ordering to the last minute before you need an item – stocking problems or mail delays are always possible.

Buying secondhand

With the rapid turnover of equipment, buying secondhand can be a sound way to save money. It is safest to keep to the well-known brands offering high standards. For cameras, makers such as Canon, Nikon, Leica, and Hasselblad produce consistently sound models. However, this equipment is often used by professionals, so it may have seen heavy-duty use. Makes such as Pentax, Minolta, and Olympus take excellent images, but may not be as popular with professionals.

Rental equipment

Do you ever need expensive equipment but cannot really afford it or would use it only occasionally? You may, for example, need a superlong telephoto lens for a safari trip, a data projector for a talk, a superior-quality scanner, or a replacement computer while yours is under repair. One answer is to rent the items you need – you will save on the purchase price, pay only when the item is really needed, and the rental cost should be fully tax deductible if you are in business. Note the following points:
- Research possible equipment sources and set up account facilities. Some companies will send items if you live far from their warehouse or depot if you are a known customer, while new customers may need to provide a full-value cash deposit.
- Contact the supplier to reserve the item as soon as you think you might need it.
- Try to pick up the item a day or two early so that you can familiarize yourself with it and fully test it.
- Check that your insurance covers any rental items.

With computers, the soundest purchase is undoubtedly Apple Macintosh machines, which are made by a single manufacturer well-known for consistently high component quality (though this is not to say that all "Macs" were great designs). Safe choices for secondhand PC computers would be from the main players, such as IBM, Hewlett-Packard, and Dell.

Shopping for specific interests

The key to shopping for a camera for some specific photographic task is to ensure that the features needed for that particular job are available or well implemented in the camera.

Challenging conditions Camera should be sealed against dust and damp, and have a rugged construction, such as the Kodak DC5000 or DCS series. Any digital camera with an underwater housing may also be suitable.

Collecting Good close-up facilities provided by cameras such as the Nikon Coolpix 990, or an SLR design with a macro lens. For small objects, such as coins, stamps, or medals, a flatbed scanner may be preferable – and much, much cheaper.

Interiors Distortion-free, wide-angle lens: if high quality is needed, use a Kodak 600 series camera or scanning backs providing full-size coverage, such as the Phase One StudioKit.

Nature Very long lens and quiet operation: consider SLR digitals, such as the Canon D30, Fuji S1, Nikon D1, or Olympus E-10.

Low light Fast lens, such as on the Olympus E-10 or an SLR type with a large maximum-aperture lens. Consider models able to correct for the increased "noise" associated with long exposures – Canon D30, Nikon D1X, and Kodak DCS 320.

Portraiture Digital camera with rapid response, such as Olympus 2010 or SLR types such as Kodak DCS series and Nikon D1H. A large-aperture medium telephoto is most useful – 50mm f/1.4 for 35mm format is a very useful equivalent focal length of 75mm and f/1.4 on some SLR digitals.

Sports Rapid response and a long lens: consider an Olympus E-10 or an SLR digital such as a Nikon, Fuji, or Canon. For difficult conditions, an SLR such as the Kodak DCS 300, 500, 600 series with a 70–200 mm zoom. May need a rain- or waterproof cover in addition.

Still-life and studio Synchronization with studio flash essential: ensure that the camera accepts an adaptor to allow direct connection between digital camera and flash unit. Ideal if the camera controls can be set from the computer.

Travel Good-quality SLR-type digital, such as Olympus E-10 or Fuji 4900, plus attachments to extend zoom range. Power pack to enable extended working session, extra memory cards or a laptop to download images.

Underwater Housings available for some Canon Ixus, Olympus, and Nikon models. Underwater flash must be synchronized with camera model.

Shopping checklist

- Shop with somebody knowledgeable, if you are lucky enough to know one.
- Write down the details of your computer model, operating system, and the details of other equipment that needs to work with the item you need.
- If it is second-hand, check that the equipment appears to have been well treated.
- If it is second-hand, enquire about the history of the equipment – what type of person used it, for what purpose, and for how long.
- Check that there is a guarantee period and that it is long enough for any likely faults to appear.
- When buying computer peripherals, make sure they will work with your exact computer model and operating system. You may, nonetheless, still need to test equipment at home with your computer, so if any compatibility problems arise, make sure the store will provide you with free technical support. If these problems prove to be insurmountable, enquire about the store's policy regarding refunds.
- Don't be afraid to ask about anything that may be causing you confusion. You will not look foolish – the only foolish thing is to pay for equipment that later proves useless.

Disabilities

Compared with traditional photography – film-based and with its chemical processes – many of the features found on modern digital equipment make photography more accessible to people with some forms of disability. The reduced need for darkroom or workroom processing, for example, as well as the greater level of automation of equipment, mean that it is easier to produce good-quality, satisfying results. On the whole, however, any advantages disabled photographers may enjoy from using digital equipment have been incidental rather than as a result of the industry taking their needs into account at the design stage.

Accessibility is all about accommodating the characteristics a person cannot change by providing options. For example, a person who has impaired dexterity could control equipment via voice commands. The whole subject of photography for disabled people is a complicated one, but some points can be summarized here (*see also p. 393 for web resources*).

Physical dexterity

Digital cameras could, almost without exception, be designed to make life easier for those with impaired dexterity. In reality, however, buttons are usually tiny, at times two have to be pressed simultaneously, sockets need connectors that are small and have to be aligned precisely if they are to marry up, and so on. The Kodak DC 5000 stands out from other digital cameras for its larger-than-normal controls and its sturdy, chunky design, which makes it easy to grip and manipulate. In addition, the larger SLR digital cameras, such as the Nikon D1 or Kodak DCS range, are in general far easier to handle than compact models. However, on the downside, they are considerably bulkier and heavier.

Some digital cameras allow remote release – the camera can be set up on a rig or support while the release is conveniently located some distance away. While the remote controls are usually very small, it should be possible to adapt them by attaching a large handgrip. Most digital cameras are small and light enough to be easily mounted on a helmet or metal bracket attached to a wheelchair. If so, the mounting should have some type of self-leveling mechanism to keep the camera horizontal even if the chair is tilted by an uneven surface.

On the computer side, some software features voice-activated commands, which help to reduce reliance on the the keyboard. With sufficient programming, this software can be used to perform basic image manipulation as well as produce text for captioning or record-keeping notes. There is a wide range of Windows-based software that offers improved access to computing.

Visual ability

The relatively large LCD screens found on digital cameras may help the visually impaired: the Ricoh RDC-i700 is notable for its unusually large LCD screen with touch-screen controls allowing you to select menu items using a pointer.

Back at home, viewing images on a large-sized monitor offers considerable advantages over the traditional prints from most film processors. Selecting a low resolution – for example, 640 x 480 dpi, on a 17-in (43-cm) screen renders palettes and labels very large and, therefore, far easier to read. Many software applications employ symbols rather than words to indicate options, which can also be an advantage. Software utilities, such as KeyStrokes, are available, which place an easy-to-read keyboard on the monitor screen: mouse clicks on the screen have the effect of typing letters. Keyboards with extra large keys are also available.

Hearing ability

Most digital cameras give feedback on actions and functions with visual confirmation, so people with hearing difficulties will not be affected. However, with digital cameras there is no physical sensation of a traditional shutter release being triggered. It may be important to find a camera that indicates shutter release with some form of visual signal: many do so indirectly, using a light to indicate that an image is being written to disk.

Survival guide

Do not lose sight of the fact that photography is really about taking pictures. The more familiar you are with your equipment, and the more care you take to ensure that nothing is likely to go wrong and therefore distract you, then the more you can put purely technical considerations to one side and concentrate instead on bringing back that winning shot.

Tips for trouble-free photography

Here are some points you might want to consider to help you get the most pleasure from your digital photography:

● Before going away on a trip or out on assignment, test all your equipment before leaving home or the studio. This means checking the entire process – from capture right through to printout. Take some test pictures, download them onto your computer, and check the image at high magnification for any obvious defects. Then resize the images and print them out.

● Include a battery charger with a travel plug adaptor as part of your basic photographic kit. If you know there will be no electricity where you are going, then make sure you take along more than enough spare batteries. For expeditions likely to last more than a month to really remote regions, consider buying a solar-powered battery charger.

● Take as many spare memory cards as you can reasonably afford to buy. Always try to keep at least one memory card safe and empty (but ready and preformatted). However, check it with your camera first – sometimes a camera will take against an individual card for no apparent reason.

● Prepare your equipment carefully against the worst the elements can throw against it. Wrap up everything in double plastic bags if conditions are dusty. Never take your camera from one type of temperature immediately into a radically different one without first sealing it in a case or an airtight bag. If you carry camera equipment from a cool environment, such as an air-conditioned hotel room, into the heat of a tropical afternoon, condensation is almost certain to form on the outer casings as well as on the glass surfaces of lenses and other optical systems. And if you move your equipment the other way – from tropical afternoon temperatures into a cold, air-conditioned room – without giving it a chance to adapt, you could damage it. In hotel rooms, the bathroom is often not air-conditioned. If so, store your camera bag in there. Otherwise, before leaving your room, turn the air-conditioning down to its minimal (warmest) setting.

● Don't let your camera get too hot – never leave it in a car's glove compartment, for example.

● Keep all optical surfaces clean. Blow dust and sand off the lens and eyepiece optics before wiping any marks off. Use the inside surface of a clean double-thickness tissue to clean your lenses and eyepiece: you can breathe carefully on it and wipe off the pure water condensation. Do not scrub at the lens surface as if it were a car window.

● Batteries are more the cause of camera malfunctions than anything else. If your camera will not work, first check that you have installed the batteries the right way around. Clean and check the contacts to make sure the batteries are making good contact (contacts can become distorted if roughly handled). Finally, check that all the batteries are fresh – one old battery in a set of three good ones may give sufficient reason for the camera to complain. If you use rechargeable batteries only, take at least one spare as a precaution. In addition, take a set of alkaline-manganese (non-rechargeable) batteries as a back-up.

● Take a small toolkit. The most useful tool is a jeweler's screwdriver. Many cameras have up to 10 exposed screws, which may come loose. Check regularly and screw them tight if they have come loose. A pair of pliers may help you bend metal parts back into shape if you have an accident. Repairs like this will invalidate any warranties, however, so regard this as a last-resort measure.

● Obtain insurance to cover you against theft, loss in transit, and damage to equipment.

● Take a film-based camera (one that is not totally reliant on batteries) with some rolls of film in case all else fails.

Glossary

24x speed The device in question reads data from a CD-ROM at 24x the basic rate of 150 KB per second. As a guide, modern CD players may reach speeds of 48x or greater.

24-bit A measure of the size or resolution of data that a computer, program, or component works with. A color depth of 24 bits produces millions of different colors.

2D Two-dimensional, as in 2D graphics. Defining a plane or lying on one.

3D Three-dimensional, as in 3D graphics. Defining a solid or volume, or having the appearance of a solid or volume.

35efl 35 mm equivalent focal length. A digital camera's lens focal length expressed as the equivalent focal length for the 35 mm film format.

36-bit A measure of the size or resolution of data that a computer, program, or component works with. In imaging, it equates to allocating 12 bits to each of the R, G, B (red, green, blue) channels. A color depth of 36 bits gives billions of colors.

5,000 The white balance standard for pre-press work. Corresponds to warm, white light.

6,500 The white balance standard corresponding to normal daylight. It appears to be a warm white compared with 9,300.

9,300 The white balance standard close to normal daylight. It is used mainly for visual displays.

A

aberration In optics, a defect in the image caused by a failure of a lens system to form a perfect image.

aberration, chromatic An image defect that shows up as colored fringes when a subject is illuminated by white light, caused by the dispersion of white light as it passes through the glass lens elements.

absolute temperature A measure of thermodynamic state, used to correlate to the color of light. Measured in Kelvins.

absolute colorimetric A method of matching color gamuts that tries to preserve color values as close to the originals as possible.

absorption Partial loss of light during reflection or transmission. Selective absorption of light causes the phenomenon of color.

accelerator A device that speeds up a computer by, for example, providing specialist processors optimized for certain software operations.

accommodation An adjustment in vision to keep objects at different distances sharply in focus.

achromatic color Color that is distinguished by differences in lightness but is devoid of hue, such as black, white, or grays.

ADC Analog-to-Digital Conversion. A process of converting or representing a continuously varying signal into a set of digital values or code.

additive A substance added to another, usually to improve its reactivity or its keeping qualities.

additive color synthesis Combining or blending two or more colored lights in order to simulate or give the sensation of another color.

address Reference or data that locates or identifies the physical or virtual position of a physical or virtual item: for example, memory in RAM; the sector of hard disk on which data is stored; a dot from an ink-jet printer.

addressable The property of a point in space that allows it to be identified and referenced by some device, such as an ink-jet printer.

algorithm A set of rules that defines the repeated application of logical or mathematical operations on an object: for example, compressing a file or applying image filters.

alias A representation, or "stand-in," for the continuous original signal: it is the product of sampling and measuring the signal to convert it into a digital form.

alpha channel A normally unused portion of a file format. It is designed so that changing the value of the alpha channel changes the properties – transparency/opacity, for example – of the rest of the file.

analog An effect, representation, or record that is proportionate to some other physical property or change.

anti-aliasing Smoothing away the stair-stepping, or jagged edge, in an image or in computer typesetting.

aperture The size of the hole in the lens that is letting light through. *See* f/numbers.

apps A commonly used abbreviation for application software.

array An arrangement of image sensors. There are two types. *1* A two-dimensional grid, or wide array, in which rows of sensors are laid side-by-side to cover an area. *2* A one-dimensional or

Glossary continued

linear array, in which a single row of sensors, or set of three rows, is set up, usually to sweep over or scan a flat surface – as in a flatbed scanner. The number of sensors defines the total number of pixels available.

aspect ratio The ratio between width and height (or depth).

attachment A large file that is sent along with an email.

B

back up To make and store second or further copies of computer files to protect against loss, corruption, or damage of the originals.

bandwidth *1* A range of frequencies transmitted, used, or passed by a device, such as a radio, TV channel, satellite, or loudspeaker. *2* The measure of the range of wavelengths transmitted by a filter.

beam splitter An optical component used to divide up rays of light.

bicubic interpolation A type of interpolation in which the value of a new pixel is calculated from the values of its eight near neighbors. It gives superior results to bilinear or nearest-neighbor interpolation, with more contrast to offset the blurring induced by interpolation.

bilinear interpolation A type of interpolation in which the value of a new pixel is calculated from the values of four of its near neighbors: left, right, top, and bottom. It gives results that are less satisfactory than bicubic interpolation, but requires less processing.

bit The fundamental unit of computer information. It has only two possible values – 1 or 0 – representing, for example, on or off, up or down.

bit depth Measure of the amount of information that can be registered by a computer component: hence, it is used as a measure of resolution of such variables as color and density. 1-bit registers two states (1 or 0), representing, for example, white or black; 8-bit can register 256 states.

bit-mapped *1* An image defined by the values given to individual picture elements of an array whose extent is equal to that of the image; the image is the map of the bit-values of the individual elements. *2* An image comprising picture elements whose values are only either 1 or 0: the bit-depth of the image is 1.

black *1* Describing a color whose appearance is

due to the absorption of most or all of the light. *2* Denoting the maximum density of a photograph.

bleed *1* A photograph or line that runs off the page when printed. *2* The spread of ink into the fibers of the support material. This effect causes dot gain.

BMP Bit MaP. A file format that is native to the Windows platform.

bokeh The subjective quality of an out-of-focus image projected by an optical system – usually a photographic lens.

brightness *1* A quality of visual perception that varies with the amount, or intensity, of light that a given element appears to send out, or transmit. *2* The brilliance of a color, related to hue or color saturation – for example, bright pink as opposed to pale pink.

brightness range The difference between the lightness of the brightest part of a subject and the lightness of the darkest part.

browse To look through a collection of, for example, images or Web pages in no particular order or with no strictly defined search routine.

Brush An image-editing tool used to apply effects, such as color, blurring, burn, or dodge, that are limited to the areas the brush is applied to, in imitation of a real brush.

buffer A memory component in an output device, such as printer, CD writer, or digital camera, that stores data temporarily, which it then feeds to the device at a rate the data can be turned into, for example, a printed page.

burning-in *1* A digital image-manipulation technique that mimics the darkroom technique of the same name. *2* A darkroom technique for altering the local contrast and density of a print by giving specific parts extra exposure, while masking off the rest of the print to prevent unwanted exposure in those areas.

byte Unit of digital information: 1 byte = 8 bits. A 32-bit microprocessor, for example, handles four bytes of data at a time.

C

C An abbreviation for cyan. A secondary color made by combining the two primary colors red and blue.

cache The RAM dedicated to keeping data recently

read off a storage device to help speed up the working of a computer.

calibration The process of matching characteristics or behavior of a device to a standard.

camera exposure The total amount of the light reaching (in a conventional camera) the light-sensitive film or (in a digital camera) the sensors. It is determined by the effective aperture of the lens and the duration of the exposure to light.

capacity The quantity of data that can be stored in a device, measured in MB or GB.

cartridge A storage or protective device consisting of a shell (a plastic or metal casing, for example) enclosing the delicate parts (film, ink, or magnetic disk, for example).

catch light A small, localized highlight.

CCD Charge Coupled Device. A semiconductor device used as an image detector.

CD-ROM Compact Disc–Read Only Memory. A storage device for digital files invented originally for music and now one of the most ubiquitous computer storage systems.

characteristic curve A graph showing how the density of a given film and its development relate to exposure.

chroma The color value of a given light source or patch. It is approximately equivalent to the perceived hue of a color.

CIE LAB Commission Internationale de l'Éclairage LAB. A color model in which the color space is spherical. The vertical axis is L for lightness (for achromatic colors) with black at the bottom and white at the top. The a axis runs horizontally, from red (positive values) to green (negative values). At right-angles to this, the b axis runs from yellow (positive values) to blue (negative values).

clipboard An area of memory reserved for holding items temporarily during the editing process.

CLUT Color Look-Up Table. The collection of colors used to define colors in indexed color files. Usually a maximum of 256 colors can be contained.

CMYK Cyan Magenta Yellow Key. The first three are the primary colors of subtractive mixing, which is the principle on which inks rely in order to create a sense of color. A mix of all three as solid primaries produces a dark color close to black, but for good-quality blacks, it is necessary to use a separate black, or key, ink.

codec co(mpression) dec(ompression). A routine or algorithm for compressing and decompressing files, for example, JPEG or MPEG. Image file codecs are usually specific to the format, but video codecs are not tied to a particular video format.

cold colors A subjective term referring to blues and cyans.

color picker The part of an operating system (OS) or application that enables the user to select a color for use – as in painting, for example.

color synthesis Re-creating the original color sensation by combining two or more other colors.

color temperature The measure of color quality of a source of light, expressed in Kelvins.

colorize To add color to a grayscale image without changing the original lightness values.

ColorSync A commercial color-management software system used to help ensure, for example, that the colors seen on the screen match those to be reproduced by a printer.

color *1* Denoting the quality of the visual perception of things seen, characterized by hue, saturation, and lightness. *2* To add color to an image by hand – using dyes, for example – or in an image-manipulation program.

color cast A tint or hint of a color that evenly covers an image.

color gamut The range of colors that can be reproduced by a device or reproduction system. Reliable color reproduction is hampered by differing color gamuts of devices: color film has the largest gamut, computer monitors have less than color film but more than ink-jet printers; the best ink-jet printers have a greater color gamut than four-color CMYK printing.

color management The process of controlling the output of all the devices in a production chain to ensure that the final results are reliable and repeatable.

color sensitivity A measure of the variation in the way in which film responds to light of different wavelengths, particularly in reference to black and white film.

complementary colors Pairs of colors that produce white when added together as lights. For example, the secondary colors – cyan, magenta, and yellow – are complementary to the primary colors – respectively, red, green, and blue.

Glossary continued

compliant A device or software that complies with the specifications or standards set by a corresponding device or software to enable them to work together.

compositing A picture-processing technique that combines one or more images with a basic image. Also known as montaging.

compression *1* A process by which digital files are reduced in size by changing the way the data is coded. *2* A reduction in tonal range.

continuous-tone image A record in dyes, pigment, silver, or other metals in which relatively smooth transitions from low to high densities are represented by varying amounts of the substance used to make up the image.

contrast *1* Of ambient light: the brightness range found in a scene. In other words, the difference between the highest and lowest luminance values. High contrast indicates a large range of subject brightnesses. *2* Of film: the rate at which density builds up with increasing exposure over the mid-portion of the characteristic curve of the film/development combination. *3* Of a light source or quality of light: the difference in brightness between the deepest shadows and the brightest highlights. Directional light gives high-contrast lighting, with hard shadows, while diffuse light gives low-contrast lighting, with soft shadows. *4* Of printing paper: the grade of paper used – for example, high-contrast paper is grade 4 or 5, while grade 1 is low contrast. *5* Of color: colors positioned opposite each other on the color wheel are regarded as contrasting – for example, blue and yellow, green and red.

copyright Rights that subsist in original literary, dramatic, musical, or artistic works to alter, reproduce, publish, or broadcast. Artistic works include photographs – recordings of light or other radiation on any medium on which an image is produced or from which an image may by any means be produced.

CPU Central Processor Unit. The part of the computer that receives instructions, evaluates them according to the software applications, and then issues appropriate instructions to other parts of the computer system. It is often referred to as the "chip" – for example, G4 or Pentium III.

crash The sudden and unexpected nonfunctioning of a computer.

crop *1* To use part of an image for the purpose of, for example, improving composition or fitting an image to the available space or format. *2* To restrict a scan to the required part of an image.

cross-platform Application software, file, or file format that can be used on more than one computer operating system.

curve A graph relating input values to output values for a manipulated image.

cut and paste To remove a selected part of a graphic, image, or section of text from a file and store it temporarily in a clipboard ("cutting") and then to insert it elsewhere ("pasting").

cyan The color blue-green. It is a primary color of subtractive mixing or a secondary color of additive mixing. Also, the complementary to red.

D

D65 The white balance standard used to calibrate monitor screens. It is used primarily for domestic television sets. White is correlated to a color temperature of 6,500 K.

daylight *1* The light that comes directly or indirectly from the sun. *2* As a notional standard, the average mixture of sunlight and skylight with some clouds, typical of temperate latitudes at around midday, and with a color temperature of between 5,400 and 5,900 K. *3* Film whose color balance is correct for light sources with a color temperature between 5,400 and 5,600 K. *4* Artificial light sources, such as light bulbs, whose color-rendering index approximates to that of daylight.

definition The subjective assessment of clarity and the quality of detail that is visible in an image or photograph.

delete *1* To render an electronic file invisible and capable of being overwritten. *2* To remove an item, such as a letter, selected block of words or cells, or a selected part of a graphic or an image.

density *1* The measure of darkness, blackening, or "strength" of an image in terms of its ability to stop light – in other words, its opacity. *2* The number of dots per unit area produced by a printing process.

depth *1* The sharpness of an image – loosely synonymous with depth of field. *2* A subjective assessment of the richness of the black areas of a print or transparency.

depth of field The measure of the zone or distance over which any object in front of a lens will appear acceptably sharp. It lies both in front of and behind the plane of best focus, and is affected by three factors: lens aperture; lens focal length; and image magnification.

depth perception The perception of the absolute or relative distance of an object from a viewer.

digital image The image on a computer screen or any other visible medium, such as a print, that has been produced by transforming an image of a subject into a digital record, followed by the reconstruction of that image.

digitization The process of translating values for the brightness or color into electrical pulses representing an alphabetic or a numerical code.

direct-vision finder (or **viewfinder**) A type of viewfinder in which the subject is observed directly – for example, through a hole or another type of optical device.

display A device – such as a monitor screen, LCD projector, or an information panel on a camera – that provides a temporary visual representation of data.

distortion, tonal A property of an image in which the contrast, range of brightness, or colors appear to be markedly different from those of subject.

dithering Simulating many colors or shades by using a smaller number of colors or shades.

d-max *1* The measure of the greatest, or maximum, density of silver or dye image attained by a film or print in a given sample. *2* The point at the top of a characteristic curve of negative film, or the bottom of the curve of positive film.

dodging A darkroom technique for controlling local contrast when printing a photograph by selectively reducing the amount of light reaching the parts of a print that would otherwise print as being too dark. The term also applies to the equivalent digital effect.

down-sampling The reduction in file size achieved when a bit-mapped image is reduced in size.

dpi Dots per inch. The measure of resolution of an output device as the number of dots or points that can be addressed or printed by that device.

driver The software used by a computer to control, or drive, a peripheral device, such as a scanner, printer, or removable media drive.

drop shadow A graphic effect in which an object appears to float above a surface, leaving a fuzzy shadow below it and offset to one side.

drop-on-demand A type of ink-jet printer in which the ink leaves the reservoir only when required. Most ink-jet printers in use today are of this type.

drum scanner A type of scanner employing a tightly focused spot of light that shines on a subject that has been stretched over a rotating drum. As the drum rotates, the spot of light traverses the length of the subject, so scanning its entire area.

duotone *1* A photomechanical printing process in which two inks are used to increase the tonal range. *2* A mode of working in image-manipulation software that simulates the printing of an image with two inks.

DVD-RAM A Digital Versatile Disc variant that carries 4.7 GB or more per side that can be written to and read from many times.

dye sublimation Printer technology based on the rapid heating of dry colorants that are held in close contact with a receiving layer. This turns the colorants to gas, which then solidifies on the receiving layer.

dynamic range The measure of spread of the highest to the lowest energy levels that can be captured or reproduced by a device, such as a scanner or film-writer.

E

email Electronic mail. Simple files that can be sent from one computer connected to the internet to another or group of computers on the internet.

edge effects Local distortions of the image density in a film due to the movement of the developer and developer products between regions of different exposure. Similar effects can be seen with some image-processing techniques.

effects filters *1* Lens attachments designed to distort, color, or modify images to produce exaggerated, unusual, or special effects. *2* Digital filters that have effects similar to their lens-attachment counterparts, but also giving effects impossible to achieve with these analog filters.

engine *1* The internal mechanisms that drive devices such as printers and scanners. *2* The core parts of a software application.

enhancement *1* Change in one or more qualities

Glossary continued

of an image, such as color saturation or sharpness, in order to improve its appearance or alter some other visual property. **2** The effect produced by a device or software designed to increase the apparent resolution of a TV monitor screen.

EPS Encapsulated PostScript. A file format that stores an image (graphics, photograph, or page lay-out) in PostScript page-description language.

erase To remove, or wipe, a recording from a disk, tape, or other recording media (usually magnetic) so that it is impossible to reconstruct the original record.

EV Exposure Value. A measure of camera exposure. For any given EV, there is a combination of shutter and apertures settings that gives the same camera exposure.

exposure *1* A process whereby light reaches light-sensitive material or sensor to create a latent image. *2* The amount of light energy that reaches a light-sensitive material.

exposure factor The number indicating the degree by which measured exposure should be corrected or changed in order to give an accurate exposure.

F

f/numbers Settings of the diaphragm that determine the amount of light transmitted by a lens. Each f/number is equal to the focal length of the lens divided by diameter of the entrance pupil.

fade The gradual loss of density in silver, pigment, or dye images over time.

fall-off *1* The loss of light in the corners of an image as projected by a lens system in, for example, a camera or a projector. *2* The loss of light toward the edges of a scene that is illuminated by a light source whose angle of illumination is too small to cover the required view. *3* The loss of image sharpness and density away from the middle of a flatbed scanner whose array of sensors is narrower than the width of the scanned area.

false color A term usually applied to images with an arbitrary allocation of color to wavebands – for example, with infrared-sensitive film.

feathering The blurring of a border or boundary by reducing the sharpness or suddenness of the change in value of, for example, color.

file format A method or structure of computer data. It is determined by codes – for example, by indicating the start and end of a portion of data

together with any special techniques used, such as compression. File formats may be generic – shared by different software – or native to a specific software application.

fill-in *1* To illuminate shadows cast by the main light by using another light source or reflector to bounce light from the main source into the shadows. *2* A light used to brighten or illuminate shadows cast by the main light. *3* To cover an area with color – as achieved by using a Bucket tool.

film gate The physical aperture in a camera that lies close to the film and masks the image projected by the lens. Its size defines the shape and size of the image that is recorded on the film.

filter *1* An optical accessory used to remove a certain waveband of light and transmit others. *2* Part of image-manipulation software written to produce special effects. *3* Part of application software that is used to convert one file format to another. *4* A program or part of an application used to remove or to screen data – for example, to refuse email messages from specified sources.

fingerprint Marking in a digital image file that is invisible and that survives all normal image manipulations, but one that can still be retrieved by using suitable software.

FireWire The standard providing for rapid communication between computers and devices, such as digital cameras and CD writers.

fixed focus A type of lens mounting that fixes a lens at a set distance from the film. This distance is usually the hyperfocal distance. For normal to slightly wide-angle lenses, this is at between 6½ and 13 ft (2 and 4 m) from the camera.

flare Non-image-forming light in an optical system.

flash *1* To provide illumination using a very brief burst of light. *2* To reduce contrast in a light-sensitive material by exposing it to a brief, overall burst of light. *3* The equipment used to provide a brief burst, or flash, of light. *4* The type of electronic memory that is used in, for example, digital cameras.

flat *1* Denoting a low-contrast negative or print in which gray tones only are seen. *2* The lighting or other conditions that tend to produce evenly lit or low-contrast image results.

flatbed scanner A type of scanner employing a set of sensors arranged in a line that are focused, via mirrors and lenses, on a subject placed face

down on a flat glass bed facing a light source. As the sensors traverse the subject, they register the varying light levels reflected off the subject.

flatten To combine multiple layers and other elements of a digitally manipulated or composited image into one. This is usually the final step of working with Layers prior to saving an image in a standard image format; otherwise, the image must be saved in native format.

focal length For a simple lens, the distance between the center of the lens and the sharp image of an object at infinity projected by it.

focus *1* Making an image look sharp by bringing the film or projection plane into coincidence with the focal plane of an optical system. *2* The rear principal focal point. *3* The point or area on which, for example, a viewer's attention is fixed or compositional elements visually converge.

fog Non-image-forming density in a film or other light-sensitive material.

font A computer file describing a set of letter forms for display on a screen or used for printing.

foreground *1* The part of scene or space around an object that appears closest to the camera. *2* The features in a photographic composition that are depicted as being nearest the viewer.

format *1* The shape and dimensions of an image on a film as defined by the shape and dimensions of the film gate of the camera in use. *2* The dimensions of paper on which an image is printed. *3* The orientation of an image: for example, in a landscape format the image is orientated with its long axis running horizontally, while in a portrait format the image is orientated with its long axis running vertically.

fractal A curve or other object whose smaller parts are similar to the larger parts. In practice, a fractal displays increasing complexity as it is viewed more closely and the details bear a similarity to the whole.

frame *1* A screen's worth of information. *2* An image in a sequence replicating movement.

G

gamma 1 In photography, a measure of the response of a given film, developer, and development regimen to light – for example, a high contrast results in a higher gamma. *2* In monitors, a measure of the correction to the color signal prior to its projection on the screen. A high gamma gives a darker overall screen image.

GIF Graphic Interchange Format. This is a compressed file format designed for use over the internet. It uses 216 colors.

grain *1* In film, it is the individual silver (or other metal) particles that make up the image of a fully developed film. In the case of color film, grain comprises the individual dye-clouds of the image. *2* In a photographic print, it is the appearance of the individual specks comprising the image. *3* In paper, it is the texture of its surface.

graphics tablet An input device allowing fine or variable control of the image appearance in an image-manipulation program. The tablet is an electrostatically charged board connected to the computer. It is operated using a pen, which interacts with the board to provide location information, and instructions are issued by providing pressure at the pen-tip.

grayscale The measure of the number of distinct steps between black and white that can be recorded or reproduced by a system. A grayscale of two steps permits the recording or reproduction of just black or white. The Zone System uses a grayscale of ten divisions. For normal reproduction, a grayscale of at least 256 steps, including black and white, is required.

greeking The representation of text or images as gray blocks or other approximations.

H

half-tone cell The unit used by a half-tone printing or reproduction system to simulate a grayscale or continuous-tone reproduction. In off-set lithography, the half-tone cell is defined by the screen frequency: continuous tone is simulated by using dots of different sizes within the half-tone cell. With desktop printers, the half-tone cell consists of groups of individual laser or ink-jet dots.

hard copy A visible form of a computer file printed more or less permanently onto a support, such as paper or film.

highlights The brightest (whitest) values in an image or image file.

hints Artificial intelligence built into outline fonts, to turn elements of a font on or off according to the size of the font. Intended to improve legibility and design.

Glossary continued

histogram A statistical, graphical representation showing the relative numbers of variables over a range of values.

HLS Hue, Lightness, Saturation. A color model that is good for representing a visual response to colors, one that is not satisfactory for other color reproduction systems. It has been largely superseded by the LAB model.

hot-pluggable A connector or interface, such as USB or FireWire, that can be disconnected or connected while the computer and machine are powered up.

hue The name given to the visual perception of a color.

I

IEEE 1394 A standard providing for the rapid communication between computers and devices, and between devices without the need for a computer, such as between digital cameras and CD writers. It is also known as FireWire and iLink.

image aspect ratio The comparison of the depth of an image to its width. For example, the nominal 35 mm format in landscape orientation is 24 mm deep by 36 mm wide, so the image aspect ratio is 1:1.5.

indexed color A method of creating color files or defining a color space based on a table of colors chosen from 16 million different colors. A given pixel's color is then defined by its position, or index, in the table (also known as the "color look-up table").

ink-jet Printing technology based on the controlled squirting of extremely tiny drops of ink onto a receiving layer.

intensity *1* A measure of energy, usually of light, radiated by a source. *2* A term loosely used to refer to the apparent strength of color, as in inks or the colors of a photograph.

interpolation The insertion of pixels into a digital image based on existing data. It is used to resize an image file – for example, to give an apparent increase in resolution, to rotate an image, or to animate an image.

J

jaggies The appearance of stair-stepping artifacts.

JPEG Joint Photographic Expert Group. A data-compression technique that reduces file sizes with loss of information.

K

k *1* An abbreviation for kilo, a prefix denoting 1,000. *2* A binary thousand: in other words, 1024, as used, for example, when 1024 bytes is abbreviated to KB. *3* Key ink or blacK – the fourth color separation in the CMYK four-color print reproduction process.

Kelvin A unit of temperature that is relative to absolute zero, and is used to express color temperature.

kernel A group of pixels, usually a square from 3 pixels up to 60, that is sampled and mathematically operated on for certain image-processing techniques, such as noise reduction or image sharpening.

key tone *1* The black in a CMYK image. *2* The principal or most important tone in an image, usually the mid-tone between white and black.

keyboard shortcut Keystrokes that execute a command.

L

layer mode A picture-processing or image-manipulation technique that determines the way that a layer, in a multilayer image, combines or interacts with the layer below.

light *1* That part of the electromagnetic spectrum, from about 380–760 nm, that stimulates the receptors of the retina of the human eye, giving rise to normal vision. Light of different wavelengths is perceived as light of different colors. *2* To manipulate light sources to alter the illumination of a subject.

light box A viewing device for transparencies and films consisting of a translucent, light-diffusing top illuminated from beneath by color-corrected fluorescent tubes in order to provide daylight-equivalent lighting.

lightness The amount of white in a color. This affects the perceived saturation of a color: the lighter the color, the less saturated it appears to be.

line art Artwork that consists of black lines and black and white areas only, with no intermediate gray tones present.

load To copy enough of the application software

into a computer's RAM for it to be able to open and run the application.

lossless compression A computing routine, such as LZW, that reduces the size of a digital file without reducing the information in the file.

lossy compression A computing routine, such as JPEG, that reduces the size of a digital file but also loses information or data.

lpi Lines per inch. A measure of resolution or fineness of photomechanical reproduction.

LZW Lempel-Ziv Welch compression. A widely used computer routine for lossless file compression of, for example, TIFF files.

M

Mac Commonly used term for Apple Macintosh computers and its operating system (OS).

macro *1* The close-up range giving reproduction ratios within the range of about 1:10 to 1:1 (life size). *2* A small routine or program within a larger software program that performs a series of operations. It may also be called "script" or "action."

marquee A selection tool used in image-manipulation and graphics software.

mask A technique used to obscure selectively or hold back parts of an image while allowing other parts to show.

master *1* The original or first, and usually unique, incarnation of a photograph, file, or recording: the one from which copies will be made. *2* To make the first copy of a photograph, file, or recording.

matrix The flat, two-dimensional array of CCD sensors.

matte *1* The surface finish on paper that reflects light in a diffused way. *2* A box-shaped device placed in front of camera lens to hold accessories. *3* A board whose center is cut out to create a window to display prints. *4* A mask that blanks out an area of an image to allow another image to be superimposed.

megapixel A million pixels. A measure of the resolution of a digital camera's sensor – For example, a 6-megapixel camera has a 6-megapixel sensor.

moiré A pattern of alternating light and dark bands or colors caused by interference between two or more superimposed arrays or patterns, which differ in phase, orientation, or frequency.

monochrome A photograph or image made up of black, white, and grays, which may or may not be tinted.

N

native *1* The file format belonging to an application program. *2* An application program written specifically for a certain type of processor.

nearest neighbor The type of interpolation in which the value of the new pixel is copied from the nearest pixel.

node *1* A computer linked to others in a network or on the internet. *2* A word or short phrase that is linked to other text elsewhere in a hypertext document.

noise Unwanted signals or disturbances in a system that tend to reduce the amount of information being recorded or transmitted.

Nyquist rate The sampling rate needed to turn an analog signal into an accurate digital representation. This rate is twice the highest frequency found in the analog signal. It is applied to determine the quality factor relating image resolution to output resolution: pixel density should be at least 1.5 times, but not more than 2 times, the screen ruling. For example, for a 133 lpi screen, resolution should be between 200 and 266.

O

off-line A mode of working with data or files in which all required files are downloaded or copied from a source to be accessed directly by the user.

on-line A mode of working or operating with data or files in which the operator maintains continuous connection with a remote source.

operating system The software program, often abbreviated to OS, that underlies the functioning of the computer, allowing applications software to use the computer.

optical viewfinder A type of viewfinder that shows the subject through an optical system, rather than via a monitor screen.

out-of-gamut The color or colors that cannot be reproduced in one color space but are visible or reproducible in another.

output *1* The result of any computer calculation – any process or manipulation of data. Depending on the context, output may be in the form of new

Glossary continued

data, a set of numbers, or be used to control an output device. *2* A hard-copy print-out of a digital file, such as an ink-jet print or separation films.

P

paint To apply color, texture, or an effect with a digital Brush or the color itself.

palette *1* A set of tools, colors, or shapes that is presented in a small window of a software application. *2* The range or selection of colors available to a color-reproduction system.

peripheral A device, such as a printer, monitor, scanner, or modem, connected to a computer.

Photo CD A commercial system of digital-image management based on the storage of image files on CDs, which can be played back on most types of CD players.

photodiode A semiconductor device that responds very quickly and proportionally to the intensity of light falling on it.

photograph A record of physical objects, scenes, or phenomena made with a camera or other device, through the agency of radiant energy, on sensitive material from which a visible image may be obtained.

photomontage A photographic image made from the combination of several other photographic images.

PICT A graphic file format used in the Mac OS.

pixel The smallest unit of digital imaging used or produced by a given device.

pixelated The appearance of a digital image whose individual pixels are clearly discernible.

platform The type of computer system, defined by the operating system used – for example, the Apple Macintosh platform uses the Mac OS.

plug-in Application software that works in conjunction with a host program into which it is "plugged," so that it operates as if part of the program itself.

posterization The representation of an image using a relatively small number of different tones or colors, which results in a banded appearance in flat areas of color.

PostScript A programming language that specifies the way in which elements are output: it uses the full resolution of the output device.

ppi Points per inch. The number of points that are seen or resolved by a scanning device per linear inch.

prescan In image acquisition, it is a quick view of the object to be scanned, taken at a low resolution for the purposes of, for example, cropping.

primary color One of the colors – red, green, or blue – to which the human eye has a peak sensitivity.

process colors Colors that can be reproduced with the standard web offset press (SWOP) inks of cyan, magenta, yellow, and black.

proofing The process of checking or confirming the quality of a digital image before final output.

Q

quality factor The multiplication factor – usually between 1.5 and 2 times the screen frequency – used to calculate a file size that is sufficient for good-quality reproduction.

QuickDraw An object-oriented graphics language native to the Mac OS.

R

RAM Random Access Memory. The component of a computer in which information can be temporarily stored and rapidly accessed.

raster The regular arrangement of addressable points of any device, such as scanner, digital camera, monitor, printer, or film writer.

read To access or take off information from a storage device, such as a hard disk, Zip disk, or CD-ROM.

resizing Changing the resolution or file size of an image.

refresh rate The rate at which one frame of a computer screen succeeds the next. The more rapid the rate, the more stable the monitor image appears.

res The measure of the resolution of a digital image expressed as the number of pixels per side of a square measuring 1 x 1 mm.

RGB Red Green Blue. A color model that defines colors in terms of the relative amounts of red, green, and blue components they contain.

RIP Raster Image Processor. Software or hardware dedicated to the conversion of outline fonts and vector graphics into rasterized information – in other words, it turns outline instructions such as "fill" or "linejoin" into an array of dots.

S

scanner An optical-mechanical instrument that is used for the analog-to-digital conversion, or digitization, of film-based and printed material and artwork.

scanning The process of using a scanner to turn an original into a digital facsimile – in other words, a digital file of specified size.

screengrab An image file of the monitor display or part of it. Also called a screenshot.

scrolling The process of moving to a different portion of a file that is too large for it all to fit onto a monitor screen.

SCSI Small Computers Systems Interface. A standard for connecting devices, such as scanners and hard disks, to computers.

shadows The dark (or black) areas of an image or digital image.

soft proofing The use of a monitor screen to proof or confirm the quality of an image.

stair-stepping A jagged or steplike reproduction of a line or boundary that is, in fact, smooth.

subtractive color synthesis Combining of dyes or pigments to create new colors.

SWOP Standard Web Offset Press. A set of inks used to define the color gamut of CMYK inks used in the print industry.

system requirement The specification defining the minimum configuration of equipment and operating system needed to run application software or a device. It usually details the type of processor, amount of RAM, free hard-disk space, oldest version of the operating system, and, according to the software, any specifically needed device.

T

thumbnail The representation of an image in a small, low-resolution version.

TIFF Tag Image File Format. A widely used image file format that supports up to 24-bit color per pixel. Tags are used to store such image information as dimensions.

tile *1* A subsection or part of a larger bit-mapped image. It is often used for file-storage purposes and for image processing. *2* To print in small sections a page that is larger than the printing device is able to output.

tint *1* Color that is reproducible with process colors; a process color. *2* An overall, usually light,

coloring that tends to affect areas with density but not clear areas.

transparency *1* Film in which the image is seen by illuminating it from behind – color transparency film, for example. Also known as a slide. *2* The degree to which background color can be seen through the foreground layer.

transparency adapter An accessory light source that enables a scanner to scan transparencies.

TWAIN A standardized software "bridge" used by computers to control scanners via scanner drivers.

U

undo To reverse an editing or similar action within application software.

upload The transfer of data between computers or from a network to a computer.

USB Universal Serial Bus. A standard for connecting peripheral devices, such as a digital camera, telecommunications equipment, or a printer, to a computer.

USM UnSharp Mask. An image-processing technique that has the effect of improving the apparent sharpness of an image.

V

variable contrast A coating formula that mixes emulsions of different speeds and sensitivities to light, with the effect that the mid-tone contrast can be varied by changing the spectral qualities of the illumination.

vignetting *1* A defect of an optical system in which light at the edges of an image is cut off or reduced by an obstruction in the system's construction. *2* Deliberately darkened corners – used to help frame an image or soften the frame outline.

VRAM Video Random Access Memory. Rapid-access memory that is dedicated for use by a computer or graphics accelerator to control the image on a monitor.

W

warm colors A subjective term referring to reds, oranges, and yellows.

watermark *1* A mark left on paper to identify the maker or paper type. *2* An element in a digital image file used to identify the copyright holder.

write To commit or record data onto a storage medium, such as a CD-R or hard disk.

www.resources

NEWS, INFORMATION, REVIEWS

www.allthingsphoto.com
All Things Photo is a mixed bag of many resources – essentially a rich portal to photography sites.

www.bjphoto.co.uk
Extensive site with up-to-date news, this is an excellent source of links and current photography, and is constantly updated.

www.dpreview.com
Digital Photography Review: up-to-date, highly detailed and informative reviews of digital cameras, as well as news and information. Excellent.

www.internetbrothers.com/phototips.htm
Basic information and advice on digital photography presented in a simple way.

www.megapixel.net
The Megapixel site offers good information and a mix of news, reviews, and retailer links.

www.shutterbug.net
Wide-ranging photography resource run by the great eponymous magazine with a section on digital photography. Excellent source.

www.totaldp.com
News, information, reviews, sample images from review cameras, and a good set of links.

www.zonezero.com
A superb site offering a mixture of photography and digital photography, electronic books, and debates. Text in English and Spanish. A must-visit site.

COPYRIGHT SITES

www.benedict.com
Wide coverage of copyright issues with relevant case law: it is heavily US-biased since much new law is being created in the American legal system.

www.intelproplaw.com
The Intellectual Property Law server contains useful material on copyright, patents, designs, and so on.

www.tilj.com
The Internet Law Journal site is an excellent source of changes in law and cases relating to internet law in general, much of it useful to photographers.

PORTFOLIO SITES

www.fotango.com
Photo-processing services and a site that hosts portfolios of images free of charge. It also provides other services.

www.printroom.com
Free membership makes on-line albums available for private (password-protected) or public viewing. Prints can be ordered from the site.

www.smugmug.com
Low-cost portfolio hosting in a straightforward site, offering password-protected access if required.

TECHNICAL INFORMATION

While technical information is easy to obtain on the internet, the quality can be variable. Visit the manufacturer of your equipment or software before deciding to visit any others – some are very informative.

www.dcresource.com
Reviews, sample images, and buyers' guides to digital cameras.

www.dpcorner.com
General information on digital photography and cameras, glossary, and features on photographers.

www.ephotozine.com
A rich site aimed at film-based photography as well as digital photography, together a mixture of reviews, news, and galleries.

www.imaging-resource.com
Well-run and reliable site combining how-to features with product news (cameras, scanners, and printers), up-to-date reviews, a useful photo-lessons section, and a newsletter. Useful Getting Started features.

www.photodo.com
An eccentric site notable for its wide range of detailed lens tests – it is a useful basis for shopping once you learn how to read the charts. Also offers a range of links as well as some highly technical articles.

www.shortcourses.com
A sound educational site introducing and elaborating on many aspects of digital photography, with links to other resources. Packed with excellent-quality material. Recommended.

Panoramas

www.panoguide.com
An excellent specialist site devoted to the creation of panoramas, covering equipment, techniques, and software. Also features a gallery.

Ink-jet
www.epson.com
Helpful technical guides for troubleshooting your printer and how to obtain the best results.
www.inkjetmall.com
Resources, techniques, products, and services relating to ink-jet products.
www.piezography.com
Leading source of inks for black and white photography, with sound technical support.
www.wilhelm-research.com
Reports of tests on inks and papers to help judge quality, longevity, and other attributes. Essential.

Underwater photography
www.aquapac.co.uk
Suppliers of underwater housings for cameras, with Webzine.
www.wetpixel.com
Information for underwater digital photography, including specialist equipment, diving updates, and portfolios of images.

Photojournalism
www.digitaljournalist.org
A first-rate site with excellent features by leading photographers, a superb gallery of modern photojournalism. Must be visited.
www.foto8.com
A showcase of the work of young photojournalists. Worth supporting.
www.robgalbraith.com
An invaluable site by the guru of digital photo-journalism, offering technical information and plenty of links to the latest information and software upgrades.

Web authoring
http://builder.com.com
This site is packed with information on all things Web for the more advanced user: maintenance, design, news, resources, programming, and more.
http://hotwired.lycos.com/webmonkey
Web Monkey: an excellent site for help with creating Web sites, Web graphics and technologies. Invaluable.
www.webreference.com/graphics
Covers a range of relevant issues from scanning and formats to animation. Also has excellent links.

www.wpdfd.com/wpdhome.htm
Web-page design written for designers but valuable to all: updated monthly with excellent links and a good reference section.

SOFTWARE ON THE INTERNET
See also pages 396–7 to reach Web sites for commercial software.
www.creativepro.com
Provides tools for finding fonts and stock photography.
www.lemkesoft.de
Contains GraphicConverter – an excellent yet inexpensive software for image conversion and basic manipulations. Also available is FontBook, which can be used for printing out font samples.
www.moochers.com
General collection of freeware utilities, including those suitable for viewing images, basic manipulation, format conversion, and so on.
www.versiontracker.com
Add /macos or /windows after the above address to reach the best site for keeping up-to-date with software for your computer.

ON-LINE IMAGE EDITING
http://playground.kodak.com
www.gifworks.com
www.myimager.com
These three sites allow you to edit images for the Web without owning your own image-manipulation software. Obviously it is not as fast as working with the application on your own computer, so files should be kept small to start with. The sites are also full of image-editing hints and help, as well as tips on digital photography and graphics.

RESOURCES FOR THE DISABLED
http://joeclark.org/access/
www.microsoft.com/enable
http://store.prentrom.com/
www.madentec.com/
The first two sites offer information for the disabled. The others detail and offer for sale adaptive technologies, such as those designed to improve accessibility of computing to those with disabilities. These include voice-activated commands, being able to hear Braille and text documents, adapting keystrokes, and so on.

Picture sources

Thanks to two parallel developments – the World Wide Web and the universal adoption of the CD-ROM on computers – it is easier than ever before to access reproduction-quality images. The total number of pictures available runs into the millions, if only because some of the largest of the agencies now have their collections in electronic form. Listed below is a selection for different categories of usage and rights-management.

FREE IMAGES

Many sites offer free images to be used for personal purposes, such as screen savers, or to practice image-manipulation techniques. Many search engines, such as Yahoo!, Google, and AltaVista, can be set to look for images according to keywords. Beware that if you find an image this way, copyright notices may not be obvious, nor can you assume the Web-site owner has permission to use the image: if you were to download it, you could be infringing copyright. Many research institutions and museums are good sources for great images.

ROYALTY-FREE IMAGES

Once you pay for the CD or downloaded image, you have no further fees to pay for unlimited use. However, some contracts require you to pay an extra amount of money if the image is used for marketing purposes, such as a book cover or other form of packaging.

DigitalVision Wide range of subjects with images in a range of sizes, some up to 75 MB, available on CD, also on-line: **www.digitalvision.ltd.uk**

FotoSearch Check out more than 30 sites from one portal at **www.fotosearch.com**, covering video clips and clip art as well.

GettyOne Huge collection on CDs, with large printed catalogs, and tens of thousands of images available on-line: **http://creative.gettyimages.com/**

Stockbyte Specializing in still-life images of objects and people in a variety of poses. Available on-line as well as on CD. **www.stockbyte.com**

OTHER IMAGE SOURCES

http://images.jsc.nasa.gov
The Johnson Space Center digital image collection is an astonishing collection – it contains hundreds of thousands of images for you to peruse and enjoy. An absolute must-see site.

www.fotki.com
Rich and lively site for checking on what other photographers are up to, with useful "most-visited members" list. You can join and add your own photo album for others to view too. Also retail links.

ON-LINE PRINTING

The following offer printing services to customers who either download image files or send in their film or images on removable media. But this is only the core of the service: several sites allow registered customers to manage their own album to store images so that others may view the pictures. Check on postal costs if the printing service is based in a different country from the one you reside in. Note, however, that a site may require the download of a small application: check whether it is compatible with your computer's operating system.

www.agfanet.com
Lively print-service site that also offers guides on photography, useful links, and software reviews.

www.bonusprint.com
Extensive services for both film and digital image printing with an international presence.

www.cartogra.com
Prints made on Kodak Professional paper on a step-by-step site run by Hewlett-Packard.

www.fotango.com
Users with their own Web sites can use script supplied by Fotango to make it easy for visitors to order hard-copy prints (mouse mat, mug, and so on) – with printing handled by Fotango.

www.ofoto.com
On-line printing and shopping for albums, cards, and frames. Newsletter from Kodak.

WEB PRESENCE PROVIDERS (WPPS)

The cheapest way (it's free!) to have a Web presence is to use the album-sharing facilities of on-line printing services. However, Web space is inexpensive for noncommercial use, and some WPPs offer free space as part of a package of services. Be aware that by using the service, you may lose some control over your images and there may also be limits on the level of traffic allowed. Check before uploading any files. For listings of some WPPs look up: **www.hostpile.com**, **www.hostinghound.com**, and **www.hostingstart.com**. For advice on how to choose a provider, try **www.4w.com/wpp.html**

Manufacturers

Many of the multinational manufacturers provide different Web sites for each of their sales regions. It may be worth visiting those outside your region, since the quality and information can vary greatly between sites: some, for example, may simply offer pages of their product catalogs, while others are a rich resource of practical and technical tips, as well as giving product information. The following is a selected list of photographic manufacturers: it is well worth visiting these, since many contain much useful general information.

EQUIPMENT MANUFACTURERS

Agfa Digital cameras, scanners, film
www.agfa.com

Apple Computers, displays
www.apple.com

Belkin Products for connecting devices, including card readers and computer accessories
www.belkin.com

Canon Cameras and lenses and accessory system, digital cameras, printers, scanners
www.canon.com

Casio Digital cameras
www.casio.com

Contax Digital and film cameras: *see* Kyocera

Epson Printers, digital cameras, scanners, as well as driver downloads
www.epson.com

Formac Monitors, media drives, and converters
www.formac.com

Fuji Digital, film, and medium-format cameras
www.fujifilm.com

HandSpring Personal Data Assistants (organizers) and accessories
www.handspring.com

Hasselblad Medium-format cameras with lenses and accessory system
www.hasselblad.com

Heidelberg Scanners, fonts, color software
www.heidelberg.com

Hewlett-Packard Printers, ink-jet papers, scanners, digital cameras, computers
www.hp.com

Jobo Digital scanning camera backs, darkroom and other accessories
www.jobo.com

Kodak Digital cameras, film cameras, film, printers
www.kodak.com

Konica Digital cameras, film cameras
www.konica.com

Kyocera Digital and film cameras
http://global.kyocera.com

LaCie Storage drives and media, displays
www.lacie.com

Leica Cameras, lenses, and accessory system
www.leica.com

Lexar Memory cards and readers for digital cameras
www.digitalfilm.com

Lexmark Printers
www.lexmark.com

Microtek Scanners
www.microtek.com

Minolta Cameras and lenses and accessory system, digital cameras, film scanners
www.minolta.com

Nikon Cameras and lenses and accessory system, digital cameras, film scanners
www.nikon.com

Nixvue Digital album for computerless storage
www.nixvue.com

Olympus Cameras and lenses, digital cameras, printers, removable storage
www.olympus.com

Panasonic Digital cameras and electronic devices
www.panasonic.com

Pentax Cameras and lenses, digital cameras, medium-format cameras and lenses
www.pentax.com

Ricoh Digital and conventional cameras
www.ricoh.com

Rollei Compact AF 35 mm and digital cameras, superb medium-format cameras and lenses
www.rollei.de

Samsung Digital cameras and camera phones
www.samsung.com

SanDisk Memory cards, photo viewers, card readers.
www.sandisk.com

Sigma Digital SLR cameras and lenses
www.sigmaphoto.com

SmartDisk Storage devices and media readers
www.smartdisk.com

Sony Digital cameras, computers, accessories, devices
www.sony.com

Toshiba Digital cameras and electronic devices
www.toshiba.com

Umax Scanners
www.umax.com

Software sources

IMAGE-MANIPULATION SOFTWARE

Despite the dominance of Photoshop, there are
many software applications capable of producing
excellent results. The simpler programs are more
suitable for the beginner or if you don't wish to
commit a large amount of time to learning how to
use the software.

Photoshop

The all-out standard application thanks to
professional features such as color control and a
vast range of features. However, it is difficult to
master and at its best when used on powerful
computers with large RAM installations. For Mac
OS and Windows.

> www.adobe.com

Photoshop Elements

An extremely capable image-manipulation
application that is easy to use. For Mac OS and
Windows.

> www.adobe.com

Digital Image Suite

Good batch-processing abilities with numerous
templates and images included.

> www.microsoft.com

Painter

Enormous range of Brush tools with highly
controllable painting effects available, as well as
powerful cloning tools. Provides an excellent
supplement to Photoshop.

> www.corel.com

PaintShop Pro

Affordable, powerful software with good Layers
features, able to meet most requirements, including
work intended for the Web. Windows only.

> www.jasc.com

PhotoImpact

Very good range of tools that are strong on features
for Web imagery, in an affordable package that is
easy to use. Layers-based work is cumbersome.

> www.ulead.com

PhotoPaint

Powerful and comprehensive features with good
Layers and cloning features. Usually part of
CorelDraw suite of graphics applications but is also
available as an affordable, stand-alone program.

> www.corel.com

PhotoSuite

Inexpensive, tutorial-based software with a good
range of tools and Layers handling, together with
good functions for Web work.

> www.roxio.com

Satori PaintFX

Vector-based painting program of great power and
flexibility, but tricky to learn and expensive to buy.
Windows only.

> www.satoripaint.com

PHOTOSHOP PLUG-INS

Plug-in software adds functions to the prime
software, appearing in its own dialog box for
settings to be made. Many of these will work with
applications – such as Painter, which accepts
Photoshop-compatible plug-ins. Check with the
supplier prior to purchase.

Alien Skin Eye Candy

With more than 20 different filters to create a wide
range of effects, this is an excellent introduction for
filter enthusiasts – and easy to use.

Alien Skin Image Doctor

Useful tools for correcting image defects plus
powerful cloning techniques.

Alien Skin Xenofex

Wide range of highly controllable effects, such as
adding elements or distorting the image.

> www.alienskin.com

Andromeda

Varied range of plug-ins, including 3D wrap
images, vari-focus, and perspective.

> www.andromeda.com

Extensis Intellihance

Automatic enhancement of images through color
balance, saturation, sharpness, and contrast.

Extensis Mask Pro

Effective and powerful tool for extracting images
from backgrounds.

Extensis Photoframe

Quick and versatile method of creating custom
frames to images, with a large collection of designs.

> www.extensis.com

Knoll Lens Flare Professional

Extends Photoshop's lens flare filter for impressive
effects, but it is limited to this one trick.

> www.pinnaclesys.com

Paint Alchemy

Wide range of paint textures can be produced easily and controllably – far superior to Photoshop's range and worth investigating.

Terrazzo

Creates tesselated patterns, sometimes of great beauty, from any image – well worth investigating.

www.xaostools.com

DESIGN AND OTHER SOFTWARE

BBEdit

HTML editor beloved of experts working on Mac OS and containing many useful features. The Lite version is available as freeware.

www.barebones.com

Binuscan PhotoRetouch

Powerful image-retouching program with excellent color-correction features. Superior in many ways to Photoshop.

www.binuscan.com

Dreamweaver

Professional, full-featured software for designing Web pages and managing Web sites. For Mac OS and Windows.

www.macromedia.com

Flash

Powerful software for drawing, animation, and multimedia creation. Flash animation is widely readable on the internet. For Mac OS and Windows.

www.macromedia.com

FotoStation

Simple and effective tool for creating sets of pictures and management, with multiple printing and Web-page-output options. For Mac OS and Windows.

www.fotostation.com

FrontPage

Fairly easy-to-use software for the creation of Web pages, but it lacks the power features for top-quality designs. Windows only.

www.microsoft.com

Genuine Fractals

Powerful image-compression utility that helps save space but also gives superb file enlargements.

www.lizardtech.com

GoLive

Industrial-strength design tool for Web-page and Web-site management with a full range of features, but difficult to learn. For Mac OS and Windows.

www.adobe.com

InDesign

Very powerful page-design software with excellent feature set, but difficult to learn and demanding on computer resources. For Mac OS and Windows.

www.adobe.com

Photo Album

Picture-management software that can burn CDs, optimize for email, and perform other tasks.

www.jasc.com

Portfolio

Powerful tool for the management of picture libraries with the ability to publish on the internet, and has search facilities. Suitable for use over networks but can be slow. For Mac OS and Windows.

www.extensis.com

QuarkXPress

Industry-standard software for page design. It can be made very powerful with extension software and is relatively easy to learn. However, it is expensive to buy and can be unreliable. For Mac OS and Windows.

www.quark.com

Retrospect

Widely adopted backup software – not the most straightforward to use, but appears reliable.

www.dantz.com

S-Spline

Powerful and easy-to-use software for enlarging images.

www.shortcut.nl

VueScan

An independent scanner driver supporting the majority of flatbed and film scanners. In many cases superior to the manufacturer's own efforts.

www.hamrick.com

Further reading

Specialist publishers of books on software and computing such as Peachpit, IDG, New Riders, and Que can be relied on to produce books of good to excellent quality, which go far beyond software instruction manuals.

Ang, Tom, *Silver Pixels*, Argentum, London, UK (ISBN 1 902538 04 8), published by Amphoto in the United States
An introduction to the digital darkroom, showing how digital techniques can mimic the darkroom techniques of print-making. Has several useful technical sections.

Ang, Tom, *Dictionary of Digital Photography & Digital Imaging*, Argentum, London, UK (ISBN 1 902538 13 7), published by Amphoto in the United States
A comprehensive listing of technical terms used in conventional and digital photography, with explanations ranging from imaging sciences and the internet, to publishing and computing. It is of use to all digital photographers, with easy-to-understand explanations that are suitable for beginners as well as experts.

Ang, Tom, *Digital Photography*, Mitchell Beazley, London, UK (ISBN 1 84000 178 X), published by Amphoto in the United States
A general introduction aimed at bridging the gap between traditional and digital photography, containing numerous photographs and workshop examples produced by masters of image-manipulation techniques.

Burckholder, Dan, *Making Digital Negatives for Contact Printing*, Balded Iris Press, Texas (ISBN 0 9649638 3 3)
A step-by-step guide on the subject and essential reference for the advanced darkroom worker.

Cotton, Bob and Richard Oliver, *The Cyberspace Lexicon: an illustrated dictionary of terms*, Phaidon, London, UK (ISBN 0 7148 3267 7)
Its numerous illustrations and hyperactive layout combine to make this a restless read, but it is a valuable visual source in its own right. Well worth dipping into, and it is hard not to learn something new from the experience.

Evening, Martin, *Adobe Photoshop 6.0 for Photographers*, Focal Press, Oxford, England (ISBN 0 240 51633 8)
Though not a lively read, this book's production-oriented approach to Photoshop benefits photographers. It is well illustrated with numerous screen shots and contains useful techniques that are hard to find elsewhere. Some of the basics are also well covered.

Groff, Pamela, *Glossary of Graphic Communications*, Prentice Hall, New Jersey (ISBN 0 13 096410 70)
This is an excellent example of the thorough specialist glossary. The definitions provided are brief but sound.

Hansen, Brad, *The Dictionary of Multimedia Terms & Acronyms*, Fitzroy Dearborn, London, England (ISBN 1 57958 084 X)
An up-to-date book on the internet and multi-media, written with the more knowledgeable reader in mind, and with extensive appendices listing Java instructions, HTML code, and so on.

Kasai, Akira and Russell Sparkman, *Essentials of Digital Photography*, New Riders, Indianapolis (ISBN 1 56205 762 6)
A thorough and careful treatment of the subject that is suitable for experienced and advanced digital photographers. Comes with a CD-ROM containing image files.

Ladd, Eric, et al., *Using HTML 4, Java and JavaScript*, Que, California (ISBN 0 7897 1477 9)
A superlatively comprehensive reference book on all aspects of creating Web pages. Contains excellent CD resources, including several extra books.

maranGraphics, *HTML*, IDG, California (ISBN 0 7645 3471 8)
The clearest presentation around of writing HTML code for Web pages, with excellent tips and full details. This is a recommended title for all those, including beginners, wishing for a thorough grounding in the subject.

Microsoft Press, *Microsoft Press Computer Dictionary*, Microsoft Press, Redmond, Washington
A comprehensive, even-handed, and extremely useful title, which is accompanied by a searchable CD. Because this book is regularly updated, you need to look for it by title, rather than by ISBN.

Ray, Sidney F., *Photographic Imaging and Electronic Photography*, Focal Press, Oxford, England (ISBN 0 240 51389 4)
This is more encyclopedia than dictionary: it is strong where the treatment of entries can be more leisurely; however, the shorter definitions are often illuminating only to technophiles.

Ray, Sidney F., *Photographic Technology & Imaging Science*, Focal Press, Oxford, England (ISBN 0 240 51389 4)
A good book on the photographic technology side but not as strong on the imaging sciences. The lengthier entries are useful, while the shorter definitions presume technical knowledge – or demand a lot of digging around for additional explanation.

Stroebel, Leslie and Hollis N. Todd, *Dictionary of Contemporary Photography*, Morgan & Morgan, Inc., New York (ISBN 0 871000 065 2)
Safe, sound, and solid as ever from these authors: clear definitions and excellent coverage, though the book is rather hampered by its lack of depth on digital matters.

Tally, Taz, *Avoiding the Scanning Blues*, Prentice Hall, New Jersey (ISBN 0 13 087322-5)
Subtitled "a desktop scanning primer," it goes much further than this, offering good advice on scanning for pre-press preparation with step-by-step guides; however, coverage is patchy.

Wiener Grotta, Sally and Daniel Grotta, *The Illustrated Digital Imaging Dictionary*, McGraw-Hill, New York (ISBN 0 07 025069 3)
Many indulgently long-winded entries spoil what could be a useful work. Good on explanations of menu items and tools, but it is dominated by Photoshop.

Index

Index continued

Index continued

Index continued

Acknowledgments

Author's acknowledgments

My first thanks go to Judith More, for commissioning the book, and to the team at Dorling Kindersley who saw it through to completion, namely Sharon Lucas, Neil Lockley, Kevin Ryan, Simon Webb, Lee Riches, and Samantha Nunn.

Thanks to Adobe, Corel, Fotoware, Alien Skin, Binuscan, Extensis, ShortCut, TypeMaker, LizardTech, and Equilibrium for their technical assistance. To my editors at *MacFormat*, *Digital Camera Shopper*, *Digital Camera Magazine*, *Computer Arts*, *iCreate*, and *Total Digital Photography*: my warm thanks for your commissions, which keep me up to date and on my toes.

Many thanks to John Curno for permission to use the gentle images shown on pages 152–5 and to Louise Ang for her hot panorama on pages 336–7.

The greatest and deepest are my thanks to Wendy for all she has done for me. The word "all" encapsulates a universe of support, help, and inspiration which has made possible the enormous project that has been this book.

Tom Ang
London 2004

Publisher's acknowledgments

Original edition produced by: **Senior Editor:** Neil Lockley; **Senior Art Editor:** Kevin Ryan; **DTP Designer:** Sonia Charbonnier; **Production Controller:** Heather Hughes; **Managing Editor:** Sharon Lucas; **Art Director:** Carole Ash

Dorling Kindersley would like to thank the following for their contributions:
Editorial: Georgina Garner; **Design:** Derek Coombes, Simon Webb, Lee Riches, Simon Wilder, Marianne Markham, Paul Drislane, Jenisa Patel, and Janis Utton; **Index:** Ann Parry; **Picture Research:** Anna Bedewell, Samantha Nunn, Carlo Ortu; **Picture library:** Richard Dabb; **Illustrator:** Patrick Mulrey; **Model** (pp. 78–9): Jennifer Lane; and Mike Edwards, Stephanie Jackson, and Judith More.

Picture credits

The publisher would like to thank the following for their kind assistance and for permission to reproduce their photographs:
ACDSee, Adobe, Agfa UK, Louse Ang, Apple, Aquapac International Ltd, Belkin Components Ltd, Better Light Inc., M. Billingham & Co. Ltd, Bite Communications Ltd, Blitz PR, Broncolor, Calumet International, Canon UK Ltd, Casio UK, Casio Electronics Co. Ltd, Centon, Companycare Communications, Compaq UK, Contax, Corel, Andy Crawford, John Curno, Epson UK, Extensis, Firefly Communications, Fuji, Fujifilm UK, FutureWorks, Inc., Gateway, Goodmans Industries Ltd, Gossen, Hasselblad, Heidelberg USA, Hewlett-Packard, IBM, Ilford Imaging UK Ltd, Iomega, JASC, Johnsons Photopia Ltd, courtesy of Kodak, Konica Minolta Photo Imaging (UK) Ltd, Kyocera Yashica (UK) Ltd, LaCie, Leica, Lexar, Lexmark, Linho, Linhof, Logitech Europe SA, Lowepro UK Ltd, Macromedia Europe, Mamiya, Manfrotto, Megavision, Mesh, Metz, Microsoft, Microtek, Mitsubishi, Nikon UK Ltd, Nikkor, Nixvue Systems, Nokia, Olympus UK Ltd, Packard Bell, Panasonic Industrial Europe Ltd, Peli Cases, Pentax UK Ltd, Phillips, Ricoh EPMMC UK, Rollei, Roxio, Sigma Corporation, Smartdisk Europe, Sony United Kingdom Ltd, Tamrom UK, Tenba Quality Cases, Tokina, Ulead, Umax, Wacom.

All other images © Dorling Kindersley. For further information, see **www.dkimages.com**

Jacket picture credits
Front: Getty Images: Gary Holscher (t, bl), Michael Busselle (tl). **Author photo:** Carolyn Watts